Yale Studies in English, 194

Ruskin and the Rhetoric of Infallibility

Gary Wihl

Yale University Press: New Haven and London

Designed by Sally Harris
and set in Janson type by
Brevis Press, Bethany, Connecticut.
Printed in the United States of America by
Murray Printing Company, Westford, Massachusetts.

Library of Congress Cataloging in Publication Data

Wihl, Gary, 1953–
 Ruskin and the rhetoric of infallibility.

 (Yale studies in English; 194)
 Bibliography: p.
 Includes index.
 1. Ruskin, John, 1819–1900—Criticism and
interpretation. 2. Art criticism—England.
I. Title. II. Series.
PR5264.W6 1985 828'.809 85–5310
ISBN 0–300–03321–4 (pbk.: alk. paper)

The paper in this book meets the guidelines for
permanence and durability of the Committee on
Production Guidelines for Book Longevity
of the Council on Library Resources.

10 9 8 7 6 5 4 3 2 1

When a man is dutifully deceiving himself
he will often admit the truth in his metaphors.
 William Empson

Contents

Illustrations

Preface

John James Ruskin once called his son's descriptions of Norman Gothic cathedrals "truth in mosaic." He offered the phrase as an editorial criticism of his son's fragmentary, almost chaotic, focus on detail, which was often at the expense of a coherent, higher perception of some "truth." All of John Ruskin's readers, wherever they begin, soon confront his textual fragmentariness. Often the response is to look for a metaphor that might suggest a continuity for the reader. For Marcel Proust, Ruskin's writings are a "pilgrimage" in search of beauty. Jay Fellows enters into the "labyrinth" of the Library Edition of Ruskin's works. Elizabeth Helsinger takes readers on a "picturesque tour" in which they must grasp Ruskin partially at first so as to understand him better in the end. Each of these metaphors is taken from Ruskin, but critics generally do not make the metaphor serve his original intention. However narrowly he may have conceived the term in comparison to contemporary critics, John James Ruskin correctly linked his metaphor to his son's quest for truth. Truth, it cannot be repeated too often, was Ruskin's object in his studies of art, natural forms and substances, and in his analysis of the human faculties of perception and imagination. His resort to metaphor was often a way of stating the difficult nature of truth. Does truth mean empirical observation? A revelation of divine truth? An emotive truth, often called sincerity?

This book attempts to define the nature of truth in Ruskin's writing. No aspect of his criticism is more neglected than the lengthy theoretical texts on the truth of cognition, sense-perception, and memory, or on the modes of "error," such as idolatry, associationism, and, in particular, mimesis. Together these texts make up a mosaic of "truth" that demands some effort of understanding. To retreat from this mosaic into a noncritical discussion of Ruskin's epistemological metaphors is to mistake the point of most of his writings. When, for example, Kenneth Clark, a sympathetic reader of Ruskin, anthologizes numerous texts from *Modern Painters* I and *The Stones of Venice* because they are "poetic descriptions," he thinks he is rescuing them from Ruskin's supposed analytical "abuse" or "nonsense." Ruskin's inability to separate analysis from aesthetic appreciation at times makes him "unreadable."

I argue that Ruskin's theoretical texts comment upon his own figurative texts in such a way that the latter become unreadable. To read Ruskin closely is to become aware of an intense uncertainty in his writings. His search for truth is often contaminated by the very modes of error he condemns. The theoretical and figurative texts are sometimes mutually illuminating but often self-canceling. To adopt Proust's metaphor for the experience of reading Ruskin, theory and poetic description, epistemology and figurative language, constitute a mosaic pattern of scintillating points of light often shrouded in darkness.

In chapter 1 of this book I discuss Ruskin's use of John Locke to oppose landscape painting as an ideational construct to the predominant sensationist and mimetic doctrines. Chapter 2 takes up Ruskin's attempt to ground empirical truth in Christian typology. Mimetic detail may be nondeceptively rendered if it serves a "symbolic" purpose; it should call attention to our imperfect realization of the totality of the divine. As a substitutive image for the divine, it is prone to error, however; mimetic accuracy does not always coincide with divine meaning. In chapter 3, I discuss the fictive nature of allegory, first as it is defined in the opening chapters of *Modern Painters* III, then as it becomes the governing principle of Ruskin's history of landscape painting in the succeeding volumes. For Ruskin, allegory has the virtue of offering mimetic detail without asserting it as a truth; allegory, in principle, is imaginative. The final chapter treats the problem of idolatry in Ruskin. Proust defines Ruskin's idolatry as the worship of hollow, phenomenally worthless images. He fundamentally misconstrues the antimimetic thrust in Ruskin's writings, but he also raises the important question of self-deception. Ruskin often seems to confuse the idolatrous belief in the existence of an allegorical figure with an imaginative recognition of it as a fiction.

For Ruskin, the issue is always how to evade erroneous deceptions and substitutions. This problem is rhetorical as well as epistemological. Substitutions, symbols, and figurative meanings involve Ruskin in verbal modes of analysis. His epistemology fails to master deceptions to the degree that it fails to recognize the rhetorical nature of much of its analysis. At the same time, such rhetorical blindness is often successful and highly productive when it comes to the writing of "poetic descriptions."

My concern has not been to fault Ruskin, to make him seem less worthy of critical attention. Recent literary theory has begun to teach new ways of appreciating a writer's difficulties. Difficulty itself seems to be an indication of merit when it stands for the limits of critical rigor in the face of rhetorical deception. In this sense, Ruskin's difficulties are not unique, though I think they have been greatly underestimated. Other Victorians have fared better. Raymond Williams, in *Culture and Society 1780–1950*, described John Stuart Mill's tendency to mistake abstract, verbal for substantial knowledge, and

Matthew Arnold's unintentional transformation of concrete aspects of cultural institutions into vague, unrealizable abstractions. Ruskin criticism, by contrast, is for the most part still where Williams found it, a "mass of irrelevant material and reactions," leaving Ruskin "little read."

I have tried to present Ruskin as economically as possible. The four chapters may be read as the study of a series of related, increasingly complex epistemological cruces underlying Ruskin's works. I have combined a selection of theoretical texts from Ruskin's major works, particularly *Modern Painters*, with several famous "purple passages" such as the text on J. M. W. Turner's *Slave Ship*. In placing certain well-known texts within an epistemological argument, I hope to make them a little more "unreadable," in the sense of requiring further examination. Other texts, such as Ruskin's chapter on the Contemplative Imagination or *Aratra Pentelici*, have never been examined closely. My hope in this book, therefore, is to revive some of the texts that have been too hastily ignored by previous critics.

For the sake of consistency, I have followed Ruskin's spelling and naming of various literary figures. Thus "Juno" rather than "Hera" is used in the discussion of Homer; I use "Vulcan" or "Hephaestus" according to Ruskin's text. Dante's "Matelda" is spelled, after Ruskin, as "Matilda," and Spenser's "Florimell" as "Florimel."

In its original form, this book was submitted as a doctoral dissertation to the Faculty of the Graduate School of Yale University. The Social Sciences and Humanities Research Council of Canada generously supported my preliminary research with several doctoral fellowships. This support was supplemented by a graduate fellowship from the Yale Center for British Art, which enabled me to visit the Ruskin Art Collection at the Ashmolean Museum in Oxford. The staff of the Ashmolean's Department of Western Art kindly made available to me the entirety of the Ruskin Collection; I thank in particular Gerald Taylor and Dr. David Brown, both of whom answered many questions. Herbert Cahoon, curator of manuscripts at the Pierpont Morgan Library, gave me permission to read the manuscript of Ruskin's first draft of *Modern Painters* II. Marjorie Wynne, of the Beinecke Rare Book and Manuscript Library at Yale, located Proust's allusions to *Aratra Pentelici* in the library's copy of *Sésame et les lys* and sent the information to me. Teri Edelstein, formerly the assistant director for academic programs at the Yale Center for British Art, gave me the opportunity to present the two appendices to this book as public lectures at the center. I thank the Deutscher Kunstverlag for permission to reprint the essay on the Crystal Palace, which first appeared, in a slightly different version with fuller illustration, in *Architectura*. The essay on William Bell Scott first appeared in *The Journal of Pre-Raphaelite Studies*.

Revisions to the dissertation were undertaken with the support of a Killam

Postdoctoral Fellowship at Dalhousie University. The Faculty of Graduate Studies generously added a special research fund to this fellowship, which offset most of the cost of the photographs for the book. Barbara Goodman managed the ordering of all the photographs with great efficiency, for which I am grateful. Alan Kennedy read my work and encouraged new work on Ruskin's application of typology to his study of Gothic architecture.

The kind support and advice of my teachers at Yale made possible the publication of this book. Harold Bloom, the most Ruskinian of modern critics, guided and encouraged me from the outset. Paul de Man gave generously of his time; many topics in the book first took shape in his graduate seminars. From George Hersey, I learned to see Victorian painting and architecture through Ruskin's eyes; he too supported my work from the start. John Hollander's favorable comments on the dissertation helped to win it consideration for Yale Studies in English. J. Hillis Miller supervised the dissertation with care at every stage; he has been one of my closest readers. Martin Price's support is difficult to measure. He took a strong interest in the dissertation when it was only a collection of vague ideas; discussions with him helped me shape the argument and taught me much about aesthetic criticism. As a reader for the Yale Studies in English Committee, he first recommended the manuscript and then showed me a hundred ways to improve it. I have tried to thank him by following, as best I could, his high standards. I also thank the anonymous Yale University Press reader for his similarly careful evaluation of the manuscript. Finally, it is a pleasure to thank my editors at the Press, Ellen Graham, Cynthia Baughman, and Channing Hughes.

1

Epistemological Beginnings:
Modern Painters I

The Rhetoric of Infallibility

John Ruskin, it is often repeated, became an art critic because he failed at all
other endeavors. Extremely talented at writing verse in his youth, he felt, by
age twenty-six, that he could write verse no longer. A precocious student of
natural science, with scientific papers published in Loudon's *Magazine of Nat-
ural History* at the age of fifteen, he turned violently against the methods of
Victorian science later in his career, echoing William Wordsworth's famous
accusation of science's murder of nature by dissection. Taught by the finest
artists of the Watercolour Society, at home and abroad, he gave up artistic
ambitions, also by age twenty-six (though he continued throughout his career
to sketch, in astonishing detail, stones, flowers, and architectural ornamen-
tation).[1] His married life is his most famous failure; it has been linked to his
numerous forms of mental illness, and even to his more aberrant architectural
speculations.[2] And, where he seems to have succeeded most brilliantly, in the
writing of magniloquent prose—perhaps, as John Rosenberg has suggested,
the finest in the language—he felt the frustration of a massive misapprehen-
sion. As a critic of art, he "came to deplore his popularity as a 'word-painter'
rather than a thinker." "What incensed him was the assumption that his
descriptive passages were merely decorative and could be admired apart from
their context."[3]

This last failure—a supposedly valueless intellectual or analytical framework
which supports a highly rhetorical series of "word-paintings"—is the major
concern of this book. Ruskin, invoking the full authority of an elaborate Lock-
ean critical apparatus, which governs, in spite of numerous revisions and
digressions, the structure of *Modern Painters*, saw himself as an epistemological
critic. If epistemology is a "theory of knowledge, a theory distinct from the
sciences because it was their foundation," and if it is "based on the patient

labor of sorting out the 'given' from the 'subjective addition made by the mind,'"[4] then Ruskin is, arguably, the most important epistemological critic in English, as well as one of its master rhetoricians.

The failure of epistemology to overcome rhetoric is not so easily shrugged off as a youthful false start, nor is it reducible to biographical explanation. William James laughs at the "direful reports" of young philosophers "fed on 'books of reference' and never confounding 'Aesthetik' with 'Erkenntnistheorie' ";[5] but to read Ruskin is to grow serious about the distinction. Ruskin, too, could mock the seemingly grotesque terminology of German Idealism (see the second appendix to *Modern Painters* III), and could, with false confidence, claim to have separated the given from the subjective in his famous discussion of the pathetic fallacy (in the same volume); but the footnotes and textual revisions, the massive subtext of *Modern Painters*, assiduously gathered by Alexander Cook and E. T. Wedderburn in their monumental edition, tell a different story—the story of Ruskin's continuous uncertainty about the truth of his opinions.[6] Ruskin invented the critical concept of the pathetic fallacy, but, in practice, the concept was another failure; for as Harold Bloom has noted, all Ruskin's later works (beginning perhaps with the final volume of *Modern Painters*) are massive pathetic fallacies. Subjectively motivated personifications of flowers, minerals, and cloud formations are woven into literal descriptions of botanical forms and elemental compositions. In Ruskin's later poetic mythologies mind is inseparable from matter, just as epistemological judgment is inseparable from rhetorical falsehood.

The dilemma of dissociating rhetoric from epistemology begins, properly, with Ruskin's publication, at age twenty-three, of the first volume of *Modern Painters* (1843). Its rhetorical brilliance was a sensation. It immediately established Ruskin's literary reputation. But the volume had only marginal impact on contemporary art theory and criticism. W. G. Collingwood writes: "[T]he descriptive passages were such as had never before appeared in prose. . . . Of professed connoisseurs, such as had reviewed the book adversely in 'Blackwood's' and the 'Athenaeum,' not one took to refute it seriously with a full restatement of the academic theory."[7] Even to this day, when examined for its intellectual argument, the volume seems to disappoint the reader.

Ruskin's theoretical arguments are confined to the opening chapters. These discuss a series of Ideas: Power, Imitation, Truth, Beauty, and Relation. Only three of these Ideas correspond to Lockean categories, since Locke posited no Ideas of Truth or Imitation. The volume then concentrates on Truth, in the narrow sense of the empirical, referential accuracy of landscape painting. Turner, Ruskin argues, against received opinion, does not distort natural appearances. On the contrary, his depictions of clouds, chiaroscuro, geological formations (whether of rocks in the foreground or mountains in the back-

ground), the movement and reflection of water, and, most of all, the brilliance of sunlight, achieve a higher degree of "truth" than any previous artistic school. The comparison boldly includes Venetian colorists; the Dutch school; the English idealists, such as Richard Wilson or Thomas Gainsborough; even members of the Watercolour Society.

The flimsiness of Ruskin's scholarship has been pointed out, though this weakness does not necessarily negate Ruskin's evaluation of a particular painter's ability to render "truth."[8] The confidence of his judgment was deliberately based on amateurism. The appreciation of nature must precede the appreciation of art. In his acute perception of natural form and color, Ruskin could claim critical superiority. Seeing nature more clearly enabled Ruskin to compose his "word-paintings." This, in turn, raised public awareness of Turner's finer grasp of the manifold texture of natural form and color on his canvases. Patricia Ball writes:

> To [Ruskin] the key to a true appreciation of nature's "variety and mystery" lies in the readiness to allow for complexity on the smallest and the largest scale, and his descriptive prose is conditioned by the need to convey that complexity in full. Words cannot be vague, general and few where the eye reports with a keen particularity. Ruskin's verbal powers must reflect his visual capacity, depicting not merely the surface, but penetrating the object, to announce its identity without loss of force, however tense or fluent with energy, however evanescent, however highly organized it may be.[9]

Yet this same energy of description, implicitly founded on an organic analogue with nature itself, need not be, as Ball goes on to argue, "intellectually profound." As soon as moral or epistemological judgments are brought in, the power of seeing vividly and, by extension, writing vividly, turns "naive and whimsical." Ball dissociates Ruskin from his romantic predecessors, particularly Wordsworth and Samuel Taylor Coleridge, primarily on the grounds of his inability, or perhaps deliberate effort (we are not sure which), to render nature either symbolically or phenomenologically as psychological intuition rather than descriptive fact. The so-called true appreciation of nature shrinks to objectivity, however rhetorically animated through metaphor and simile, for the colors of speech correspond, presumably, to those of nature. Is this what Ruskin meant? Is seeing the only end of his descriptive task?

More recently, Elizabeth Helsinger has taken Ball's analysis one step further. Helsinger similarly emphasizes the visual acuity of Ruskin's descriptive prose. Like Ball, she notes his amateurism, his lack of interest in the idealized compositions exemplifying the academic theory of Sir Joshua Reynolds. She does not call Ruskin intellectually naive. More than most critics, Helsinger is sensitive to the conflict of the first volume: its internal vacillation between "word-painting" which "dazzles" the reader and a program of teaching the viewer to

look at the natural object more closely. Even within Ruskin's rhetoric, there-
fore, a tension exists. This tension refers to the earlier theoretical chapters,
which prepare the verbal account of "truth." As Helsinger reminds us, the
object of the description is not truth as such, but Ideas of Truth.[10] This
category Ruskin explicitly designated at the beginning of his inquiry. From
Truth, he would be able in later volumes to move on to Beauty and Relation.
As soon as we begin to read his rhetoric not simply as a referential discourse,
mirroring in its own figurative "dazzlement" (to use Helsinger's term) a sim-
ilarly dazzling natural sight, but as an ideational structure, a cognitive effort
at reflecting nature, then the task of reading Ruskin grows complicated—as
indeed it should. Helsinger's formulation of the conflict between rhetoric and
epistemology is based on an exhaustive analysis of what we might call synec-
doche as Ruskin's master rhetorical figure. She shows a consistent effort, in
all Ruskin's works—socio-historical, architectural, descriptive, art historical—
to substitute part for whole, partial, limited perspectives for total "sublime"
apprehensions. Synecdoche, Helsinger argues, is Ruskin's method of control-
ling his tendency toward excessive rhetorical dazzlement. This insight is pro-
found. (I explore it from a different angle in chapter 4.) Nevertheless, the
ideational process of organizing percepts into a cognitive rather than a strictly
visual whole is circumvented in Helsinger's argument.[11]

Unlike most critics, I begin my investigation of the nature of Truth with
Ruskin's own definition in chapter 5 of *Modern Painters* I. From the outset
Truth is dissociated from its neighboring idea, Imitation, though most critics
have tended to read truth as if it were synonymous with imitation. It is not,
though Ruskin himself often seems to lapse from what he calls truth into
imitation. It is this lapse that requires explanation, even more than its sup-
posedly intelligible aftermath. What, then, does Ruskin mean by Idea of
Truth?

Ideas and Ideals

Since W. G. Collingwood's biographical study of Ruskin (1893), it has been
noted that Ruskin's "style, in the opening chapter [s of *Modern Painters*
I], his arrangement in divisions and subdivisions, even his marginal summaries,
should recall [Locke's] 'Essay on Human Understanding,' from which the
scheme and system of his thought were derived."[12] At the same time, it is
equally obvious that, properly speaking, Locke has very little to do with the
opening scheme. Locke provides the crucial definition of the term "Idea," on
which the entire theoretical introduction rests, but hardly the content of any
of the specific ideas.

Ruskin defines "Idea" at the conclusion of his second chapter, "The Defi-
nition of Greatness in Art." The definition is explicitly taken from Locke,

and it seems best to dwell on it before turning to a closer examination of the antithetical categories of Truth and Imitation: "[T]he term idea, according to Locke's definition of it, will extend even to the sensual impressions themselves [of a painting] as far as they are 'things which the mind occupies itself about in thinking;' that is, not as they are felt by the eye only, but as they are received by the mind through the eye" (3.91–92).[13] Ruskin has seized the central epistemological issue in Locke: "perception" not mere "impression" defines the status of the Idea. Or, as Jonathan Bennett has written: "Locke's thought is dominated by his attempt to use 'idea' univocally as a key term in his accounts of perception and of meaning—or, in shorthand, his use of 'idea' to cover both sense-data and concepts."[14] Analogously, for Ruskin painting is not a window on nature which presents a scene to the viewer. The painting is always the expression of a mental judgment which determines the composition, degree of finish, and choice of subject matter. Ruskin attaches special importance to the Idea because of its extensive applicability to other forms of art or forms of painting (although the defense of Turner requires a primary emphasis, in the first volume, on landscape painting). Ruskin's definition of painting as an ideational structure takes into account art forms that lack mimetic value:

> If I were to say, on the contrary, that the best picture was that which most closely imitated nature, I should assume that art could only please by imitating nature; and I should cast out of the pale of criticism those parts of works of art which are not imitative, that is to say, intrinsic beauties of colour and form, and those works of art wholly, which, like the Arabesques of Raffaelle in the Loggias, are not imitative at all. [3.92]

The Idea is the most inclusive epistemo-aesthetic principle: one which will account for the "grammar of painting"—its sensory effect as line and color— and for its meaningful choice of subject. A representational painting, when defined as a network of Ideas rather than impressions, suggests the presence of "meaning and intended arrangement." Every perception is a critical perception.

At first, Ruskin's argument seems to differ little from the academic theory of Reynolds. For Reynolds, artistic purpose is an idealizing process which selects only the potential best of nature. Reynolds's *Discourses* equates idealization with mental effort: the "value and rank of every art is in proportion to the mental labour employed in it, or the mental pleasure produced by it. As this principle is observed or neglected, our profession becomes either a liberal art or a mechanical trade."[15] Reynolds, like Ruskin, condemned mechanical imitation, servile verisimilitude, which pleases the eye more than the intellect. But for Ruskin a certain degree of representational abstraction was not necessarily the result of ideation. The disagreement with Reynolds is most

sharply expressed in Ruskin's preface to the second edition of _Modern Painters_ I, written in 1846: "Now there is but one grand style, in the treatment of all subjects whatsoever, and that style is based on the _perfect_ knowledge, and consists in the simple, unencumbered rendering of the specific characters of the given object, be it man, beast or flower" (3.25). Replying, further, to Reynolds's fourteenth discourse, Ruskin states that, even with the introduction of mythological figures in the landscape, which require "imaginary character of form in the material objects with which they are associated, . . . there must be a true and real connection between that abstract idea and the features of nature as she was and is" (3.26). Ruskin summarizes his disagreement with Reynolds thus:

> [Painting should be] idealized in the right sense of the word, not by audacious liberty of that faculty of degrading God's works which man calls his "imagination," but by perfect assertion of entire knowledge of every part and character and function of the object, and in which the details are completed to the last line compatible with the dignity and simplicity of the whole, wrought out with that noblest industry which concentrates profusion into point, and transforms accumulation into structure. [3.47]

This end is more easily asserted in principle than in practice. Each significant term and phrase in this statement—the degradation of the imagination, perfection of the part, function of the object, simplicity of the whole—undergoes continual revision in _Modern Painters_. The result is a critical project that in itself is hardly concentrated or well structured. But Ruskin's objective, at least, is clear. Reynolds places too much emphasis on intellectual beauty. The elimination of "accidental" distortions of natural forms through idealization results in the loss of recognizable shape. The various species of flowers, trees, and stones are blurred into one dimly lit foreground. The composition of the painting becomes, in Ruskin's terms, an "idol" which places the mind of the artist before God's creation. As such, idealism is as bad as imitation, which entraps the eye in a deceitful "substitution" of appearance for reality:

> The picture which is looked to for an interpretation of nature is invaluable, but the picture which is taken as a substitute for nature had better be burned: and the young artist . . . may be equally certain of being betrayed by those who . . . would thrust canvas between him and the sky, and tradition between him and God. [3.12]

Similarly, Ruskin writes:

> There are then two dangerous extremes to be shunned: forgetfulness of the Scripture, and scorn of the divine; slavery on the one hand, and free-thinking on the other. The mean is nearly as difficult to determine or keep in art as in religion, but the great danger is on the side of superstition. He who walks humbly with Nature will seldom be in danger of losing sight of Art. He will commonly find

in all that is truly great of man's works something of their original, for which he will regard them with gratitude and sometimes follow them with respect; while he who takes Art for his authority may entirely lose sight of all that it interprets, and sink at once into the sin of an idolater, and the degradation of a slave. [3.45n]

Ruskin's Idea of Truth wavers unsteadily between formal appreciation (an almost musical sense of color and line as pattern) and an anti-Reynoldsian thesis that representational ideas should contain a high degree of detail. In conformity with Ruskin's counterstatement to Reynolds, in the second preface, Ideas of Truth could be characterized in various ideological ways so that they are differentiated from an idealized landscape. In conjunction with Ideas of Power, for example (the third chapter of *Modern Painters* I), one could argue that Ruskin demands more labor from the artist than does Reynolds. The artist must "concentrate" truth with extraordinary economy and refinement of technique. Such refinement demands perfect command over materials on the part of the artist. No superficial washes or flat brush strokes are permissible in the foreground, for example. To use Ruskin's witticism, a locomotive may crack a walnut, but artistic power is recognizable in the painting of a single hair on a human head. Ideas of Power (which clearly have nothing to do with what Locke calls Ideas of Power) make the viewer aware of the "difficulty of the obstacle overcome." In conjunction with Ideas of Beauty and Relation (which concern, respectively, "objects most worthy" of the spectator's contemplation, mixed with the "thought and feelings with which these were regarded by the artist himself" [3.133]), Ideas of Truth achieve translucent clarity. This translucence is metaphorically illustrated (with a satiric allusion to the Claude glass):

And thus, though we want the thoughts and feelings of the artist as well as the truth, yet they must be thoughts arising out of the knowledge of truth, and feelings arising out of the contemplation of truth. We do not want [the artist's] mind to be as badly blown glass, that distorts what we see through it, but like a glass of sweet and strange colour, that gives new tones to what we see through it; and a glass of rare strength and clearness too, to let us see more than we could ourselves, and bring nature up to us and near to us. [3.137]

The idealized landscape, with its dim illumination and deliberate interposition of intellectual modification before observed fact, is, to Ruskin, the badly blown glass.

Ruskin has determined to link intellectual judgment and emotional response to sight in a more thorough way than Reynolds, or even than Edmund Burke. The Ruskinian landscape painting would retain distinct, immediately intelligible forms, would show exact execution upon material inspection of the swiftness and depth of the brush strokes, and would display intense chiaroscuro and brilliant light and color. Most important, the "true" landscape painting

would achieve an unprecedented coherence of part and whole, detail and compositional unity. The structural coherence of the various ideas of truth demonstrates the artist's intellectual power. No detail, in theory, can be withdrawn without significantly altering the whole. Artistic selection falls within the domain of the Beautiful. The artist has the right to emphasize the most pleasing objects in nature, but arrangement cannot be decided by rule (a point which agrees with Reynolds), nor by a too ready resort to abstraction.

In pushing for a closer connection between sight and understanding, Ruskin (as I mentioned earlier) found the Lockean term "Idea" to be of great value. The Idea, in principle, offered an epistemological foundation for the sort of landscape art Ruskin sought to define. Henry Ladd has argued that Ruskin seems to have followed Locke only "up to the point of calling simple perceptions ideas." He seems to have been unconcerned, at least directly, with the epistemological limitations implicit in the Lockean Idea. Ruskin takes over the Lockean equation of thought with sight, but ignores the crucial difference, in the Idea, between "Nominal and Real Essence."[16] Locke states that only nominal knowledge is possible through Ideas. Complete knowledge of the essential properties of any object or "substance" is not humanly possible. Ruskin's supposed confusion of the nominal and the essential, the modal and the substantial, profoundly affects and disrupts the initial identification of seeing and understanding, premised upon the aesthetic object as an ideational structure. The proper degree of congruence between the aesthetically structured image or sign (Ruskin follows Locke in allowing for either) and its supposed referent is a matter of truth, of what is knowable beyond immediate, simple perceptions. As soon as a structuring operation has taken place, it becomes a critical problem to decide whether or not the complex image or sign is truly "transparent." The structural tension among the ideas of truth, beauty, and relation is what distinguishes the Ruskinian aesthetic from a doctrine of strict mimesis, on the one hand, and from idealization, on the other.[17] Ideas of Truth, which, for the moment, we may take to be simple, undifferentiated perceptions, when properly structured, do not resemble direct sensations. Nor do they depart from positive, verifiable facts. The structure seeks to achieve "transparency." Is this transparency an illusion? Indeed, is the simple idea of truth an illusion? Where we expect to find a greater understanding of the object world of sense experience, mediated as ideas, do we in fact find the notoriously deceptive "substitutions" and "idols" attacked in the second preface? In Ruskin's own terms, is an idea of truth really no different from the falsehoods belonging to ideas of imitation? To answer this set of questions, we must look more closely at Ruskin's adaptation of Locke.

Imitations and Sensations

The usual romantic and postromantic departure from Locke proceeds as a

critique of the passivity implied in the various associationist doctrines. Wordsworth, for example, has been compared to Locke so as to demonstrate the poet's emphasis on the inner direction of the train of thought and image. Wordsworth seeks to overcome the "accident" of chance or custom. He overcomes the arbitrariness of the Lockean explanation of our sympathies and antipathies. Coleridge, even more than Wordsworth, answered Locke's (and David Hartley's) mechanics of association with an emphasis on the creative role of emotion: "[A]ssociation depends in a much greater degree on the recurrence of resembling states of Feeling, than on Trains of Idea," and "Ideas *never* recall Ideas . . . any more than leaves in a forest create each other's motion—The Breeze it is that runs thro' them . . . the Soul, the state of Feeling." In the romantic "interchange between man and nature, . . . the mind modifies sensation as much as sensation modifies the mind."[18] The active/passive opposition, when applied to memory, to imagination, even to perception, seems to account for the major opposition of the romantics to Locke.

Ruskin takes this post-Lockean mental activity for granted. The landscape artist, whether directly memorizing nature or modifying it in a representational image, is a self-consciously directed agent. Moreover, like Wordsworth, Ruskin seeks to establish a necessary link between natural and psychological beauty and sublimity. His critique of associationist theories of beauty in the second volume of *Modern Painters* attacks the principle of "accidental" cause.

What about the more important divergence between nominalism and essentialism in the structuring of simple ideas? Neither active nor passive structurings of ideas escape this epistemological crux. It becomes increasingly difficult to tell apart the intentional from the accidental, the substantial from the modal, not only in the case of complex (structured) ideas but even in simple ones. Ruskin may assume an active self or ego, responsible for every aesthetic structure, but the structure itself remains thoroughly Lockean, and subject to the errors and aberrations Locke foresaw. Even "simple" ideas, Locke realized, have the possibility of confusing nominal and substantial properties, and the same would apply to Ruskin's correspondingly simple category, ideas of truth. The idea of truth may itself already contain a substructure, may already be partially complex. Immediately, therefore, modal (which concerns combinations of like ideas), relational (of distinct ideas), and abstract false constructions of reality are possible.[19]

Joseph Addison, the first critic to adapt Lockean epistemology toward a nonclassical, nongeneric, subjectivist theory of aesthetics, realized that the aesthetic idea is never simple: "As we look on any object, our idea of it is, perhaps, made up of two or three simple ideas; but when the poet represents it, he may either give us a more complex idea of it, or only raise in us such ideas as are most apt to affect the imagination."[20] Addison, as Ernest Lee

Tuveson has pointed out, in his study of Locke's influence on romantic aesthetics, makes us aware of the irresolvable tension between representation and illusion in all post-Lockean aesthetics. In Addison, the complex aesthetic idea paradoxically fluctuates between "likeness to its object" and the bestowal of existence upon "several objects which are not to be found in nature." The aesthetic imagination is both the receiver of "the impressions of a nature that is an unfoldment of divinity, and, also, a creator of illusion shows after the manner of the divine art." These "divine" illusions do not "complete and exemplify an objective ideal design which imperfect matter can only partially realize in nature"; rather, they reveal the imagination as a "skillful manipulator of pictures, the master of the sensations."[21] The so-called divinity of the human imagination situates us in what Tuveson calls the "anteroom of Wordsworth and Ruskin." Nature as a revelation of God's grace or sublimity grows directly out of the expansion of the imagination and its ability to manipulate perception, so that infinity, or timelessness, or the vastness of the sublime all become mental acts. Ruskin, in particular, never let go of the initial complication: the determination of the precise point where likeness to an object ceases, in the idea, and the bestowal of existence upon a nonexistent object begins. The threat of the "idol" mentioned in the second preface ultimately develops into a massive concern over the theoretical possibility of differentiating idolatry from imagination. Even Wordworth is placed among the idolaters, or false bestowers, in Ruskin's opinion. A great deal is at stake in the difference between Truth and Imitation, the simple and the complex, the like and the false construct. Upon its foundation all religious and moral certainty lies.

Ideas of Imitation are opposed explicitly to those of Truth in chapters 4 and 5 of the first section of *Modern Painters* I (3.99–109). We may begin with Ruskin's categorical list of the differences between the two ideas:

> First,—Imitation can only be of something material, but truth has reference to statements both of the qualities of material things, and of emotions, impressions and thoughts. There is a moral as well as a material truth,—a truth of impression as well as of form,—of thought as well as of matter; and the truth of impression and thought is a thousand times the more important of the two. Hence, truth is a term of universal application, but imitation is limited to that narrow field of art which takes cognizance only of material things.
>
> Secondly,—Truth may be stated by any signs or symbols which have a definite signification in the minds of those to whom they are addressed, although such signs be themselves no image nor likeness of anything. Whatever can excite in the mind the conception of certain facts, can give ideas of truth, though it be in no degree the imitation or resemblance of those facts. If there be—we do not say there is,—but if there be in painting anything which operates, as words do, not

by resembling anything, but by being taken as a symbol and substitute for it, and thus inducing the effect of it, then this channel of communication can convey uncorrupted truth, though it do not in any degree resemble the facts whose conception it induces. But ideas of imitation, of course, require the likeness of the object. They speak to the perceptive faculties only: truth to the conceptive.

Thirdly, and in consequence of what is above stated, an idea of truth exists in the statement of *one* attribute of anything, but an idea of imitation requires the resemblance of as many attributes as we are usually cognizant of in its real presence. A pencil outline of the bough of a tree on white paper is a statement of a certain number of facts of form. It does not yet amount to the imitation of anything. The idea of that form is not given in nature by lines at all, still less by black lines with a white space between them. But those lines convey to the mind a distinct impression of a certain number of facts, which it recognizes as agreeable with its previous impressions of the bough of a tree; and it receives, therefore, an idea of truth. If, instead of two lines, we give a dark form with the brush, we convey information of a certain relation of shade between the bough and the sky, recognizable for another idea of truth: but we still have no imitation, for the white paper is not the least like air, nor the black shadow like wood. It is not until after a certain number of ideas of truth have been collected together, that we arrive at an idea of imitation.

Hence it might at first sight appear, that an idea of imitation, inasmuch as several ideas of truth are united in it, is nobler than a simple idea of truth. And if it were necessary that the ideas of truth should be perfect, or should be subjects of contemplation *as such*, it would be so. But, observe, we require to produce the effect of imitation only so many and such ideas of truth as the *senses* are usually cognizant of. [3.104–05]

At first sight, this threefold opposition seems to contract to only one: imitation is opposed to truth as sense impressions are opposed to conceptualizations or intellectually recognizable forms. Imitation is of the order of appearance. It involves likeness, but in a shallow "material" sort of way. Imitation has the potential to deceive the intellect, or arrest it, by the charm of the false appearance, though this aspect of imitation is not dwelt upon in this passage except in passing. Collections of truths may suddenly amount to an imitation. Truth, by contrast, is by a certain paradox superior to imitation. It is superior because it is less like sensory impressions. Truth is abstract. It is "communicated" through bare outlines or through totally nonrepresentational signs and symbols, which are knowable, or cognizant to the mind, but of no perceptual value. In losing its perceptual force, truth, paradoxically, gains an intellectual appeal. It speaks directly to what Ruskin calls the "conceptive" faculty. *Thus it gains "universal application" though it may consist of only "one attribute."* On the level of what we may call the "signifier"—the material aspect of the image or the sign—truth is easily distinguished from imitation. The "resemblance of as many attributes as we are usually cognizant of " in

the imitation is immediately distinguishable from the pointedly limited but universal sign of truth.

Solomon Fishman, discussing the same text in Ruskin, complains of a certain unfairness in the comparison. Imitation "in this context refers not to realistic art but to illusionist art, to *trompe l'oeil*, regarded as a mechanical trick."[22] Far from a critique of mimesis, in the Aristotelian sense, Ruskin's concept of imitation is a straw man for his notion of truth. No mature mind or experienced viewer could be deceived for more than a moment, if at all, by what Ruskin calls an Idea of Imitation.

There is support for Fishman's argument in the chapter devoted to the Idea of Imitation (3.99–103). It opens polemically with a criticism of Henry Fuseli, Coleridge, and especially Burke. These critics attempted to separate "*copy*" from "imitation," but Ruskin holds that there is no difference between the two. For Ruskin, there is no Burkean "power of imitation," which Burke (following the Aristotle of the *Poetics*) had defined as the representation of an object in poetry and painting such "as we could have no desire of seeing in the reality."[23] Ruskin interprets absolutely Burke's distinction between the "power" of imitation, which makes pleasurable objects that are unpleasant in themselves (such as a "mean . . . cottage," "dunghill," "ordinary kitchen utensil"), and the power of an object which in itself causes pleasure (a garden, the female sex). When the latter objects are imitated, Burke says, "the power of the poem or picture is more owing to the nature of the thing itself than to the mere effect of imitation, or to a consideration of the skill of the imitator however excellent." Ruskin attributes no pleasure or power to what we might call, today, the alienation effect of the imitation. An imitation is always a mere copy, regardless of subject. The "power" of a painting has nothing to do with the playfulness of an illusion; for Ruskin it has to do with the recognition of the artist's control over his materials, or what he calls, in the chapter on Imitation, "the dexterity of the artist's hand," or "a beautiful or singular arrangement of colours, or a thoughtful chiaroscuro, or the pure beauty of certain forms." Where Burke allows us to feel pleasure in the imitation of a mean object *as* imitation or as imitative skill, Ruskin deprives these of all pleasure. The Ruskinian Idea of Power is closer to the Idea of Truth than to the deceptiveness of the Idea of Imitation. Where subject is concerned, Ruskin's equation of imitation to copy again pushes Burke further:

> Ideas of imitation are contemptible in the second place, because not only do they preclude the spectator from enjoying inherent beauty in the subject, but they can only be received from mean and paltry subjects, because it is impossible to imitate anything really great. . . . We can imitate fruit, but not a tree; flowers, but not a pasture; cut-glass, but not the rainbow. [3.102]

Burke allows mean objects to be transformed, through imitation, into plea-

surable sights, but Ruskin reverses Burke. The meanness of the object only reveals the inherent inferiority of the copy. Even when a copy produces pleasure, it is a pleasure that derives from the object itself. Unlike Burke, or Reynolds, Ruskin would not suggest the inherent inferiority of any natural object to any other. The flower, or fruit, is as beautiful as the tree, or tree-covered mountain. But Ruskin would direct us to the object, or to a "truly" artistic rendering of it, be it great or small, in which case we are dealing with a non-"mimetic" interpretation of the object as line, color pattern, point of illumination, or shadow—with a Turnerian interpretation, in short.

Ruskin has seemingly reduced imitation to such a low status, to an error of the eye, that, properly speaking, there is no idea of imitation for there is no moment of cognition. As soon as the idea of the imitation penetrates the mind, it is overturned. We recall, in the lengthy text cited above contrasting imitation and truth, that imitation does not participate in the higher mental faculties of emotion and conceptualization. Imitation is merely "perceptive," as Ruskin says. An idea of imitation exists in only the most pragmatic sense of the term, as a positive impression of an image transmitted from the eye to the mirror of the mind. Imitation is an idea only according to the crudest Lockean psychology.

Ruskin would like to dismiss mimesis as a critical concept from his theory of aesthetics. Of this there is no doubt. When the public judges Turner as an imitative artist, they are failing to respond with their intellects. The entrapment of the Victorian public in a nonreflective mode of judgment is one of Ruskin's consistent complaints. The preference for Dutch landscape over Turner signifies, to Ruskin, a sensual mass culture. Even Burke lends support to this sense of social danger, when read as a sensualist (which is how Ruskin reads him). For Burke writes, in the section on imitation, that, after sympathy, the

> second passion belonging to society is imitation. . . . For as sympathy makes us take a concern in whatever men feel, so this affection prompts us to copy whatever they do; and consequently we have a pleasure in imitating, and in whatever belongs to imitation merely as it is such, without any intervention of the reasoning faculty.

The pleasure of the artistic imitation has the same source, in the human constitution, as the social urge to imitate. Ruskin would have found such a connection to be chilling. The preference for mimetic art would not only indicate a certain loss in reason, but a massive blindness. Everyone seems to imitate the social preference for mimetic art. The impulse for social reform, especially in Ruskin's later architectual writings, always proceeds from a critique of mimetic or sensory values.

The concept of imitation has been reduced to the realm of the senses. Yet there is a major twist in the argument which has gone unnoticed. Toward the

conclusion of the text in question Ruskin states that "after a certain number of ideas of truth have been *collected* together . . . we arrive at an idea of imitation. Hence it might at first sight appear, that an idea of imitation, inasmuch as several ideas of truth are *united* in it, is nobler than a *simple idea of truth*" (emphasis added). The idea of imitation, it would seem, tells us more about the object world, although it may deceive us. It has the advantage, lacking in ideas of truth, of structural unity or completion. Ruskin quickly averts the threat of falsehood by reducing imitation once again: "[W]e require to produce the effect of imitation only so many and such ideas of truth as the *senses* are usually cognizant of "—meaning, in this context, "space and projection." The idea of imitation is returned to the realm of the simplest modalities, which do not involve intellectual judgment.

Yet there is something unsatisfying about this reduction. It is a little too easy. We want to know how simple ideas of truth, once they are structured into larger wholes, can avoid being taken for imitations. The simple idea of truth is still far from a translucent ideational structure. It needs to be made complex. A thick line may signify shadow, as in the example of the painted bough, but, Ruskin now suggests, the mind will tend to group several such lines into a general idea of recession or projection, leading to the sensory beguilement of the intellect. The materiality of the sign of truth, the visibility of the media of the painter, is replaced by an illusion of presence before natural objects. Furthermore, Ruskin has not yet defined his use of the term "simple." The simple idea of the bough is perhaps simple in a Lockean sense. It belongs to a phase of cognition Locke calls "abstraction," in which the idea of an object is entirely devoid of spatial and temporal context and of any concomitant ideas.[24] The "simple" idea of truth is already the product of reflection, while, again in strictly Lockean terms, the seemingly complex (because "collected") idea of imitation produces a nonreflective effect in the mind. A theoretical crossing of values has taken place, a crossing that hinges on the highly ambiguous word "collected." We would like this pivotal term to be more explicit. Is "collected" synonymous with complex? Is it active or passive? Does it refer to a collection of ideas in the mind or to a compositional ordering on the surface of a canvas?

Here I must venture a speculation that Ruskin has followed Locke in spirit if not to the letter. The attachment of the term "simple" to ideas of truth leads us badly astray if we take it in a strict Lockean sense. Ruskin has obfuscated the issue further by failing to distinguish between the purely pragmatic sense of "idea" as positive mental image (as applied to mimesis) and "idea" as a cognitive construct (as applied to beauty, relation, and power). Ruskin speaks of ideas of imitation and truth mixing with one another as if they were parts of the same paradigm. Yet the mixing is really a shifting between kinds of

conscious awareness, from immediate perception to reflection and cognition, from the eye to the mind.

The ambiguities and crossings of Ruskin's text can be partially clarified by a comparison of Ruskin's chapter on Ideas of Imitation to Locke's chapter on "Some farther Considerations concerning our simple Ideas" (bk. 2, chap. 8). I cannot prove a direct connection between these two texts, but there are a number of striking affinities in the examples chosen and the argument.

The principal topic of Locke's chapter is stated in the seventh paragraph:

> To discover the nature of our *Ideas* the better, and to discourse of them intelligibly, it will be convenient to distinguish them, as they are *Ideas* or Perceptions in our Minds; and as they are modifications of matter in the Bodies that cause such Perceptions in us: that so we *may not* think (as perhaps usually is done) that they are exactly the Images and *Resemblances* of something inherent in the subject; most of those of Sensation being in the Mind no more the likeness of something existing without us, than the Names, that stand for them are the likeness of our *Ideas*, which yet upon hearing, they are apt to excite in us.[25]

Even in the simplest idea, or the most immediately intelligible idea, there may be a total lack of congruence between mental image and external causality; "likeness" or resemblance is by no means synonymous with "simple." Absolutely crucial in Locke's argument is the fact that this lack of resemblance is not complex. Lack of resemblance does not imply that the mind has falsely constructed a picture of the external world out of several distinct simple ideas. We are not in the higher realm of "mixed modalities" or "complex ideas of substance," where error is very likely. On the contrary, lack of resemblance has to do strictly with "modifications in matter in the Bodies that cause such Perceptions." Locke continues:

> *Flame* is denominated *Hot* and *Light*; *Snow White* and *Cold*; and *Manna White* and *Sweet*, from the *Ideas* they produce in us. Which Qualities are commonly thought to be the same in those Bodies, that those *Ideas* are in us, the one the perfect resemblance of the other, as they are in a Mirror. . . . And yet he, that will consider, that *the same Fire*, that at one distance produces in us the Sensation of *Warmth*, does at a nearer approach, produce in us the far different Sensation of *Pain*, ought to bethink himself, what Reason he has to say, That his *Idea* of *Warmth*, which was produced in him by the Fire, is actually *in the Fire*; and his *Idea* of *Pain*, which the same Fire produced in him the same way, is *not* in the *Fire*. Why is Whiteness and Coldness in Snow, and Pain not, when it produces the one and the other *Idea* in us . . . ? [p. 137]

Resemblance or its lack in simple ideas is determined, in Locke's argument, by primary or secondary qualities. The primary qualities of bulk, number, figure, and motion create resemblances, whereas the secondary qualities of

taste, color, and sound bear no resemblance to the material properties of the perceived object. Locke argues that the mind tends to equate primary and secondary qualities, as in the case of mistaking the play of red and white colors over a piece of porphyry for real properties of the stone. The mind, at its simplest level of ideation, does not separate subjective perceptions from objective causes.

Ruskin seems to have adapted Locke to his ideas of imitation. For the absolute reduction of mimesis to sense impression leads to a similar confusion, in the viewer, of the primary and the secondary, but not to any Addisonian sort of appreciation of mimesis as complex. Ruskin is a Burkean or Aristotelian to the extent that he argues that the pleasure of an imitation consists of being nearly deceived "at the same moment" that there is some means of "proving" that the mimesis "*is* a deception." But the proof occurs "when one sense is contradicted by another, both bearing as positive evidence on the subject as each is capable alone; as when the eye says a thing is round, and the finger says it is flat." An idea of imitation is produced by a contradiction among the senses; it has nothing to do with the conceptualization of an object. The painting or sculpture has been absurdly reduced to a material cause in Ruskin's argument.[26] "Juggling" is Ruskin's principal metaphor for mimesis, and it is now clear why: the visual illusion of stasis in juggling is contradicted by the feeling of movement in the hand.

In the context of primary qualities, such as form, truth and imitation are not easily differentiated. The idea of truth bears a *formal resemblance* to an object but also to an idea of imitation. The two types of ideas become dissociated in the mind only after further sensory input, as Ruskin makes clear in his example of the outline of the bough:

> [Ideas of imitation are] never felt in so high a degree as in painting, where appearance of projection, roughness, hair, velvet, etc., are given a smooth surface, or in waxwork [one of Locke's chief examples], where the first evidence of the senses is perpetually contradicted by their experience. But the moment we come to marble, our definition checks us, for a marble figure does not look like what it is not: it looks like marble, and like the form of a man, but then it *is* marble, and it *is* the form of a man. It does not look like a man, which it is not, but like the form of a man, which it is. Form is form, *bonâ fide* and actual, whether in marble or flesh—not an imitation or resemblance of form, but real form. The chalk outline of the bough of a tree on paper is not an imitation; it looks like chalk and paper— not like wood, and that which it suggests to the mind is not properly said to be *like* the form of a bough, it *is* the form of a bough. [3.101]

Form, texture, and media seem to blend into one another in the imitation, creating mingled contradictions among the senses, specifically sight and touch. With an idea of truth, however, the primary and the secondary are disjoined. The materiality of the medium does not act as a sensory cause but rather as

a visual relief to the primary quality of form. A different sort of a reduction has taken place: chalk and marble are not experienced as tactile sensations, as one imagines in Ruskin's argument the velvet and the smooth surface of the painting are. Rather, they are experienced as images of the actual substance that they are. The mind perceives a simpler but "truer" contradiction between form and matter than is the case with imitation. Fishman's protest against Ruskin's reduction of mimesis to *trompe l'oeil* can be extended to a similar reduction of "truth" to either abstract form or sheer substance. Truth and imitation are equally simple at this stage of the analysis. The opposition of truth to imitation, in spite of the word "collected," is not an opposition of the simple to the complex, but of two kinds of simple ideas. "Collected" may be read as "increase in sensory input." To the degree the ideas of truth degenerate into stimuli, into their material causes rather than mental reflections, they become imitation. In phenomenological terms, truth is the mental distancing of sensation.

The simple contrast of truth and imitation is still far from a theory of aesthetics. Form as a Lockean primary quality does not account for what I. A. Richards has called the "sense of form" necessary to the appreciation of the aesthetic object, a sculpture, for example. Ruskin has not yet explained how the simultaneous presentation of mental images of marble as marble and human form as form makes up the sculpture from which the argument is derived (see fig. 1). Sculptures do not happen by the mere coincidence or association of ideas, not even (as is implicitly the case here) by what Locke calls Ideas of Relation (the comparison of two distinct ideas in the mind which do not blend into one another). Without some theory of how the mind constructs an aesthetic object, or appreciates it, all forms will be "insubstantial and incomplete," as Richards observes. As he further has noted in *Principles of Literary Criticism*, the "proportions and relations of the volumes" which make up the statue "are by no means necessarily the same as those of the mass of marble from which we receive our signs."[27]

Ultimately, however, Ruskin surpasses Richards. His discussion of proportion, in the second volume of *Modern Painters*, be it in architecture or sculpture, is certainly among the most sophisticated in English aesthetics, while Richards, in the text that I am quoting, often confuses "signs" with "stimuli," as if the two were interchangeable parts of aesthetic responsiveness. Richards's goal is a pleasurable psychological, even neurological, "tension." All that Ruskin has done so far is to make sure that aesthetic signs are never confused with sensory stimuli. Ruskin follows custom in often using the word "pleasure" to characterize beauty, but there is really no pleasure-principle in his epistemology. The uniqueness of Ruskin's position, which has so often been ignored or missed, lies in his thorough devaluation of the role of the senses

in aesthetic appreciation, a devaluation that is unprecedented in the Lockean tradition out of which he comes, and which is then eclipsed by his followers, particularly Walter Pater and Oscar Wilde, and later Roger Fry and Marcel Proust. Tuveson has noted that in the post-Lockean aesthetic image "the stronger the sense impression, the less immediately obvious its intellectual connections, the deeper it penetrates into the depths of the mind and the more likely it is to evoke a meaning which lies outside the scope of the understanding."[28] Ruskin reverses the preference for sensory charm, or penetration over cognition. As Jerome Buckley observes, Ruskin valued "intellectual significance" above all in art.[29]

The reduction of mimesis to sensation is, therefore, part of a larger reduction of the role of sense experience. Ruskin has exploited a loophole in Locke's epistemology. The equation of perception and intellection is neatly modified by the lack of correspondence between sensation and mental image, or idea. The ideational resemblance of perception to certain conceptualizations, such as man, verges on mimetic beguilement of the mind when the perceptions turn into sensations. Then we are not contemplating the aesthetic properties of an ideational category or structure (its proportion, say, or unity). Rather, we are being stimulated by it as if it were a cause. Judgment is suspended. Obviously Burke's emphasis on sensation was unacceptable to Ruskin, who denied the existence of the category of the sublime, demoting the term to a synonym for "elevation." Unlike Pater or Proust, or even Wordsworth, Ruskin never seeks a suspension of meaningfulness. Wordsworth's "language of the sense" must be truly a "language," a meaningful statement. Similarly, I suspect that Ruskin would have found the tactile influence of the Eliotic symbol equally "mimetic."

The apparently simple devaluation of mimesis in Ruskin's epistemology turns out to be very subtle. Even so careful a reader as Graham Hough has missed Ruskin's argument. Hough reads Ruskin backwards, so to speak, as a progenitor of Pater and Fry, but he is able to do so only by denying that Ruskin actually understood Locke. He accuses Ruskin of failing to understand the Lockean distinction between "sensation and perception," "the physical fact and the psychic result."[30] Yet the burden of Ruskin's preliminary argument is precisely to free ideation, even when taken in the most pragmatic sense of perception, from the influence of sensation. For Hough, Ruskinian perception is equivalent to "sense-impression"—by which he means sensibility and sensuous charm. Ruskin certainly would have appreciated Fry's description of a Sung bowl in terms of the purity of its curved lines and the harmony of its decorative color. But I think he would have questioned Fry's statement that the bowl's "sensually logical conformities are the outcome of a particular feeling, or of what, for want of a better word, we call an idea"—for Fry seems to be closing the aesthetic gap between idea and sensory charm. The problem

with Fry, or with Pater—whose elegant tracing of color and line, in Giorgione for example, is often couched in a terminology of "sensation"—is that the idea is often confused with the sensation, as it is not in Ruskin. By the time Fry has extended his "artistic vision" of the Sung bowl to a general theory of the creative dissolution of objects, we have entered the realm of material sensation:

> In such a creative vision the objects as such tend to disappear, to lose their separate unities, and to take their places as so many bits in the whole mosaic of vision. The texture of the whole field of vision becomes so close that the coherence of the separate patches of tone and colour within each object is no stronger than the coherence with every other tone and colour throughout the field. . . .
>
> Every solid object is subject to the play of light and shade, and becomes a mosaic of visual patches, each of which for the artist is related to other visual patches in the surroundings. It is irrelevant to ask him, while he is looking with this generalised and all-embracing vision, about the nature of the objects which compose it.[31]

We are a long way here from Ruskin's doctrine of transparency. Fry's mosaic is a metaphor for a field of discrete sensations. To Ruskin, in *The Stones of Venice*, the literal Venetian mosaic is, once again, an ideational structure, a purposeful arrangement of line and color; its "rudeness" reflects not light (as Proust would have it) but narrative coherence and a sophisticated proportioning of natural forms for the sake of decorative effect. The rudeness of the mosaic is what makes allegorical interpretation possible, because, like the idea of truth, it limits sensation.

Sensibility and Error

Hough raises a problematic issue when he introduces "sensibility" into the discussion. Sensibility, not epistemology, is the basis of Ruskin's literary reputation. The transparency versus the reflectiveness of moving water, the delicate interweaving of purples and blues in a distant mountain chain, the precise degree of tapering in the upward growth of a tree branch, the tints of the various shadows in a flower patch—these are evidence of what Hough has called Ruskin's "delicate and practised sensibility." Hough writes: "The critique of visual appearances to which Ruskin devoted so much of his time is, as he practised it, almost a new genre: there is nothing to which it can be compared."[32] How do these brilliant prose descriptions fit into the shift from sensation to ideation? The first volume of *Modern Painters* is where most of the famous purple passages are found, yet they fall under various headings of "truth." To read them properly, the exact nature of the Idea of Truth must be considered further.

Sensibility is explicitly linked to truth in the second of the seven chapters on the general properties of truth, "That the Truth of Nature Is Not to Be

Discerned By the Uneducated Senses" (3.140–48). Hough rests his argument on this text, yet the text is perhaps the most faithful to Locke in the whole volume. The chapter opens with Locke's definition of "perception" (that is, only "impressions" that "reach the mind"; *Essay*, bk. 2, chap. 9). Its criticisms of the interferences of custom and habit upon truthful perception are thoroughly Lockean. Moreover, the discussion of "reflection and memory"— which, Ruskin says, are "necessary for the retention [of perceptions of facts], and recognition of their resemblances"—parallels the discussion of Locke's chapter "Of Discerning, and other Operations of the Mind" (bk. 2, chap. 11). Ruskin's title alludes to Locke's.

The discussion of sensibility reveals a new problem in Ruskin's epistemology, one that lies beyond the entrapment of sensation. Sensibility, in the particularly moral sense Ruskin gives to the term, promotes the discovery of truth. Sensibility means the "energy and passion of our moral nature" that "sharpens" and "heightens" with gratitude and veneration, the "powers of physical perception and abstract intellect"—on which, in principle, the discovery of truth properly rests, "wholly independent of our moral nature." Sensibility functions as an impetus to vivify and accumulate perceptions, but cannot, in itself, mediate the perception into an idea of truth. It is "necessary for the perception of facts" insofar as it prevents dull, habitual, superficial consciousness of objects. By the same token, "the more sensibility and imagination a man possesses, the more likely will he be to fall into error; for then he will see whatever he expects" (3.143–44). Just as imitation may be indistinguishable from truth, so sensibility may be indistinguishable from its opposite, habit. Imitation suggests a state of seeing without knowing, without conceptualization or cognition. Yet sensibility goes too far in the other direction: it is "peculiarly observable in the perpetual disposition of mankind to suppose that they *see* what they *know*."

Far from misapprehending Locke, Ruskin seems to have hit upon the Lockean epistemological crux. Sensibility suggests a border zone between acuity of perception and habitual, not necessarily accurate, judgment, in which the two are totally confused. Addison, by contrast, thought that Locke had sufficiently separated perception from judgment. His well-known terminology of Fancy or Imagination versus Understanding (as in *Spectator* 411) makes an easy distinction between the liveliness and pleasure of the former and the laboriousness of the latter. The joining together of percepts, which Addison also termed "wit," conflicts with judgment's or understanding's function of separating and discriminating differences among the percepts. Addison's formulation stems directly from Locke's chapter on discernment, in which Locke writes:

Men who have a great deal of Wit, and prompt Memories, have not always the

clearest Judgment, or deepest Reason. For *Wit* lying most in the assemblage of *Ideas*, and putting those together with quickness and variety, wherein can be found any resemblance or congruity, thereby to make up pleasant Pictures, and agreeable Visions in the Fancy: *Judgment*, on the contrary, lies quite on the other side, in separating carefully, one from another, *Ideas*, wherein can be found the least difference, thereby to avoid being misled by Similitude, and by affinity to take one thing for another. [p. 156]

With Ruskin, the problem has become even more fundamental. Sensibility, which acts like wit or fancy in its rapidity and heightening of perceptions, is confused with judgment from the outset. Ruskin seems to have in mind an earlier remark of Locke, from the chapter on perception (bk. 2, chap. 9). Speaking of sight in particular, Locke states that judgment often operates as if it were merely a habit:

[W]e take that for the Perception of our Sensation, which is an *Idea* formed by our Judgment: so that one, *viz.* that of Sensation, serves only to excite the other, and is scarce taken notice of itself; as a Man who reads or hears with attention and understanding, takes little notice of the Characters, or Sounds, but of the *Ideas*, that are excited in him by them. [pp. 146–47]

Locke continues in the next paragraph: "Nor need we wonder, that this is done with so little notice, if we consider, how very *quick* the *actions* of the Mind are performed." As Ruskin puts it: "We are constantly supposing that we see what experience only has shown us, or can show us, to have existence, constantly missing the sight of what we do not know beforehand to be visible" (3.145).

The confusion of judgment and quickness of perception is more disruptive than the Addisonian aesthetic shift from the labor of understanding to the pleasures of the imagination would indicate. Ruskin is not interested in Locke's reference to "excitation" as such, nor in the direct role of the senses in psychological pleasure. His concern is with the possibility of error, which seems hardly avoidable. The more energetic the perception of truth, the likelier the possibility of error.

Sensibility may be independent of truth, but its moral purposefulness corresponds to the abundant existence of natural truth; the range of sensibility cannot be avoided if the "true" range of nature is to be grasped. Ruskin writes:

Be it also observed, that all these difficulties [of separating truth from error, seeing from knowing] would lie in the way, even if the truths of nature were always the same, constantly repeated and brought before us. But the truths of nature are one eternal change—one infinite variety. There is no bush on the face of the globe exactly like another bush. [3.145–46]

Vividness and acuity of perception are therefore necessary to the idea of truth. For a conceptualization of a bush needs to be constantly revived and tested

against fresh perceptions of other bushes. Otherwise, intellectual knowledge becomes dead, a habitual obliviousness to natural surroundings. On the other hand, the bush must be recognized as such, as belonging to a general idea of bushes. It must not be dissolved into mere sensation, nor confused with similar but distinct forms.

The problem of sensibility may be translated into various confusions: fancy/judgment, eye/mind, resemblance/distinctness. But the underlying epistemological crux, which, again, is thoroughly Lockean, is the problem of relating the specific to the conceptual. This problem is considered metaphorically at the conclusion of Ruskin's chapter, when he likens the proper description of nature to the proper definition of man: we may describe the body or the spirit, look at man through the senses or the intellect, as a cumulative expression of accidental, external blemishes, or as an inner, universal essence. But Ruskin's metaphor of nature as man, specifically his personification of sensibility (making sensibility, a problematic human faculty, into an image of the specific versus the universal *in man*), is only a repetition of the initial difficulty.

The very "truthfulness" of the subsequent stunning prose descriptions of Turnerian landscapes and of mountains, water, clouds, and vegetation, all that makes up the rest of this volume, is thrown into doubt. It becomes necessary to separate the specific, living descriptions of natural forms from false judgments, which result from the *blindness of immediate intuition*—not the immediacy of sensation, but the *immediacy of signification*—"as a Man who reads or hears with attention and understanding, takes little notice of the Characters, or Sounds, but of the Ideas, that are excited in him by them." If we look to Locke's statement for a parallel, we may find it in the most disruptive place possible, in the very definition of the Idea of Truth as a sign. The threat of imitation, in this particular volume, is easily dismissed (in the chapters on Ideas of Power, for example, where power as "sensation" is totally negated). Sensation is reducible to material causality. The "sign" of truth, however, which has no material effect, poses the greater threat of falsehood and deception. Ruskin's discussion of sensibility makes readers aware that error, unlike "power," is a difficulty that cannot be overcome. The Lockean theory of the sign, which Ruskin has adopted, shows why this is so.

The Sign of Truth

In his chapter on Ideas of Truth, Ruskin had stated that truth, unlike imitation, "may be stated by any signs or symbols which have a *definite signification* in the minds of those to whom they are addressed, although such signs be themselves no image nor likeness of anything" (emphasis added; 3.104). Likeness is confined to the realm of the senses. But truth as a sign gains access to the mind. It is also associated with qualities of sensibility, "emotions,

impressions, and thoughts"; thus it presents an idea of "universal application," not specific to a single, isolated sense-impression. Truth as a sign seems to resolve the problematic tension between the specific and the universal: its signification is simple, "definite." It presents, to its own advantage, a distinct conceptualization of its referent, whereas the image of likeness presents a confusing array of impressions. The sign, in principle, has no ambiguity about it; it corresponds to one and only one percept—which is why Ruskin needs to explain, almost immediately, why the sign can nonetheless tell more about natural truth than the more seemingly complete likeness. But it is really as a *substitutive* conceptualization that the sign obtains universality. Ruskin says the sign is like a "word" in that it "substitutes" for direct perception. This argument is central. The sign is definite in its signification yet capable of being infinitely repeated in a chain of substitutions, and so in various contexts.

The one aspect of the sign that goes unquestioned in Ruskin's argument is the immediacy of its signification. Yet this aspect is what is so troublesome. Ruskin trusts in the immediacy of signification as a guarantee of the sign's truthfulness. The sign itself is what Ruskin calls a "channel of communication" (3.104), which is actually *effaced* at the moment of cognition. Concerning the "last and greatest distinction between ideas of truth and imitation," Ruskin writes:

> [T]he mind, in receiving one of the former, dwells upon its own conception of the fact, or form, or feeling stated, and is occupied only with the qualities and character of that fact or form, considering it as real and existing, being all the while totally regardless of the signs or symbols by which the notion of it has been conveyed. These signs have no pretense, nor hypocrisy, nor legerdemain about them;—there is nothing to be found out, or sifted, or surprised in them;—they bear their message simply and clearly, and it is that message which the mind takes from them and dwells upon, regardless of the language in which it is delivered. But the mind, in receiving an idea of imitation, is wholly occupied in finding out that what has been suggested to it is not what it appears to be: It does not dwell on the suggestion, but on the perception that it is a false suggestion: it derives its pleasure, not from the contemplation of a truth, but from the discovery of false-hood. So that the moment ideas of truth are grouped together, so as to give rise to an idea of imitation, they change their very nature—lose their essence as ideas of truth—and are corrupted and degraded, so as to share in the treachery of what they have produced. [3.108]

Ruskin's statement echoes Locke's, about the immediacy of judging the total significance of the idea or sign, so that the sign itself is not at all noticed. The trivial empirical aspect of the sign prevents a seduction of the senses. As soon as its semantic function comes into play, its visible aspect, as sign, is forgotten. The sign is totally eclipsed by the signified. The disappearance of the sign in the recognition of truth is a recurrent theme in *Modern Painters* I.

Ruskin speaks about the artist, for example, as sharing the properties of the sign. The artist who conveys truth is forgotten, or effaced, like the sign:

> If we stand for a little time before any of the more celebrated works of landscape, listening to the comments of the passers-by, we shall hear numberless expressions relating to the skill of the artist, but very few relating to the perfection of nature. . . . Multitudes will laud the composition, and depart with the praise of Claude on their lips; not one will feel as if it were *no* composition, and depart with the praise of God in his heart. [3.22]

Then, Ruskin adds:

> These are the signs of a debased, mistaken, and false school of painting. The skill of the artist, and the perfection of his art, are never proved until both are forgotten. The artist has done nothing till he has concealed himself; the art is imperfect which is visible.

These remarks are further echoed in the metaphor of the union of truth, beauty, and relation as a transparent glass, which contrasts with the imperfectly blown Claudean glass.

Transparency, immediacy, negligibility—these are the properties of the sign of truth. But they are very dangerous properties, for we hardly seem to have escaped the threat of error.[33] No opportunity exists for judging the correctness of the signification. We seem to be in the intermediate realm of sensibility—beyond the sensory realm of imitation, where all forms are confused and beguiling, but not quite in the realm of discriminating judgment. What we have are signs without some theory which would explain their organization *as signs*. Locke provides no help here; indeed, Paul de Man has shown that the same problem exists in Locke, who gives a "semantic rather than semiotic" explanation of the meaning of signs:

> Unlike such later instances as Warburton, Vico, or, of course, Herder, Locke's theory of language is remarkably free of what is now referred to as "cratylic" delusions. The arbitrariness of the sign as signifier is clearly established by him, and his notion of language is frankly semantic rather than semiotic, a theory of signification as a substitution of words for "ideas" (in a specific and pragmatic sense of the term) and not of the linguistic sign as an autonomous structure. "Sounds have no natural connexion with our *ideas*, but have all their signification from the arbitrary imposition of men. . . ." Consequently, Locke's reflection on the use and abuse of words will not start from the words themselves, be it as material or as grammatical entities, but from their meaning.[34]

The emphasis on semantics rather than on the autonomy of the structure of signification leads to "haphazard and unreliable" results. As we move through the Lockean sequence from simple ideas to substances and then mixed modes, it becomes evident that concepts, properties, and definitions are "not

a question of ontology, of things as they are, but of authority, of things as they are decreed to be." De Man demonstrates that, although the Lockean sign begins "in the arbitrary, metonymic contiguity of word-sounds to their meanings, in which the word is a mere token in the service of the natural entity," the positing power of the sign may lead to a reshaping of the "texture of reality" in the "most capricious way."[35] Lack of concern, or awareness, about the autonomy of linguistic structure, the means by which signs produce meaning, rather than simply signify, results in a loss of control over the production of meaning. Ruskin's emphasis on the semantic immediacy of the sign seems to lead to the same haphazard positing of meaning, though he is not quite "capricious." Still, in the descriptive passages in the first volume of *Modern Painters* we cannot be sure whether a scene is carefully analyzed or haphazardly constituted. These ambiguous passages contain verbal or semiotic "abuses" of the sort Locke describes, for example, in the word "gold" (bk. 3, chap. 10), a word that is crucial in Ruskin's famous description of Turner's *Slave Ship*. The name of the substance is allowed to stand in, mistakenly, for an imperfect idea of the substance's "real essence." Some property of the substance gold, such as solubility, may be wrongly emphasized in the use of the word "gold," as if it were its essence. In this way, a sign becomes a figure of speech, an "abuse," in that it may lead to further distortions in our idea of a substance.

Locke suggests we avoid this danger by keeping in mind a clear idea of the substance, and when this is not possible, we should recognize that the word is strictly nominal in meaning. But this guidance results in what Richard Rorty calls an "awkward" epistemic balance of "knowledge-as-identity-with-object" and "knowledge-as-true-judgment-about-object."[36] The *immediate* identity of the idea with the object, as Rorty and others have shown, cannot be trusted; privileged mental representations of objects are rich in ambiguities. Is the mind "having" an idea transmitted from the eye? Or is it already judging this idea?

Often Ruskin does speak of the arrangement of signs, what he calls their "grammar." At times he seems to verge upon structural insights about Turner's nonmimetic method of differentiating degrees of luminosity, or the aetherial perspective of color, or the abstracting of the curves of boughs or the strata of mountains in the form of distinct "grammatical" patterns. The grammatical level of analysis seems to convey an awareness of individual signs within a differential structure, or what Ruskin calls a "system." Ruskin's grammar and system are the closest that we come to a proper semiology. They correspond to what Locke calls "judgment" in that they suggest the analytic separation of the "truth" of Turnerian landscape into discrete signs. Locke's definition of judgment seems to be echoed in Ruskin's definition of the term "system":

I repeat then, generalization, as the word is commonly understood, is the act of a vulgar, incapable, and unthinking mind. To see in all mountains nothing but similar heaps of earth; in all rocks, nothing but similar concretions of solid matter; in all trees, nothing but similar accumulations of leaves, is no sign of high feeling or extended thought. The more we know, and the more we feel, the more we separate; we separate to obtain a more perfect unity. Stones, in the thoughts of the peasant, lie as they do on his field; one is like another, and there is no connection between any of them. The geologist distinguishes, and in distinguishing connects them. Each becomes different from his fellow, but in differing from, assumes a relation to, his fellow; they are no more each the repetition of the other, they are parts of a system; and each implies and is connected with the existence of the rest. That generalization then is right, true, and noble, which is based on the knowledge of the distinctions and observance of the relations of individual kinds. That generalization is wrong, false, and contemptible, which is based on ignorance of the one, and disturbance of the other. It is indeed no generalization, but confusion and chaos. [3.37–38]

The translation of types of stone into a system of differential relations is a semiological interpretation of a classificatory scheme. Yet any system, the peasant's or the geologist's, remains arbitrary and haphazard. This becomes evident toward the conclusion of the first volume of *Modern Painters*, when, Ruskin says, numerous systems of interpretation may be applied to a single painting (or drawing or engraving). Of the stony foregrounds of Turner's oil paintings *Mercury and Argus* (Royal Academy [R.A.] 1836; fig. 2) and *The Bay of Baie* (R.A. 1823; fig. 3) Ruskin writes:

Often as I have paused before these noble works, I never felt on returning to them as if I had ever seen them before; for their abundance is so deep and various, that the mind, according to its own temper at the time of seeing, perceives some new series of truths rendered in them, just as it would on revisiting a natural scene; and detects new relations and associations of these truths which set the whole picture in a different light at every return to it. And this effect is especially caused by the management of the foreground: for the more marked objects of the picture may be taken one by one, and thus examined and known; but the foregrounds of Turner are so united in all their parts that the eye cannot take them by divisions, but is guided from stone to stone and bank to bank, discovering truths totally different in aspect according to the direction in which it approaches them, and approaching them in a different direction, and viewing them as part of a new system every time that it begins its course at a new point. [3.492]

Ruskin draws a "lesson" from this multiplicity of systems: to the rightly perceiving mind, nature is "infinite," not capable of being summarized. The judging of differences between the signs avoids a simple repetition of a simple meaning. The picture as a whole is not reducible to a single statement. The endless systematization of signs is given the "divine" infinity of nature itself. Yet this infinity is not teleological. It may lead in confusing and erroneous

directions. The sign's ability to substitute for other signs within various systems does not lead to a better understanding of natural truth. It has the metonymic quality that de Man uncovered within the Lockean epistemology. Systems, like sensibility, do not mark a clear transition from part to whole, or from concrete to universal. Rather, they translate the problem of repetition into arbitrary patterns of association which cannot claim to progress from error to truth. The problem inheres in the very iterability of the sign as a substitution, capable of endlessly contingent repetitions. Repetition, or, in psychological terms, habit, is necessary to the cognitive construction of meaning, although it is also an evil that one would like to avoid. The system has all the accidental, random qualities that belong to associationism.

In spite of the emphasis on difference and relation—the very defining properties of the system—Ruskin has not solved the problematic confusions: distinctness of detail, concreteness of form, immediacy of signification blend into the inability to take truths "by division" and the ineffability of the totality of the relations. No proper explanation of the structure of signification has been offered. We still seem to move from a simple grasp of a single truth to a blurred "mysterious" (one of Ruskin's favorite terms) incomprehensibility.

Ruskin's system is in itself a repetition of the problems inherent in the doctrines of picturesque sensibility and romantic "poetic truth." Martin Price's remarks on the Reverend William Gilpin's doctrine of the picturesque could apply almost as well to Ruskin's system. Price notes Gilpin's "will to see [the untouched landscape] as a series of potential works of pictorial art." "Gilpin does not expect nature to provide him with finished works of art," for nature's harmonious schemes are not accessible to man's limited comprehension. The task of the artist is to adapt "such diminutive parts of nature's surface to his own eye, as come within its scope" (Gilpin). Price continues: "Since art can provide the composing unity, and nature the rich variety, Gilpin moves back and forth—sometimes praising nature at the expense of art, sometimes the reverse. All depends on where he starts."[37] Ruskin does not treat art at the expense of nature, or the reverse. As in Gilpin, the starting point for the comparison is arbitrary, and one term of the comparison easily exchanges places with the other. Whatever can be understood on the limited level of signs of nature's "diminutive parts" is systematically raised into a mystery. By the same token, the "mystery" of nature could be said, in principle, to permeate every part.

Price notes Gilpin's fear of aestheticism, the complete eclipse of meaningfulness by the "energy" of the imagery.[38] Ruskin, too, feared aestheticism, which he tried to counter by assuming that lack of intelligibility or determinate meaning suggested divine mystery. But if the lack of intelligibility is the result of the forcefulness of emotionally composed impressions, then the appeal to divine authority disguises the very "idolatry," or self-imposition before natural

truth, that the first volume of *Modern Painters* set out to destroy. When, for example, Ruskin praises Turner above all other artists because "we most forget him" and that he "becomes great when he becomes invisible" (3.470), perhaps what is really being forgotten is the sign's metonymical substitution for the percept. The need to be able to judge Turnerian truth immediately depends upon the effacing of the "grammatical" nature of the painting. But because such hasty and customary judgments are prone to error, what is really at stake is the substitution of our feelings and readings for natural truths under the illusion of transparency. The control over sensation by means of the sign is jeopardized by the sign's link to a memorized significance, which functions, ironically, according to the forgetting of the arbitrariness of the sign.

Another important source for Ruskin's definition of the system (other than Locke's definition of judgment) is Leigh Hunt's essay, "What is Poetry?" prefixed to his anthology, *Imagination and Fancy* (originally published in 1844). Ruskin seems to have studied Hunt's essay closely. He recommends it in the second volume of *Modern Painters* (1846), in his own discussion of the imagination and fancy, and makes use of several of Hunt's poetic selections. Hunt seems to have inspired Ruskin's comparison of the peasant to the geologist. For Hunt,

> Poetry begins where matter of fact or of science ceases to be merely such, and to exhibit a further truth; that is to say, the connexion it has with the world of emotion, and its power to produce imaginative pleasure. Inquiring of a gardener, for instance, what flower it is we see yonder, he answers, "a lily." This is a matter of fact. The botanist pronounces it to be of the order "Hexandria Monogynia." This is matter of science. It is a "lady" of the garden, says Spenser; and here we begin to have a poetical sense of its fairness and grace.[39]

Hunt is demonstrating the ease of nominal comparisons here; a lily by any other name would still be a lily. The names used by the gardener, the scientist, and the poet each reflect a different system of interpretation. Implicit, too, is the notion, also found in Ruskin, that the highest, or poetical, truth names not only a distinct object but a feeling and moral conceptualization of it (the "fairness and grace"). Ruskin, we recall, emphasizes "a moral as well as a material truth, a truth of impression as well as of form" although at first these truths are, necessarily, confined to a single attribute of the object in the hope of avoiding false associative constructs. Hunt's first concern is the same as Ruskin's: to show that poetic truth is made up of factual perception joined to moral association.

As Hunt develops his argument, he anticipates Ruskin's definition of system. Poetic truth emerges in the subtlety of analogical relations. The subtlety of the analogy determines, in turn, the difference between fancy (distinct) and imaginative (subtle) analogies. Hunt's first demonstration of a subtle anal-

ogy is taken from Ben Jonson. He concludes with a reference to Baconian "paths" that sounds very close to Ruskinian "systems."

> Consider this image of Ben Jonson's—of a lily being the flower of light. Light, undecomposed, is white; and as the lily is white, and light is white, and whiteness itself is nothing *but* light, the two things, so far, are not merely similar, but identical. A poet might add, by an analogy drawn from the connexion of light and colour, that there is a "golden dawn" issuing out of the white lily, in the rich yellow of the stamens. I have no desire to push this similarity farther than it may be worth. Enough has been stated to show that, in poetical as in other analogies, "the same feet of nature," as Bacon says, may be seen "treading in different paths."[40]

The analogy itself—lily is to whiteness as whiteness is to light—is based upon so abstract a middle term as to be relatively uninteresting. It is a subtle analogy perhaps only from a scientific point of view, not a poetical one. What is more interesting is the "poetical" point where further analogies begin to be built upon the initial one. The literal scientific equation of whiteness with light is figuratively extended to the yellow stamens as a golden dawn. As new aspects of the lily are added, the likelihood of error grows, for this second analogy, as Hunt immediately intuits, begins to push things too far.

Hunt's trivial reading provides an economical demonstration of how the feet of nature may err (or wander) as they proceed down certain paths. No scientist would literally identify light and a lily, substituting one for the other. But, as analogies develop, the possibility of mistaking similarity for identity is very great. Forms and properties are confused and predicative of further analogies. The lily as light makes possible the subsequent trope of the stamens as dawn. The same could be said for Ruskin's systems. The substitutability of the signs of nature increases the likelihood of tropological error, as they become identified or blurred with each other instead of sharply differentiated.

Ruskin's praise of Turner and his lengthy critique of numerous European schools and artists in the first volume of *Modern Painters* exploits two antithetical properties of the sign: its narrow referentiality as a token for a single idea, or perception, and its far-ranging significance when placed within an elaborate system, where it may trade places with neighboring signs.

The sign as a simple deictic unit of meaning, standing for only one attribute of an object, is truly infinite in its negative power. It is always possible to argue that a painter has not been specific enough. Every painting must remain incomplete if it is to be coherent. Ruskin, often with great unfairness to Turner's predecessors, attacks incompletion without, however, recognizing compositional unity. I have noted his criticism of Reynolds's grand style as too generalized, but he faults equally Dutch landscapes, Venetian colorist paintings, picturesque sketches, and so on. Lady Elizabeth Eastlake with equal

savagery uncovered Ruskin's trick. In collaborating with her husband Sir
Charles in the development of England's national collection, she probably
gained a wider appreciation of the various European schools than Ruskin had.
Her indignation was fired by Ruskin's "offensive sentiments levelled at such
men as Claude, Poussin, Canaletto, Wilson, Cuyp, Hobbema and Ruysdael,"
or his treatment of Rubens "with an insulting apology" for his lack of seri-
ousness. Titian and Veronese have "feelingless eyes" and "untaught imagi-
nations." Ruskin's massive inability to appreciate these artists, Lady Eastlake
argued, resulted from his failure to understand that "where there is the pre-
ponderance of even one part of the painter's speech, there must be the defi-
ciency of another." She applies this to Turner as well:

> [Turner's] earth, however replete with all that botanical and geological truth which
> Mr. Ruskin so much overrates, [is] wanting in that first truth of all proper to it,
> viz., substantiality. What wonder then that, however exquisitely he traces the
> bramble and veins the rocks, the scene below is often but the secondary accom-
> paniment to the still more elaborately worked out scene above. Not that Turner
> did this by deliberate choice; on the contrary, he could not have done otherwise;
> he had chosen one world for his brush to delight in, and he knew that no picture
> could contain two. To have made out the substance of this Terra firma with the
> same solidity, precision, care, and detail according to its nature, as he did that
> of clouds according to theirs; to have rendered earth earth, as he rendered sky
> sky, would have been to paint what no eye, and, least of all his, could have
> endured.[41]

Artistic accomplishment, therefore, is "the power of getting rid of the trou-
blesome surplus." "It would be an interesting inquiry to ascertain how far
two such opposite means as Rembrandt's shadow and Turner's light both
conduced to the same end of concealment or subordination to a principal
object."

Ruskin's specific, often inconsistent, attacks on various painters lack the
support of a definition of compositional unity, of an explicit definition of the
proper relation of part to whole. The sign's conveyance of a singular attribute
is a handy tool with which to point out the deficiencies of many artists, but
Ruskin offers no definition of an adequate representation of nature. The ex-
traordinary emphasis on details in the first volume is motivated by a deep
suspicion of all compositions as interpolations or substitutions of human imag-
ination for natural truth.

The immediacy or transparency of Turnerian landscape supposedly avoids
the lies of composition. Yet this same immediacy cannot be defined, nor is it
compatible with the specificity of the individual sign. The attempt to link
acuteness of detail with semantic clarity, whether through systems of associa-
tion or through sensibility, always fails. Ruskin is often forced to praise Turner
because the truth of his painting is beyond definition. The forgetability of the

sign leads, perhaps, to the least self-conscious understanding of composition and introduces even great possibilities for error. Whether discussing "truth of space" in Turner, his attempt to render more precisely than earlier schools of painting the visual complexity of distant objects, or Turnerian "truth of clouds," or his "truth of foreground," Ruskin always leaps, apodictically, from specificity to "mystery" without defining structure. He asserts the "unity and symmetry" of the Turnerian landscape as a whole, but only as the cessation of analytical awareness. The unity and symmetry verge on pure aestheticism, for judgment and meaningfulness are suspended within an experience too complex to name. I offer as evidence a series of excerpts representative of the entire discourse of truth in the first volume. I conclude with Ruskin's famous discussion of Turner's *Slave Ship* (1840). In each case he moves from part to whole through a "system of truth" that is far from systematic.

In his chapter on truth of space, Ruskin finds a similarity between Turnerian distance and the lines of Westminster Abbey seen from Highgate Hill early in the morning:

> Look at [Westminster Abbey] in its parts, and it is all inextricable confusion. Am I not, at this moment, describing a piece of Turner's drawing, with the same words by which I describe nature? And what would one of the old masters have done with such a building as this in the distance? Either he would only have given the shadows of the buttresses, and the light and dark sides of the two towers, and two dots for the windows; or if, more ignorant and more ambitious, he had attempted to render some of the detail, it would have been done by distinct lines, would have been broad caricature of the delicate building, felt at once to be false, ridiculous, and offensive. . . . Turner, and Turner only, would follow and render on the canvas that mystery of decided line, that distinct, sharp, visible, but unintelligible and inextricable richness, which, examined part by part, is to the eye nothing but confusion and defeat, which, taken as a whole, is all unity, symmetry and truth.
>
> Nor is this mode of representation true only with respect to distances. Every object, however near the eye, has something about it which you cannot see, and which brings the mystery of distance even into every part and portion of what we suppose ourselves to see most distinctly. [3.336–37]

Here the shift from eye to mind, from the specificity of the signs (the lines and dots) to the unintelligibility of the moment in which the signs are effaced is treated phenomenologically, as a constitutive moment that moves between closeness and distance. Yet there is not a theory of unity or symmetry that would explain properly this wavering status or spatialization of truth. The passage attempts to persuade us through a series of rhetorical questions that are not really answered that we are perceiving internally the appearance of the unintelligible, which lies beyond the merely mimetic realm of the eye. How do we decide what is merely confusing and what is unintelligible? Unity

and symmetry are posited, but they remain in principle a "mystery." At what point do signs capture some of the object's richness without lapsing into mere vagueness? Ruskin seems to be praising a certain delicacy in Turner's technique. Turner alone seems to be able to realize lines on canvas with subtlety, but when Ruskin attributes mystery to these lines he cannot claim to have explained the mind's grasp of the whole.

The third section of *Modern Painters* I, "Of Truth of Skies," with its series of chapters on clouds, is often considered to be Ruskin's finest, and is, as Lady Eastlake noted, the most pertinent to a defense of Turner. The variety of cloud shapes in motion, their subtle transmission of light which is partially transparent and partially opaque, their various atmospheric densities—these make clouds into a test of an artist's capacity for "infinity." Clouds decide the difference between the infinity of truth and the dullness of repetition:

> [I]f we wish, without reference to beauty of composition, or any other interfering circumstances, to form a judgment of the truth of painting, perhaps the very first thing we should look for, whether in one thing or another—foliage, or clouds, or waves,—should be the expression of *infinity* always and everywhere, in all parts and divisions of parts. For we may be quite sure that what is not infinite cannot be true. It does not, indeed, follow that what is infinite is always true, but it cannot be altogether false; for this simple reason, that it is impossible for mortal mind to compose an infinity of any kind for itself, or to form an idea of perpetual variation, and to avoid all repetition, merely by its own combining resources. The moment that we trust to ourselves, we repeat ourselves, and therefore the moment we see in a work of any kind whatsoever the expression of infinity, we may be certain that the workman has gone to nature for it. [3.387]

Infinity is a natural attribute of truth. Repetition is the human distortion of truth, for we repeat "ourselves," not nature. The combining of forms and colors as an imaginative activity tends toward repetition rather than infinity, suggesting our limited capacity to apprehend the totality of nature. Infinity cannot be grasped structurally. But the passage suggests that it can be grasped systematically, through endless differentiation of the parts or signs of a painting. Like mystery, infinity is in all parts and divisions of parts.

According to this principle of infinity, Ruskin condemns the sort of clouds often found in Salvator Rosa's paintings (fig. 4). Rosa's clouds repeat each other in shape and size; they are formed from the same curves, often of the same length, and they appear to be "cauliflower-like protuberances." Their heavy shadows suggest solid objects, not delicate masses of illuminated vapor. But Turner's *Rouen Seen from St. Catherine's Hill* in his *Rivers of France* series has the whole sky as "one ocean of alternate waves of clouds and light, so blended together that the eye cannot rest on any one without being guided to the next, and so to a hundred more, till it is lost over and over again in every wreath" (3.388). (This watercolor is currently unknown; see fig. 5 for Turner's

sketch of it.) In this complex of lines, colors, and vague forms "too mysterious and too delicate for us to analyze," we have truth: it "*must* be nature because man could not have originated it." Every form "must be faithful because none is like another."

Here again we find a problem with the sign of truth. Infinity presents the latest version of this problem. The systematic, nonrepetitive differences among the strokes, forms, and colors of Turner's sky suddenly translate into a mysterious whole. Individual differences among the parts are forgotten, and this forgetting is named infinity. We also see that for all Rosa's artificiality there is no possibility of mistaking his lines for any precise likeness to nature, whereas Turner's complex sky allows erroneous substitutions. Infinity mixes ocean and sky. We are back to the subtle analogies of Leigh Hunt in which similarity is overextended to the point of identity. Rosa's brush strokes are the true signs. Their visible linearity and abstract patterning are closer to Ruskin's first example of a sign of truth, the line of the bough of a tree. When Ruskin substitutes ocean for sky, he creates a trope (clouds as ocean waves) instead of explaining a sign (brush strokes as cloud outlines). Infinity's un-intelligibility leads to confusion. Ruskin's terminology of the unanalyzable yet infinitely differentiated parts of a painting leads to a false sense of certainty. W. K. Wimsatt has neatly summarized the "aesthetic" way in which confusion may appear in the guise of certainty (Wimsatt is referring specifically to Alexander Baumgarten, but compares him in this context to Addison and Burke):

> Clear but confusedly sensuous ideas (that is, ideas which are distinguishable from one another but not internally analyzable) constitute one form of the ineffable. The theory of the ineffable, the nameless object of "taste" (the Leibnizian *je-ne-sais-quoi*, in more amateurish terms the "grace beyond the reach of art") is strongly in the ascendant at the birth of modern aesthetics, and along with it, let us add, the theory of an "internal" aesthetic "Sense," no less simple and ultimate than the external senses, no less autonomous, no less infallible.[42]

Ruskin had no doubt of Turner's infallibility, for Turner had brought the ineffable directly into the mind of the viewer. But it would seem that this internalization is a matter of shifting, without explanation, from distinct part to blurred whole, from the sign as a simple marker of a percept to the sign as rhetorical device that allows for the substitution and confusion of percepts. The more active the sensibility, the more likely error, as Ruskin noted.

The final text from the first volume that I would like to consider is Ruskin's description of Turner's *Slavers Throwing Overboard the Dead and Dying, Typhon Coming On*, also known as *The Slave Ship* (R. A. 1840; fig. 6). The description is part of the chapter "Of Truth of Water." The text has exemplary value for several reasons. Ruskin considered *The Slave Ship* to be Turner's finest oil

painting. He wrote of it: "I believe, if I were reduced to rest Turner's im-
mortality upon any single work, I should choose this" (3.572). His description
of the painting is one of the most eloquent in the volume:

> It is a sunset on the Atlantic, after prolonged storm; but the storm is partially
> lulled, and the torn and streaming rain-clouds are moving in scarlet lines to lose
> themselves in the hollow of the night. The whole surface of sea included in the
> picture is divided into two ridges of enormous swell, not high, nor local, but a
> low broad heaving of the whole ocean, like the lifting of its bosom by deep-drawn
> breath after the torture of the storm. Between these two ridges the fire of the
> sunset falls along the trough of the sea, dyeing it with an awful but glorious light,
> the intense and lurid splendour which burns like gold, and bathes like blood.
> Along this fiery path and valley, the tossing waves by which the swell of the sea
> is restlessly divided, lift themselves in dark, indefinite, fantastic forms, each cast-
> ing a faint and ghastly shadow behind it along the illumined foam. They do not
> rise everywhere, but three or four together in wild groups, fitfully and furiously,
> as the under strength of the swell compels or permits them; leaving between them
> treacherous spaces of level and whirling water, now lighted with green and lamp-
> like fire, now flashing back the gold of the declining sun, now fearfully dyed from
> above with the undistinguishable images of the burning clouds, which fall upon
> them in flakes of crimson and scarlet, and give to the reckless waves the added
> motion of their own fiery flying. Purple and blue, the lurid shadows of the hollow
> breakers are cast upon the mist of night, which gathers cold and low, advancing
> like the shadow of death upon the guilty ship as it labours amidst the lightning
> of the sea, its thin masts written upon the sky in lines of blood, girded with
> condemnation in that fearful hue which signs the sky with horror, and mixes its
> flaming flood with the sunlight, and, cast far along the desolate heave of the
> sepulchral waves, incarnadines the multitudinous sea. [3.571–72]

Both Herbert Read and Elizabeth Helsinger have singled out Ruskin's text
as the most concise and thorough demonstration of his place in the English
aesthetic tradition that begins with Locke and Hogarth.[43]

For Read, Ruskin's description of *The Slave Ship* illustrates his general theory
of the imagination, which accounts for Turner's surpassing of the lesser realm
of natural facts and mimesis, to which William Hogarth and John Constable
belong: "In Hogarth, generally speaking, the primary act is one of judgment,
of criticism, of rational selection." Hogarth's primary aim was "social criticism
or social honesty when it was a question of direct portrait." Quoting Ruskin,
Read shows why Constable belongs to the inferior, mimetic class of artists:
his truths "give a *deceptive resemblance* to Nature." Only Turner, according to
Ruskin's theory, gives an adequate picture of natural truth, especially in *The
Slave Ship*. Read writes: "[W]hat appears at first to be a confused torment of
water and spray, transfused by the rays of the setting sun, is actually packed
with realistic incident—agitated fishes, pieces of wreckage, disappearing
limbs, despairing hands, hovering gulls, and, in the offing, two ominous sea-

monsters with gaping jaws." We have Hogarthian social criticism,[44] yet the criticism is mixed with a typically Turnerian wealth of visual detail confused with agitated water and brilliant sunlight, a presentation Constable would have found "extravagant."

Read does not find the overall impression of Turner's painting or Ruskin's "parallel work of art" (in prose) confusing. Turner and Ruskin "achieve a synthetic vision in which every detail focuses to clarity." The clarity is a product of the imagination as Ruskin has defined it for the first time in the English tradition:

> The vacancy of a truly imaginative work results not from absence of ideas, or incapability of grasping or disdaining to tell more; and the sign of this being the case is, that the mind of *the beholder is forced to act in a certain mode, and feels itself overpowered, and borne away* by that of the painter, and not able to defend itself, nor go which way it will: and *the value of the work depends on the truth, authority and inevitability of this suggestiveness.*[45] [Emphasis added.]

We have encountered this theory before, in Ruskin's definition of the suggestiveness and authority of systems of truth. What is new in Read's discussion is the acceptance of the overpowering effect of the connections made between the parts or details of the painting. For Read, there is no problem in the fact that the authority of the artist's power rests on temperament; indeed, Read finds in this characterization of the imagination the first example of "expressionist" doctrine in the criticism of the arts in England. We have seen that Ruskin emphasizes the role of emotion in the construction of systems. There is no cause for argument if Read wishes to call this "expressionist." It is not apparent, however, that the result of this imaginative activity should be synthetic clarity, or that clarity is synonymous with forcefulness of suggestion. Read does not seem to be arguing for objective clarity. He goes so far as to say that Ruskin is not interested in the mere seeing of things steadily. Read equates forcefulness of suggestion, what I have been characterizing as the rhetorical force of associative links, with clarity of perception. Clarity in that case does not refer to distinctness of parts, but to the more ineffable unity of impression, to an internal clarity that is self constituted. The confusion of the painting is rendered clear through the operation of the imagination. Read thus reduces Ruskin's ambivalence about the relation of distinctness to mystery into a theory of subjective response. Emotional temper is all that counts. The cognition of truth is really not important at all, since it is always, for Read, subjective. The text on *The Slave Ship* becomes a central document in the evolution of expressionism—which is not at all what Ruskin intended. For all its internal contradictions, *Modern Painters* I is an attempt at an epistemology of landscape painting.

Helsinger's reading of the text on *The Slave Ship* seems to have been strongly

influenced by Read, although she does not mention him. She, too, invokes Hogarth, and tries to place Ruskin's text within the English tradition, notably associationist criticism. Like Read, Helsinger calls Ruskin an "expressionist," but she has in mind a far more sophisticated understanding of the term. Turner's "expressive language" of painting implies "neither the intellectual pleasure of reading emblematic images [as in Hogarth] nor the sensual pleasure of immediate sensation, but a combined activity of discovering both sensation and ideas together with the movements of the mind that produced them." This sounds much closer to Ruskin. Indeed, her point of departure is the Lockean idea, which comprehends sensation and cognition.

Unlike earlier critics, Ruskin does not sacrifice sensation, immediacy of effect to meaning (as do the Richardsons), nor the reverse (as does Hazlitt). The text on *The Slave Ship* reveals a union of the two. I would qualify Helsinger's thesis with regard to sensation, which she seems to confuse with the immediacy of signification that Locke attributes to the sign. Sensation, as such, has no role to play in Ruskin's epistemology. Helsinger is most acute, and makes the greatest advances over Read, when she begins to define the associative process, the so-called movements of the mind. Ruskin's "system," Read's "synthetic vision" of the imagination, are concerned with this associative movement, which seems to fluctuate so ambiguously between clarity and obscurity, judgment and sensibility, truth and error.

Helsinger's understanding of Ruskin's commentary on *The Slave Ship* is intended to support her thesis. For her, "energy" of description and "visual richness" in Ruskin lead to meaningful patterns of interpretation. Ruskin "interweaves literal description and metaphoric evocation." Helsinger's method of interpretation is similar to Leigh Hunt's: subtle physical analogies generate metaphorical significance. Like Read, she senses an inevitability, or powerful directness, in Ruskin's description, which projects the reader into phenomenological space and then calls him back to the surface of the painting. Such a movement is characteristic of Ruskin's writing. Yet the spatial constitution of objects of intuition is not the primary goal of Ruskin's description. Rather, it is the combination of thought and image in one vortexlike associationist train of ideas:

> In [Ruskin's] account of *The Slave Ship* . . . the visual impression is neither simple nor immediately grasped; the relation of ship, sea, and sky to each other is visually complex. Relationship, primarily expressed through color, does exist, but must be traced from touch to touch and color to color by the eye. That process of following out visual connections not immediately comprehensible is, in Ruskin's prose description, made identical with the process of following out an imaginative train of ideas (the flight of the clouds, the torture and relief from the storm, the bath of blood, the valley of the shadow of death, fearful dye, reckless waves, guilty ship, the ineradicable stain of crime). Thus for Ruskin the Turner painting does

not convey emotion through visual unity of impression, stimulating dream or reverie. Rather it guides the mind through a temporal process of imaginative association which is inseparable from a temporal experience of tracing formal visual relationships, especially of light and color. Painting, like poetry, has become not just the occasion for mental process but also the embodiment of it.[46]

A visual impression that is not immediately graspable is thus unraveled as a sequence, or associative train, of ideas; the unraveling of the visual constitutes meaning. We move from detail to detail through formal patterns of color which appeal to the eye, but which also make up metaphorical connections—blood, death, crime, guilt. The meaningfulness of the metaphors prevents the mind from wandering into a (mimetic or sensory) dream. Helsinger seems to have reconciled the visual with the cognitive. Beyond the aesthetic confusions of distinctness and unintelligibility, the mystery of the whole and the infinity of the parts, there lies a very workable theory of associationism, typified by the text on *The Slave Ship*.

The final paragraph of Ruskin's chapter on water, immediately following the discussion of *The Slave Ship*, states that the painting "complet[es] thus the perfect system of all truth, which we have shown to be formed by Turner's work." Turner's painting of the "illimitable" sea (which, for Ruskin, has the same infinity as the clouds) completes a system of truth that includes vegetation, skies, and mountains. The question still remains: is this system arbitrary and accidental? The system explicitly refers to natural facts, to empirical perceptions, yet these perceptions, as Helsinger indicates, achieve the status of truth only by being internalized, by being translated into meaningful, ideational patterns. What prevents the intrusion of error into this pattern? For Helsinger, literal and figurative language is entirely compatible within the train of ideas. Metaphors serve primarily to link or connect the parts of the picture, its signs. The movement of metaphorical meaning, from sign to sign, reflects the movement of the mind, both internally and externally. The internal association of ideas corresponds to the "embodiment" of truth in the painting. Does this movement have what Ruskin would call an "inevitable suggestiveness"? Or is the movement merely rhetorical in its authority? For Helsinger, the meaningfulness of Ruskin's metaphors in no way alters the referentiality of the signs, or colors, of the painting. On the contrary, the metaphors clarify the otherwise unintelligible mass of colors and forms. It is possible, however, to read Ruskin's metaphors as the final falsehood of this volume, the final idolatrous substitution of illusion for clarity which it has been the task of the volume to evade. What Helsinger calls the association of ideas in the text on *The Slave Ship* summarizes the undoing of Ruskin's early epistemology by his use of tropes, which he mistakes for signs. Far from clarifying the relation of sign to sign, tropes constitute a pattern of error, all the more persuasive by their sign-like immediate effect upon judgment.

The temporal movement that Helsinger describes in this text begins with two references to time: "sunset," "after prolonged storm." Ruskin is already in error here. The subtitle of the painting is *Typhon Coming On*, and, as Andrew Wilton has noted, the storm to the left of the painting, in which we see the slave ship being tossed, is "brewing" and "impending."[47] We should be wary of Ruskin's characterization of the broad heaving of the whole ocean after the torture of the storm. The agitation of the waves is prior to their swelling, not an aftermath. Similarly, the "flying clouds" which add to the motion of the "reckless" waves are actually approaching, about to cover rather than reveal the setting sun. A single, very casual mistake has a tendency to call forth associations with all the force of an *idée fixe*. The motion of the waves, neither calm nor reckless, could easily be mistaken for tending in either direction. The mistaking of after for before is easy to make without knowledge of the title. Ruskin's mistake does, however, lessen the theme of guilt. Read in the proper temporal order, the throwing overboard of the "dead and dying" stands for a desperate attempt at self-preservation, as the slavers attempt to lighten the load of their ship. Turner's ironic poem from the *Fallacies of Hope* that accompanied this painting emphasizes the slavers' despair at sacrificing excess profit and the riskiness of the business venture.[48] The death of the slaves and their consumption by sea-beasts prefigure the fate of the slavers on board, and make their "bloody" mast a symbol of their own death rather than a symbol of guilt.

More interesting than this zealous moral misreading is Ruskin's metaphorical manipulation of the colors of the painting: the gold (possibly signifying the loss of money in the setting of the sun), the crimsons, the greens, and the blues. The train of metaphors that Helsinger identifies—"flight of the clouds, the torture and relief from the storm, the bath of blood, the valley of the shadow of death, fearful dye, reckless waves, guilty ship, the ineradicable stain of crime"—amounts to a systematic troping of certain colorful signs within the painting. The themes are derived from the metaphors of Ruskin's reading.

The first key sentence is: "Between these two ridges [of enormous swell] the fire of the sunset falls along the trough of the sea, dyeing it with an awful but glorious light, the intense and lurid splendour which burns like gold, and bathes like blood." This "fiery path" (as Ruskin calls it) opens the way for an extensive series of metaphors: the "lamp-like fire" of the whirling water, the waves "dyed" with the "undistinguishable image of the burning cloud," the clouds' "flakes of crimson and scarlet" (suggesting burning wood). The bath of blood is later associated with the masts of the ship, seen as "lines of blood," and, of course, with the incarnadine sea. The "scarlet lines" of the clouds at the opening of the text come full circle as they meet with the guilty mast of the ship. In the brilliant colorful contrast between the setting sun, with its golds, oranges, and crimsons, and the greenish-blue of the sea, and in the

mingling of shadows and reflections as the two opposing bodies of color meet we have the complex visual patterning that allows Ruskin to generate the metaphorical connections between gold, blood, and "dyeing" (perhaps a pun on the fate of the slaves) and "burning." The meeting of sun and water, as the sun sets, is, properly speaking, within the compositional surface of the painting, a meeting of (the signs of) fire and water. As the two bodies approach, the properties of the sun transfer to the waves of the sea. Flames and waves become identical. Because gold, heated into a liquid, partakes both of the fire and the waves, it, too, blends into the description. The intense reflection of the sunset on the water does create a "path" in its narrowing perspective and vanishing point. (Turner may also be enjoying a joke, since the sun makes the term vanishing point into a literal event in the painting.) We have, therefore, subtle analogies which seem to have a certain inevitability in their connections. The meaning of the painting becomes totally coherent.

It is important to note, however, that in order for the metaphors to work, a single sign or word (like "blood") has to enter into multiple relationships with other signs and words, not all of which are compatible. This presents no problem as long as the painting is read as an associative "system," which allows for repetitions and substitutions of signs along various sequences or paths. But to read the painting as a single *structure* of signification would impose a tension on the signs that would impede the sort of reading Ruskin performs. In the series of metaphors that begins with the fire of the sun, a single sign—the brilliant patch of yellow, more yellow than anything else in the painting, with the heavy, short strokes of white set within it, signifying the barely visible orb of the sun—subtly translates, through substitution, into a set of tropes. The substitutive pattern is clear as a sequence, in which each substitution completely effaces the previous one, but the pattern is not clear as a structure of meaning. The yellow patch signifies fire. The notion of heat remains, but the yellow suddenly stands for burning gold. The notion of liquidity remains, but now the color is red, signifying blood. The path from yellow to red, from sun to gold to blood is made up of substitutions, not of the yellows and reds as distinct signs purposefully differentiated from each other within a structured whole. Meaningful structures—comparison, contiguity, resemblance, order—are all done away with by Ruskin's substitutions. Sunlight is linked to the blood that signifies guilt, yet the sun itself has no guilt. The composition of the picture, taken as a whole, makes the sun into an ironic witness, illuminating the death of the slaves, while the slave ship is cast into darkness. The presence of brilliant light renders the spectacle pathetic, not cruel. Yet to transfer the burning sun to the burning waves gives an incompatible suggestion of damnation and guilt. Neither the sun nor the slaves are guilty. The setting of the sun, in fact, parallels the sinking of slaves. A more structurally aware reading than Ruskin's would show that the crimson

color that surrounds the setting sun is thematically parallel to the death of the slaves in the dark water. Yellow sets into crimson as the dark slave drowns in the greenish-blue water. To go from sun to slaves by substitution, literally to identify them in terms of colors, seems to me an error.

Similarly, when the wandering metaphor of blood attaches itself to the reddish mast of the ship, this means, to Ruskin, "condemnation" of the "guilty" ship. Perhaps the ship is indeed guilty. We need not pity the slavers as we do the slaves, who are chained and cannot swim. There is irony in the fact that now the slavers are slaves of the storm, which cannot be escaped. Again, however, the visual blending of the deep red masts with the crimson patches of the sky leads to a false transference of guilt back to the sun and then from the sun back to the incarnadine sea. The mast, like the "fiery path," opens the way for substitutive meanings which distort the composition of the painting. The ship is to the sun as the sun is to the slaves perhaps in the common fate of "death" but not guilt.

In his substitutive readings of the signs of lights, shadows, and wave-motions, Ruskin does not address the issue of compositional unity. Composition would suggest falsehood, an artificial manipulation of waves and colors into either a mimetic or an idealized deception. Yet the semantic immediacy of Ruskin's system of truth, which judges so quickly the meanings of guilt and condemnation in the colors, creates its own deceptions. To see the meaning of Turner's painting, we have to work against Ruskin's interpolation. The semantic immediacy of the sign, as Locke noted, triggers the least self-conscious acts of judgment. The specific referent of the sign—for example, a set of very definite brush strokes of red signifying the setting of the sun—is empty of meaning, a hollow marker made over into a trope for blood. Robert de la Sizeranne detects in such moments of immediate judgment the very idolatry, or self-imposition before the painting of nature, that Ruskin condemns: "Occupied always with visual sensations, Ruskin passes without transition from the red of vermilion to the red colour of blood—because in colour there is no transition. His images, as successively he calls them up, warp and destroy his argument."[49]

In a letter dated September 28, 1847, to the Reverend W. L. Brown (36.80–82), Ruskin describes in retrospect how he had "mistaken" the simple signs or pigments of Turner's "The Slaver." Without his re-creation of the experience captured in the painting, the painting would not have suggested any "truth," he claims. A "clear conception" of the painting would amount to statements such as "line of eye, two-fifths up the canvass; centre of light, a little above it; orange chrome, No. 2 floated in with varnish, pallet-knifed with flake white," and so forth. To grasp the "truth" of a painting, the beholder must risk a certain amount of error. The imaginative perceiver, who leaps from the surface of the canvas into an "immediate" feeling, even an

"enthusiasm" for the painting, "may sometimes mistake [his] own creations for reality, yet will *miss* no reality." Without this leap, the canvas remains a mass of dead shapes and colors. Ruskin concludes: "of course such a mode of interpretation is often liable to error, and necessarily sometimes involves it. Many of the passages respecting Turner are not actual descriptions of the pictures, but of that which the pictures were intended to suggest, and *do* suggest to me."

For Ruskin, the truthful interpretation of a painting must involve some imaginative error. Nevertheless, these errors should not be confused with the errors of mimesis or idealization, which are simpler, easier misapprehensions of the infinity of nature. The errors of Ruskin's interpretation are of greater theoretical interest. They are best defined as metaphors, and as such they are not to be refuted. Instead, they open possibilities for interpretation, any one of which is inevitably limited in what it conveys of the painting's totality. The one claim of the first volume that clearly fails is the claim for infinite apprehension or complete truth. Ruskin's shift from signs to tropes and back gives his prose great suggestiveness; the danger lies in holding to any particular metaphor as if it were a descriptive truth.

Lars Aagaard-Mogensen has explained this danger in an essay on the metaphorical animation of the "blank" primary qualities of paintings (what Ruskin calls their signs).[50] Aagaard-Mogensen sees the transference of human qualities and contexts to the blank surface of the painting as a "grand semanticizing system," which leases "complexity to the intransitive aesthetic qualities." For Aagaard-Mogensen, the "primary aesthetic qualities resist the metaphorical transfer," and so they keep the metaphorical axis of explanation aligned with the painting's texture. Metaphors must not be too aberrant, and at the same time they must not be given "perpetual life." He concludes that explanatory metaphors are "unique," devoid of predicative value. When Ruskin realizes that he has erred, he cautions us against giving his descriptions a perpetual life. But the task of interpretation cannot rest there. Error must be risked anew.

As Ruskin moves away from landscape painting, and so from the direct threat of mimesis, and turns toward the Italian painters of Christian symbolism the theory of the sign gives way to a theory of typology. Ruskin advances toward a structural account of meaning, most importantly in terms of unity and proportion. He explores in much greater depth the problems of part/whole, distinctness/mystery, and constructs a general theory of the imagination. But these advances bring with them equally obstructive deceptions.

2

The Typology of Metaphor:
Modern Painters II

Types

Modern Painters II, written and published in 1846, was conceived in 1843, at the same time as the first volume and as a complement to that work. It was to have concluded the defense of Turner in terms of ideas of beauty and relation, as the opening chapters of the first volume had promised. In the intervening three years Ruskin had learned to doubt his ability to write authoritatively on the topic of beauty and had recognized his limited familiarity with European art. The fundamental epistemological concerns did not change, however. The focus shifts from Turner to the Christian artists of Northern Italy, notably Fra Angelico, and to the Venetians, notably Tintoretto. But the argument continues the earlier devaluation of sensation, which now is termed *aesthesis* in its root meaning of sense-perception. Ruskin continues to emphasize cognition, not in terms of the Lockean idea or sign, but in terms of what he calls "types": the character of a material thing by which an immaterial idea is conveyed. The result is a strangely nonaesthetic discussion of beauty, which values rudely drawn frescoes or overtly biblical images, images that are hardly aesthetic in the sense of classically restrained form or in the more modern sense of sensuously appealing. Beauty is presented as an epistemological problem, having to do with the determination of the "laws" of form, not in the sense of *forma*, but in the allied sense of *figura*. Beauty stands for a "positive" representation of formal perfection that can only be called divine. The types include such divine attributes as infinity, unity (and proportion), repose, symmetry, moderation, and purity. Ruskin seeks to establish these qualities, which usually take on a certain abstract form, as substantive properties of perceived objects. The argument has shifted from the nominalism of Locke to the metaphysics of substance of Aristotle.[1]

As a whole, *Modern Painters* II is perhaps the most curious volume Ruskin

ever wrote. It is certainly the one about which he felt most ambivalent. It presents, in the tone of some of Ruskin's most dogmatic prose (in imitation of Richard Hooker), a massive theoretical uncertainty. The lengthy critiques of associationist doctrines of beauty and all functional definitions of beauty, in the opening chapters, continue the exuberant smashing of received ideas so characteristic of *Modern Painters* I. At the same time, the entire plan of the volume underwent two major revisions: a proposed section on the sublime was never written, and the second part, on the imaginative faculty, was added to the first draft. The six types were shuffled and expanded and contracted several times. Of the five volumes which comprise *Modern Painters*, the second was the only one that Ruskin was ashamed to reprint later in his career, while Slade Professor of Fine Art at Oxford. When he eventually arranged a new edition for publication in 1883, as a protest against the aesthetes, he added an elaborate set of footnotes approving or disqualifying almost every page of text.[2]

My concern is to show the decisive points in this volume where Ruskin's tone of assurance conceals (or tries to conceal) an epistemological crux. I have argued that Ruskin was not a very systematic thinker (an opinion he would have shared by the time of his middle carreer), but he was an extremely rigorous thinker. When religious concerns enter Thomas Carlyle's writings, they become apocalyptic pronouncements on the evils of materialism. Matthew Arnold's early religious doubts fostered a temperate skepticism, but religion in Ruskin is usually a rhetorical mask for a difficult epistemological problem. Ruskin is truly an "aporetic" thinker, in the Aristotelian sense of the term.[3] Beyond the refutation of associationism and the criticism of Northern Italian art, the second volume continues the cognitive problem of relating the part to the whole and deciding between the externally given and the internal, imaginative modification. Rhetorically, Ruskin's attempt to reveal the divine is not more moving than Carlyle's. Philosophically, the divine types of this volume point to a series of conceptual difficulties which recur in Ruskin's career, whether he is writing about Venetian architecture, the Pre-Raphaelite Brotherhood, or, in his later works, Greek sculpture.

Ruskin prepares his discussion of the types of divine beauty with a series of short essays doing away with "false opinions" concerning beauty. Beauty is a "theoretic" or "contemplative" pleasure, not a sensory one. Beauty has nothing to do with custom or association, or with utility or "fitness," as Archibald Alison had argued. Custom or association works through a "false or metaphorical" confusion of two sensations (and so is similar to what Ruskin had earlier called "mimesis"). Beauty, for Ruskin, must be "inherent" in the object, must be "positive" and "universally" recognizable. The theoretic or contemplative mode, therefore, isolates the typical character stamped upon substance, which "reminds" or causes the viewer to think of the moral per-

fection of God's creation. The cognitive goal of the first volume was the transparency of the sign of the natural object, but in the second volume, as Malcolm Mackenzie Ross has noted (in his essay on Hooker's influence on Ruskin), the theoretic perception of beauty is the recognition of the "mark of the divine . . . on the make of things. The Glory of God is declared not by things-as-windows but by things-as-themselves." Ruskin's laws of beauty "are promulgated and conveyed in the divine attributes which are stamped and sealed into the particularities of the Creation, made 'intra-real' not 'extra-real,' *in* the Creation, *of* the Creation, *from* the Creator."[4]

The antithetical terms *theoria* and *aesthesis* Ruskin had casually adopted from Aristotle's *Ethics* in order to make the distinction between the perception of typical characters and mere sense-experience.[5] As such, the terms present little improvement upon the earlier Lockean distinction between idea and sensation. *Theoria* grows in complexity as Ruskin attaches other, quasi-Aristotelian terms to it. These terms anticipate but do not yet clearly define the two key types, unity and purity.

In the opening chapters of the volume, "unity" frequently modifies *theoria*. The beauty of Creation must be seen in its "right relation." True judgment depends upon the subordination of certain objects for the sake of the total scheme. Unity and proportion reach toward the "infinity" and "mystery" of the first volume, but not by blurring or confusing forms within a single continuum. Theoretic unity comprehends the divine through differentiation, in which parts that are separately "imperfect" achieve perfection in relation to others. Theoretic unity seeks a structural perfection that is immanent in the totality of nature, but is not the property of any isolated object. In fact, a certain fallen, imperfect quality in nature is necessary in order to make room for the proper function of the human imagination. Ross rightly emphasizes the centrality of unity in this volume, for upon it hinges the passage from *theoria* to imagination, from part one to part two of the volume. Ruskin "stresses the comprehensiveness of the imagination as it grasps and refashions the clashing and seemingly ill-sorted contraries and imperfections of nature." Theoretic perception receives those objects which "appear" to be grouped in harmonious structures, while the imagination forms similarly structured wholes out of imperfect parts and thus "assists in the economy of redemption." The imagination raises the "temple even out of the fragments of the Fall."[6] In both theoretic and imaginative unity some degree of imperfection of the parts is assumed. The very transition from the imperfection of the part to the perfection of the whole constitutes the logic of *Modern Painters* II.

Purity, the type of divine energy as light, is perhaps the most difficult of Ruskin's six types, and it cost him the greatest labor in revisions, as the Pierpont Morgan Library manuscript of the volume shows.[7] More than unity, purity is associated with *theoria* in the opening chapters. Yet purity is less

well defined. It may correspond to Aristotle's *energeia:* the actualization, in matter, of potential form.[8] More than the other types, purity implies a substantial presence. For this reason, Ruskin suggests that it is logically prior to the other types. Through purity, divinity first enters matter, animating it and making possible, through its illumination, the appearance of the other types. James Sherburne, who has given full recognition to the importance of this type in *Modern Painters* II and in Ruskin's subsequent works, notes that Ruskin's purity differs from the association of divinity with light in such writers as Berkeley, Coleridge, and Carlyle. In these writers, there is no attempt to make the metaphor of God as light into a material fact. Light is the material *symbol* of the idea of divinity, precisely because it is the least earthbound. In Ruskin, however, purity *is* a material condition, though the relation of spirit to matter remains ambiguous.[9] Sherburne is particularly helpful when he notes the affinity of purity and unity. Both types deal with the problem of defining structural integrity, the perfect adaptation or reconciliation of all the parts into a single whole. The more well-structured an object, the higher its degree of internal coherence, the more "pure" it is. Like unity, purity tends to occur in the most crucial places in the second volume. In the opening chapters, *aesthesis* passes into *theoria* through "purity." Later, human beauty, the most difficult sort of "vital" beauty to represent, depends upon the translation of man's imperfections into a pure image. This problem carries over into all of Ruskin's later social writings.[10] The problem of explaining how perfect, idealized images of divinity or humanity could be the product of possibly fallen, imperfect, even immoral artists, obsessed Ruskin. It is impossible to overestimate, therefore, the issues at stake in the definition of this type.

Before examining in more detail these crucial types of unity and purity, it is necessary to set the term "type" in its proper context. George Landow has resorted to the Evangelical doctrine of biblical typology to explain Ruskin's methods of interpreting Christian art. Ruskin's "Evangelical upbringing" shows in his "attention to detail" and "delight in elaborate pictorial symbolism." Thus in the second volume, Ruskin gives a "figural reading of Tintoretto's Scuola San Rocco *Annunciation*." The Virgin is placed in a ruined and abandoned palace vestibule. Carpenters' tools lie among "scattered" brickwork. Ruskin notices, however, that Tintoretto has connected these unused tools, through a narrow line of light, "with an object at the top of the brickwork, a white stone, four square, the corner-stone of the old edifice, the base of its supporting column. This [Ruskin adds] sufficiently explains the typical character of the whole. The ruined house is the Jewish dispensation; that obscurely arising in the dawning of the sky is the Christian; but the corner-stone of the old building remains, though the builders' tools lie idle beside it, and the stone which the builders refused is become the Headstone of the Corner."[11]

Herbert Sussman, following Landow, has gone on to show the typological character of Ruskin's writings on the Pre-Raphaelite Brotherhood and Venetian architecture. Pre-Raphaelite art fuses, in typological fashion, "mimesis and revelation." The Book of Nature and the Book of God reflect each other.

> At the heart of Ruskin's aesthetic lies the belief in an integrated mode of perception, what might be called a figural sensibility, that can focus on the natural fact while simultaneously comprehending this fact as sign of transcendent power. In his most important definition of this moralized vision, the discussion of the Theoretic Faculty in *Modern Painters* II, Ruskin likens this faculty of the artist to the ability of the exegete to read the Bible typologically.[12]

Similarly, *The Stones of Venice* writes the history of Venice "in the typological mode of the Bible." "It is in placing the richly detailed representation of St. Mark's within the historical process that Ruskin's pictorial methods are closest to those of the Brotherhood." Natural detail and architectural ornament on St. Mark's become a "type of the ancient Temple."

Landow and Sussman clearly emphasize the "figural" nature of the type, as it has been brilliantly defined by Erich Auerbach.[13] *Figura*, Auerbach argues, comes to dominate, grammatically and semantically, *forma*, just as *typos* dominated *morphē* or *eidos;* for *figura* and *typos* acquired a substantive meaning that went beyond "form" or "outline" or "appearance." The terms suggested the concrete embodiment of form, what Ruskin calls form's "positive" existence. Auerbach shows how this definition of *figura* makes possible the patristic method of typological interpretation. The Old Testament is given a "figural" rather than an "allegorical" meaning. The Old Testament becomes a historical document, in which *figura* of the New Testament are materially enacted; events no longer exist in an "allegorical" or "fictive" sense. The real events of the New Testament fulfill their historically real *figura*. Moreover, and perhaps most relevant to Ruskin, the figural interpretation of the Old Testament, Auerbach argues, made possible the "procession of prophets in the medieval theater and the cyclic representations of medieval sculpture." The sculptured arrangements of the prophets, saints, and Old Testament stories, alongside the sculptures of the apostles, on the façades of Gothic cathedrals are the result of an acceptance of the figures as "portraits" of historical people. Certainly Ruskin, from *The Stones of Venice* (1851–53) on through such late works as *The Bible of Amiens* (1880–85), was preoccupied with this sort of figural sculpture, which, indeed, he tended to treat as "portraiture" no matter how "rude" or nonmimetic the sculpture seemed to be.

It is crucial to note that, parallel to the extension of the concept of *figura* in patristics and medieval sculpture, there is a continuing concern with the "substitutive" images of "allegory" and "symbol." Auerbach's study of *figura* was an attempt to explain certain problems in the interpretation of Dante's *Com-*

media. He never concludes that *figura* completely did away with the allegorical tradition of biblical interpretation, in which the image or material realization has no essential connection to the concept or abstract power for which it stands. Often Auerbach suggests that it is difficult, etymologically and semantically, to tell *figura* apart from allegory. His caution should be applied to Ruskin as well. Landow and Sussman neglect the numerous cases in Ruskin's writings, even in *Modern Painters* II, where Ruskin himself has difficulty deciding between a concrete type and an abstract "symbol," or between a type and an "idolatrous" sensuous image, especially when discussing architectural ornament.[14] Occasionally, the concreteness and detail of the type seem to claim an idolatrous attention of their own. Ruskin seems to respond more to the image as a sensuous appearance than as a concrete embodiment of a divine character.

Ruskin's use of the term "type" is often contradictory or ambiguous, as can be seen in his discussion of Tintoretto (Landow's chief example) in *Modern Painters* II. Toward the conclusion of the volume, for example, Ruskin compares the "typical" use of a supernatural lion in Tintoretto's *Doge Loredano before the Virgin* (fig. 7; see upper right edge) to the "actual occurrence" of an ass colt in Tintoretto's *Crucifixion* (4.304–05; fig. 8). Because the lion serves what Ruskin calls a "symbolical" purpose as a substitutive image for Christ, it would have been a mistake to realize it wholly. It is only "partly of magnificent realization." "Type," in this context, belongs to the realm of "ideal form." Yet the ideality, or abstractness of the form, characterizes the *appearance*, the external form of the type. The lion is "typical," meaning "idealized," but this has nothing to do with an idealized image of Christ. Ruskin accepts the idealization of form, which is not, according to Landow, theoretically permissible when dealing with a type, because this "type" is purely symbolical, in no way an actual representation of Christ.[15]

The highly mimetic image of the ass colt in the crucifixion scene, by contrast, contributes to the impression of an actual happening. Ruskin suggests, however, that this ass colt has a "concealed meaning." In an earlier reading of this painting, Ruskin reveals this meaning as a reference to the time "five days before," when Christ was "received with hosannahs, riding upon an ass" (4.271). The ass colt standing in the background of the scene becomes a temporal reference, a memory as well as a prefiguration of the "excitement" and the "madness" of the people. Yet Ruskin does not attach any figural significance to the ass colt. Its mimetic, naturalistic image suggests, Ruskin argues, Tintoretto's instinct for realizing detail as fully as possible (like Turner) *when the structure of meaning and the composition allow it*. The mimetic detail of the ass colt draws attention *away from the impossibility of imitating the actual* agony of Christ. To give a detailed representation of Christ's agony would be blasphemous. Christ cannot and should not be the subject of mimetic

art. Such art is too prone to falsehood. Yet the sharply depicted circumstances of the agony contribute to the sense of its "reality" without degrading it. Mimesis's distracting, illusory quality—so hotly criticized in *Modern Painters* I—becomes useful as a secondary means of realizing a structure of typological significance.[16]

Ruskin's concluding discussion of typology circles back, therefore, to the concern, early in the volume, with the proper degrees of unity and proportion. Typical or symbolic abstraction contrasts with mimesis according to the proper degree of realization of any part within a structural whole. Typology ultimately verges on a theory of architectural ornamentation, not in the fusion of detail and transcendental meaning advocated by Sussman, but in the apparent relation of part to whole. As Ruskin writes in the context of his discussion of Tintoretto:

> I think it is only when the figure of the creature stands, not for any representation of vitality, but merely for a letter or type of certain symbolical meaning, or else is adopted as a form of decoration or support in architecture, that such generalization [i.e., abstract form] is allowable; and in such circumstances it is perhaps necessary to adopt a typical form. [4.304]

The proportional abstraction of form tends in two antithetical directions: in the context of theoretic perception, form *appears* but remains immanent in substance. Form is "imprinted." As such, typical form is like the earlier sign of truth. The materiality of the parts cannot be dissociated from the total form, yet it nonetheless acts as a relief to the form. In the context of imagination, typical form, as in Tintoretto, attempts to represent an event that is actually impossible to represent. In the crucifixion scene, typical form, in the concrete sense adopted by Landow, turns out to be "allegorical." The mimetic perfection or realization of the details suggests but cannot actually capture an image of the crucifixion. The whole is imperfectly realized. The type thus seems to draw us back to the ambivalent realm of the idea or the sign. To try to clarify these ambivalences, we must look more closely at Ruskin's chapter on unity and proportion.

Unity and Proportion: Metaphor as Symbolic Representation

The chapter "Of Unity, or the Type of Divine Comprehensiveness" (4.92–112) contains, according to Ruskin's gloss in the 1883 edition, some of his most "valuable" and "essential" writing. He refers specifically to the second paragraph of the chapter, which proclaims, in some of the volume's most colorful rhetoric, the unities of matter, human spirit, and living creatures. Each of these achieves unity through integration with like members of its class in the hierarchy of creation. Imperfect, separate members are formed

into unified "perfect" complexes. Matter is built up into "temples of the spirit" as dust is transformed into crystal. Human sympathies take us beyond the "dead and cold peace of undisturbed stones" into a "living peace of trust." The class of living creatures, as a whole, has an "inseparable dependency on each other's being."

Ruskin's vision of unity is remarkable for its controlled rhetorical force. Distinct objects or species are not "mysteriously" blurred into a sublimely unrealizable sense of unity. Metaphors capture the working out of the principle of unity in precise ways. The paragraph is as figurative as any purple passage from *Modern Painters* I, but a new precision in the use of metaphor is evident. The "working and walking and clinging together" of personified matter is figuratively extended in the collective image of "syllables and soundings" in air, "weight in waves," and the "burning" of sunbeams, yet these elements do not exchange properties as they do in the earlier text on *The Slave Ship*. The language of the air does not blend into the heavy waves, nor do the waves burden the burning light. In the context of unity, Ruskin strongly emphasizes, difference and variety are essential to the sense of total integrity. The opening rhetorical flourishes do not yet define a structural principle, but they do attempt to make *apparent* the emergence of unity out of well-differentiated parts or classes.

I emphasize "appearance" because it is the most frequently recurring term in the definition of unity. "Appearance" is a complex word, not easily defined. It seems to apply to unity in a metaphorical way. Appearance does not seem to have any necessary ontological connection with the concept of unity. Ruskin states that appearance is "essential" to unity, but not in the sense of a total fusion of form and matter or of image and concept. Perfect unity can "appear" as an "appearance" (in the simple sense of "superficial aspect") or as a "sign, type or suggestion." In its "most determined sense" the appearance of unity reduces to the abstract visual unities of "lines, colours or forms." Unity, therefore, may "appear" in a variety of guises, sometimes as a complex of signs and physical objects, sometimes in a thoroughly concretized form, sometimes as a pure sign. All that is essential is the appearance of unity, however nonessential the link between the specific appearance and the concept of unity. Unity, like all the types of divinity in *Modern Painters* II, must have a material, sensory component, but this component is so broadly conceived that abstract lines become as typical as natural objects or phenomena.

Moving from the discourse based on the sign in *Modern Painters* I to the typology of *Modern Painters* II, a sharper focus on the distinct properties of natural objects seems to be found, as in the second paragraph of Ruskin's chapter on unity. But this referential accuracy, in spite of the presence of connective metaphors, seems to have no proper relation to the concept of unity. Though he praises the meaning of the paragraph in 1883, Ruskin con-

demns, at the same time, the "pedantry" and "tinkle" of the literary art of this paragraph. The "literary" mode of appearance has not falsified or negated the principle of unity. The figurations here have not confused sameness with variety or difference with likeness, but the paragraph by no means presents an authoritative or conclusive image of unity.

The contingent nature of appearance calls for a structural definition of unity. The signs, objects, and vital creatures must somehow be related to each other so as to bring to light the common principle at work. Knowledge of the structure of unity would prevent us from wasting our attention on any appearance, especially one with an arresting literary appeal. The chapter moves toward a structural definition of unity. It proceeds from the most immediate impressions of unity, such as the collective movement of waves and clouds, to analogous but abstract unities in melody, and finally on to proportional unities in the natural world. Yet this movement, the "sequence" of the chapter as Ruskin calls it, is by no means straightforward. The contingency of appearance keeps intruding. As we move from the most immediate to the more cognitive unities, we do not move, in parallel fashion, from objects to phenomena to signs. Ruskin shifts unpredictably, at every stage of his discussion, from signs to types to objects. By the time we reach the discussion of proportion, the need to explain, in a precise way, the various "appearances" of unity has become crucial.

Ruskin seeks to refute Alison's doctrine that proportion is identical with functional "fitness" as well as Burke's dismissal of proportion, as a "mathematical" concept, from the sensory realm of beauty. He tries to establish a novel theory of "Apparent Proportion," which would make this form of unity immediately intelligible to the eye. Upon the *appearance* of proportional unity rests the joint refutation of Burke and Alison, both of whom argue that it is only by habit or custom that we "associate" irrelevant appearance with the (mathematical or functional) concept of proportion. For Ruskin, the appearance of proportion would prove its external existence. Proportion would no longer be a mental construct.

At this point in his argument, different definitions of "appearance"—signs, objects, types—cannot claim equal value. If the appearance of proportion reduces the object to a semiotic structure, for example, it would be difficult to see how this would differ from Alison's argument that the translation of an object into a sign is the result of association.[17] At the same time, if Ruskin asserts the immediacy of apparent proportion, it would align proportion too closely with Burke's equation of material forms with sensations. I will trace Ruskin's discussion of unity up to the consideration of proportion, where the relation of appearance to unity must finally be determined. For upon the final status of appearance rests the deeper and fundamental distinction between type and allegory, between essential and nonessential conceptual figures.

Ruskin defers consideration of the ambiguities of "appearance" for most of

the chapter. He quickly abandons the issue of sensory appearance versus the "appearance" of signs, types, or suggestions, turning instead to a more accessible set of terms, classed, simply, as the "several kinds" of the "appearances of unity." Throughout the chapter, he seems to remain firmly within a referential discourse. The kinds of unity may be described, named, categorized, and compared. No ambiguity intrudes. There is only finer qualification. The subtlety of the qualification seems only to reinforce the sense of the complexity and diversity of unity's presence. He ranges from the branches of the trees and "starry rays of flowers and beams of light" (Unity of Origin) to the driving of sea waves and clouds (Unity of Subjection) to the higher unities accessible to reason, such as melody, and the "orderly successions of motions and times" (Unity of Sequence), and, finally, the Essential Unity of Membership, "which is the unity of things separately imperfect into a perfect whole." Unity, therefore, is a remarkably dialectical concept. It reconciles the trivial with the sublime, the most fragmentary with the most harmonious, the physical motion of nature with the rationality of melodic arrangements.

The only disruption to universal unity occurs with lapses from awareness of unity-in-difference to variety for its own sake. Membership, the most inclusive unity, depends, by definition, on "difference of variety." Without differentiation among the members, repetition or habit would set in. Unity would cease to expand into its full comprehensiveness. Thus "out of the necessity of Unity, arises that of Variety" (4.96). But where variety is pursued for its own sake, the mind is perceiving only "at the surface of things." The appetite for variety calls forth the most vehement rhetoric of the chapter. The pursuit of variety leads to "disgust, indifference, contrariness and weakness." There is no better test of the perception of unity than its "surviving or annihilating the love of change" (4.99). Only those variations in nature that lead to the melodious growth of unity are acceptable.

The distinction between variety for its own sake and variety that contributes to difference turns out, surprisingly, to have little relevance to the human grasp of the divine harmony that permeates creation. Although the concern over variety's disruptive influence occurs in the context of the unity of membership, variety is discussed in the context of the lesser unities of subjection and sequence. The perfect unity in variety, or the necessity of variety to membership, is never demonstrated. The tirade against variety turns the argument back upon itself, as Ruskin starts over again with subjection, which is to be followed by variety within the unity of sequence, that is, apparent proportion. The discussion of membership has served the limited purpose of clearing away the sensationist notion of variety. As a necessary part of the development of unity, variety had to be made safe, subjected, so that unity may proceed, not to absolute comprehensiveness but to the human spheres of knowledge, melody, and proportion.

The subjection of variety is a relatively simple case of unity. In fact, it is

almost an arbitrary act of positing unity, as the term "subjection" would imply. The subjection of variety to unity is exemplified, once again, in winds driving clouds and sea waves. The variety of these natural events seems to be of little interest. The subtle gradations of movement or the play of colorful reflections in agitated sea waves, which received so much attention in *Modern Painters* I, is now ignored. There is really little variety in this impression of unity. Subjectional unity in nature may not be very sensational, but neither is it capable of much dialectical progress. When the winds of unity blow out, so too, presumably, does the notion of unity. As a strictly empirical event, sub-jectional unity seems to consist of little more than the deliberate eclipse of subtle changes within a broad perspective; the perspective appears to be wide but its elements are narrowly perceived.

Subjectional unity becomes much more complex as it is manifested aes-thetically, as in Fra Angelico's fresco *The Spirits in Prison* (St. Mark's cloister, Florence). The image of Christ in the fresco becomes the literal representation of the principle of subjection. As the object of the prisoners' worship, Christ unifies their "infinite and truthful variation of expression" and "multitudinous passion" of the human heart. The seriousness, the moral intensity, of the fresco offers an image of unity that is hardly sensationist (Fra Angelico's distinct but relatively abstract outlines have little mimetic value), yet the image is wonderfully varied and as extensive as the range of human sympathy. The fresco conveys "ineffable adoration." It places us, as viewers, before a complex image, limitless in its implications, but unified by the central image of Christ. With Fra Angelico, there seems to be no need for temporal unity of sequence. We seem to leap over sequential apprehension into the perfect unity of mem-bership. The image of Christ appears to be typical of our membership with God.

But we cannot make this leap into typical meaning until we are able to determine the status of the fresco's appearance. Empirically, the fresco seems to belong to the realm of signs and abstract forms. Though it may "suggest" the endless variety of human feeling, it does so by severely restricting the scope of its imagery and composing the human figures into a collective expres-sion of subjection. The worship of Christ is various in suggestion but limited in its actual variety of appearance. To vary the appearance of Christ, as Ruskin frequently asserts in this volume, is to degrade and spoil him. Ruskin prefers Tintoretto to Michelangelo, in this volume, because Tintoretto's paintings seem to situate us in an actual landscape; but this mimetic background, it must be remembered, serves the purpose of calling our attention away from the impossibility of imaging Christ.

For subjectional unity to occur in Fra Angelico's fresco, we must see the image of Christ symbolically rather than typologically. His appearance is neither concretely realized nor superficially abstracted (as are the clouds and

waves in the previous example). Christ is not a type of divine infinity within human finitude, or even a type of membership. That would require a historically detailed representation of his image, too prone to human imaginative distortion. As a symbol, however, Christ suggests the divine much more "rudely."

But if the fresco is symbolic rather than typological or phenomenological, why has it been squarely placed within a discussion of the problem of unifying our perception of the brilliant variety of natural shapes and colors? Somehow, Fra Angelico's symbolism belongs, for Ruskin, within the context of appearances of variety-in-unity, even though the actual appearance of the fresco is nugatory.

Van Akin Burd's subtle research into what he calls "Ruskin's Quest for a Theory of Imagination" provides a possible explanation.[18] Burd notes the importance of Ruskin's discovery of Fra Angelico during his Italian tour of 1845, the tour that precipitated many of the revisions and additions to *Modern Painters* II. In Fra Angelico, Ruskin saw a "spontaneous expression of feeling for natural form." Fra Angelico's recording of "pure form," not religious feeling as such, was what fascinated Ruskin. The "soft lines" of Fra Angelico's backgrounds seemed almost detachable. The same lines could be discerned in the hanging vines of brilliant, golden colors in the countryside outside Lucca. Burd discovers the significance of Ruskin's admiration for Fra Angelico's "intense" (because unfinished) yet soft delineation of abstract form: its lack of "associational values." The "purity" of form did not suggest pleasure, pain, joy, or despair. Such a state of aesthetic detachment was rare for Ruskin during this tour, for he felt within himself, as Burd documents, "an inability to separate abstract values from the values of association." As he traced the progress of Italian art from Giotto, through Fra Angelico, on to Tintoretto, and reexperienced the geography of Northern Italy against his memory of earlier trips, Ruskin was troubled by his tendency to "mistake the feeling of association for insight into beauty." Abstract form—which could make a river wave or an aspen branch equivalent, in terms of linear curvature, to a tomb sculpture—solved the problem of mistaking the beauty of these appearances for an associational pleasure. Abstract form provided access to "intrinsic beauty."

Appearance varies with each physical object—a wave, a tree, a sculpture— but remains constant as a formal abstraction. We seem, momentarily, to be back in the realm of the sign, as in *Modern Painters* I. But Ruskin has a new purpose in mind. He does not resort to abstract form to overcome the entrapment of mimesis. As Burd shows, Ruskin found a certain sensuous attractiveness in Fra Angelico's manipulation of light and shadow, but these effects led in no way to an illusory sensation of presence before a real object. The "divine" meaningfulness of Fra Angelico's imagery remains intact, as does the

sense of his control over form. In *Modern Painters* II, in an altogether different argument, abstract form is opposed to association, not mimesis. Disembodied lines and forms take us beyond empirical "truth" into a symbolic realm of meanings. Accuracy of perception is not enough, or even, finally, what is desired. Abstract form must deliver us out of the confusing world of associative connections into the symbolic realm of "intrinsic" meaning. The sign now belongs with associationism, the symbol with beauty proper.

Ruskin seems to have realized that his earlier emphasis on signs may have subjected the senses but failed to subject the errors of association. At the conclusion of an illuminating passage in the second volume, "Of Accuracy and Inaccuracy in Impressions of Sense" (4.51–65), he makes clear his fear that associationism, as in Alison, reduces all objects to signs of *equally* expressive value. An object, through association, may *signify* almost any idea, historical or mathematical. Association transforms objects into signs so as to make what Ruskin calls "metaphors," "false" or "erroneous" equations between objects that are not *symbolically* equivalent. Thus Ruskin criticizes Alison for allowing, in theory, the equation of the "beauty of a snowy mountain and of a human cheek or forehead." Without any proper meaning, the mountain and the face may be "externally" associated in terms of "certain qualities of colour and line, common to both and by reason extricable." Associational abstraction of external appearance denies rather than reinforces proper meaning. When symbolic value is taken into account, the signs of face and mountain cease to interchange with each other: "[T]he flush of the cheek and moulding of the brow, as they express modesty, affection, or intellect, possess sources of agreeableness which are not common to the snowy mountain, and the interference of whose influence we must be cautious to prevent in our examination of those which are material or universal" (4.63).

Ruskin's "discovery" of Fra Angelico (which was probably more of an arbitrary decision to call an end to his own associationism) suggests the mastery of varied appearance by the symbolism of form. The high degree of linear relief in the depiction of form in Fra Angelico's frescoes raised, for Ruskin, the problematic, free-floating nature of the sign. But the overt, unassailable Christian context in which these outlines "appeared" in these frescoes grounded them in symbolic expression—indeed, gave them a necessarily symbolic function. Without the right degree of abstraction, Christ could not appear at all.

The threat of associationism—the potential lapse from symbolic form to the contingency of the sign—has not been conclusively removed. The image of Christ is an exceptional case of symbolic form. Bronzino, as Ruskin argues, may degrade Christ in his attempt to dramatize his facial expressions, but that is a very different argument from attributing modesty or affection to a blushing cheek. Is a modest blush symbolic or associational? Innate and proper

or acquired by social custom and habit? As we move into the more varied world of animals, flowers and plants, melodies and architectural constructions, symbolic meaning is not always immediately knowable. The problem is to decide between those forms which are symbolic in and of themselves (which would link them to divine creation) and those which are valued primarily for their human associations. Symbolic form finally rests upon what Ruskin calls "Apparent Proportion": a "sequential" or "melodious" sort of variety-in-unity that points toward divine harmony.

Ruskin distinguishes two sorts of proportion, the confusion of which, he suggests, has led to the "greater part of the erroneous conceptions of the influence of either." Apparent proportion "takes place between quantities for the sake of the connection only, without any ultimate object or causal necessity." Constructive proportion "has reference to some function to be discharged by the quantities" (4.102). Apparent proportion is "sensible." No cognition of function is necessary for its appreciation. It is "one of the most important means of obtaining unity amongst things which otherwise must have remained distinct in similarity."[19] Constructive proportion is not necessarily agreeable in appearance; it appeals primarily to the mind. Adopting Alison's example of the constructive proportioning of architectural columns, Ruskin states that they vary in form according to their supportive function. The decision whether to use a wooden or a stone column has to do with the "weight to be borne and the scale of the building." The materials and proportions of the columns have "no more connection with ideas of beauty, than the relation between the arms of a lever adapted to the raising of a given weight." The distinction between apparent and constructive proportion seems to rest on the difference between an appeal to the eye and an appeal to the "intelligence," between theoretic disinterestedness and utilitarian functionalism. Only apparent proportion is of critical consequence in Ruskin's argument. Constructive proportion, at least since Alison, had been very well defined.

Ruskin makes no attempt to deny that some proportions must be explained in terms of the fitness of the parts within a functioning whole. Such proportions require knowledge of mechanical principles. Only as the constructive shades into the apparent is Alison's emphasis attacked. Alison writes:

> The habit, indeed, which we have in a great many familiar cases, of immediately conceiving the Fitness [of proportion] from the mere appearance of the Form, leads us to imagine, as it is expressed in common language, that we determine Proportion by the eye; and the quality of Fitness is so immediately expressed to us by the material Form that we are sensible of little difference between such judgments and a mere determination of sense.[20]

The intimate link between material form and judgment, to the point where proportion seems to "appear" to the eye with the same immediacy as a sense impression, is not, in itself, cause for objection. Some constructive proportions may, indeed, be immediately intelligible. Ruskin objects to the suggestion that *all* apparent proportions are really immediately recognizable constructions that are familiar through habitual occurrence. The question of appearance, in Alison, does not lead, as Ruskin's distinctions suggest it ought, to the varied realm of the visible. Rather, Alisonian appearances are metonymical substitutions, in the mind, of the visible for the conceptual. Constructive proportion functions like the Lockean sign. The substitution of concept for appearance leads to the far more dangerous substitution of fitness for beauty, for the mind is not actually paying any attention to the appearance of the proportioned object. The mind thinks it sees, and so ignores the varied visual texture of the object.

All animals, plants, or even well-designed buildings may function equally well, but, Ruskin argues, "all things are not equally beautiful."

> The megatherium is absolutely as well proportioned, in the adaptation of parts to purposes, as the horse or the swan; but by no means so handsome as either. The fact is, that the perception of expediency of proportion can but rarely affect our estimates of beauty, for it implies a knowledge which we very rarely and imperfectly possess, and the want of which we tacitly acknowledge. [4.110]

Ruskin fears that Alison's denial of any necessary connection between beauty and fitness will lead to a haphazard aesthetic. The beauty of an object becomes too relative; beauty is made to depend on an imperfect, associational form of knowledge. The fitness principle may be made to serve any number of associative constructs, including some that may neglect more beautiful ways of looking at a particular object. Alison's notion of a proportional scheme is too neutral for Ruskin, who seeks a definite perceptual value in an object's apparent structure. Alison's example of the architectural column suggests all that is troublesome, for Ruskin, in the equation of appearance with fitness:

> [The] Column (considered as in the former case, merely in relation to its peculiar Form, and independent of its ornaments) is not more beautiful, as a Form, and perhaps not so beautiful, as many Forms of a similar kind. The Trunk of many Trees, the Mast of a Ship, the long and slender Gothic Column, and many other similar objects, are to the full as beautiful, when considered merely as Forms without relation to an End, as any of the Columns in Architecture. If, on the contrary, these Forms were beautiful in themselves, and as individual objects, no other similar Forms could be equally beautiful, but such as had the same Proportions. . . . It would appear, therefore, that it is not from any absolute Beauty in these Forms, considered individually, that our opinion of their Beauty in Composition, arises. [p. 337]

Each of the forms mentioned—tree, mast, Gothic column—is externally similar. This very similarity proves, to Alison, their lack of an inherent formal perfection. Only as each form takes on a functional role does its appearance become "beautiful" and distinct from the other forms.

Ruskin's earlier criticism of Alison—that he ignored expressive values—seems to apply to Alison's discussion of proportion. Proportion's "beauty" has been reduced to fitness. We may apply the term "beauty" to the structure of a face or of a mountain, to the form of a column or of a mast. If these various appearances have an indifferent influence upon us, then they become mere signs. Appearance is significant only as it contributes to the immediate sense of a well-built natural object or machine or piece of architecture. Ruskin would like to set another value upon proportion. Proportion ought to be the orderly grasp of variations in appearance, the discovery of unity in difference. The cognitive movement from appearance to construction must be reversed. Proportion must be discovered in its own right, independent of the judgment that would reduce it.

But Alison is not so easily overturned. He has, at least, offered one possible explanation for the notion that proportion may appear. Ruskin rejects the extension of this explanation to all appearances, but leaves unanswered the question, how else can we recognize proportion? For Alison, all nonfunctional attempts to explain the connection between form and proportion, as in Pythagorean or Albertian doctrines, are "futile" (Alison, p. 329). Much more damaging to Ruskin's task, however, is Alison's argument that all nonfunctional appearances that are contiguous to constructive proportions can be reconciled with proportion only as "associations," that is, nonessentially. As we move out of the restricted realm of constructive proportions, the meaning of any appearance becomes difficult to determine. To reverse Alison would be to open up the possibility of associational error in the link between expressive meaning and apparent forms and structures.

Toward the conclusion of his essay on proportion, Alison emphasizes the dangers of associating proportion with any value or concept other than fitness. He notes that architectural proportion often occurs in the context of "Grandeur, Magnificence or Elegance." It is in "such scenes" and with "such additions, that we are accustomed to observe [architectural proportion]; and while we feel the effect of all these accidental Associations, we are seldom willing to examine what are the causes of the complex Emotion we feel, and readily attribute to the nature of the Architecture itself, the whole pleasure which we enjoy." The same associational complex develops around the proportions that are valued because of their venerable historical origin, such as the Grecian. In such complex cases, there are "so many and so pleasing Associations" that it is "difficult," even for a man of "reflection," to determine which portion of pleasure is to be attributed to the proportion "alone." Ar-

chitecture, says Alison, is a "material sign, in fact, of all the various affecting qualities which are connected with it, and it disposes us in this, as in every other case, to attribute to the sign, the effect which is produced by the qualities signified" (p. 342). But, in the end, in "calmer moments," we are "induced" to consider proportion as the sole source of pleasure. No building, however ornamented, or set in nature or in a particular light, can be pleasing if it contradicts our sense of fitness, if, simply, it looks as if it might collapse or if it offends our sense of economy. The "assent of all ages" has nothing to do with musical harmonies or the proportions of the human body, but with the time-tested discovery of which sort of buildings stand up and which do not. As for natural objects, particularly animals and plants, their construction is so complex, so beyond human knowledge, that we must be guided by the most "common forms." These forms become the most beautiful to us, but they have no original or independent beauty in and of themselves (see Alison, p. 328).

As Ruskin attempts to free the appearance of proportion from the concept of fitness he reencounters the problem of associationism. Apparent proportion must avoid two extremes: first, the extreme of pure appearance, or superficial form, which, Ruskin had shown, leads to aberrant "metaphorical" meanings, like the face of a mountain; second, the extreme of conceptualization, in which appearance is subsumed under the sign of some constant property, such as fitness. This would make variations in appearance responsible for contingent meanings only. Apparent proportion must operate symbolically, like Fra Angelico's frescoes. Like the image of Christ, an apparent proportion must express a proper, not a metaphorical, relation between distinct forms. Furthermore, these forms must remain within the "sensible" realm, as Ruskin stated in his definition.

Ruskin develops his theory of apparent proportion as a reply to Burke. Burke's position is even more reductive than Alison's. Proportion, for Burke, has nothing at all to do with beauty, which is entirely the result of material causes acting upon the senses. Proportion, as a mathematical concept, is simply out of bounds.[21] Burke would not seem to be a promising point of departure, but he offers Ruskin a much greater recognition of the influence of variety, which Ruskin attempts to use against Alison. Burke may treat beauty as sensory stimuli, but he accepts the variety of this experience, the pleasure that seemingly irreconcilable shapes and forms equally afford the viewer. Ruskin sets himself the task of explaining this delight not in terms of the mechanics of sensation but as a hitherto hidden delight in apparent proportions.

Variety itself is not difficult to establish. Ruskin is in complete agreement with the Burkean description of "gradual variation" (pt. 3, sec. 15; Boulton, pp. 114–16). For example, we take pleasure in lines that continually but grad-

ually change their angles, in curves. Straight lines are monotonous and dull, whereas angles arrest movement. Curves may be observed in the steep descent of a mountain stream, as it gradually flattens out where it meets the plain. A "curious error" intrudes in Burke's discussion, however, as he separates variation in lines from the subject of proportion. Burke, seeing that he could not "fix upon some one given proportion of lines as better than any other," supposed, Ruskin says, that proportion "had no value or influence at all." Variety, in Burke, exists independently of proportion. The curves of a mountain stream, the outline of a bird, the curvaceous form of a woman are, for Burke, equally pleasing in their gradations of line, but are radically different in their proportions. Ruskin argues that is the same as saying that "because no one melody can be fixed upon as best" no such thing as melody exists (4.108). Ruskin locates Burke's error in a passage from an earlier section of the *Enquiry*, "Proportion not the cause of Beauty in Animals" (pt. 3, sec. 3; Boulton, pp. 95–96), in which Burke compares the proportions of a horse, a cat, and a dog, and concludes that, each being equally "beautiful" yet so "very different and even contrary" in form, there can be "no certain measures" that would explain their common appeal. The situation is even worse with birds, for they "vary infinitely" in their proportioning of tail to body or neck to body. Often, birds are "directly opposite to each other" (such as the swan and the peacock), yet they are all "extremely beautiful."

Ruskin replies that Burke, in seeking a constant measure that would apply to all animals or birds, has failed to observe "subtle differences" (4.109). Each of these various forms reveals a "harmonizing difference" when all the parts are considered as a whole. We should not compare a swan's neck to a peacock's, or a horse's ear to a dog's. Within each species, form is proportional. Unfortunately, Ruskin goes no further than this. He leaves completely unexplained what the proportion is. If it is not fitness, or constant measure, then what is it? He bluntly asserts that each form *is* harmonic, in which case he is merely repeating Alison's point that, in nature, proportion is simply what is familiar. Ruskin's reply is made even less convincing when we take into account Burke's analysis of a "beautiful bird" from the section on gradual variation, the very section with which Ruskin began:

> [W]e see the head increasing insensibly to the middle, from whence it lessens gradually until it mixes with the neck; the neck loses itself in a larger swell, which continues to the middle of the body, when the whole decreases again to the tail; the tail takes a new direction; but it soon varies its new course; it blends again with the other parts; and the line is perpetually changing, above, below, upon every side. In this description I have before me the idea of a dove; it agrees very well with most of the conditions of beauty. [Boulton, p. 115]

Burke demonstrates here a refined grasp of the subtle relations of parts within

a whole, and he appreciates the harmony of the gradations as each part leads to the next. His description is practically musical. But he is trying to reveal the beauty of variation, not proportion. Proportion, for Burke, would lead to a static, fixed relation of part to whole. It suggests the angular. Ruskin's denial of the harmonic quality in Burkean aesthetics is, simply, a distortion. When Ruskin adds that Burke also misunderstood the term "proportion," whose "whole meaning" has "reference to the adjustment and functional correspondence of *infinitely variable* quantities," he is merely substituting "adjustment" for Burke's "gradual variation." "Infinite variation," as Burke had already shown, is of the order of curvaceous lines rather than discrete parts fitted into a whole. If, on the other hand, Ruskin rests his definition on "functional correspondence," he returns, again, to Alison.

Ruskin's third objection to Burke is the most significant, for it is supposed to do away with Alison as well. When Burke says that different, even contrary, forms are "consistent with beauty," he has overlooked the "fact" that "they are by no means consistent with equal *degrees* of beauty." Ruskin equates proportion and harmony of form with "station and dignity." The "horse, eagle, lion, and man" have "better" proportions "expressing the nobler functions and more exalted powers of the animal." If this point is accepted, then we may do away with the leveling theory of constructive proportion, which sacrifices degrees of beautiful appearance for the sake of fitness.

Much is at stake in the recognition of the inherent superiority of some creatures over others, of the swan over the megatherium. We say that a lion or a swan is well proportioned because these creatures have an expressive value—let us say dignity or nobility—lacking in other, less significant creatures. "Proportion," it should be noted, has not been defined as either a concept or an abstract form, but it functions as a *representation*. Proportion is the representation of hierarchical value within the natural order. As a representation it necessarily appears, but these appearances may not be confused or reduced. If, for example, we were to compare a man to a lion, we would have to find the appropriate *proportional* relation. Man compares to lion in terms of their respective lordships over certain domains. But we would not confuse the appearance of a lion with a man to make the same analogy. Degrees of moral stature seem, finally, to stabilize the notion of proportion. Well-proportioned creatures are expressive. They unite around them various forms. They subject other creatures. Proportion thus performs the task that Ruskin had originally assigned to it: it achieves unity of sequence, or unity-in-variety. Proportion, Ruskin suggests, has the continuity of melody, but it goes a step further. As a structure that represents, it refers to concrete objects, or at least appears to refer to them.

What happens to proportion if the values upon which it has been premised are questioned or denied? To rest a theory of proportion upon an analogy

with the chain of being would seem to be poor judgment, standing as it does midway between Alison's denial of the inherent meaning of form and the radical Darwinian separation of the appearance of living forms from a divine teleology.[22] A symbolism of form that depends upon proportional value within a divinely sanctioned scheme collapses when the scheme does. At the conclusion of the 1846 text of the chapter on unity, Ruskin invokes Sir Charles Bell's Bridgewater Treatise on the hand in support of the principle that each variation in natural form has an ultimate purpose in God's design. By 1883, however, Ruskin complains that he can no longer find support in Sir Charles's arguments. In fact, Ruskin's faith was never all that secure. It always fluctuated between inner doubts raised by modern science and blind proclamations of faith drilled into him from his earliest days as a reader.

Ruskin's theory of proportion remains one of his decisive epistemological advances, in spite of its link with religion. It determines, I argue, much of his subsequent writings on the imagination, architectural ornamentation, even his speculations on pagan and medieval allegories. Ruskin continues to find in the appearance of proportion meaningful expressions. These meanings may not, following Alison, be proper, but neither are they entirely accidental. Proportion is metaphorical structure, one which intensifies cognition. It has little to do with wit or poetic decoration.

For example, in his discussion of ornamental "treatment," five years later in *The Stones of Venice*, Ruskin takes up the old Burkean example of the swan versus the peacock (see fig. 9):

> What, then, *is* noble abstraction? It is taking first the essential elements of the thing to be represented, then the rest in the order of importance, and using any expedient to impress what we want upon the mind, without caring about the mere literal accuracy of such expedient. Suppose, for instance, we have to represent a peacock: now a peacock has a graceful neck, so has a swan; it has a high crest, so has a cockatoo; it has a long tail, so has a bird of Paradise. But the whole spirit and power of peacock is in those eyes of the tail. It is true, the argus pheasant, and one or two more birds, have something like them, but nothing for a moment comparable to them in brilliancy: express the gleaming of the blue eyes through the plumage, and you have nearly all you want of peacock, but without this, nothing; and yet those eyes are not in relief; a rigidly *true* sculpture of a peacock's form could have no eyes,—nothing but feathers. Here, then, enters the stratagem of sculpture; you *must* cut the eyes in relief, somehow or another. [8.288]

Proportioning has become the "order of importance," emphasis rather than a strict or "rigid" formal imitation. In order to "express" the "whole spirit and power" of the peacock as a distinct form, the sculptor must abstract and exaggerate the most essential characteristic of the bird, and solve the material problem of representing this characteristic in stone. The eyes (in themselves a metaphor) cannot be literally imitated, but in representing the eyes as sculp-

tural relief, the ornamental peacock approximates the idea and the effect of an actual peacock. No divine value has been invoked to account for this (dis)proportional abstraction of form. We are strictly within the practical context of "treatment." Yet treatment itself is posed as a cognitive problem. The translation of the actual peacock into a symbol of peacockness falls within an epistemological theory of "How ornament may be expressed with reference to the eye and the mind." Noble abstraction must, simultaneously, represent the idea of a peacock and work effectively as an image that appeals to the eye of the viewer. Formal proportioning unites visual effect with cognitive sorting. Far from an addition to a functional structure, architectural ornament reveals the link, in Ruskin, between proportion and representation.[23]

This discussion of the peacock grows directly out of the earlier studies of Fra Angelico, by way of Burke and Alison. In criticizing Alison, Ruskin did not exactly eliminate cognition from the consideration of proportion. In fact, he evolved a theory of how symbolic meaning is structured, how it represents the idea or the value of an object even though the appearance of the symbol may not fit the natural proportion of the object to which it refers.[24] The appearances that concerned Ruskin in subsequent volumes—Gothic ornament, Pre-Raphaelite painting, Greek vase reliefs, Turnerian landscapes (once again)—really have little proportion, in the sense of an elegant, balanced relation of part to whole that would appeal to the eye. But they all have a great deal of condensed, organized meaning for Ruskin.

When Ruskin invokes the term "metaphor" he means the confusion, through a purely external analogy of abstract form, of two distinct objects. His emphasis on appearance, or what he was later to call the "science of aspects," restrains abstract form, subordinates it to purposeful comparisons. But these comparisons are still "metaphorical." They do not constitute proper meanings (how is a peacock noble except by comparison to a royal personage?), and they are open to possible errors of judgment. The confusion of appearance with the symbolic presentation of meaning results in erroneous references to natural objects. Symbols do not, of course, belong to the empirical realm of appearances. An ornamental peacock may express the peacock "essence," but it participates only mentally in the actual world of peacocks that may appear before our eyes. That is why Ruskin emphasizes that the symbolic treatment of a peacock is an operation of the eye *and* the mind. But types, unlike symbols, are supposed to belong to the empirical world, and it is still the type, in *Modern Painters* II, with which Ruskin is concerned. The type is a metaphor that is taken literally. It confuses "apparent" proportion with actual appearance, metaphorical structure with empirical reality. Compare Ruskin's discussion of vital beauty, based upon the type of purity, to the discussion of the ornamental peacock.

There are many hindrances in the way of our looking with this rightly balanced

judgment [esteeming those most beautiful whose functions are most noble] on the moral functions of the animal tribes, owing to the independent and often opposing characters of typical beauty, as it seems arbitrarily distributed among them; so that the most fierce and cruel creatures are often clothed in the liveliest colours, and strengthened by the noblest forms. . . .

[That moral] perfections indeed are causes of beauty in proportion to their expression, is best proved by comparing those features of animals in which they are more or less apparent; as, for instance, the eyes, of which we shall find those ugliest which have in them no expression nor life whatever, but a corpse-like stare, or an indefinite meaningless glaring, as (in some lights) those of owls and cats; and mostly of insects and of all creatures in which *the eye seems rather an external optical instrument, than a bodily member through which emotion and virtue of soul may be expressed* as pre-eminently in the chamaeleon, because the seeming want of sensibility and vitality in a creature is the most painful of all wants. . . . [B]y diminishing the malignity and increasing the expressions of comprehensiveness and determination, we arrive at those of the lion and eagle [see figs. 10, 11]; and at last, by destroying malignity altogether, at the fair eye of the herbivorous tribes, wherein the superiority of beauty consists always in the greater or less sweetness and gentleness, primarily; as in the gazelle, camel, and ox; and in the greater, or less intellect, secondarily; as in the horse and dog; and, finally, in gentleness and intellect both in man. [4.157–59]

Proportion, in this context, cannot be called an appearance. No mention is made of the eagle's superior formal proportions compared to the owl. Rather, "proportion" means intensity of apparent energy, really brightness of eye, as, literally and figuratively, an "expression" of moral worth. Proportion is a metaphor that equates brightness with moral life, and attempts to sort out the "arbitrary" distribution of God's types of perfection in living creatures. Cruel creatures attract our eye, by their often bright colors, but, Ruskin warns, their eyes reveal a sloth and "want of sensibility" beneath their vital exteriors.

Ruskin's own metaphor—bright appearance of eye as moral indicator—is itself completely arbitrary. As Ruskin applies the metaphor over a wide range of creatures, the supposed sorting of types results in a moral hierarchy. Within this hierarchy, "proportion" has shifted meaning from "structural emphasis," as in the ornamental peacock, to "relative appearance of gentleness in life." The latter meaning, though more arbitrary, has the appeal of direct experience. It seems to refer to actual nature. The cognitive function of proportion is suppressed. We may visualize or imagine Ruskin's argument, for it is, quite literally, an "argument of the eye" (to adopt Robert Hewison's phrase). Strangely, Ruskin's types, though they are supposed to have concrete existence, prove to be more illusory and deceptive than the peacock of stone, with its sensuously appealing, bejeweled eyes set in relief.

The figurative status of "appearance" in Ruskin's argument is finally determined on the somewhat shaky ground of visual relief. The sign, we recall,

appears in sharp relief to natural objects. Lines, dots, curves must stand out, be abstract, in relation to the images depicted. The materiality of the sign contributes to its relief. We are supposed to see, immediately, that the sign is just that. But Ruskin quickly discovered that the sign, while guarding the mind against sensory deception, had the effect of floating, freely, into various, not always compatible, contexts. Abstract form was too associational. The material symbol, by contrast, has an internal organization of form, a proportion, that governs meaning, though not by direct imitation. Form is set in relief, often in a distorted way, so as to attract the eye, but the distortion calls forth a cognitive response. Appearance is not referential. It is representational. The type, however, hovers ambiguously between sign and symbol. It is a character of a natural object that suggests an "immaterial idea." The type is like an inscription. It belongs intimately to substance yet emerges as a pure idea. The form of the type may not be abstracted, nor distorted, yet it must be seen in relief. This relief is defined in terms of luminosity, as a brilliant outline relieved by shadow or various colors.

The appearance of the type is always problematic, for as it stands forth it seems to speak clearly and authoritatively to the mind. It seems to require less effort to understand than the sign or the symbol. But in fact it blinds the mind. The type enters the mind as a positive "idea," but the significance of the idea has been predetermined by a metaphor eclipsed at the moment of illumination, as in the text on the animal tribes' apparent worth. The type offers the least opportunity to question the metaphor that underlies each of the modes of signification.

The ambiguities of "appearance" point to a general problem in Ruskin's epistemology: the attempt to determine the proper relation of form to substance, eye to mind, is never free of tropological deflection. "Appearance" connects abstract lines with visual sequence, the brilliance of the life of the soul to varied outer shapes and colors, a decisive meaning to an act of seeing. None of these connections is peculiar to Ruskin. (He is clearly indebted to the philosophers he criticizes.) What is peculiar is Ruskin's attempt to work through these connections relentlessly, only to fall into ever greater patterns of error. "Appearance," the prereflective empirical certainty of the "thisness" of a signifier—sign, object, icon—constantly occurs in Ruskin's writings, but it never prevents the intrusion of hidden metaphors into his discourse, as "apparent proportion" demonstrates. Ruskin's major blind spot seems to have been his treatment of metaphor as a strictly phenomenal error rather than a property of language difficult if not impossible to avoid. His later writings, the most metaphorically confused that he ever wrote, frantically point to historical events, contemporary behavior, industrial pollution as "living" proof of cultural death. The basic metaphor becomes so mixed that referential cer-

tainty is completely lost, though the discourse continues to invoke evil "appearances."

Two other important texts in *Modern Painters* II demonstrate in crucial ways Ruskin's ability to be superbly aware of figurative meanings in language and yet, at the same time, fall prey to a confusion of linguistic metaphor with either substance or appearance. In the chapter on Purity, out of which comes the whole discourse on vital beauty and the morality of the brilliant and the energetic, metaphor is made substantial. In the chapter on the contemplative imagination, out of which comes Ruskin's criticism of phenomenological errors in Wordsworth, and his break with romantic imagination in general, we have the confusion of metaphor with appearance.

Purity: Metaphor as Substance

The primary aim of Ruskin's chapter on Purity, the type of divine energy (4.128–34), is the replacement of the "metaphorical" meaning of purity as "sinlessness" with its "original notion," that is, the "material quality" of "healthy" or "organic" interrelatedness of the parts of an animate or inanimate object.[25] Ruskin is unusually self-conscious, throughout the chapter, about the danger of metaphorically altering this original, material meaning of purity; yet purity seems difficult to substantiate. It seems to lack a material or typological existence that would prevent its wandering into "abstract" relations with non-material ideas. Ruskin explains purity's tendency to take on metaphorical meaning as the result of human interference. We, in our fallen, impure state, tend to conceive purity under various false "associations," particularly under "moral" connotations of the term. These associations are all the more difficult to purge because they seem to be based upon Scriptural authority. But Scripture itself is often "metaphorical," and we err in taking its metaphors literally. The isolation of purity in substance finally depends upon the manifestation of divine energy in substance as light. Substance, light, organic structure, and divinity are decisively opposed to fallen, human, metaphorically impure, moral interpretations of nature. But the opposition is confounded by the uncertainty of knowing when we are perceiving the pure light of the divine without human distortion. The ambiguous status of the type as a visual relief of form in relation to substance now becomes an acute problem. As divine light shines through pure or healthy substances, form seems to be disembodied. At that moment, form, once again, becomes susceptible to abstract association. Light, the positive proof of the divine in substance, seems to lead to metaphorical confusion as it translates distinct substances into various colors and degrees of translucency. These allow us to make all sorts of moral but by no means proper comparisons between objects. The text on purity, in the

end, fails to escape from its own criticism of metaphor. The emphasis on substance proves to be no safeguard against metaphorical error.

The criticism of the metaphorical meaning of purity builds upon Ruskin's earlier discussion of the metaphors of associationist psychology (with particular reference to Alison; see 4.63–64). Scriptural metaphors influence us in the same way that associated ideas do. In this way, further metaphors or false associations develop. The authority of Scripture has a strong "influence on our sympathies" and provides a meaning for purity that has the most "immediate agreeableness." The practice of reading Scripture so conditions our understanding of purity, in the sense of sinlessness, that we transfer, by association, the Scriptural meaning to the realm of visible objects. With this transfer, Scripture is dangerously reified into empirical properties. We create a false connection between purity as sinlessness and purity as "spotlessness" in certain perceived objects. For Ruskin the connection between sinlessness and spotlessness is entirely arbitrary. Between the concept of sin and the sight of a spotless object, one cannot "trace any rational connection." When the metaphor of sinlessness as spotlessness goes unquestioned we tend to invent moral significance for other natural objects. We form the habit of seeing the divine in supposedly "pure" objects, whose purity is really a mental association.

Ruskin sets out to correct this mistake by undoing the initial, Scriptural metaphor, that purity is sinlessness. If this metaphor is recognized, so too is the second one, that physical spotlessness is sinlessness. It is the concept of (the lack of) sin that falsely links divine purity to a quality of matter. The connection seems to break easily: "[I]f it be indeed in the signs of Divine and not of human attributes that beauty consists, I see not how the idea of sin can be formed with respect to the Deity; for it is an idea of relation borne by us to Him, and not in any way to be attached to His abstract nature" (4.132). We violate God's perfection by attributing to "Him" any human properties, even a negative relation to human sin, the very property that radically dissociates us from Him. The purity of God conceived as sinlessness therefore emerges as a negative reflection of ourselves rather than a positive attribute of God. The recognition of such an idolatrous interposition of ourselves before God ought to awaken us to our metaphorical use of "purity." The proper, typological evidence of God in matter must be found in the properties of matter itself, not in figurative, Scriptural images of Him. Ruskin concludes: "So that I conceive the use of the terms purity, spotlessness, etc., in moral subjects, to be merely metaphorical; and that it is rather that we illustrate these virtues by the desirableness of material purity than that we desire material purity because it is illustrative of these virtues" (4.132).

What, then, is material purity in the nonillustrative or nonfigurative sense?

Purity is a "quality difficult to define." In its simplest sense, it is "the type of Energy," a definition which, Ruskin admits, has just as "little traceable connection in the mind" to the term "purity" as "spotlessness." Strangely, Ruskin's definition of this energy is negative, a characterization of our "ideas of impurity," against which we may conceive purity itself. This approach is identical to the one rejected as "metaphorical." Just as God is defined negatively as sinlessness, so purity's energy is defined negatively, as the opposite of the definition of impurity. The "impure" refers "especially to conditions of matter in which its various elements are placed in a relation incapable of healthy or proper operation." There can be no doubt about our recognition of these conditions, for they cause within us an immediate feeling of disgust or displeasure. The sight of corruption and decay is universally painful.

As Ruskin applies his negative definition, he seems to fall into the same associationist trap that he criticizes with reference to sinlessness. The impure operates associatively within the mind. It may be true that disease or foulness causes displeasure, but to term this displeasure an "idea of impurity" is to moralize matter in the same way that the misreader of Scripture transfers to matter the concept of the absence of sin. The impure and the pure as material qualities seem equally metaphorical. Their definitions do not actually refer to empirical properties. The definitions actually constitute a semantic opposition, an opposition of the metaphorical meaning of certain objects. The definition of the impure—a decaying object as the sign of the absence of divine energy— seems no less figurative than the definition of the pure—a spotless object as the sign of the absence of sin. With a remarkable blindness to the contradictions of his argument, Ruskin proceeds to build up his own definition of purity as the negation of the negatively defined impure. He does so by invoking further human "associations." These associations are as metaphorical as any that Ruskin criticizes in this volume, but he is unwilling to forego the support they lend to his argument. The "association" of inorganic with organic matter presents the crucial example of our human associations of pain and pleasure with these sorts of matter.

> [T]here is a peculiar painfulness attached to any associations of inorganic with organic matter, such as appear to involve the inactivity and feebleness of the latter; so that things which are not felt to be foul in their own nature become so in association with things of greater inherent energy: as dust or earth, which in a mass excites no painful sensation, excites a most disagreeable one when strewing or staining an animal's skin; because it implies a decline and deadening of the vital and healthy power of the skin. [4.129]

Ruskin makes explicit here the possible disjunction between the idea of impurity and the actual properties of a substance. Dust in itself is not impure. It becomes so only by an associational, or metonymical, link to skin. At this

point of contact we have the emergence of a binary structure of signification. The contrast between the ideas, qualities, or moral significances of dust and skin defines the meaning of purity. But this meaning is figurative. Dust does not mean death or disease until it is brought into contact with skin; but then skin, too, at this moment takes on an opposed, equally figurative meaning of vitality and health. An animal's hide is, of course, "vital" matter, but within the structure of this opposition it also means the energy of the divine. Arbitrary, associational juxtapositions of matter seem to achieve the status of ontological truths. A chance association, once it becomes a categorical opposition, has the power to generate further oppositions. The opposition of skin to dust becomes the opposition of health to sickness, the living to the dead.

The metaphor of purity as spotlessness is broken by the disjunction of God and human representations of Him. All representations of God, even Scriptural ones, are necessarily metaphorical. Matter is not related directly to spirit but to other matter. Any object or substance may be categorized in terms of the pure versus the impure. Though *Modern Painters* II opens as a critique of associationist errors, of improper meanings attached to objects, Ruskin's text on purity has difficulty evading associationism. Purity is prone to the distortions of associational meanings:

> [A]ll reasoning about this impression [of sand upon hide] is rendered difficult, because the ocular sense of impurity connected with corruption is enhanced by the offending of other senses and by the grief and horror of it in its own nature, as the special punishment and evidence of sin: and on the other hand, the ocular delight in purity is mingled, as I before observed, with the love of the mere element of light, as a type of wisdom and of truth; whence it seems to me that we admire the transparency of bodies; though probably it is still rather owing to our sense of more perfect order and arrangement of particles, and not to our love of light, that we look upon a piece of rock crystal as purer than a piece of marble, and on the marble as purer than a piece of chalk. [4.129–30]

The proper meaning of purity is the "perfect order and arrangement" of the particles or parts of any substance. But this abstract definition is rendered impure by a host of associations. Sin comes to mind as soon as we perceive organic disorder. Similarly, our preference for marble over chalk, or crystal over marble, is not often understood properly, as an appeal to our sense of each substance's internal structure. We must overlook the powerful but distracting comparative luminosity of each substance, which calls forth associations of God's wisdom. Ruskin suggests that statements such as "chalk is more corrupt than marble" or "crystal is more expressive of wisdom than marble" are figurative in meaning. But comparisons of substance based on organic structure cannot prevent the intrusion of these moral judgments. As soon as the organic structure of a particular substance is outlined or illumi-

nated in relief to substance it becomes expressive of human vice or virtue, so much so that Ruskin invokes Spenserian allegories to confirm the presence of these virtues.

The beauty of translucent form may be found in the virtuous Shamefacedness or Belphoebe, with their delicate, glowing faces, suggestive of red roses and white lilies, or in Florimel, who represents the translucency of "purest snow." The feminine face, with its perfectly delineated form, translucent skin, and glowing color is the central emblem of purity. But the human face, we recall, enters easily into metaphorical relations with other objects. It was Alison's supposed confusion of human faces with mountains that Ruskin criticized. Now we find roses and lilies, snow and shady glades, fair skin and sparkling diamonds all brought together upon the morally "pure" faces of Spenserian allegories. Edmund Spenser's personified virtues mediate substances, give them a human face.

The thorough personification of substance has the effect of displacing material qualities altogether, substituting in their place human virtues. The vital and energetic connection of particles that defines material purity assumes human-like behavior. Rocks are "living." Life itself is full of "practical analogies":

> . . . the invariable connection of outward foulness with mental sloth and degradation, as well as with bodily lethargy and disease, together with the contrary indications of freshness and purity belonging to every healthy and active organic frame (singularly seen in the effort of the young leaves when first their inward energy prevails over the earth, pierces its corruption, and shakes its dust away from their own white purity of life). [4.133–34]

In this statement we have the inception of this volume's entire discourse on Vital Beauty and evidence of the pathetic fallacy in the personification of the emerging flower. Substance has been thoroughly allegorized, translated into an extended personification of human vice and virtue, disease and health. Far from having eliminated the interposition of the human before the divine, Ruskin's concept of purity is a total allegorization of the natural world as human. There seems to be no escape from the associations that constitute the allegory. Every object in nature could be placed within the moral spectrum that goes from absolute death and foulness to health and vitality. As soon as matter becomes pure it seems to take on human qualities, or else Ruskin describes divine energy in apocalyptic language, as pure spirit, in which case substances become transparent, "like unto clear glass."

The end of the chapter is a little baffling. Was Ruskin aware of the figurativeness of his own text? Did he believe in the substantive existence of "pure" structures whose meaning was so obviously determined by human associations? There is no clear answer. To the extent that he takes Purity further in

his discussion of Vital Beauty, he seems to have taken his metaphors quite literally, as, for example, in the text cited earlier on the moral superiority of some animals to others. To the extent that he develops the highly self-critical concept of the pathetic fallacy, in *Modern Painters* III, he seems to have realized the falsehood of his moralizing personifications.

The text on purity demonstrates Ruskin's ability to be critical of figurative language and also his tendency to explain figurative meaning in psychological rather than linguistic terms. Throughout his career, Ruskin was concerned with man's interposition of "idols," "errors," or "metaphors" before God or before simple empirical reality. This does not seem to have prevented him from writing his own elaborate pathetic fallacies and moral allegories. Ruskin's inability to separate human distortion from true perception or conceptualization is, I suggest, a symptom of his inability to separate figurative from literal uses of language. The text on purity begins by emphasizing the empirical certainty of purity's existence. As illuminated organic structure, it partakes of the actual existence of substance and of light, which is "evidently necessary to the perception" of all other types of divinity. Then we are supposed to see how light shines through such nonexistent "forms" as Shamefacedness, Belphoebe, Florimel, or Una, forms that are constituted by language itself. These forms are pure metaphors, mixing references to substances in ways that please our imaginations but which are beyond the evidence of our senses, as when Spenser tells us that Florimel is made of "purest snow, in mossy mould congealed" and tempered with "fine mercury."

In the second part of *Modern Painters* II, Ruskin turns from the realm of concrete divine types to that of human imagination, in which objects appear without actually existing. He recognizes, in this context, the figurativeness of such appearances, especially when such appearances belong to the literary imagination. For "in literature the faculty [of imagination] takes a thousand forms according to the matter it has to treat, and becomes like the princess of the Arabian tale, sword, eagle, or fire, according to the war it wages; sometimes piercing, sometimes soaring, sometimes illumining, retaining no image of itself, except its supernatural power" (4.224). The literary imagination is so supreme in its powers of modification that Ruskin decides to confine himself to the operation of the imagination in painting and sculpture. Material media set limits on the imagination in a way that language does not. Despite this deliberate limitation, the chapters on the Associative, Penetrative, and Contemplative Imaginations consistently invoke poetic examples in order to explain the nature of each mode. Language may not retain an image of the imagination itself, but imagination seems to be allied closely with particularly verbal modes of representation. Each form of the imagination depends upon metaphor, "a particular mode of regarding the qualities or ap-

pearances of a single thing, illustrated and conveyed to us by the image of another" (4.227). Tropes and figurative language in general determine this mode of conveyance as much as traditional psychological categories such as memory, judgment, association, and fancy.

Ruskin criticizes Dugald Stewart's psychology of the imagination on the ground that it fails to consider the decidedly figurative nature of imaginative appearances (see 4.224–27). Stewart gives a poor account of the imagination as the mere "combination" of separate images in the mind. To Stewart, images are compared, abstracted from the "qualities and circumstances which are connected with them in nature," and finally made into new wholes. Ruskin dismisses such theorizing as an explanation of "composition" rather than imagination. Imagination occurs only when one image is substituted for another. Composed images lack distinctness and may be made up of the "commonest kind" of images of objects. Imaginative substitutions, however, have an unmistakable distinctness. This distinctness is evident in poetic metaphors: Milton's "opening eyelids of the morn," or the wandering moon riding "like one that had been led astray," or Hesperian fruit which is "burnished with golden rind."[26] Sharpness of detail and clarity of image are achieved through metaphorical substitutions.

Ruskin chooses not to pursue this insight into the verbal nature of the imagination. As soon as an image is distinctly realized, Ruskin treats it as an appearance rather than a trope. His emphasis, finally, is visual rather than linguistic, even though the tropes that constitute the "appearances" cannot literally be seen. Ruskin uses his insight into metaphorical substitutions to go beyond various associationist doctrines and the doctrine of the imagination provided by Wordsworth in his 1815 preface to his collected poems.[27] These doctrines fail to demonstrate the distinctness of truly imaginative appearances. For Ruskin, the power of the imagination lies in "seeing anything we describe as if it were real" (4.226n). So "seeing" actually eclipses the linguistic process of describing. Thus, once again, Ruskin confronts the issue of figurative language and quickly abandons it.

Of the three forms of the imagination Ruskin defines, the Contemplative Imagination best illustrates Ruskin's break with traditional psychology not only in his emphasis on metaphor but also in his failure to carry through his insight. As soon as distinctness of image is realized, a distinctness that "could not have occurred to vague memory," metaphor is forgotten.

The Contemplative Image: Metaphor as Appearance

Ruskin, like the literary hero of his youth, William Wordsworth, constantly tries to fit particular poems (or fragments of poems) into the right psychological category. Unlike Wordsworth, Ruskin categorizes with a certain exuber-

ance. Where Wordsworth, in the 1815 preface, is content to discuss the general opposition of imagination to fancy, Ruskin transects this opposition in three ways, giving us the Associative, Penetrative, and Contemplative Imaginations. Such apparent overrefinement was bound to seem excessive rather than economical, and the Contemplative Imagination is usually thought of as the excess part. The Penetrative Imagination, as its name would suggest, is traditionally seen as the cornerstone of Ruskin's discussion. It modifies and abstracts sense-impressions and so establishes an image of sublime force and presence in the mind. It is the most Wordsworthian of the three classes and is, indeed, ranked first in importance by Ruskin. The Associative Imagination is misnamed, because, again in Wordsworthian fashion, its function is to break down passive association. It associates images by weakening external resemblances between perceived objects, by blurring them. It reconstitutes partial, exterior aspects of an object, again with more vivid though less mimetic results.

These operations of the imagination would have been familiar to Ruskin's readers in 1846; the opposition of fancy to imagination was hardly an original formulation. Ruskin's analysis appears to be a belated rehearsing of arguments presented by Wordsworth and Coleridge in the *Biographia Literaria*. Ruskin's Contemplative Imagination (4.289–313) presents the least familiar aspect of the imagination, which is not necessarily to say that it was an original insight. On the contrary, it seemed to be a regression, an afterthought. Ruskin calls it a "habit" or a "mode"—terms that would connote mental passivity in image making, the very antithesis of romantic doctrine. Sister Mary Goetz, the most careful reader thus far of Ruskin's writings on the imagination, calls the whole chapter on the contemplative mode "unsatisfactory." She sees its function as a mere repetition of the associative and penetrative functions, conducted in a leisurely, extended fashion. Whenever a specifically contemplative function is named, it usually seems to lead to trivial results. Ruskin writes about Contemplative Imagination with "insecurity," suggests Goetz. Similarly, Robert Hewison calls the discussion of the Contemplative Imagination the "weakest" of the three. Hewison and Goetz are very attentive readers of Ruskin, who prefer to integrate, not dismiss, Ruskin's varied writings. It is rare for either of them to single out a text in Ruskin as aberrant. They refuse to accept the Contemplative Imagination for different reasons, but in each case the reason has to do with a total reversal of expectations, and those reversals make their objections significant.[28]

For Goetz, Ruskin's contemplative mode confuses fancy and imagination. Ruskin suddenly turns against the romantic theory that considers them to be fundamentally distinct. The externalization of products of the Contemplative Imagination as distinct figures and outlines seems to be a reversal of the Wordsworthian emphasis on the internal modification of distinct or bounded forms through the imagination. We seem to pass suddenly, in Ruskin, from

imagination to the external fixities associated with fancy. Earlier in his discussion, Ruskin had emphasized the "ghostly unreal" status of products of Penetrative Imagination. Now he writes of the high degree of mimesis of details and ornaments made possible by the contemplative mode.

Hewison, too, finds that the contemplative mode breaks with the romantic character of Ruskin's general theory, but not in the way that Hewison would like. The break with Wordsworth, for Hewison, ought to be in the return to visual perception, in the triumph of the eye over the imagination. Hewison emphasizes Ruskin's views of Wordsworth as presented in *Modern Painters* III, written ten years after the second volume of the series. Here Ruskin argued that Wordsworth distorted empirical perception too much for the sake of the imagination. Wordsworth personifies objects. Blinded by excess emotion, he lost sight of natural fact. This is the famous argument of the pathetic fallacy. But Contemplative Imagination breaks with Wordsworth in a way that is asymmetrical with this outcome. Rather than leading to clarity of perception, to what Hewison calls the "argument of the eye," Contemplative Imagination leads to the production of symbols and abstract signs which are not "testable by visual perception." Their signification is so abstract, so unrelated to perception, that it seems to be random. The original object of perception is not traceable.

These difficulties that Goetz and Hewison sense center upon a set of questions: Is the Contemplative Imagination truly a break with romantic doctrine, specifically with Wordsworth? If so, to what end? What function did Ruskin intend to describe by the seeming addition of a contemplative mode to the theory of the imagination?

The most apparent break with Wordsworth occurs at the opening of the chapter. Surprisingly, memory serves as the basis of the contemplative mode. Absent objects, whose images are retained only in the memory, constitute the contemplative image. This unusual point of departure seems to have escaped the attentiveness of both Goetz and Hewison. Nothing could be more unlike the Wordsworth of the 1815 preface than to make memory the basis of an imaginative mode. Imaginative modification of perception, according to Wordsworth, takes place in relation to visual or aural perception, not mnemonic impressions. The imagination in Wordsworth is usually set directly against the tyranny of the eye or the light of sense. Imagination decays into fancy precisely to the degree that the percepts retain distinctness. (This is why, in the 1815 preface, sound is more conducive than sight to imagination.) Moreover, memory, of the five psychological faculties defined in the preface, is the least successful basis for differentiating imagination from fancy.

Wordsworth's differentiation of imagination from fancy takes place as a critique of William Taylor's mistaken theory of the imagination as memory.[29] Taylor defines imagination as the distinct "copy in idea [of] the impressions

of sense." Imagination is in direct "proportion" to vividness and distinctness of the retained phenomena. It is the depicting in the mind of sensory objects with accuracy and clarity. Fancy, on the other hand, is made up of operations of connection and association of these ideal representations of absent objects provided by the imagination. Wordsworth compares these definitions to an account of a building's foundation which omits all consideration of the super-structure. In less figurative terms, Wordsworth objects to the passivity and reductiveness implied in Taylor's definitions, specifically the reduction of imagination *and* fancy to memory, to the building blocks, as it were: "It is not easy to find out how imagination, thus explained, differs from distinct remembrance of images; or fancy from a quick and vivid recollection of them: each is nothing more than a mode of memory." Such a confusion, Wordsworth argues, in a way that seems to anticipate Ruskin's argument, allows fancy to "insinuate" itself into the "heart of the creative activity." To avoid this, Words-worth redefines imagination: it "has no reference to images that are merely a faithful copy, existing in the mind, of absent external objects; but is a word of higher import, denoting operations of the mind upon those objects, and processes of creation or of composition, governed by certain fixed laws." Ruskin, in general, would agree with Wordsworth. The Associative and Pen-etrative Imaginations do not offer faithful copies of phenomena. They offer vague ideas, so abstracted from substantial properties as to seem immaterial. The associative and penetrative operations assume distinct ideas, which it is their task to make "imperfect." Their tendency is toward what we would think of as the romantic sublime.

All this is thoroughly reversed when we arrive at the contemplative image. Indistinct, vague recollections need to be rendered as distinct ideas by con-templation. Ruskin's contemplative image reverses Wordsworth's reading of Taylor. Memory, for Ruskin, provides vague rather than distinct images of absent objects. The sublimity of impression typically associated with the imagination is given gratuitously as a mnemonic operation. (Ruskin uses the term "sublime" to characterize memory.) The Wordsworthian modal opera-tion, which allows memories to be distinct only so that the imagination might sublimate them into insubstantiality, is transferred to the passive faculty of memory. For Wordsworth, the imagination dissociates itself from fancy when fancy is aligned with memory. Ruskin, however, dissociates memory, as in-distinct images, from the distinct images of fancy, thus aligning memory and imagination. Memory and imagination, in a thoroughly Ruskinian twist, can only be brought together in terms of fancy. The indistinct images of memory and imagination can only be rendered distinctly in the mind through fancy.

Far from being an excrescence, the contemplative mode, when read as a reply to Wordsworth, turns out to be the most economical feature of the general theory of the imagination. Rather than dismiss fancy outright, Ruskin

finds a new use for it; he puts it to work by redefining the value and meaning of distinct ideas. The historical thrust implied in Wordsworth's doctrine, which equates the imaginative negation of fancy with the movement beyond neoclassical poetic diction, now appears as a wasteful movement, a sort of Pyrrhic victory over fancy, which leads to the loss of phenomenal values. At the same time, the return to empirical observation is typically equated with Victorian aesthetics and poetics: Arnold's "to see the object as in itself it really is" or the highly finished details of a Pre-Raphaelite painting. Thus much is at stake in the reinscription of fancy into the romantic imagination. The transition from Romanticism to Victorian aesthetics depends on the revaluation of the role of distinct impressions in the mind based on the firm perception of external objects.

There is another aspect of fancy that remains problematic. Fancy denotes more than distinctness. It denotes comparison or structure. It is not a unity in and of itself. To conceive fancy merely as distinctness misses the point. Such a conception returns us to a doctrine of mimesis, against which Ruskin wrote throughout his career. The distinctness of the fanciful image emerges in the comparison of one blurred image to another (that is, memory to imagination) or in the substitution of one blurred image for another. Fancy, in Ruskin, is therefore explicitly defined as a trope, as metapahor;[30] it is certainly not accurate, literal perceptions or copies of perceptions. It was this strange confusion of distinctness of conception with lack of empirical certainty that baffled Robert Hewison.

The figurative nature of the contemplative mode is defined, interestingly enough, as a figure:

> [O]n this indistinctness of conception . . . is based the operation of the Imaginative faculty with which we are at present concerned . . . whereby, depriving the subject of material and bodily shape, and regarding such of its qualities only as it chooses for particular purpose, it forges these qualities together in such groups and forms as it desires, and gives to their abstract being consistency and reality, by striking them as it were with the die of an image belonging to other matter, which stroke having once received, they pass current at once in the peculiar conjunction and for the peculiar value desired. [4.291]

Ruskin explicitly states that this exchanging and substituting of properties is possible only through language. Words provide the dies of an image which cannot be imitated in painting or sculpture. The forging and casting and stamping operation is a distinct metaphor for what is not at all a material process. The "subject" that has been deprived of material shape regains "reality" but only by a process of being made over in another image. This process is literally inconceivable, except as a reading of linguistic figures. And so Ruskin turns immediately to a poetic example, John Milton's description of

Satan burning like a comet (*Paradise Lost*, bk. 2, 1.708). Here bodily shape is destroyed, yet the image of the comet gives the abstract conception of evil "distinctness and permanence." Yet, Ruskin adds, "this could not be done, but that the image of the comet itself is in a measure indistinct, capable of awful expansion" (4.292). Superhuman evil is compared to a burning comet so as to render distinct the concept of evil, but only in terms of metaphor. Unsubstantial ideas, which are meaningful but not necessarily imaginable, achieve distinctness through figurative language.

It is interesting that Wordsworth, in the 1815 preface, similarly uses Milton's descriptions of Satan to define imagination. Moreover, he uses the very term "contemplation" to describe Milton's Satanic similes. By contemplation, Wordsworth means the taking advantage of the "appearance" of the simile to the senses, so that the mind is gratified in the contemplation of the image itself. When Milton compares the flying fiend to a fleet at sea that seems to hang in the clouds, we have not only imaginative modification (fleets do not literally hang in the clouds) but contemplative enjoyment. The simile is assumed to be an appearance that gratifies the intuition in the mixture of motion and sublimity of size and number. The knowledge that a fleet rests on the water is pleasurably confused with the notion of its hanging from the clouds. Here, Wordsworth is not concerned with the principle Ruskin had detected: that the contemplative moment is not strictly an appearance or phenomenological intuition but is a function of metaphor, of language. To treat the figure as an appearance, as Wordsworth does, is to be blind to trope. For in fact the mind literally cannot conceive, in the way Wordsworth would like us to believe it can, the simultaneous presence of stasis and motion, weight and airy lightness. These physical oppositions can be reconciled only in terms of reading, not perceiving.[31]

The return of language as imagination occurs, in Ruskin, only in the case of the contemplative function, precisely because Ruskin recognized the impossibility of making sublime comparisons or realizing abstractions in the mind as intuitions. Language, which had been treated as irrelevant in the chapters on the Associative and Penetrative Imaginations, returns in the chapter on Contemplation. In the earlier chapters, Ruskin had argued that the definiteness of verbal knowledge—the ability to describe perceptions in terms of number or to name specific colors or degrees of shadow—interfered with the modifying power of the imagination. Definiteness of perception or description was an obstacle to imaginative transformation. Or, in more conventional terminology, fancy, in its definiteness of relation between objects, threatened to arrest the more plastic flow of images belonging to imagination proper. The return of fancy in the chapter on Contemplation brings with it the return of verbal knowledge, now defined structurally as a relation of indistinct impressions through metaphor or synecdoche. The insinuation of

fancy into imagination turns out to be the reinscription of verbal structure into the random flow of indistinct intuitions in the mind.

Whenever Ruskin lapses from his linguistic insight into a phenomenological notion of fancy, the results are disappointing. He judges a series of texts from Coleridge, Wordsworth, Keats, Shelley, and Scott in terms of each poet's "belief" in the truth of his substitutive tropes (see 4.293–98). Distinctness of figurative expression is thus confused with immediate intuition. Wordsworth "truly" believes in the various personifications of a daisy as a queen or a nun, or as a pretty star ("To the Same Flower," poem written in 1805, quoted in Ruskin, 4.294–95). The images of the daisy remain "fanciful," unbelievable as references to actual existence. Yet, for Ruskin, they become expressive of the vividness of the image within the mind. Metaphor, or personification, has become ideation. The "truth" of the intuition displaces the falsehood of the linguistic figure. Ruskin becomes concerned with the issue of sincerity, with evidence of the poet's personal belief in his poetic imagery. Keats is less "feeling" than Wordsworth because his tropes, or resemblances, seem to lack a certain "solemnity," as when he compares (in "Isabella," canto 24) the passage of the sun over eglantine to the sun counting "His dewy rosary." The image may be rescued if we assume that Keats meant "sun worship and orison in its race" (4.294). Ruskin has shifted his criticism from the consideration of how tropes may render unsubstantial images distinctly to the intended meaning of the poet. The criticism is no longer linguistic. The poem must reflect the personality of the poet.

Ruskin's emphasis on the poet is not necessarily improper, but it tends to displace the recognition of the figurativeness of the poet's language. The internalization of appearance is a theme that causes Ruskin to lose sight of the illusory character of the poetic image. This blindness results in a growing uncertainty in later volumes of *Modern Painters* about the "sincerity" of literary texts. It is difficult to reconcile the joint recognitions of poetic falsehood and personal belief. The concept of the pathetic fallacy, developed in *Modern Painters* III, will criticize Wordsworth and Keats as equally "false" though equally "sincere." Only tropes that cannot be internalized or believed will be defined as both "true" and "sincere." But the externalization or mental distancing of tropes tends to be defined in terms of material arts, sculpture and architecture, not poetry. Ruskin returns to the premise that opened the discussion of the imagination in this volume: material media allow a more controlled and critical grasp of the workings of the human imagination. The literary imagination is too deceptive, too prone to lead to empirical error.

At the conclusion of the chapter on the Contemplative Imagination, Ruskin lays the foundation of his later emphasis on the material arts. He closes with a consideration of the Contemplative Imagination in architecture and painting, particularly Gothic and Romanesque decoration. Victorian audiences have

viewed these forms as "seeming barbarity," says Ruskin. In fact they reveal the contemplative "stamp" of their creators. But this stamp, which refers to the metaphor of contemplation's forging process, is no longer substitutive. Material representations of contemplative images do not achieve distinctness like linguistic representations, which exchange forms and properties of objects.

> Now, it is evident that the bold action of either the fancy or the imagination, dependent on a bodiless and spiritual image of the object, is not to be by lines or colours represented. We cannot, in the painting of Satan fallen, suggest any image of pines or crags; neither can we assimilate the briar and the banner [as does Scott in the extract from the *Lady of the Lake*, quoted on 4.296], nor give human sympathy to the motion of the film [as in Coleridge's "Frost at Midnight"], nor voice to the swinging of the pines. [4.299]

In material media, contemplation idealizes rather than mixes forms and properties. Highly finished forms, conversely, appear to be "ludicrous." Since stone in particular cannot capture detail in animal forms, for example, the attempt to represent lions, cocks, fish, and so forth in highly finished forms signifies thoughtless preference for mimesis on the part of the artist. This is especially the case in architecture, where the visual distance from the viewer necessitates a certain abstraction so that the form may be seen more clearly (as in the case of the ornamental peacock). Ruskin continues:

> I can only ask the reader to compare the effect of so-called barbarous ancient mosaics on the front of St. Mark's . . . with the veritably barbarous pictorial substitutions of the seventeenth century . . . and also I would have the old portions of the interior ceiling, or of the mosaics of Murano and Torcello, and the glorious Cimabue mosaic of Pisa, and the roof of the Baptistry at Parma . . . all of which are as barbarous as they can well be, in a certain sense, but mighty in their barbarism, compared with any architectural decorations whatsoever, consisting of professedly perfect animal forms, from the vile frescoes of Federigo Zuccaro at Florence to the ceiling of the Sistine. [4.305–06]

Idealization is opposed to mimesis, but in either case distinctness of conception is no longer the issue. Nor need it be. The imagination in material media is not concerned with phantoms and unsubstantial shapes. The materiality of the signifier guarantees the presence of the image to the mind. The mind need not work, as it must in language, to retain an image before the inner eye. The danger is not faintness of conception but its opposite, over-realization, a sensuously deceptive mimetic image which conflicts with material deadness. Mimesis, in material art, is possible in "capitals and other pieces of minute detail," but never in the whole (4.306).

The last trace of Ruskin's insight into verbal modes of representation may

be found in his discussion of Tintoretto's supernatural lion, in *Doge Loredano before the Virgin* (4.304–05; I alluded to this discussion at the opening of this chapter; see fig. 7). The supernatural lion, in its strictly visual aspect, is idealized, or only "partly of magnificent realization." But like the verbal contemplative image, it is made of substitutions, specifically metonymies. In the plumes of its mighty wings there is a "cloudlike repose." The wings also contain the "strength of sea winds shut within their foldings." Read in this way, the lion is neither an appearance (there is no evidence of wind or clouds in the wings) nor a mimesis (the lion being only partly realized). As a totality, the lion gives a "symbolical treatment" of certain elements of nature. It substitutes for these elements animal features associated with them. The "appearance" of the lion is therefore nonessentially linked to its substantive meaning. Tintoretto's painting of the lion functions like a verbal structure of meaning. It substitutes forms for substances, one appearance for another. Ruskin's insight into the meaning of the lion is not determined by his recognition of the limits of material representation. He is not concerned primarily with the reason for the idealization of the lion. Rather, he is concerned with the wings, which are themselves metonymically linked to the ideal form of the lion. The materiality of sculptural decoration, or, more precisely, the painting of sculptural decoration, would seem to be at the opposite extreme from the unsubstantial letters and signs that constitute a language, but Ruskin reads Tintoretto's lion like Milton's Satanic similes, as substitutive tropes. The materiality of the signifier in this case is what resists phenomenalization, or an emphasis on psychological intuition. The impression of the clouds, sea, and wind is not distinct as an idea. The impression is in fact a metonymical structure of signification.

For Ruskin the abstractness of the lion's form calls attention to its possible "typical" or "symbolic" meaning. The lion represents something other than what it is. But this lion is an exceptional instance of Ruskin reading rather than perceiving a decorative form. The general thrust of *Modern Painters* II is toward appearance, intuition, and substance. Figurative meaning is usually subsumed under empirical or phenomenological modes of cognition. Ruskin has advanced his epistemology well beyond the Lockean confusion of ideas in *Modern Painters* I. Perception is not immediately related to the cognition of meaning. A structural account of organic wholeness, or of differentiation within unity, or of the emphasis of an "essential" part within a whole precedes every account of the relation of perception to cognition.

Ruskin's general structural insight is repeated (without reference to Ruskin) in W. K. Wimsatt's formulation of what he called the "Substantive Level" of poetic discourse. For Wimsatt, postromantic metaphor begins with such writers as Pater, James, and Proust, and with imagists such as Pound and Eliot. These writers tried to restore the fixities of poetic diction, which romanticism

had destroyed in an excessive wave of "phenomenalism." A return to poetic
diction was obviously out of the question, but a more substantial definition
of metaphor was needed. Wimsatt formulated such a definition:

> In . . . a structure of substantial meaning there is indeed precise extension of
> specifically named concrete objects and deep intension of radiated relation or
> symbolic significance. . . . [P]oetry is that type of verbal structure where truth
> of reference or correspondence reaches a maximum degree of fusion with truth
> of coherence—or where external and internal relation are intimately mutual re-
> flections.[32]

Wimsatt, as a faithful Augustan, made his own attempt to reinstate fancy into
postromantic literature, but his insights into verbal structure were anticipated
by Ruskin, whose essays on the imagination and the symbolism of forms
provide the best formulations for approaching writers such as Pater or Proust.

Unlike Wimsatt, Ruskin made the mistake of confusing linguistic structures
with actual substance. Every appearance, substance or symbol, is momentarily
uncertain in meaning for Ruskin. He often doubts whether he is being faithful
and sincere in his grasp of significance or idolatrously substituting himself in
the place of the signifier, however broadly it may be conceived. This uncer-
tainty is Ruskin's momentary encounter with linguistic modes of figuration.
Yet Ruskin consistently evades the disruptive power of these modes within
his own texts. Ruskin's career over the fourteen years it took him to complete
Modern Painters was shaped by an increasing emphasis on the allegorical sig-
nificance in all art of material objects and forces. Ruskin exploits the allegorical
level of meaning, in pagan as well as Christian art, in an attempt to evade
indeterminate meaning by emphasizing the determinateness of the image or
object. Allegory, the disjunction between the aspect of the signifier and its
significance, becomes the master trope of Ruskin's later works. Its inception
is brought about by Ruskin's attempt to substitute the empirically certain for
the cognitively uncertain. The true significance of allegory for the student of
Ruskin's works lies in his (futile) attempt to master figurative meaning by
empirical means. The relief of form against substance or the opposition of the
sign to the senses finally becomes the radical debasement of the signifier in
relation to its meaning.

3

Allegorical Landscapes:
Modern Painters III–V

Historical Ideals

After 1846, Ruskin suspended work on *Modern Painters* for nearly ten years. The third volume, "Of Many Things," did not appear until 1856. Architectural studies, particularly of Venetian and Norman Gothic, had occupied Ruskin during the intervening period. Ruskin chose to regard his major architectural study of this period, *The Stones of Venice* (1851–53), as a bridge between *Modern Painters* II and III. But the bridge is not apparent. What theoretical connection could there be between Turner's revolutionary capacity to depict natural phenomena and the "rudely" carved biblical narratives on the façades of Norman churches or the capitals of the Doge's Palace at Venice? For Ruskin the connection lay in a structural analysis of the relation of ornamental parts to an architectural whole, a structure as complex as the modes of ideation discussed in *Modern Painters* I or the typology of the natural world in *Modern Painters* II. Architectural media do not compare to painting or natural forms in their visual effect, but then Ruskin did not care much about such effects. Comparisons may be made in terms of cognitive constructs. Determining the proper relation of an ornamental vine to the biblical narrative, in stone, of which it is part, is similar to the determining of the proper degree of abstraction or realization of a natural form in a painting by Turner or Tintoretto.

A full account of Ruskin's theory of ornamentation has yet to be written. I can offer only a brief account of the ornamental/pictorial "ideals" that are first described in the famous chapter on the nature of the Gothic in the second volume of the *Stones* (10.180–269) and then developed in the first half of *Modern Painters* III. The crucial, new element in these discussions is history. The ideals reflect earlier concerns of Ruskin, such as the opposition of deceptively mimetic ideals to "pure," extremely abstract, almost semiotic, ideals. But these opposites mingle in a series of subtle, intermediate forms. A history of forms

is traceable between these opposites, a history that characteristically proceeds from extreme abstraction to decadent mimesis. The ideals are not stable, or, as Ruskin says, both at the conclusion of the *Stones* and at the opening of *Modern Painters* III, the ideals cannot be "systematized." The instability of the ideals necessitates a historical reflection upon art.

The chapter on the nature of the Gothic, in the *Stones*, first presents the "purist" ideal, which begins with abstract design. It may be completely non-referential, as in Oriental art, but is best exemplified in art that displays a high degree of conventional representation, such as Greek vases or Byzantine mosaics. Mimetic detail is sacrificed because either a mass effect is intended (for example, the harmonious arrangements of colored stones on the exterior of a building) or the material medium prevents subtle realizations. The "naturalist" ideal presents the opposite extreme: an attempt at complete mimesis, as in Dutch art or in some early English romantic landscapes of George Beaumont and John Constable. Ruskin condemns this class as "idolatrous," for the mimesis tends to interpose itself, deceptively, before true perceptions of nature; it tends to make us forget that we are regarding compositions. The "synthetic" ideal is found in artists such as Michelangelo, Leonardo, Giotto, Tintoretto, and Turner. These artists achieve a high degree of local detail but remind us that we are regarding a design.

Ruskin's basic triad is capable of considerable refinement. Naturalism may be further subdivided into its own sensualist and purist ideals. Sensualist-naturalists, such as Salvator Rosa or Caravaggio, aim at the horrible aspects of nature. They dwell upon the evil that is necessarily a part of the fallen world. Purist-naturalists, such as Fra Angelico, do not achieve perfect abstraction and represent only the good in man and nature. The sensualists prefer confused, irregular foliage; the purists prefer simple, symmetrical groupings, as in medieval herbariums.

The same triadic scheme may be applied to architects and artisans. Ancient Greek and Egyptian architects demanded a slavelike obedience from the laborer. Purity of design comes at the expense of individual creativity. Renaissance art, at the opposite extreme, Ruskin believes, attaches too much importance to the refinement of each sculptor's skill. Mimesis of detail becomes an end in itself. The architecture as a whole suffers from meaningless embellishment. The mean is found in the naturalism of the Gothic. The laborer is allowed to express his love of nature and fear of God exuberantly, in rudely carved but abundant floral ornaments and grotesques.

All these triads are theoretical, for as soon as Ruskin applies his categories to the interpretation of a particular building or painting, a historical shift of the triad occurs. The Gothic, for example, fluctuates between earlier, abstract Byzantine forms and later, mimetic forms. The mean is difficult to fix. A temporal reading is required, in which neither abstraction nor perfect reali-

zation dominates. The precariousness of the mean leads to a general theory of the inevitable collapse of the naturalist ideal and a nostalgia for the innocence of rude forms. The ideal fails but the history of the triad continues.

When Ruskin returns to the consideration of landscape painting, in *Modern Painters* III, the history of the ideals becomes ever more complex. This complexity is evident in the remarkable first chapter of the volume, "Of the Received Opinions Touching the 'Grand Style'" (5.17–34), in which Ruskin sets out to subvert the Reynoldsian distinction between "historical" schools, such as the Dutch, and "poetical" schools, such as the Venetian. Reynolds's (Aristotelian) separation of the specific from the universal is shown to be a "fallacy." What emerges instead is a new synthesis of the historical and the poetic, a new "ideal." This ideal sets a standard for the subsequent ideals defined in this volume: false religious and profane ideals, true purist, naturalist, and grotesque ideals. Each of these represents a considerable refinement of the categories set down originally in the *Stones*. An exposition of the argument of the opening chapter of *Modern Painters* III establishes a context for the remainder of the entire work, which consists of a history of landscape ideals. The systems of *Modern Painters* I and II are replaced with a history that cannot, in principle, be concluded.

Examining Reynolds's *Idler*, no. 79, Ruskin finds that

> Dutch painting is *history;* attending to literal truth and "minute exactness in the details of nature modified by accident." That Italian painting is *poetry*, attending only to the invariable; and that works which attend only to the invariable are full of genius and soul; but that literal truth and exact detail are "heavy matter which retards the progress of the imagination." [5.24]

History is to poetry as the variable is to the invariable, as slow laborious study is to imaginative genius. But invariable forms, for Ruskin, seem to have little poetic quality. They are too abstract. Nor is invariable form an essential characteristic of Italian art, as Ruskin sees it, for Tintoretto and Titian and Veronese often depict vegetation, clothing, even Venetian history with extraordinary detail. Something must be wrong with an antithetical definition that denies the acuity of Venetian observation, while it makes "literal" and exact a mimetic form that Ruskin considers to be shallow. Dutch art is more "poetic" in the Reynoldsian sense, for it treats natural forms superficially. The opposition of the literal to the ideal may be crossed on the grounds that Dutch literalism is vague, while Italian idealism is often very specific.

There is nothing new in Ruskin's criticism of Reynolds's oblivion toward the value of detail. This criticism was already made in the second preface to *Modern Painters* I. But now the criticism goes an important step further: "[O]ur author has entangled himself in some grave fallacy, by introducing this idea

of invariableness as forming a distinction between poetical and historical art"
(5.27). Invariableness leads only to blandness or monotony. It offers no ground
for a definition of poetry. Invariableness is of the order of "composition." It
is rulebound, made of a loose aggregate of parts.

The problem of separating historical from poetical ideals begins properly
with the recognition of the inevitability of variation, the multitudinous detail
of the natural world. Variety cannot be ignored, but it must be raised into
artistic significance. Poetry (a term that includes painting) is the use of "detail"
for the purpose of awakening the imagination. The imagination is defined as
"the power of assembling . . . such images as will excite [noble emotions]"
(5.29). It is the literal power of the "Maker." The objects of the imagination
are always fictions. By the word "ideal" Ruskin does not mean anything like
a transcendent, Platonic form, or a perfect image. He means a fiction, a mental
construct. The status of the ideal derives from the Lockean idea. The imag-
ination aims neither at vague forms nor at strictly literal copies of objects.
The imagination uses detail economically to create a sharp but extensive effect.
The proper ratio of imaginative reconstruction to literal accuracy is not readily
determinable, but it is a problem that may not be evaded.

Ruskin had struggled with this problem before. There are parallels between
this discussion of poetry and the attempt to find unity-in-variety, or the
separation of composition from imaginative distinctness, or, in *Modern
Painters* I, the attempt to reconcile vivid sensibility with narrowly defined
signs of truth. *Modern Painters* III introduces a deeper recognition of the in-
stability of this problem. The ideal is now by definition historical. It is neither
truthful nor strictly imaginative. The ideal changes. Furthermore, for the first
time Ruskin seems willing to accept empirical errors for the sake of imaginative
unity. When Ruskin speaks of history, he does not imply denotative accuracy.
It is the fiction that has a history. A historical science is not the point. The
acceptance of historico-poetical error is evident in Ruskin's discussion of Lord
Byron's "The Prisoner of Chillon" (5.25–27). The poem provides numerous
details about the setting of the Castle of Chillon, but the details are imaginative
rather than historical, in the Reynoldsian sense of literal descriptions. Byron's
poem is "distinguished from a truly historical statement, first, in being simply
false" (5.25). Byron gives the detail that the waters below Chillon Castle are
one thousand feet deep—a false but poetically useful detail. The detail leads
to further specification, such as the "massy" movement of the waters. Byron
also gives a metaphorical account of the Castle's appearance. It is "snow-
white"—again, a fine detail but literally false.

Errors of description and tropes in general are now acceptable as long as
they contribute to the making of a "noble" fiction. Fiction should not dwell
on ephemera or trivia. It should raise feelings, elevate them to the level of
disinterested admiration for the subtlety of a detail. Fireworks, a street of

shops, the emotions of horror and grief are the stuff of history in the usual sense of the term. History thus becomes a record of the mundane and the transitory. But a "noble" fiction might be premised upon the budding of a flower "because it is impossible that this manifestation of spiritual power and vital beauty can ever be enough admired" (5.29). The impossibility of sufficiently admiring the flower is the condition of the flower as a fiction, its "spiritual power." The poetic history of the flower consists of the impossibility of realizing its implications fully. Unlike Reynolds's history, Ruskin's poetic history is the observation of detail whose meaning cannot be specified:

> [I]t is altogether impossible for a writer not endowed with invention to conceive what tools a true poet will make use of, or in what way he will apply them, or what unexpected results he will bring out by them; so that it is vain to say that the details of poetry ought to possess, or ever do possess, any *definite* character. Generally speaking, poetry runs into finer and more delicate details than prose; but the details are not poetical because they are more delicate, but because they are employed so as to bring out an affecting result. [5.30]

The history of poetic ideals therefore becomes an ever finer but theoretically endless task of specifying the relation of delicate observation to inventive manipulation. History becomes an act of reading rather than the determination of the empirical referents of a poem.

 The nine chapters that follow the opening discussion of history and poetry in *Modern Painters* III provide an outline of the various ways in which invention lapses into either a mimetic, excessively realized mode of representation or a symbolical, totally fictive mode. The ideal mean is rarely recognized. Only Homer and Dante seem to achieve the ideal in language, only Giotto and Tintoretto in painting. These "poets" or "makers" are able to blend mythological symbolism with common experience and naturalistic detail. Their "poetry" is manifestly fictive but at the same time clearly conceived. Their poems or paintings are neither "windows" nor "mirrors," for they are not "statements of fact." They do not assert anything, Ruskin argues. They are neither true nor false.
 Falsehood begins with an attempt at mimesis, as in Raphael's cartoon of Christ showing himself to his disciples at the lake of Galilee, entitled *Christ's Charge to St. Peter* (see 5.80–83; fig. 12). Raphael substitutes technical skill for the imaginative apprehension of this narrative moment. The representation of this moment is necessarily fictive to the belated viewer. Even so, we may judge the relevance of certain details to the constitution of the fiction. Ruskin urges viewers to imagine the reality of Peter shivering by a coal fire, broiling fish perhaps, as Christ, with the sunlight directly behind him, approaches and stands over his disciple. Raphael, however, gives us a popish Peter, and

fishermen with "handsomely curled hair and neatly tied sandals." Peter wears an "apostolic fishing costume." Raphael's fiction takes away our belief. It is a "mythic absurdity," a concoction of muscular human forms in the Grecian style, representative of Peter the Church Father rather than Peter at a decisive moment, encountering Christ.

Raphael's influence becomes pernicious. The technical accomplishment of his work cannot be denied, in spite of its conceptual errors. In denying Raphael's version of the event we must forcefully reject his mimetic skill at the same time. Hence, Ruskin argues, Protestantism smashes Raphael's idol and suffers, in consequence, from "*dulness*": "A dim sense of impossibility attaches itself always to the graceful emptiness of [Raphael's] representation" (5.83). A "fatal sense" of "well-composed impossibility" gradually taints the Protestant's ability to read the Bible faithfully. The imagination becomes so sensitive, so resistant to mimetic beguilement that a peculiar form of Protestant aestheticism results. The Gospels become the object of "admiring, but uninterested, incredulity." The radical negation of mimesis leads to a complete suspension of belief. The critical reflection upon the techniques of representation reduces all narratives to graceful fictions.

To the noncritical mind, Raphael's cartoon becomes an idol, an image that is used "to excite certain conditions of religious dream or reverie." As an idol, the mimesis is regarded "not as representations of fact, but as expressions of sentiment respecting the fact." The idol functions as a stimulus, as a sensational object. It activates the viewer's desire to imagine the divine. Without the idol, the viewer has a "wonderfully feeble sense of the presence and power of God." The monk is particularly susceptible to such idolatry, for he otherwise has no opportunity for "graceful indulgence." Similarly, though at an opposite extreme, for the "young lady . . . jaded by her last night's ball" the idol serves the purpose of translating "folly" into "feverish" atonement. The mimetic idol makes self-dramatization possible. Eventually, however, entrapment in mimesis leads to sentimental confusion. When the emotions are invested in a false or deceptive image they soon weaken into a state of ambivalence. The votaries of idols form the habit of "sentimentally changing what they know to be true, and of dearly loving what they confess to be false" (5.85).

Similarly fallacious modes of representation may be found in pagan art. Heathen mythology becomes the Christian's vehicle for sensual indulgence because it "could be delighted in, without being believed." It is false religion to compose a Grecian image of Peter, but pagan "errors might be indulged." As fictions, they cannot be said to assert anything and so cannot falsify moral concepts. But this confidence in the ability to indulge in fiction soon results in the pursuit of a "doubly false" ideal. The fiction once again becomes an idol. To beautify Peter is to falsify a fact, but to admire the beauty of a pagan

god is to reify a falsehood. The mimesis of Greek allegorical figures becomes a "shadow of a shadow." Paganism returns to the sensualist ideal: the worship of luxurious, sensual forms for the sake of amusement or excitement.

The falsehood of certain pagan or Christian ideals has nothing to do with the intrusion of fiction as such into a truthful conception. Falsehood begins when the fiction takes on the power of assertion. "True" ideals are equally fictive, but they do not attempt to seduce viewers into taking them literally. Fra Angelico's purist truth, for example, presents figures in clothes as beautiful as those found in Raphael. But Fra Angelico paints "spiritual beings," not mortals, and so the viewer does not take the clothing as a literal statement. Still, Fra Angelico's purism is "childish" and "weak," for it sacrifices too much realization in order to retain its ideality. The naturalistic ideal, as in Tintoretto, achieves ideality without excluding the common or the vulgar. Tintoretto takes the contrasts that exist in nature and arranges them in a harmonious balance. In the *Adoration of the Magi* (Scuola di San Rocco) the Madonna is portrayed as a girl of childish sweetness (see fig. 13). She is opposed to the old Magi, who remind one of Venetian senators. The Magi are opposed, further, to the black and Indian servants. Taken separately, each of these "portraits" reduces to a historical figure. As a group, the figures present an idealized, or imaginatively arranged, contrast of human types. The structure of the opposition within the painting conveys a "universal principle": "the greater the master of the ideal, the more perfectly true in *portraiture* will his individual figures be always found, the more subtle and bold his arts of harmony and contrast" (5.112). Distinctness of detail finds its place within a generalizable structure of contrasts. We might suppose that there is a certain artificiality in the deliberate juxtaposition of youthful femininity to venerable masculinity. But Ruskin treats the arrangement of the carefully realized faces as a cognitive rather than an emotive statement. Tintoretto has neither blended facial forms into an academic composition nor given us a simple mimesis. He has avoided all "egotistic" errors of composition. The biblical event is sharply defined, but the structuring of the faces reminds the viewer that the painting is of universal significance. The reconciliation of parts within a whole is all important. A sentimental response would beguile the mind and favor the eye. The sentimentalist ignores the harmony of the structure and dwells upon the affectivity of each face. "[T]he universal endeavour to get *effects* instead of facts" is at the root of "false idealism" (5.126).[1]

Tintoretto's *Adoration* exemplifies the naturalist ideal because its portraiture is, ironically, nonreferential. The detail of the portraits, Ruskin speculates, is derived from Tintoretto's everyday observations of contemporary Venetians. But the specificity of the portrait does not present a historical document of Venetian life. The details cohere within an atemporal structure of significa-

tion. This point is crucial. When detail is used to refer to events outside the frame of the painting, the painting lapses into history. Any attempt to establish a genre of historical painting as such is bound to fail. The historical painter will inevitably seek to compose his facts; he wishes to immortalize an event. Like the sentimentalist, he confuses truth with error. As soon as a painting is named a history it asserts facts. This assertion must fail as long as we recognize the painting *as painting*. History paintings, Ruskin warns, "EFFACE THE RECORDS which departed ages have left of themselves" (5.129). The power of painting may be used to monumentalize a detail but not to preserve the image of the departed. Tintoretto achieves truthful representation by balancing details within a fictive framework.

The portrait, like the sign of *Modern Painters* I or the type of *Modern Painters* II, has a high degree of specificity but no definite significance until it is placed within a cognitive construct. What is new in Ruskin's naturalist ideal is a sense of fictiveness that goes beyond anything encountered in the discussions of the sign or the type. Truth, in *Modern Painters* III, is strictly "idealistic," a mental event. Art, if it would lead to truth, must not assert anything. The naturalist ideal, as well as the other "true" ideals, does not oppose the materiality of the signifier to the idea signified, nor the material property of an object to its metaphorical significance. Ruskin, it seems, is no longer concerned with establishing an immediate empirical ground for the cognition of truth. I have been arguing that, in any case, the attempt to ground cognitive truth in the empirical properties of a signifier fails. The simple sign, as soon as it is intuited, becomes a trope. The material properties of the type prove to be "symbolic" substitutes, or metaphors, for hidden meanings. In giving up his focus on the empirical properties of a signifier, Ruskin seems to escape self-deception. The epistemology of *Modern Painters* III is founded upon a new opposition: deceptive errors (as in Raphael) versus fictive truths (as in Tintoretto). Ideal is opposed to ideal, rather than sign to idea or substance to form. In Ruskin's chapter on the third and final true ideal, the grotesque, the opposition of true to false ideals reaches its most complex phase. It is necessary to consider the category of the grotesque with some care, for it reveals, more than the naturalist ideal, certain dangers inherent in the opposition of ideal to ideal.

The Grotesque Ideal

Ruskin presents three grotesques: a playful, irrational form; an "irregular and accidental" form; and a confusing form, representative of the imagination's inability to grasp wholly the presence of supernatural truths. These forms have affinities with other ideals. In its playful, innocent form, the grotesque has a childish quality reminiscent of the childish abstractions of the purist

ideal. As an expression of evil, the irregular grotesque resembles the sensualist ideal. As a partial realization of divine truth, the confusing grotesque resembles the naturalist ideal.

It is the third form that is of prime concern to Ruskin, for it alone is "thoroughly noble." The confusion evident in a grotesque sculpture usually has a noble cause. It does not originate in playfulness or wickedness but in "the use or fancy of tangible signs to set forth an otherwise less expressible truth" (5.132). It includes "nearly the whole range of symbolical and allegorical art and poetry." There is a "concentration" of meaning in such grotesques which is similar to that found in the naturalist ideal. But unlike naturalist ideals, symbolical or allegorical grotesques disguise their meaning. These grotesques "convey truths which nothing else could convey . . . which no mere utterance of the symbolised truth would have possessed, but which belongs to the effort of the mind to unweave the riddle" (5.133). The mind senses "an infinite power and meaning in the thing seen, beyond all that is apparent therein, giving the highest sublimity even to the most trivial object so presented and so contemplated."

In the context of natural idealism, the detailed definition of an object or person gives a concreteness to the image as a whole but conveys no ulterior meaning. In grotesque allegory, however, the details convey some figurative meaning, as Ruskin demonstrates in a reading of Spenser's allegory of Envy. The image of Envy is as fully realized, in its parts, as Tintoretto's *Adoration*, but the details do not cohere on a literal level of interpretation. There is no connection apparent between the ravenous wolf, upon which Envy rides, and the snake of many folds in Envy's bosom, as there is between a venerable old Magus and a childlike Madonna. We must read the wolf as a symbol of the "untamable and unappeasable" nature of Envy's passion. Similarly, the snake suggests that Envy is never "free from the most bitter suffering, which cramps all its acts and movements, enfolding and crushing it while it torments" (5.132). The symbols accurately present aspects of the concept of Envy, but their visible relation to each other is purely contiguous.

Ruskin is not interested in the ugliness of the grotesque image. The parts that make up the grotesque complex serve a strictly cognitive function. They make distinct contributions to the conceptualization of Envy but, by definition, fail to realize the totality of the concept. Each part is imperfectly related to the others; the parts constitute a riddle. The truth of the allegorical grotesque is not perfectly expressible. The disjoined character of the whole indicates the lack of perfect conceptualization. Yet no part is amiss. Nothing in the grotesque ought to distract the viewer from the concept of Envy.

The internal economy of the grotesque is as rigorous as that of the naturalist ideal. Poor or "false" grotesques have a *composed* disjointedness, not unlike Raphael's cartoon of Peter. The parts are related by formula or rule. In a

Roman griffin, on the frieze of the temple of Antonius and Faustina, the parts are manifestly disjoined, even incongruous (see 5.141–48; fig. 14). An eagle's head is joined to a lion's shoulders. In a vain attempt to connect the two forms smoothly, the sculptor inserts a horse's mane, strengthened with vertebrae running down its front. Moreover, the weight of the griffin is depicted in a ludicrously off-balance position. One of its paws is extended "in a most painful position merely to touch a flower" (5.144). The griffin is grotesque, to be sure, but in a nonallegorical way. There is no suggestion that the sculptor was struggling with a concept that he could not realize perfectly. The sculptor was simply playing, abstracting, and mixing natural forms. But even as play the griffin serves no purpose, for the play is not unusually exuberant—the only sort that counts for Ruskin.

The grotesque ideal, of all the ideals discussed in *Modern Painters* III, would seem to be the least deceptive, the least likely to lapse into mimesis. As an allegory or a symbol, the grotesque is necessarily fictive in its literal aspect. We may judge the literal character of the grotesque and decide whether or not it is well realized, but such a judgment is strictly formal. We do not refer the literal appearance of the grotesque to nature, nor are we involved in the more complex task of "unweaving the riddle." It is therefore surprising to discover that, for Ruskin, the allegorical or symbolical grotesque is potentially the most deceptive of the ideals. The allegorical and the symbolical are not in fact complementary modes of representation, as their interchangeability within the context of the grotesque would lead us to believe. Ruskin, in the *Stones*, had concluded that symbolism and allegory, particularly personification, are antithetical:

> It is to be noted that personification is, in some sort, the reverse of symbolism, and is far less noble. Symbolism is the setting forth of a great truth by an imperfect and inferior sign (as, for instance, of the hope of the resurrection by the form of the phoenix); and it is almost always employed by men in their most serious moods of faith, rarely in recreation. Men who use symbolism forcibly are almost always true believers in what they symbolize. But personification is the bestowing of a human or living form upon an abstract idea: it is, in most cases, a mere recreation of fancy, and is apt to disturb the belief in the reality of the thing personified. Thus symbolism constituted the entire system of the Mosaic dispensation: it occurs in every word of Christ's teaching; it attaches perpetual mystery to the last and most solemn act of His life. But I do not recollect a single instance of personification in any of His words. And as we watch, thenceforward, the history of the Church, we shall find the declension of its faith exactly marked by the abandonment of symbolism, and the profuse employment of personification,— even to such an extent that the virtues came, at last, to be confused with the saints; and we find in the later Litanies, St. Faith, St. Hope, St. Charity, and St. Chastity, invoked immediately after St. Clara and St. Bridget. [10.377]

Personification, in this passage, disturbs belief in the reality of the idea personified in the same way that Raphael's cartoon of Peter disturbs belief in Scripture: the distinctness of the realization interferes with the sense of having grasped the idea imperfectly. A contradiction develops between the literal aspect of the personification and its figurative meaning. The literal image threatens to interpose itself before the idea that it ought to serve. Personification verges on idolatry. Once we forget the fictive nature of allegories, we are liable to confuse them with portraits of saints. The symbol, by contrast, has the properties of the grotesque as it is defined in *Modern Painters* III. The symbol is imperfect and manifestly inferior to the idea it conveys. Why then has Ruskin united these opposite modes in the discussion of the grotesque in *Modern Painters* III?

In the *Stones*, Ruskin suggests that personification, when used under the condition of strong, uncorrupted faith, has an expressive extensiveness that symbolism lacks. Personification enables the painter or sculptor to construct a narrative or a "system," because personifications, unlike symbols, may be compared to each other directly. The virtues and the vices may be set forth in various relations to each other in terms of personification. In its conventionality, personification allows the most individual expressions of religious views. "Giotto, for instance, arranges his system altogether differently at Assisi, where he is setting forth the monkish life, and in the Arena Chapel, where he treats of that of mankind in general, and where, therefore, he gives only the so-called theological and cardinal virtues; while, at Assisi, the three principal virtues are those which are reported to have appeared in vision to St. Francis, Chastity, Obedience and Poverty" (10.378). Such different arrangements of the virtues would not be possible in a purely symbolic mode of representation. Systems based on personification "vary with almost every writer."

In the discussion of the grotesque in *Modern Painters* III, Ruskin once again praises the variability of personification. Variability is the quality that brings personification into line with the playfulness of the grotesque. Allegory, or personification, may be found in the work of Orcagna, Simon Memmi, Michelangelo, Dürer, Tintoretto, Veronese, Raphael, and Rubens. Allegory becomes the basis of artistic creativity:

> For observe, not only does the introduction of these imaginary beings permit greater fantasticism of *incident*, but also infinite fantasticism of *treatment;* and, I believe, so far from the pursuit of the false ideal having in any wise exhausted the realms of fantastic imagination, those realms have hardly yet been entered, and that a universe of noble dream-land lies before us, yet to be conquered. For, hitherto, when fantastic creatures have been introduced, either the masters have been so realistic in temper that they made the spirits as substantial as their figures of flesh and blood,—as Rubens, and, for the most part, Tintoret; or else they

have been weak and unpractised in realization, and have painted transparent or cloudy spirits because they had no power of painting grand ones. [5.135–36]

Personifications are virtually as extensive as the "splendour of thought." In principle, there is no limit to personification's expressive function. But personifications or allegories consistently fail to materialize properly. They tend to lapse into personifications in the negative sense defined in the *Stones*. Allegory becomes a mimesis, a false ideal. Or, allegory fails to materialize at all.

Ruskin has spoken often of the eye deceiving the mind. There seems to be nothing new in the argument that personification may lapse into mimesis, and so stray from its intended purpose in the hands of a painter more concerned with displaying his skill than with conveying, however imperfectly, a sublime idea. But what does it mean to realize an allegory too fully? Is deception really possible? The virtue of allegory, as Ruskin shows in his discussion of Envy, is that it may realize details as completely as possible and still remain a fiction. Allegory, as a substitutive trope, asserts nothing positive about the idea for which it stands. The opposition of personification to symbol, or perfect to imperfect realization, cannot be maintained. This point was made emphatically by Bertrand H. Bronson, in a discussion of the text on personification and symbolism in the *Stones:*

> When Fra Angelico shows us God the Father, he is personifying an idea; but is he not, at the same time, setting forth a great truth by an imperfect and inferior sign? Is not Botticelli's Truth, in the allegorical painting, "The Calumny of Apelles," a noble or exalted representation of the ideal, if yet inferior in the sense of more restricted; nevertheless, in fact both a symbol and a personification? (And for whom, we ask incidentally, would the representation disturb belief in the reality of the idea personified?) In truth, symbol and personification are not opposites. The two terms are not even commensurate, for the one includes and transcends the other. Symbol is a term which easily contains personification and much else: a personification is but one among many kinds of symbol.[2]

In switching, suddenly, from the consideration of personification as a substitution for an idea to personification as a mode of realization, Ruskin abandons the issue of ideality or fictiveness. More than the naturalist ideal, allegory achieves realization of detail within a nonassertive structure of signification. It is difficult to conceive of the reader who is misled by Spenser into believing in the literal existence of Envy. Envy has a nonreferential character that is markedly different from Raphael's Peter.

In *Modern Painters* II, Ruskin frequently writes of Tintoretto's "symbolism." The winged lion is one example. By "symbol" Ruskin means "substitution." In *Modern Painters* III, however, symbolism means the formal character of an allegory, its "imperfection," regardless of its substitutive function. The grotesque, as it appears in Homer or Dante or in Turner's *Garden*

of the Hesperides, becomes a mode of reconciling spiritual inventiveness with "the realistic power." Allegory ceases to be a strictly ideational mode of cognition, a "riddle" of the otherwise inexpressible, and becomes instead a governing principle in the history of the human response to landscape, whether in painting or poetry. Allegory is drawn into the realm of factual assertion, but only at the price of a repression of its substitutive meanings. When, in the chapter on the grotesque, Ruskin refers to Tintoretto's painting of Doge Alvise Mocenigo, he speaks of the decorative value of another supernatural lion (see fig. 15). The "nowise interesting Doge" is made more interesting by the presence of a ten-foot-long winged lion resting upon a Turkish carpet. The complex sort of reading of a winged lion as substitutive trope, offered in the discussion of the Contemplative Imagination, is done away with completely. This winged lion contributes to what Ruskin calls "treatment" but loses entirely its enigmatic aspect.

Bronson makes no reference to the conjunction of symbolism and personification in the discussion of the grotesque ideal. In a sense, Ruskin anticipates Bronson's criticism, for there is no difference between symbolism and personification in the context of the grotesque. But the loss of the difference simultaneously changes the purpose of allegory. In place of an emphasis on cognition, on riddling or reading, we find an emphasis on allegory as a sort of picturesque dreamwork:

> [Personification is] ever to be grasped with peculiar joy by the painter, because it permits him to introduce picturesque elements and flights of fancy into his work, which otherwise would be utterly inadmissible;—to bring the wild beasts of the desert into the room of state, fill the air with inhabitants as well as the earth, and render the least (visibly) interesting incidents themes for the most thrilling drama. [5.135]

Picturesque delight replaces the problem of deciphering these same elements in the painting. Tropological substitutions are normalized as mere fancies, or delightfully innocent fictions. The inventive power of allegory is thus reduced to play, to a low form of the grotesque.

A study of personification becomes the foundation of the history of landscape ideals that comprises the rest of *Modern Painters*. Classical, medieval, and "modern" landscapes are defined by the painter or poet's reverence for nature mixed with his self-consciousness of the necessary fictiveness of his representation. To revere the landscape is to combine naturalism with allegory. Each historical period presents a new combination. As a figure that combines fiction with concrete detail, personification is well suited to the task of defining each phase in the history of landscape ideals. But Ruskin's history of these ideals is in fact uncertain in meaning and unclear in its transitions. He seems to forget that the significance of an allegory is not determinable on

strictly empirical grounds. To generalize about the Greek or medieval mind on the basis of allegory as representation leads inevitably to error. The ambiguities and uncertainties in the "modern" response to landscape are there from the outset. This history of allegory is the unpredictable movement generated by the attempt to read allegory not as a trope but as an assertion of fact in a nonbelievable form.

Homeric Landscape

"I do not think we ever enough endeavour to enter into what a Greek's real notion of a god was," Ruskin states (5.223). Too often the belated reader of Homeric epic assumes that Homer was an "ingenious fabulist," a creator of a "witty allegory, or a graceful lie." There is an unbelievability, to the modern reader, in the river Scamander defending the Trojans against Achilles, or in the ensuing battle between Vulcan's flames and Scamander's swollen waves. Similarly, we laugh when Juno strikes Diana with a lance, for the gods are of course unsubstantial. We assume such descriptions are amusing myths, pure fictions. Most readers of Greek literature, Ruskin tells us, are Wordsworthians. Like Wordsworth in Book IV of *The Excursion*, we assume that the common Greek supplemented his "poor" poetic skill with "fanciful" images of gods and goddesses. The swain looks upon the crescent moon and fancies that he sees "a beaming Goddess with her Nymphs" (1.865). The pagan confuses his gods with perceptions of nature.

Ruskin does not deny that there is often an analogy between a Greek personification and some aspect of nature. When, for example, we read of Juno striking Diana's flushing cheek, we may conceive of the action as a figure for the clouds gathering and concealing the moon. We are allowed to "outcarry" the first idea "provided that [we] do not pretend to make it an interpretation instead of a mere extension, nor think to explain away [Ruskin's] real, running, beautiful beaten Diana, into a moon behind clouds" (5.229). Wordsworth gives a shallow explanation of Greek fancy when he treats allegory as a simple substitution for a natural phenomenon. But what is at stake in Ruskin's conception of the reality of the gods? How real is Ruskin's "real"?

The Wordsworthian theory of the gods is, for Ruskin, a symptom of our "modern" separation of the idea of divinity from the life of nature. It is impossible to believe in the spiritual life of any natural object. So we personify the object first and then disbelieve, inwardly, in a vain attempt at spiritual restitution. We form the confusing habit of "giving sympathy to nature, which we do not believe it receives." We fall "necessarily into the curious web of hesitating sentiment, pathetic fallacy, and wandering fancy, which form a great part of our modern view of nature" (5.231). We falsify nature and our feelings. Our gods are unsubstantial and ephemeral, unlike the Greeks'. Homer, the

perfect exemplar of the Greek imagination, does not foolishly attempt to con-
fuse water with water gods, dryads with trees, goddesses with flowers or with
the movement of air and clouds. In realizing his personifications as fully as
possible, Homer actually separates their existence from nature. The Homeric
allegory operates as an analogy between a personification and nature, not as
a substitutive principle that would identify the two. The "reality" or distinct-
ness of conception of the Greek god precludes a romantic, sentimental min-
gling of allegories and natural objects.

The Homeric imagination makes possible a "healthy" view of the gods. The
gods express their feelings without hesitation. They may be jealous, envious,
or magnanimous. They may, in short, be fully human, for their "humanity"
is immediately known to the Greek. The Greeks do not use the gods to
mediate between emotions and the natural world. At the same time, therefore,
a healthy response to nature is made possible. The Greek delights in the
cultivation of nature. He enjoys the sight of tilled fields, rich pastures, and
vineyards because he feels no shame in working the land. When the Greek
chops down a tree he does not feel as if he is wounding a nature spirit. The
spirit is not identical with the tree, though he may inhabit it. Ruskin's Greeks,
like Friedrich von Schiller's, are clearly unsentimental. The Greek is able to
depict nature accurately, as in the careful delineation of color in Homer's
descriptions of the sea. The Homeric imagination gives no evidence of es-
trangement from nature. Inhospitable scenes, such as rocky terrain or non-
arable land, are distressing to the Greek but not alienating. It is simply that
cultivated lands have a greater appeal to the Greek's sense of practicality.

Ruskin's depiction of Greek health is premised upon a thorough substan-
tiation of the gods. Whenever the gods weaken into "mere allegory," a diseased
impression of nature sets in. The joyful, quasi-paradisiacal Grecian landscape
that Ruskin depicts is highly appealing. Could it be that the ambivalent "web"
of the modern imagination represents a failure in our ability to personify
rather than a sophistication unknown to the Greeks? I think not.

Ruskin's notion of Greek health is perhaps what Ruskin had called, in his
earlier discussion of pagan falsehoods, a "shadow of a shadow" rather than a
substantiation of a personification. The true degree of the Greeks' sympathetic
response to nature is a moot point.[3] Theoretically, however, it is impossible
to materialize or "extend" Greek gods in the way Ruskin does without lapsing
from idealism into mimesis. The substantiation of the gods has its usefulness,
but at the price of a massive blindness to mimetic beguilement. Ruskin, usu-
ally the archcritic of mimesis, even mimetic forms of personification, now
becomes the advocate of a mode of thoroughly realized allegory. We give up
a modernist ambivalence for a more tranquil and more beguiling mode of
thought. Greek personification, as Ruskin characterizes it, might be described
as a form of sublimation, a transfer of imaginative enthusiasm from the realm

of nature to that of fantasy. The healthy gods in their clouds and the healthy Greek upon his cultivated plain disguise what is in fact a sublimation of the utilitarian ethos. Highly realized personifications release drives and impulses, free humans to work productively in nature. We must believe literally in the gods if we are to work as efficiently and happily as the Greeks.

Ruskin has simply reversed Wordsworth. Natural phenomena become fantastical; it is the allegory that is "real":

> [W]hen Diana is said to hunt with her nymphs in the woods, it does not mean merely, as Wordsworth puts it, that the poet or shepherd saw the moon and stars glancing between the branches of the trees, and wished to say so figuratively. It means that there is a living spirit, to which the light of the moon is a body; which takes delight in glancing between the clouds and following the wild beasts as they wander through the night; and that this spirit sometimes assumes a perfect human form, and in this form, with real arrows, pursues and slays the wild beasts, which with its mere arrows of moonlight it could not slay; retaining, nevertheless, all the while, its power and being in the moonlight, and in all else that it rules. [5.226–27]

The allegory of Diana has no riddle, no enigma. Ruskin does not treat Diana as he treats Spenser's Envy, as a concept to be realized partially. Diana is an allegory without a hidden meaning. Her function is perhaps aesthetic; she seems to enhance the spiritual perception of nature. But Ruskin's delightfully perfect image of Diana exploits the substitutive, imperfectly constituted literal aspect of allegory. The substantiation of Diana's body consists of a sequence of substitutions; these substitutions are permissible because an allegory has no proper form. The moonlight translates into clouds; clouds, as any child knows, easily take on the appearance of wandering animals. Finally Diana materializes as a "perfect human form," though she continues to be translucent. She retains the ephemerality of moonlight.

Diana is constituted out of various natural images, each of which is distinctly defined. At first glance, the images of Diana seem to have a literal coherence, unlike Spenser's Envy. Only the "reality" of her arrow is enigmatic. Is it "real" in the proper sense? Or is it the truly allegorical element in the passage? Its reality is contrasted with the ephemerality of Diana, which suggests that we are supposed to read "arrow" literally. Diana kills, in spite of her incorporeality. The arrow, read thus, would be the fundamental mimetic trope of the passage. It grounds the allegory of Diana in substance more thoroughly than does the moonlight or the cloud. But this same reality of the arrow also seems to be the most allegorical element in the passage. Its "reality" must stand for something else, since it is difficult to take the description of a luminous human form shooting a real arrow as a literal event. But what could it stand for? The arrow's reality imposes a "modern" sense of ambiguity. In fact William Empson finds that this ambiguity is "fairly common in the nine-

teenth century."[4] What Ruskin calls a grotesque allegory Empson calls a "fifth type" of ambiguity, which occurs when the author cannot hold all at once the idea he wishes to express.

An example is Percy Bysshe Shelley's "To a Skylark." The "keen" unattainableness of the skylark rising in the heavens (to the point of invisibility) is likened to "the arrows of that silver sphere." This sphere becomes the moon (rather than a star, which is another way of taking it) when we read the arrows as an allusion to Diana. The moon goddess Diana's arrows support the analogy of the moon's rays emerging from a cloud to give a brief, overwhelming illumination and the skylark's song overflowing the heavens even as it disappears from sight.

> The pale purple even
> Melts around thy flight;
> Like a star of Heaven,
> In the broad daylight
> Thou art unseen, but yet I hear thy shrill delight,
>
> Keen as are the arrows
> Of that silver sphere,
> Whose intense lamp narrows
> In the white dawn clear
> Until we hardly see—we feel that it is there.
>
> All the earth and air
> With thy voice is loud,
> As, when night is bare,
> From one lonely cloud
> The moon rains out her beams, and Heaven is overflowed.

But Shelley's "keen" arrows become as ambiguous as Ruskin's "real" arrows. Shelley's moon, like Ruskin's, works as a "precise symbol" (Empson explains) of poetic imagination to the degree that it makes the human apprehension of nature vague and fantastical. The resulting allegory is necessarily grotesque, in the Ruskinian sense, even violently so. Its keenness or reality is not an indication of perfect spiritual apprehension but of quite the opposite. Spiritual keenness causes swooning before nature, or, worse, it introduces violence into the human psyche. We should recall, as does Empson, that the myth of Diana always involves violence and death. Her beauty is "too keen and too unattainable, so as to destroy the humanity which apprehends it." Humanity is violently separated from, not joined to, nature in Diana's presence. The keenness of the spiritual life, for Shelley, remains beyond human limitations. For Empson, Shelley's often chaotic imagery is in fact delicate and intricate because to speak spiritually is to speak quickly. Shelley has an idea about the spirit which cannot be perfectly realized.

When Ruskin tries to realize perfectly the vision of Diana, and so link human spiritual invention to labor in nature, the result is perhaps a morbid form of the grotesque. Violent labor upon nature is seen as healthy, but we may doubt whether it is spiritually so. Ruskin seems too concerned with holding to a particular spiritual image and embellishing it. This misuses the ambiguity of the grotesque ideal; it becomes idolatrous, as Empson suggests. "Real" is ultimately less ambiguous than "keen," for "keen" implies focus without increasing realization. "Real" is too mimetic a term, which interferes with Diana's figurative meaning, her suggestions of human invention and imagination. Beneath the calm of the Greek gods we may detect a very modern sort of ambivalence. Perhaps the situation is clearer in medieval allegory.

Dantean Landscape

The medieval period, in Ruskin's history, introduces sentimentality into the human response to landscape. The medieval artist or poet is a transitional figure in the movement from Greek practicality and health to modern morbidity and ambivalence. The medieval garden, the floral ornaments that cover medieval churches, and the floral patterns that decorate medieval manuscripts attest to a new pleasure in nature. The lily is valued more than the leek. Sensual delight, particularly in color and in abstract patterns that appeal to the eye, reveals the beginning of an aesthetic response. Flowers and herbs, and other impractical forms of vegetation, serve human interests rather than needs. The medieval man is at home in his garden. The sentimental strain begins with a recognition of the "mystery" of this delight in nature. Aesthetic pleasure is in proportion to the loss of the idea of spiritual presence in nature. Nature is no longer a bountiful gift, as it was to the Greek; it becomes the scene of play rather than serious work. But the urge to revere nature remains. Its bounty and comforts cannot be reduced to mere recreation. So the medieval man grows pensive, and his mind is "laid open to all those currents of fallacious . . . and pathetic sympathy, which we have seen to be characteristic of modern times" (5.252). The medieval response to landscape develops a tension: the pleasure of the garden and its society is opposed to the serious retreat of the solitary knight or monk, who inhabits the desolate mountain tracts or dangerous forests. Sensual indulgence is opposed to self-mortification.

At first there is a quasi-Grecian solution to this emotional ambivalence. Like the Greek, the medieval man appreciates the beauty of the human form. Man is comfortably assimilated into nature in terms of his own beauty. The adornment of knights, manuscripts, and churches requires that natural forms be abstracted. Abstraction renders nature intelligibly to the peasant and the

noble alike. It also serves the purpose of codifying nature within society, specifically in the complex heraldic patterns of the nobility. In the formal reduction of the ivy leaf to a symmetrical pattern running along the border of a psalter, or in the formulaically composed depictions of a grove, a winding river, and a very "trim" garden, nature is harmonized with man but also subordinated to man.

The subordination of landscape to a human aesthetic is an important development in the history of art. The medieval artist actually invents the concept of conventionalization. Nature is brought into everyday life through the formal "laws" of decoration. In fact, Ruskin suggests that decorative art has not improved since the fourteenth century. The medieval artist chose his forms carefully, selecting only leaves or flowers which provide the basis for simple symmetries and repetitions in their own organic structure. This concept of decoration seems to originate in what Ruskin had earlier called the purist-naturalist ideal. In the discussion of medieval landscape conventional representation falls under the broader category of Symbolic art.

Sentimental ambivalence intrudes into the perception of nature once the Symbolic degenerates, as it inevitably does, into the Imitative. In a late thirteenth-century Hebrew manuscript, we find an illustration of the serpent around the tree of knowledge. The nonmimetic "chequer background" that stands for the sky in this illustration enables "the reader better to understand the peculiar feeling of the period, which no more intended the formal walls or streams for an imitative representation of the Garden of Eden, than these chequers for an imitation of sky" (5.263). But the moment an imitation of sky is introduced, "the spirit of art becomes for evermore changed, and thenceforward it gradually proposes imitation more and more as an end, until it reaches the Turnerian landscape." All the accomplishments of decorative art are instantly placed in jeopardy. The fragile balance between "honour for the superior human form" (as in the Greeks) and a peculiar "sentimental love of nature" is upset. The formalism of herbs and flowers gives way to hybrid representations of nature, the meaning of which is impossible to determine. Mimesis raises the question of artistic intention. The patterns of medieval ornament may be sophisticated in their balancing of accurate form and abstract pattern, but this sophistication is impersonal. The price of conventionalism is a loss of emotional expressiveness. Indeed, the purpose of the convention is to suppress the medieval ambivalence toward nature. When "the thing carved or painted is not intended in anywise to imitate the truth," it does not "convey to us the feelings the workman had in contemplating the truth" (5.269). Mimesis signals the emergence of the "emotion" that, for Ruskin, is "the intermediate step between the feelings of the Grecian and the modern." The problem is to ascertain that emotion "as clearly as possible." And it is Dante, particularly in cantos 28–33 in the *Purgatorio* which describe his encounter

with Matilda, who represents what the medieval man felt in the contemplation of truth.

Dante, like Homer, is one of Ruskin's true idealists. *The Divine Comedy* contains "*definite*" landscapes; no detail in the narrative is wasted. Dante does not give us a simple rock or a bridge: "[H]e tells us of various minor fosses and embankments, in which he anxiously points out to us not only the formality, but the neatness and perfectness, of the stonework" (5.270). This "formality" is strongly emphasized in Ruskin's discussion, for it is the idealizing complement to the mimetic detail. Like Tintoretto, or, in the virtuous spheres of the *Comedy*, like Fra Angelico, Dante realizes detail within an imaginative framework. The engineering of the *Inferno* is "drawn with well-pointed compasses," unlike Milton's poorly conceived, indefinite chaos; but the extreme formality of Dante's conception prevents the mimetic detail from being asserted literally. Ruskin thus touches upon a central concern in Dantean criticism: the concreteness of the detail suggests a "typological" or "theological" allegory, but then there is also much artifice and design, suggesting a "poetic" allegory, more on the order of fiction.[5] Dante clearly demonstrates the medieval capacity for mimesis at its finest, but we are not forced to read the mimesis as an assertion of fact. Only the moral significance of the details can decide the purpose of the mimesis, and it is Dante's moral attitude that Ruskin seeks.

The formalism of Dante's descriptions, which extends even to the souls in Paradise who describe letters and sentences in the air, places Dante in the context of medieval decoration. Like the illuminator of a manuscript, Dante carves a narrative path out of the multiple forms of nature. Dante presents the same scenic "definiteness which we have already traced in pictorial art" (5.272). We may stray into sin or illusion but never into a descriptive context totally devoid of naturalistic form. Like the medieval decorator, Dante uses nature to modify or emblematize a figure's nobility or debasement. But a certain new reverence for nature becomes evident within the architecture of the narrative. On one level, Dante is a conventionalist. He typifies, for Ruskin, the medieval fear of forests, or the quite literal purgatorial function of a mountain ascent. But at crucial moments, as in the encounter with Matilda, the "peculiar" feeling symptomatic of the emergence of modernity is evident. The passage into Paradise, the Garden of Eden that lies beyond the river Lethe, is, for Ruskin, a passage that goes beyond "all effort, and past all *rule*. Art has no existence for [the perfectly purified and noble human creature]." In Ruskin's reading of the concluding cantos of the *Purgatorio*, purification and the transcending of all formalisms, paths, and rules are equated. Nature is converted from a set of (narrative) paths, symbolic of the need to govern

imperfection, into the "pleasure" of "perfect liberty" in nature: "[A]s the fencelessness and thicket of sin led to the fettered and fearful order of eternal punishment, so the fencelessness and thicket of the free virtue lead to the loving and constellated order of eternal happiness" (5.275).

Within the paradisiacal state that is beyond formalism, mimesis takes on a radically new value. The pleasure of mimesis is not the aesthetic pleasure of the medieval gardener, who delights in mere external form. Mimesis becomes the attempt to capture a purity that inheres in nature itself. We are not quite at the modern stage, in which we ambivalently believe and disbelieve in the divine in nature; nor are we in the Greek stage, in which the gods and nature are radically separated from each other. In Singleton's terminology, the narrative leading up to the encounter with Matilda is poetic: it is coherent in meaning (or "rule-bound" as Ruskin would say). Following this encounter, mimesis is purified into a "theological" mode. A natural object may typify, in its concreteness, the divine. In fact, grass, for Ruskin, becomes perfectly typological of the divine, perhaps because its natural form is not susceptible to a rigorously formal representation.[6]

How does Matilda perform the redoubtable feat of liberating mimesis from formalism, and so pure mimesis from the details of a poetic or fictive allegory? The crucial transition occurs in canto 28 of the *Purgatorio*. Entering into a forest near the top of the purgatorial mountain, Dante soon arrives at the river of Lethe, or forgetfulness, which, he notices, gently bends the grass upon its banks to the left. Dante further notices, on the other side of the river, a graceful, solitary lady, singing and arranging flowers in her hands. He is reminded of Proserpine, and calls to her so that he may hear her song more clearly. With delicate steps, as in a dance, she grants his request. As she approaches the riverbank, she steps upon some of the grasses and then lifts her eyes to Dante. Her effect *upon Dante* is mimetic in the negative sense. Dante is beguiled, even erotically stimulated.[7] Not only does she have the fairness of Proserpine; she reminds the poet of Venus in love. There are ornamental aspects in her appearance, to be sure, but they are completely subdued. Perhaps she is arranging her flowers with medieval skill. We do not know; we do not care. The focus is on her beauty. Even the formality of her steps is treated as an aesthetic effect.

For Ruskin, the passage seems to demonstrate the "perfect liberty" of mimesis in the pure sense.[8] There is no formality in the descriptive detail. The river is carefully described as translucent. We are told of the movement of the grass and the breezes, even the delicate rustling of the leaves. All these details are *plastic*.

Surprisingly, Ruskin does not consider any of these mimetic effects. His account of the episode suppresses most of the detail. Only two aspects of Matilda are of mimetic significance to Ruskin: first, her bright smile, which

seems to puzzle Dante; second, her "definite personality" within her "symbolic character." The definite personality is the real Matilda of the eleventh century, who was a woman of "political genius . . . perfect piety, and deep reverence for the see of Rome" (5.277). Ruskin invokes these historical facts (facts which current scholarship cannot corroborate) in order to establish Matilda as more than a mere personification or allegory. Dwelling upon the mimetic detail of the passage would not accomplish the same purpose, for allegories, as Ruskin has pointed out often, may be substantial yet remain fictive. The existence of Matilda as a historical person, as a portrait, grounds her extratextually. Her personal virtues are compatible with her symbolic function of absolving Dante of sin, of introducing him into the unbounded realm of purity. The mimetic details in the landscape that surround her are at best proleptic. Dante's sensual response perhaps indicates the fact that he is not yet pure. His perceptions confuse erotic associations with the concrete existence of the figure of Matilda. The task of the canto is to focus upon Matilda's inherent purity. The seductive mimesis of the canto must pass into a truly unbounded appreciation of the concrete existence of divine purity in nature. As Ruskin says, "The question is, then, what is the symbolic character of the Countess Matilda, as the guiding spirit of the terrestrial paradise?" (5.277).

The answer lies in Matilda's enigmatic smile. The smile is a mimetic detail that performs an allegorical function. It is a definite outline in an otherwise fluid, sensual context; it has a certain incongruity that suggests a hidden meaning. Matilda is smiling so brightly, when Dante sees her, that she must keep him from "wondering" at her by asking him to remember the verse of the Ninety-second Psalm, beginning "Delectasti" (5.277). The psalm tells of the gladness that comes from doing God's work. This smile, Ruskin notes, does not divide the earthly from the divine realm. That division is performed by the river, through which Dante must pass in order to forget his sins. (The fluidity of the river seems to suggest the fluidity of truly pure mimesis, which it makes possible.) The smile signifies the difference between "perfect and imperfect happiness, whether in earth or heaven":

> The active life which has only the service of man for its end, and therefore gathers flowers . . . for its own decoration, is indeed happy, but not perfectly so; it has only the happiness of the dream, belonging essentially to the dream of human life, and passing away with it. But the active life which labours for the more and more discovery of God's work, is perfectly happy, and is the life of the terrestrial paradise, being a true foretaste of heaven, and beginning in earth, as heaven's vestibule. [5.278–79]

Decorative art, which partially reconciles man with nature, is now replaced with the discovery of the divine in nature. Matilda's smile has the power, in

its riddling, unknown aspect, to draw Dante and his readers out of an imperfectly realized realm of decoration into a form of mimesis that would bring God closer. Human work should imitate God's work directly. When the need to decorate ceases, when the medieval artisan or poet no longer needs to rely on conventionalism as a mode of reconciling himself with nature, he may approach God's own work in his work, as long as he keeps God in mind. Mimesis for its own sake represents the worst form of blindness, the most self-centered placing of human skill before God's work.[9]

The solving of Matilda's riddling smile initiates Dante and, by extension, the medieval period, into a new mimetic mode. Color, the aesthetic element that is the least capable of being definitely circumscribed, acquires a new value and intensity in poetic descriptions. The richly varied color of grass, in particular, brings us closer to the divine the more accurately it is imitated. At the same time, its humble omnipresence and weak form make it resistant to abstract conventionalism. Dante's subtle descriptions of grass break down "all the fettered habits of thought of his age." He "placed his terrestrial paradise where there had ceased to be fence or division, and where the grass of the earth was bowed down, in unity of direction, only by the soft waves that bore with them the forgetfulness of evil" (5.293).

Yet one puzzle in Ruskin's account of Dantean landscape remains. Arnold notwithstanding, there is the apt question: why grass? Is grass really so important, so crucial to the destruction of the rigidities of medieval conventionalism? Is a magniloquent description of grass as a paradisiacal landscape really preferable to the subtlety found in medieval decoration? Is grass's suggestiveness of the divine really a sound basis for a mimetic mode?

It is the philosopher Hegel's comments on Dantean allegory that prompt me to ask these questions.[10] For Hegel, "Allegory in general belongs less to ancient art than to the romantic art of the Middle Ages, even if as allegory it is not properly anything romantic." Allegory rises in importance in the Middle Ages because, with a (romantic) deepening of subjective "aims of love and honour, with their vows, pilgrimages and adventures," it becomes increasingly difficult to establish a universal element in "relations and situations of life." "Accidental and capricious collisions" abound. Hegel concludes that, if the artist seeks to express a universal idea without clothing it in accidental forms, "there is nothing left to him but the allegorical manner of representation." In the allegorical figure, individuality is entirely subsumed under a universal significance. It is improper to treat the allegory as a specific person. Dante, in particular, Hegel suggests, allows "personification" to hover "between allegory proper and a transfiguration of his youthful beloved" (Beatrice). Dante almost ruins his allegory with an accidental significance.

When Ruskin views Matilda as an allegory of the universal happiness that may be found in God's work, he is not careful to exclude from his thoughts

accidental elements. It is purely accidental that the mimesis of grass should come to signify the end of medieval conventionalism. Grass, as well as blowing leaves and numerous other details, is sharply realized in Matilda's Eden. But at the moment of transfiguration, in which we read Matilda's smile as a symbol of a new mimetic mode, nothing is actually imitated. The smile is a definite form that is nonreferential. We are told that Matilda is thinking of the Psalms, but they do not clarify what ought to be imitated. The smile could signify anything present to Matilda: her flowers, the river, whatever. Ruskin arbitrarily selects the grass, and then constructs an elaborate reading of the entire *Divine Comedy* in terms of an ethos of grass's humility and tenderness. The reading is forceful but far from universal. It is in fact entirely accidental. Matilda's smile is a figure of the suspension of mimetic certainty.

Ruskin, perhaps more than Dante, is the one who is absorbed by the enigma of the smile. His immediate neglect of the mimetic detail within the canto may be read as a moment of blind choice. The substantiation of Matilda as a real yet symbolical figure is an issue that disguises the unpredictability of an allegorical figure's referent within a highly mimetic context. The indeterminacy of Matilda's proper meaning is hidden by a persuasive, "colorful" discourse on grass that would have readers think that Matilda has brought them into a new harmony with God in his creation. Ruskin, once again, has lost sight of allegory as "symbolic" (as an image that substitutes for a meaning that cannot be totally realized). In Ruskinian or Hegelian terms, Matilda's bestowal of the power of mimesis is the result of her accidental realization as a personification of God's work.

Turner's Garden of the Hesperides

Turner, like Homer and Dante, is for Ruskin the representative artist of his age. His paintings, more than the poetry of his contemporaries, represent the modern landscape feeling: an ambivalent mixture of unprecedented acuity of perception and a "mysterious" articulation of feeling that fails to clarify the meaning of any perception. The modern temper, as Ruskin expounds it at the end of *Modern Painters* III and then in volumes IV and V, is "untraceable," meaning that the subjective "associations" an artist seeks to convey in a landscape bear no direct relation to that landscape. Exceptional modern "makers," such as Turner or Walter Scott, fail to achieve universality, but at least they do not allow their associations to interfere with the objectivity of their perceptions. The "spiritual" meaning of the modern poem or painting is usually a sort of "dreamy" or "fantastical" gloss upon the landscape. Ruskin often uses the metaphor of a "cloud" of thought, or a "garland" of associations. Modernity is by definition enigmatic: distinctly realized images consistently fail to convey a definite meaning. Objects are vaguely suggestive.

In the opening chapters of *Modern Painters* III, Ruskin does not appear to be troubled by the disjunction between mimetic detail and indeterminable meaning. Allegory, which he calls "symbolism," offers a mode of interpretation that eliminates the need for a reductive historical search for meaning. The allegorical or symbolical character of a painting reminds viewers that they are dealing with *Ideals:* fictions that convey human significance or spirituality without deceiving with false perceptions of the object-world. Thus far the history of the Ideal of personification reveals a troubling lapse from nonassertive fiction to a highly substantial or mimetic mode of realization, modes that disguise their figurative basis as completely as did the types of *Modern Painters* II, or the signs of *Modern Painters* I. The ambivalence of the "modern" does not awaken Ruskin to this danger. He does not see in modern art any continuity with earlier modes of allegorical representation. He regrets that it does not achieve the complete assertive power of a Diana or a Matilda. In the modern artist, the "instinctive sense which men must have of the Divine presence" is "not formed into a distinct belief." It fails to materialize adequately in the form of personification:

In the Greek it created, as we saw, the faithfully believed gods of the elements; in Dante and the mediaevals, it formed the faithfully believed angelic presence; in the modern, it creates no perfect form, does not apprehend distinctly any Divine being or operation; but only a dim, slightly credited animation in the natural object, accompanied with great interest and affection for it. [5.341]

Modern Painters IV and V constitute an attempt to heal the breach between the material and spiritual worlds in modern art. Focusing on Turner's early work this time, Ruskin attempts to find in the Turnerian picturesque, or in his careful delineation of mountain forms, or in the general superiority of Turner's grasp of the visual complexity of nature when compared to other postmedieval artists, a firm basis for a modern spiritual invention, one that might rank with Grecian or medieval invention. In a sense, Ruskin must work against his own insights, for, as he saw originally, Turner is an increasingly delicate painter of luminous landscapes rather than a creator of substantive allegories.

Numerous elements of Ruskin's early criticism of Turner are recast in "spiritual" terms. Turnerian "mystery," in *Modern Painters* IV, becomes a category of supernatural apprehension. Strictly formal aspects of Turnerian composition are given allegorical names, such as the "Law of Help." Turner's mind becomes less of a Lockean mirror and more of a Pauline mirror, in which God is grasped faintly in nature. Most important of all, Turner's early academic exercises in classical landscape become the source of Ruskin's most energetic efforts at the spiritual reorganization of modern uncertainties. These paintings best illustrate Turner's capacity for "secret meanings." The allegor-

ical figures in the landscape establish an enigma. Like Dante before Matilda's smile, we must wonder at the meaning of an allegorical figure until we can make it speak.

The Turnerian allegory that contains the deepest meaning is *The Garden of the Hesperides* (1806; fig. 16). Ruskin's reading of this painting, in the chapter entitled "The Nereid's Guide," in *Modern Painters* V, represents the culmination of the attempt to make Turner into a modern Dante. This famous reading is as important to an understanding of the later Ruskin as the text on *The Slave Ship* is to an understanding of the early Ruskin. The first mention of *The Garden of the Hesperides* is in the chapter on the Grotesque Ideal, in *Modern Painters* III (5.137). The Grotesque Ideal is by definition a mode of imperfect realization. At its best, it conveys man's inability to imagine the totality of the divine. But the reading of *The Garden of the Hesperides* in *Modern Painters* V owes more to the Garden of Eden of Matilda than to the Grotesque. The reading represents the final phase of Ruskin's history of allegory: the firm grasp of allegory in terms of a canonical reading. The allegories of Turner's garden become timeless archetypes. Turner is joined to Dante, Spenser, and Greek mythology. The canonization of the allegorical figures clarifies all enigmas. The precise genealogy that defines the significance of each allegorical figure is, as Ruskin admits, beyond Turner's own knowledge of mythology. The overdetermination of meaning is actually devoid of spiritual invention. The history of personification depersonalizes the task of spiritual invention. Allegory becomes invention by rote memory, as Ruskin's reading demonstrates. The final phase of allegory is the forgetting of all intensely self-conscious efforts to grasp the truth of the divine imperfectly. Instead, the reading of allegory becomes the immediate determination of meaning in terms of the memorized significance of traditional figures.[11]

The Garden of the Hesperides is Turner's "most important picture of the first period" of his apprenticeship as a landscape artist. Ruskin is not concerned with any technical aspects of the painting, however. The painting provides evidence of the artist's spiritual development. Turner was a "gloomy" youth. So his decision to paint the Garden of the Hesperides at first seems odd. The Garden is traditionally seen as a terrestrial paradise, "clothed with verdure, intersected by mountain-streams running through ravines filled with the richest vegetation" (7.392). The nymphs that inhabit the Garden are, furthermore, associated with the daughters of Hesperis and Atlas; they represent soft winds and sunshine.

But the "natural meaning" of the legend, Ruskin argues, is "completely subordinate." Turner intends a "moral significance" that is "far deeper." As Hesiod explains in his *Theogony*, the Hesperides are the "daughters of Night." Their brightness and domestic virtues are anomalies in Night's genealogy.

They are born "between Censure, and Sorrow,—and the Destinies" (7.393). Even their task in the Garden—the guarding of Juno's golden apples—suggests something ominous, for Juno, "preeminently the housewives' goddess," represents "whatever good or evil may result from female ambition" (7.396). Juno as the source of household peace and plenty is watched by the Hesperides. But Juno "as the source of household sorrow and desolation" is watched by a dragon. The dragon in the myth, clearly seen atop a mountain ridge in the distance in Turner's painting, recalls the genealogy of Nereus, whose children "receive gradually more and more terror and power, as they are later born, till this last of the Nereids unites horror and power at their utmost" (7.396).

Phorcys and Ceto, descendants of Nereus, "in their physical characters (the grasping or devouring of the sea, reaching out over the land, and its depth), beget the Clouds and Storms—namely, first, the Graiae, or soft rain-clouds; then the Gorgons, or storm-clouds; and youngest and last, the Hesperides' Dragon—Volcanic or earth-storm, associated, in conception, with the Simoom and fiery African winds." In its moral significance, the dragon is the culmination of a genealogy of "stormy and merciless passions." It stands for the volcanic passion of instant destruction.

The destructiveness of the dragon is confirmed in a host of other traditions, not the least of which is biblical. The dragon, in later Greek tradition, is associated with the volcanic storm of Typhon and Echidna, the "spirit of all the fatallest evil, veiled in gentleness." Similarly, Dante's Spirit of Treachery, in the lowest pit of hell, is a monster "with the deadly sting." And his Fraud is clearly derived from Echidna. Thus, the "complete idea of the Hesperian dragon" involves "fraud, rage and gloom."

Ruskin finds that Turner's conception of the dragon, "down to the minutest detail, fits every one of the circumstances of the Greek traditions" (7.402). There are "serpent-clouds floating from his head," suggesting Medusa and Typhon. The body is serpentlike. As a "demon of covetousness" he breathes fire, yet is made of ice. Ruskin finds in the body of Turner's dragon a "representation of a glacier." The head of this dragon is similar to that of a Ganges crocodile, "to show his sea descent." As a whole, the conception of the dragon is one of the "most curious exertions of the imaginative intellect."

The dominance of the dragon's gloom over the Garden is finally demonstrated with a reference to Virgil (*Aeneid*, bk. IV, ll.484–86). When Dido thinks of the Hesperides, in a moment of distress, she remembers that the priestess of the Hesperides *feeds the dragons*." Turner, Ruskin suggests, must have known this passage in Virgil "from his continual interest in Carthage."

Ruskin performs similar readings upon other figures and details in the painting, but the reading of the dragon is the most extensive. It provides a clear example of Ruskin's "collateral" method of juxtaposing analogues and thus building up a coherent meaning. There seems to be no interpretive

difficulty once the train of analogues is set in motion. Mythology, or extended allegory, is not used to puzzle out an elusive meaning; rather, it becomes a lengthy exercise in naming a singular meaning: stormy passion as a threatening dragon. This relatively simple mode of allegorization may be extended but it does not grow in complexity. The more we learn of the gloom of the painting, in Ruskin's reading, the weaker our sense of Turner's contribution to the tradition. Turnerian gloom becomes, in effect, the adoption of a set of gloomy mythological allusions. The condensation of gloom in the dragon is a theme rather than a complex mode of signification. The only ambiguity in the figure of the dragon is the possible confusion of glacial and geological lines in its serpentlike form, but such a reading seems to be based upon simple "associational" metaphors, or external resemblances. The meaningfulness of the painting is not deepened by the allusiveness of Ruskin's reading. As Harold Bloom might argue, there is allusiveness in Ruskin's reading without a sense of intertextual influence.

The situation is different in the other modes of allegory we have examined. Genuinely irresolvable epistemological difficulties occur when Ruskin tries to define the referential status of a Greek personification or the mimetic function of a medieval allegory. As *Modern Painters* draws to an end, allegorization becomes mechanical, a recitation of analogues. Ruskin no longer seems to be concerned with separating nonassertive ideals from various modes of error, figurative meanings from literal statements of fact, cognitive effort from the passivity of sense-experience. The ascertaining of moral significance empties allegory of all its epistemological problems. When Ruskin asserts that Diana shoots a real arrow, we are slightly baffled by Ruskin's meaning. But when Ruskin concludes that *The Garden of the Hesperides* is a "religious painting" depicting the English worship of the dragon (Britain's Madonna), we wince at this hyperbole. Ruskin's statement carries a certain rhetorical impact. It suggests a mass blindness toward the gloom of contemporary British industrial society. The worship of the dragon "is no irony. The fact is verily so." Ruskin accuses Victorian society of worshiping Mammon (to whom the dragon has been linked) and allowing the countryside of England to become polluted. Allegory, as a polemic, is given historical meaning. There is no irony in what Ruskin says, but neither is there any enigma nor any epistemological threat of accidental interpretation. Allegory as a canonical or collateral relation between texts reaches a dead end. It revives in Ruskin's writings when it is returned to its epistemological function. Ruskin's own "modernism" does not end with his canonical approach to allegory. Rather, as Marcel Proust realized, Ruskin's modernity, or ambivalence, continues to express itself in his shifting attitudes toward allegorical art. This art is either the most spiritual and inventive of all art, as Ruskin once seemed to suggest, or it is a hollow "idol," which no canonical reading could ever redeem.

4

Idolatry in Ruskin and Proust

To decide whether a personification is or is not "overdone" is a matter of very delicate reading.

—*I. A. Richards*

An Outline of the Argument

The most sustained criticism of the ambivalence in Ruskin's writing between allegorical and naturalistic description has been offered by Marcel Proust in his prefatory essay to his translation of Ruskin's *Bible of Amiens*.[1] The significance of Proust's essay has, I think, been greatly underestimated in the English criticism of Ruskin. Most readers of Ruskin are Proustians, consciously or not, who find in Ruskin's works the presence of a single personality or mind, however self-contradictory the works may appear. E. T. Cook and Alexander Wedderburn's definitive edition promotes this sense of unity. Their elaborate scholarly apparatus, with its cross references that link single paragraphs from one text to another, appears to give Ruskin's works a certain coherence. The same empirical fact or aesthetic object is revealed in all its occurrences; it finds its place in Ruskin's intellectual development. Proust, confronting certain contradictions between imaginative errors and empirical facts similar to the ones we have seen in Ruskin's discussions of Homer, Dante, and Turner, adopts, indeed considerably refines, Cook and Wedderburn's method. Proust's elaborate textual apparatus attempts to provide more than editorial guidance. It attempts a reconstruction of Ruskin's "physiognomy," the "underground chain of resonances" in Ruskin's thought that reveals his essential "spirit." The method attempts both to constitute a "memory" of Ruskin in the reader, and so to immortalize him, and to reconstitute Ruskin's own memories, the moments of his appreciation of a Gothic cathedral in Normandy or his visual delight in the chromatic splendors of Venice.

Many of the narrative modes and themes of *A la recherche du temps perdu* are already evident in Proust's characterization of Ruskin: sensuous description, the importance of memory, the obsession with differentiating a deceitful lie from a sincere utterance. So successful is Proust's reading of Ruskin that Ruskin, though acknowledged as an influence upon Proust, is soon totally eclipsed.[2] Proust's translations of *The Bible of Amiens* and *Sesame and Lilies* become mere tasks in the apprenticeship that precedes the writing of *Recherche*.

This view overlooks many of the difficulties Proust faced in his attempt to internalize Ruskin. These difficulties were not in the translation from English to French but in the translation of one sort of discourse into another: seemingly aberrant passages of "flat" allegorical writing,[3] in which Ruskin appears to make superficial comparisons—between, for example, the Nemean lion in the myth of Hercules and St. Jerome's lion in a painting by Carpaccio—conflict with mimetically rich descriptions of Norman countryside, with descriptions that are *memorable*.

It is difficult to reconcile Ruskin's "canonical" passages, such as we have seen in his discussion of Turner's *Garden of the Hesperides*, with passages that take the immediate visual complexity of nature, unmediated by mythological figures, for their object. Ruskin's apparent attachment to allegorical figures, nature myths, or flowers or animals that tend to recur in Western iconography (such as the hawthorn), Proust defines as Ruskin's "idolatry." This idolatry, Proust explains, derives from Ruskin's guilty conscience. As a severely raised Evangelical for whom sensory delight was taboo, but also out of an inner doubt about his ability to render physical beauty without ruining it, Ruskin substituted morally significant but empirically valueless religious images for his true or "sincere" love of physical beauty. Ruskin thus lies to himself and to his readers. Nevertheless, such idolatrous moments, which overvalue seemingly trivial images, reflect a genuine, profound tension in Ruskin's thought. Unlike similarly passionate moralists, such as Thomas Carlyle or Ralph Waldo Emerson, who also reveal a tendency to "canonize" myths, emblems, and allegories that have become isolated from empirical experience, to the end of his career Ruskin maintains a hypersensitive aesthetic sensibility. For Ruskin, idolatry emerges at the price of a severe repression of a contrary passion for beauty. Ruskinian idolatry stands midway between the enthusiastic allegorical vision of the entire natural world, as in Emerson, and superficial aestheticism, which delights passively and calmly in sense-perception.

Because Ruskin has been received in English criticism primarily as a brilliant prose stylist, and because his moralizing tendency, even in his own time, has caused his reputation to suffer, Proust's emphasis on Ruskin as the worshiper of beauty rather than of empty idols has met with little resistance.[4] The problem of idolatry extends throughout Ruskin's career, Proust cautions, but then Proust confines his treatment of the problem to a postscript to the preface of his translation of *The Bible of Amiens*. Idolatry raises its ugly head for a moment but is quickly put down by a lengthy elaboration of Ruskin's encounters with the visual splendors of Venice, Rouen, and Amiens, as described in his own prose. Ruskin the moral interpreter of the decline of Venice into sin and economic collapse gives way to Ruskin the secret admirer of the play of light upon the mosaics in the interior of St. Mark's. Ruskin the interpreter of the legends of the saints and apostles on the western porch of Amiens

Cathedral gives way to Ruskin the secret admirer of the charming *Vierge Dorée* carved upon the cathedral's southern porch. In rhetorical terms, allegory in Ruskin's writings, the massive disproportion between the object's empirical worth and its intellectual significance, should be replaced by "metaphor," as Proust defines it at the conclusion of *Recherche:*

> In describing objects one can make those which figure in a particular place succeed each other indefinitely; the truth will only begin to emerge from the moment that the writer takes the two different objects, posits their relationship, the analogue in the world of art to the only relationship of causal law in the world of science, and encloses it within the circle of fine style. In this, as in life, he fuses a quality common to two sensations, extracts their essence and, in order to withdraw them from the contingencies of time, unites them in a metaphor, thus chaining them together with the indefinable bond of a verbal alliance.[5]

The moments of intense sensation in Ruskin's worship of beauty must be made, through metaphor, successive. Images and objects must not be related allegorically, in their superificial, nonessential aspects. Allegory leads only to idolatry. The *Vierge Dorée* represents perhaps the clearest example of metaphor in Proust's essay on Ruskin. Her sculptured image becomes timeless. Moreover, she seems to fuse two distinct encounters discussed in two texts of Ruskin almost thirty years apart. For Proust, her image provides access to Ruskin's chain of memories, to his inner, "sincere" feelings. The *Vierge Dorée* has a "logocentric" power, as Proust would say; she seems to incarnate Ruskin's "spirit." Ruskin's spirit and the image of the *Vierge Dorée* fuse. She stands in marked contrast to the "idolatrous" shallow passages in Ruskin, as in his attempt to determine the religious "sincerity" of Horace according to his placing of the names of the gods within a prosodic scheme. The reader who would follow Ruskin's own attempt to canonize the sincerity of certain poetic or artistic fragments obtains only a broken image of Ruskin's true "physiognomy."

Proust's reconstruction of Ruskin's physiognomy, his revaluation of the term "sincerity," which is so prevalent in Ruskin's writings, particularly in his famous definition of the pathetic fallacy, is really an attempt to stabilize or "arrest," as Proust might say, the process of reading Ruskin. The unpredictable shiftings in Ruskin's prose between moral "lying," which suppresses a recognition of visual beauty, and vivid prose descriptions of the same beauty create a massive tension. The "idolatrous" element can never be entirely negated by the beautiful in any text by Ruskin. In every line of Ruskin's writing, just as at every moment in his life, one senses a "besoin de sincérité qui lutte contre l'idolâtrie, qui proclame sa vanité, qui humilie la beauté devant le devoir, fût-il inesthétique" (*CSB*, 129–30). The struggle affects the way we read Ruskin. We never encounter a text that is either purely aesthetic (an

alternative that Proust, in any case, would reject as shallow) or logocentric, an embodiment of Ruskin's genius in magniloquent prose. Ruskin's idolatry leaves a body of writing that is ambivalent. The love of beauty is confounded with a self-abasing ethic; the pleasure of following Ruskin's sinuous syntax tempts the reader to ignore the often hollow or false object of the description. Most important of all, idolatrous writing, at its most powerful, threatens the very project of recovering the sincere, underground chain of Ruskin's memories because of its interposition of false images before empirical facts.

Walter Kasell has given one of the finest summaries of Proust's problem of overcoming Ruskin's idolatry.[6] Kasell is particularly acute in his analysis of this last ambivalence, the problem of determining whether or not an idolatrous description has an empirical object. Kasell notes that Ruskin's passionate attachment, almost worship, of allegorical figures painted by Giotto or Tintoretto, or Gothic sculptures on the façades of Norman churches, never "quite convicts" Ruskin of idolatry. Idolatry thus defined becomes the attachment of "l'importance excessive . . . à la lettre des oeuvres" (*CSB*, 134). Ruskin often raises a relatively superficial or abstract image into sublime significance. The resulting gap between the image, or sign, and its supposed significance may seem "excessive," but this does not mean that Ruskin is insincere or that he is lying to himself.

Another sort of idolatry, Kasell notes, is far more difficult to assess. This is the idolatry that Ruskin himself had defined: "some dear or sad image we have created for ourselves" which prevents us from seeing the true nature of any object. This is the idolatrous interposition of the imagination that Ruskin had criticized in the second preface to *Modern Painters* I, and continuously thereafter, until the problem climaxes in a lengthy discussion in *Aratra Pentelici* (1871) of the opposition of idolatry—as the bestowal of existence upon an imaginative construct—to imagination—the knowingly fictive projection of an allegorical or mythical figure. Ruskinian idolatry leads to what Kasell calls the "error of literality." The crucial difference between a figure of the imagination and an empirical object is blurred. This sort of idolatry is, for Ruskin, the defining characteristic of the "modern," post-medieval mind. The referential truth of "idolatrous literalisms" (Kasell) is impossible to determine. A new, deeper ambivalence about reading follows. As Proust seeks the incarnation of Ruskin's thoughts in certain locales in France and Venice, he is never "quite sure whether the object of his 'pèlerinage ruskinien' was the critic or the cathedral." Has Proust committed his own act of idolatry? Has he falsely reified an image of Ruskin, substituting it for the intended object or scene? The attempt to "fix" Ruskin's thoughts and memories in concrete details "tempts" Proust to "mystify" the relation between text and place. Idolatry is the "failure to make the distinction between literal and figurative elements." In establishing the physiognomy of Ruskin, Proust "realized the necessary

link between idolatry and reading." His encounter with Ruskin becomes what Kasell calls an "allegory of error."

To the precise degree that Proust realized that he could not resolve the problem of idolatry, he becomes the true disciple of Ruskin. The opposition of sincerity to empirical error cannot be stabilized, as Ruskin had already theorized in his discussion of the pathetic fallacy. The problem of "sincerity," as Meyer Abrams and I. A. Richards have shown, inheres within the romantic and postromantic attempt to project a subjective inner "truth" against all external forms of deception, natural or ideological. Abrams writes:

> [Sincerity] began in the early nineteenth century its career as the primary crite-
> rion, if not the *sine qua non*, of excellence in poetry. The word, it would appear,
> had been popularized at the time of the Protestant Reformation to connote the
> genuine and unadulterated Christian doctrine, and secondarily, a lack of pretence
> or corruption in him who affirms a religious and moral sentiment. One bridge
> by which this standard passed over from religious ethics to literary criticism was
> the discussion of pious poetry. In his essays "Upon Epitaphs," Wordsworth set
> as one of his aims "to establish a criterion of sincerity, by which a writer may be
> judged."[7]

Abrams goes on to sketch the continuity of this criterion in writers such as Keble, Carlyle, Leigh Hunt, Arnold, and Pater, and finally Henry James and T. E. Hulme. Surprisingly, Abrams fails to mention Ruskin, though Ruskin, above all, was obsessed with proving the sincerity of all writers who could be called "great," who could join the "sacred classic canon." Moreover, the issue of sincerity is always linked in Ruskin's writings to its root in the choice between Protestant lack of pretense and Romanist idolatry.

Proust's linkage of idolatry and sincerity focuses upon an issue in Ruskin's writings that has never been fully defined. The "influence" of Ruskin upon Proust is not intersubjective, a transference of spirit from one writer to another. It is "intercognitive," if I may coin a term. In translating Ruskin, Proust is forced to struggle with a hollow, allegorical element in his own writing. For Ruskin, sincerity is increasingly figured as allegory, as a writer's or sculptor's self-consciousness about the fictiveness, or erroneousness, of his idealizations. The allegorical gap that separates a sign from its meaning represents this self-consciousness. For Proust, sincerity is figured as a metaphor, as the writer's constitution of a "verbal alliance" between disparate moments of perception, between memories. Metaphor, for Proust as for Wordsworth, remains in part a phenomenological concept; it participates in memory and sensation, though it has a constitutive element that is a function of language. Proust's *Vierge Dorée* bears a remarkable number of affinities to the Wordsworthian epitaph, most essentially in its attempt to make the metaphorical properties of the *Vierge* into substantive or phenomenological properties. Wordsworth does the same with the epitaph. Proust's attempt to subsume, in Wordsworth-

ian fashion, the rude, flat aspect of an allegorical figure within a metaphorical structure of phenomena and sensations goes directly against the Ruskinian attempt to preserve this very allegorical rudeness as a protection against the deceptions of the imagination.[8]

An excellent theoretical account of Proust's attempt to stabilize the ambivalent tendencies of a rhetoric of tropes of "sincerity" has been offered by Paul de Man.[9] De Man has shown how Proust achieves a stable balance of literal and figurative language through the metaphorical manipulation of an allegorical figure, specifically Giotto's allegory of Charity (one of the Arena Chapel frescoes), an allegory which, in fact, Proust discovered in his reading of Ruskin's *Fors Clavigera*. By comparing the literal aspect of Charity to the physical appearance of certain characters in *Recherche*—such as the kitchenmaid, whom Swann has nicknamed "Giotto's Charity," or the cook Françoise—the concept of Charity becomes metaphorically displaced onto characters who are not at all charitable. Proust exploits the initial disjunctiveness between the concept of charity and Giotto's personification to generate a series of new, metaphorical meanings which seem to be grounded in literal descriptions, in the actual, empirical appearance of a character, but which nonetheless seem improper. The metaphors, as de Man notes, often seem to result from the chance of the mere association of ideas. The physical resemblances are what Ruskin had called associational "metaphors," comparisons based only on external resemblance. De Man subtly argues that the resulting confusions between literal appearance and figurative meaning achieve a sort of tension, or "aporia," which actually stabilizes the act of reading. It is the stability that is all important.

Proust seeks a similar stability in Ruskin; he attempts to stabilize the fluctuations in Ruskin's prose between idolatry and highly mimetic descriptions by making them inseparable. In doing so, however, Proust supports the misconception of Ruskin as a mimetic, or empirically minded writer. Ruskinian idolatry, as it emerges in its fullest in *Aratra Pentelici*, a text that Proust may or may not have known,[10] represents Ruskin's final blindness to the disruptive power of figurative language. The attempt to master the illusory nature of the imagination by reducing and circumscribing its "power" in the form of rude, allegorical images fails. Imagination becomes indistinguishable from idolatry, the belief in the literal existence of the allegorical figures.

Many of the themes of Ruskin's later career converge in his discussion of the opposition of imagination to idolatry: the sincerity of the worker versus the lies of the poet, the nondeceitful nature of sculpture, and material arts in general, versus the falsehoods of poetic myth. These oppositions are situated, further, within a polemical critique of the idolatrous nature of Victorian commercialism, which promotes belief in the god Mammon. These clear-cut oppositions collapse as the allegories of imagination, particularly Athena, the

goddess of sculpture and weaving, become literal. *Aratra Pentelici* is a text that exposes Ruskin's final failure to master not the imagination but figurative language. Athena takes on a "literal" existence in Ruskin's text not as a sculpture, a material personification of Wisdom, but as a figure of speech. Ruskin's idolatry is not Proust's. Proust, as Robert Hewison notes, could see in Ruskin's references to allegorical figures only the "pathetic worship of empty images."[11] For Proust, metaphorical meaning, sincere consciousness, and memory could emerge only out of complex empirical experience. Proust discovers the "lying" nature of his own metaphors, but never abandons the essential emphasis on the empirical world. Ruskin, by contrast, was never a mimetic writer, and turned precisely and deliberately to increasingly "ruder" forms of art so as to emphasize the importance of cognition over sensation. His idolatry is the result of a somewhat naive belief that verbal fictions could be governed by signs of rude appearance. Proust's idolatry is the complex attempt to cover up such rude appearances with the beguiling forms of mimesis criticized in *Modern Painters* I.

The Vierge Dorée *as Epitaph*

The themes of the first part of Proust's essay converge in his discussion of the sculpture of the *Vierge Dorée*, which is placed over the southern porch of the Amiens Cathedral (see *CSB*, 83–86; figs. 17 and 18). Ruskin alludes briefly to this Virgin in his chronicle and description of the cathedral, *The Bible of Amiens* (1885), but his fullest account of the formal character and religious significance of this Virgin is found in an earlier, theoretical work on architecture, *The Two Paths* (1858). Proust, on a pilgrimage to Amiens in the hope of realizing Ruskin's "spirit" in the sight of this Virgin, gives a detailed but highly metaphorical account of her appearance.

For Proust, the Virgin brings to light Ruskin's sincerity and memory; she bridges the gap between *The Two Paths* and *The Bible of Amiens*. Most important, the Virgin makes substantial and present to perception the voice of Ruskin. This Virgin's appearance has no illusory charm. She embodies Ruskin, and mediates between the countryside of Amiens and the floral ornaments carved about her niche, natural sunlight and the nimbus that surrounds her head. She becomes what Beckett calls one of Proust's "hieroglyphs": a reconciliation of subject and object, temporal perception and timeless beauty, art and nature.

Proust the pilgrim begins his discussion of the Virgin by contradicting Ruskin the master. Ruskin, addressing the tourist to Amiens, advises passing by this Virgin and proceeding into the cathedral immediately. Proust interpolates at this point, deciding to dwell for a few moments before this Madonna. This stepping out of the path of the master is not meant to challenge

Ruskin. On the contrary, Proust would like to integrate this Virgin with the rest of Ruskin's text (and thought) by revealing her true significance for Ruskin. For Proust, Ruskin must still have some underlying attachment to this Virgin, and this attachment becomes the object of Proust's meditation. As he looks upon this *Vierge Dorée*, she seems to imply a host of memories. She is capable of awakening a sense of Amiens's past. The wind and sunlight that play upon her stone, quarried from the nearby fields, give her a substantiality, a certain monumentality, that is absent, for example, in the portrait of the Gioconda by Leonardo da Vinci. The Gioconda (Pater notwithstanding) is "déracinée," a pure work of art in that she remains unrelated to the viewers who come to admire her in the Louvre. The *Vierge Dorée*, by contrast, has watched over the generations of Amiens who have passed beneath her on their way to worship.

The awakening of the possible memories in the figure of the Virgin leads Proust to speculate on Ruskin's memories of her. Ruskin's glance at this Virgin, *en passant*, must have reawakened his memories of her from almost thirty years earlier, Proust speculates. In fact, Ruskin's attempt to draw the tourist's attention away from her does not suggest criticism of the Virgin. Proust suggests (perhaps unconvincingly) an almost selfish desire in Ruskin to keep this Virgin for himself. Even so, this may be a mark of Ruskin's sincerity as a writer. The public-minded narrator feels a need to labor everything that he sees. He has in the back of his mind, whenever he sees an object, the use it might have in a future book. The sincere writer is not entirely disinterested, but he does not labor everything in sight. Ruskin represents the pensive, watchful visitor. He has none of the qualities of the public-minded aesthete or the fashionable tourist, who makes of such visits "fetishes," or who brings with him stock responses.

The *Vierge Dorée* as an object of Ruskin's sincerity fills in a gap in his text. But the burden of "attaching" Ruskin to this Virgin remains. The praise and defense of Ruskin throughout most of Proust's essay (until the postscript on Ruskin's idolatry) suggest that Proust was using the term "sincerity" in good faith. But in what way does this Virgin actually manifest Ruskin's inner traits? For Proust the answer lies in certain "romantic" actualizations of concepts. Proust frequently refers to Ruskin's ability to incarnate the conceptual. The very title of Ruskin's work seems to summarize Ruskin's logocentrism:

> Mais il est temps d'arriver à ce que Ruskin appelle plus particulièrement "La Bible d'Amiens", au Porche Occidental. Bible est pris ici au sens propre, non au sens figuré. Le porche d'Amiens n'est pas seulement, dans le sens vague où l'aurait pris Victor Hugo, un livre de pierre, une Bible de pierre: c'est "La Bible" en pierre. [*CSB*, 88–89]

> Avant de vous l'expliquer je voudrais . . . vous faire comprendre que, quelles que

soient vos croyances, la Bible est quelque chose de réel, d'actuel, et que nous avons à trouver en elle autre chose que la saveur de son archaïsme et le divertissement de notre curiosité. [*CSB*, 89]

When Proust speaks of the "Bible" in the "proper" sense he does not seem to mean the Bible in the most proper sense, for the issue of religious belief is not at all his concern. Bible in the "proper" sense means an incarnation of the Word in stone. The western porch is not a figure, or symbolization, of prophets or saints; it is virtually the Bible *in* stone, as written text. Ruskin's own text has an identical "reality." The reality is distinguished from the superficial archaism of most picturesque tourist guidebooks. Ruskin, Proust emphasizes, reads the arrangement of the statues and didactic quatrefoils of the western porch as a virtual Sermon on the Mount, as "le Verbe Incarné."

Lui [un langage solennel où chaque caractère est une oeuvre d'art] donnant un sens moins littéralement religieux qu'au moyen âge ou même seulement un sens esthétique, vous avez pu néanmoins le rattacher à quelqu'un de ces sentiments qui nous apparaissent par-delà notre vie comme la véritable réalité, à une de "ces étoiles à qui il convient d'attacher notre char." [*CSB*, 104]

Ruskin's descriptive power realizes his sentiments, and performs the same function for his reader/disciple. Religious meaning is ancillary to the "life" of reading Ruskin. The cathedral itself, though the object of Ruskin's own description, exemplifies the Ruskinian textual "substance." The object of Proust's description of the *Vierge Dorée* is, similarly, the realization of sentiment.

As Proust focuses intensely upon the image of the *Vierge Dorée*, he describes her in terms similar to those Wordsworth uses to describe an epitaph.[12] The most obvious affinity between the Wordsworthian epitaph and Proust's *Vierge Dorée* is the way in which the sun frames them both and contributes light and shadow directly to their surface. Both Proust and Wordsworth speak of the sun passing through its diurnal phase in terms of a process of mediation. Wordsworth compares the revolution of the sun to a "subtle progress by which, both in the natural and the moral world, qualities pass insensibly into their contraries, and things revolve upon each other" (*PrW*, 53). Most of all, the sun is like a "contemplative Soul," which, "travelling in the direction of mortality, advances to the country of everlasting life; . . . till she is brought back . . . to the land of transitory things." The epitaphist, says Wordsworth, should stand at the "midway point" between the transitory, the earthly, and the everlasting, the divine. Similarly, Proust takes as the basis for his description of the *Vierge Dorée* the solar point of reconciliation between the transitory and the eternal. The *Vierge Dorée* is described within the temporal context of the sun's "momentary caress" of her within the quotidian cycle. In this moment, all contradictory aspects of her are reconciled—her permanence and

her loss, her seeming life yet stony death, her beauty and her decay. In this moment, the *Vierge Dorée* is named in the proper sense, for she is otherwise "jadis dorée," her nimbus having become faded with the passage of time. In this moment, her carved floral ornament of hawthorns, lilies, and roses seems to come alive; they are "en fleur." Proust calls the play of light and shadow among the carvings a "medieval springtime"; but he quickly adds that this seeming springtime "si longtemps prolongé, ne sera pas éternel et le vent des siècles a déjà effeuillé devant l'église, comme au jour solennel d'une Fête-Dieu sans perfums, quelques-unes de ses roses de pierre" (*CSB*, 85).

In his first essay on epitaphs, Wordsworth makes a distinction between Greek epitaphs, which partake of the natural beauty of the roadside on which they are placed, and the church epitaphs of Christendom, which, because of their location in the city or town, are less noticed by "men occupied with the cares of the world, and too often sullied and defiled by those cares" (*PrW*, 54). Church epitaphs are less well integrated with their surrounding nature. The church epitaph must therefore resort to the "general language of humanity," specifically to one's memories of an individual, in order to produce the contemplative effect of the Grecian epitaph.

Proust makes no such distinction between Greek and Christian concepts in his discussion of the *Vierge Dorée*, even though Ruskin in *The Two Paths* compares, in terms opposite to Wordsworth's, the *Vierge Dorée* as a Christian allegory of man's harmony with God's creation to Greek sculpture, in which man is always represented in isolation from nature. Proust goes further than either Wordsworth or Ruskin by conflating Wordsworth's Grecian and Christian themes, thus adding to Ruskin's Christian typification of nature (that is, the floral ornament surrounding the *Vierge Dorée*) elements of the real nature that surrounds the *Vierge Dorée*—sunlight, wind, even the stone material out of which she is carved. The Proustian *Vierge Dorée* is not only a mediation of nature and art, like the Grecian epitaph. She is a representative of the human community of Amiens, down through the generations, like the Christian epitaph. Proust speaks of the *Vierge Dorée* as a real Amiénoise regarded by generations of local inhabitants:

> Sortie sans doute des carrières voisines d'Amiens, n'ayant accompli dans sa jeunesse qu'un voyage, pour venir au porche Saint-Honoré, n'ayant plus bougé depuis, s'étant peu à peu hâlée à ce vent humide de la Venise du Nord, qui audessus d'elle a courbé la flèche, regardant depuis tant de siècles les habitants de cette ville dont elle est le plus ancient et le plus sédentaire habitant, elle est vraiment une Amiénoise. Ce n'est pas une oeuvre d'art. [*CSB*, 85–86]

Similarly, Proust uses the words "personne" and "amie" to describe the *Vierge Dorée*. Proust is not suggesting that the *Vierge Dorée* was an actual person, now figured in stone or apotheosized by the people of Amiens, such as

St. Honoré was, whose porch the *Vierge Dorée* has taken over. Proust person-
ifies the stones of Amiens; he gives the impression that he is speaking of a
real individual.

There is no evidence that Proust was acquainted with Wordsworth's first
essay on epitaphs. Moreover, Wordsworth speaks of letters, Proust of a human
icon. Yet there is an affinity between Wordsworth and Proust in the way both
gain a mediating vision of the letter's or the icon's significance by subsuming
them under the power of nature itself or under the idea signified by the letter
or icon. In this way they differ sharply from Ruskin, who attempts to preserve
an awareness of the letter or icon itself. By emphasizing perception rather
than cognition, Proust and Wordsworth achieve a similar "tranquillity" of
composition. The opposites of life and death, inanimate stone and vegetation,
solar and contemplative movement are figuratively united. The moment of
union is expressive of calm and quietude. It is also expressive of sincerity.
Wordsworth explicitly links sincerity to the reconciliation of temporal oppo-
sites: the brevity of the epitaph's message suggests spontaneous sympathy
rather than careful and cold reflection, but the "appearance of the letters" is
a testimony to the "slow and laborious hand" that must have carved them.
Wordsworth states that the epitaph provides an outlet for the human need to
express a sense of immortality. This outlet originates in the discovery that
letters could represent the *spirit* of the departed. Yet the letters of the Words-
worthian epitaph are not to be read. They retain picturesque value as light
passes over them, but lose their cognitive function as signifiers. The letter is
literally erased from view. Or, there is the "tender fiction" of prosopopoeia,
in which an imagined hearing of the voice of the departed is substituted for
the sight of the letters. The recollection of immortality, the essential purpose
of the Wordsworthian epitaph, depends therefore upon a forgetting of the
letter.

Similarly, Proust is able to immortalize the *Vierge Dorée* and make her a
mnemonic symbol of subsuming her graven aspect under the (figurative) in-
fluence of the countryside outside Amiens. Undoubtedly Proust sincerely felt
that he was following Ruskin's example, that, indeed, Ruskin's own sincerity
was figured in this sort of mediation. *The Bible of Amiens* contains numerous
passages of romantic description. We read often of the influence of the climate
of Northern Europe, of the forests of the Rhineland, and of the rivers of
France on the temperament of the early Frankish Christians. *The Bible* is mod-
eled upon martyrological works, such as Jacobus de Voragine's *Golden Legend*.
Ruskin takes the forgotten lives of St. Martin or St. Genevieve, both of whom
lend a sacred aspect to the Frankish countryside, and places them on a level
of historical importance equal to King Clovis, who fought the wars that in-
troduced Christianity into Northern Europe. Ruskin was not so much antic-
ipating the historiography of Fernand Braudel as polemicizing against Edward

Gibbon. He was attempting to depict a thoroughly Christian history of Europe, founded upon acts of charity. When Proust, in anticipation of his description of the *Vierge Dorée*, establishes an affinity between Ruskin's *Bible* and Carlyle's heroes, or the early George Eliot's scenes of rural piety, he is being faithful to these parts of Ruskin's text. It is only a small step from these allusions and themes to the association of the *Vierge Dorée* and her surrounding countryside, and to the impression that she is like some forgotten martyr.

But it is also *The Bible of Amiens*, of all Ruskin's works, that seems to disturb Proust toward the conclusion of his essay on Ruskin. Ruskin develops the themes of landscape influence and martyrological history in the first two chapters of the *Bible*, only to reverse methods, suddenly, in the third and fourth chapters, in which he establishes his theory of the "sacred classic" canon of Western art and literature. Mimetic description is abandoned in favor of seemingly superficial comparisons of icons and symbols. The delicate Madonna of the southern porch gives way to the earlier, primitive statues and quatrefoils of the western porch, with their much ruder appearance (fig. 19). As Proust approaches these passages he criticizes Ruskin as an idolater, as one who worships hollow images at the opposite extreme from the metaphorical, memorable image of the *Vierge Dorée*.

From Idolatry to Sincere Error in Ruskin

The most immediate source of Proust's treatment of the *Vierge Dorée* is not *The Bible of Amiens* but *The Two Paths*. This earlier work offers Ruskin's only study of this Virgin. This Madonna "represents the culminating power of Gothic art in the thirteenth century" (16.281). She represents a precise midway point for Ruskin, but *this* midway point is not Wordsworth's. The *Vierge Dorée* represents the correct balance between naturalistic finish of ornamental detail in relation to abstraction of human form. In Greek art the perfection of human form is represented in isolation, without a natural context. The Christian love of God in nature brings the representation of nature into art. Earlier Gothic, as at Chartres, reveals a new delicacy of technique in its human forms; it contains the first signs of man's "close association with the beauty of lower nature in animals and flowers, with the beauty of higher nature in human form." Still, the human forms are relatively "pure" or abstract. The delicacy of line in the carving indicates a new urge to realize form within the limits of the sculptor's skill. This interpretation of sculptured lines could be called Wordsworthian: there is a direct equation made between refinement of technique and artistic intention.

The *Vierge Dorée* represents the next step in the development of sculpture. Her arrangement is "exactly the same as at Chartres—severe falling drapery, set off by rich floral ornament at the side; but the statue is now completely

animated; it is no longer fixed as an upright pillar, but bends aside out of its niche, and the floral ornament, instead of being a conventional wreath, is of exquisitely arranged hawthorn." The leaning out of the ornamental frame, the foregrounding of the Virgin, is for Ruskin the culminating point of the Gothic. Ruskin insists that human figures must exist in exactly the right proportion to mimetic detail. Too much detail leads to the error of mimesis. Too little naturalistic detail represents the return to the pagan separation of man from nature. In 1858, when Ruskin wrote of the *Vierge Dorée*, he had fixed the right proportion in late medieval Gothic. But as always in Ruskin's situating of the Gothic, the culminating point is succeeded by over-refinement and a return to mimesis. As lines become more refined, the "unhappy pride of the builder" intrudes. This intrusion, or interpolation of the human skill of composition before the proper symbolization of man's relation to God's creation, is the mark of what will be known in subsequent works as "idolatry," the definition of which was already intimated in *Modern Painters* I. Beyond the *Vierge Dorée* Ruskin speaks of an "irrevocable catastrophe": ornament becomes too naturalistic and is grouped into geometric rather than organic patterns: "[S]culpture in the quatrefoils—sculpture in the brackets— . . . sculpture in the ridges and hollows of its mouldings,—not a shadow without meaning, and not a light without life" (16.283).

Ruskin uses words like "life" and "animation," but he is not at all interested in anything substantially vital in Gothic ornamentation. The words characterize the activity of the human imagination. They suggest what modern critics might call "energy" or "power." Proust and Wordsworth are not primarily interested in this sort of imagination, which, by definition, finds expression in nonmimetic art, and in a nonsensory understanding of artistic principles. For Ruskin, sincerity is evident in what he calls "errors" in art, knowingly false or imperfect forms, or knowingly fictive substitutions of a personification for a moral virtue. Ruskin's *Vierge Dorée* has a *formal* sincerity. The sculptor was not trying to deceive the viewer or beguile his senses. The focus is on the Christian relation of man to God, symbolized in the Madonna's human beauty in the midst of signs of God's creation. Proust's Madonna is more of a literary fiction. Her animation is the result of a transfer, through language, of sunlight and wind to her stone garden. It is not difficult to imagine the Madonna's flowers coming to "life" as the sun passes over them. The sincerity of Proust's text depends upon the authenticity of the phenomenon in consciousness. The question that remains is, how conscious was Proust that this experience was metaphorical? Are we supposed to know that we are reading a fiction? Or, as with the Wordsworthian epitaph, are we supposed to forget? Once figurative language becomes confused with phenomenality, epistemological confusion sets in, as Ruskin had already begun to realize. Proust is faced with the redoubtable task of making Ruskinian

fictions into descriptions of natural phenomena. This is precisely what Ruskin, in his discussion of the *Vierge Dorée*, was trying to avoid.

Ruskin's *Vierge Dorée* marks a culminating point in the devaluation of the mimetic that runs throughout Ruskin's works. Beginning with *The Stones of Venice* (1851–53) and *The Two Paths* (1858), and then continuing in the later works on architecture, *The Mystery of Life and its Arts* (1868) and *Aratra Pentelici* (1871), Ruskin increasingly values allegorical forms of art, art that exemplifies supernatural entities, pagan or Christian, in a thoroughly nonbelievable form. The "ruder the symbol, the deeper its significance" becomes the motto of his analysis. The *Vierge Dorée* is perhaps the last "tender" fiction that he allows himself to appreciate. Thenceforward, "rude" and "childish" art, totally devoid of mimetic skill or appeal, becomes an obsession. The uncertainty of the "modern" temper, which hovers between the imaginative modification of natural appearance and self-delusion, is "mastered" (to use Ruskin's term) by the disjunction between the rudeness of an allegorical figure and the "sublimity" of its significance. Perception cannot be deceived by an allegorical figure. Its very shallowness allows the mind to imagine freely, with as much enthusiasm as desired, without the threat of belief. Allegory is often linked to the "instinct" for play in Ruskin's writings from 1851 on, especially to child's play. The child is more imaginative, but in his inferiority of mimetic technique also more allegorical. The child, as Ruskin often suggests, can raise the value of any object in his mind.

Ruskin's argument is conducted on grounds that bear no resemblance to Proust's notion of idolatry. When imagination crosses over to idolatry it does so through an attribution of power to an allegorical figure. Personifications in Ruskin's argument never become beautiful or sensuously appealing. They become like gods that seem to have power over humans, but these gods nevertheless appear rudely. Sincerity, as an epistemological value in Ruskin's works, is the subject's ability to raise objects into mythic significance without making this elevation into a perceivable cause for belief. A brief sketch of a few texts leading up to the discussion of idolatry in *Aratra Pentelici* should clarify Ruskin's concepts of sincerity and error. I begin with a comparison of Proust and Ruskin on Byzantine mosaics.

When Proust compares the *Vierge Dorée* to Leonardo's Gioconda he seems to misread, deliberately, Ruskin's own references to Leonardo in his discussion of St. Mark's mosaics (in *The Stones of Venice*, 10.69–142; see fig. 20). For Proust, the viewer of the *Vierge Dorée* takes with him vivid, phenomenally complex memories. The substantiality and monumentality of the Virgin contrast to the "déracinée" Gioconda in the Louvre. The Gioconda is a charming portrait, but the portrait is meaningless without some associational and mnemonic context. Proustian memory demands a mediation between the work of

art and its immediate empirical context. Similarly, when Proust voyages to St. Mark's to experience Ruskin's description of the Byzantine mosaics, he seeks an experience like that of the *Vierge Dorée* but finds that Ruskin had lied about the mosaics. Ruskin had "idolized" their primitive technique for the sake of their Christian symbolism. Ruskin ignored their delicate harmonies of color, light, and shade. When Proust speaks of the denial of empirical delight as "idolatry" he is misreading Ruskin to a considerable degree. The text on the mosaics of St. Mark's contains one of Ruskin's earliest theoretical discussions of the topic of idolatry, the dangers of which go beyond mere sense-experience. It represents Ruskin's earliest attempt to set off idolatry from, on the one hand, "childish" but sincere allegory, and, on the other, the overly mimetic art of Leonardo. The mosaics represent a "midway point," as does the *Vierge Dorée* later:

> [The Byzantine mosaics] stand exactly midway between the debased manufacture of wooden and waxen images which is the support of Romanist idolatry all over the world, and the great art which leads the mind away from the religious subject to the art itself. Respecting neither of these branches of human skill is there, nor can there be, any question. The manufacture of puppets, however influential on the Romanist mind of Europe, is certainly not deserving of consideration as one of the fine arts. *It matters literally nothing to a Romanist what the image he worships is like.* . . . Idolatry, it cannot be too often repeated, is no encourager of the fine arts. But, on the other hand, the highest branches of the fine arts are no encouragers either of idolatry or of religion. No picture of Leonardo's or Raphael's, no statue of Michael Angelo's, has ever been worshipped, except by accident. Carelessly regarded, and by ignorant persons, there is less to attract in them than in commoner works. *Carefully regarded, and by intelligent persons, they instantly divert the mind from their subject to their art, so that admiration takes the place of devotion.* I do not say that the Madonna di S. Sisto, the Madonna del Cardellino, and such others, have not had considerable religious influence on certain minds, but I say that on the mass of the people of Europe they have had none whatever; while by far the greater number of the most celebrated statues and pictures are never regarded with any other feelings than those of admiration of human beauty, or reverence for human skill. Effective religious art, therefore, has always lain, and I believe must always lie, between the two extremes—of barbarous idol-fashioning on one side, and magnificent craftsmanship on the other. [Emphasis added; 10.130–31]

Mimetic art—that which causes "the admiration of human beauty, or reverence for human skill"—penetrates the mind of the viewer too easily. The viewer does not have the opportunity to exercise his critical faculty. The "intelligent" and the "ignorant" viewers are placed on the same level. The aesthetic response of the intelligent viewer blinds this viewer's intellect. The ignorant viewer, who takes the mimetic skill for granted, seeks out "commoner works," indicating mimesis' lack of instruction.

The criticism of mimesis is a familiar theme in Ruskin. Leonardo or Raphael stands for the same "decadence" as the late Gothic, which follows the *Vierge Dorée* in *The Two Paths*. Idolatrous art, though at the opposite aesthetic extreme of unsightliness, causes a state of equal intellectual blindness. The idolater, in his passionate act of worship, is indifferent to the appearance of the icon. No rational judgment occurs. The icon, to the idolater, is not suggestive of a divinity that can be realized only imperfectly. The icon becomes the complete object of the idolater's worship. The icon substitutes for the divine. Byzantine mosaics, however, appeal primarily to the intellect. They have an exegetical appeal; they are designed to be *read*. Ruskin places these mosaics in the same class as missal-painting and book illustration. They transform the church of St. Mark's into one monumental illuminated Bible. Ruskin's tour of St. Mark's is repeatedly treated as an exercise in reading. The architect of St. Mark's, says Ruskin, "knew that everyone would be glad to decipher all that he wrote; that they would rejoice in possessing the vaulted leaves of his stone manuscript; and that the more he gave them, the more grateful would the people be. We must take some pains, therefore, when we enter St. Mark's, to read all that is inscribed."

But why does Ruskin have to define reading as a mean between idolatry and mimesis? Wordsworth speaks of the same sort of reading when he writes of the epitaph:

> [I]t is not a proud writing shut up for the studious: it is exposed to all—to the wise and the most ignorant; it is condescending, perspicuous, and lovingly solicits regard; its story and admonitions are brief, that the thoughtless, the busy, the indolent, may not be deterred, nor the impatient tired . . . the sun looks down upon the stone, and the rains of heaven beat against it. [*PrW, 59*]

Ruskin makes the same point about the mosaics of St. Mark's. Yet Ruskin, unlike Wordsworth, feels compelled to exclude beauty and the direct influence of nature, writing, in a way also opposite to Proust's description of his experience under the cupola of St. Mark's, that the bright coloring and disregard of chiaroscuro in these mosaics were necessary to render them intelligible in the absence of light under the vaulting. Proust, in a moment of recollection, claims that these same mosaics are full of natural light and shadow, even during a Venetian storm. But Ruskin denies the occurrence of any complex play of light and shadow.

Ruskin seems to imply that St. Mark's is "effective religious art"—that is, art which provides a vision of man's fall, his eventual redemption, the story of Christ, art that is "the channel of the Word"—because, paradoxically, it is *powerless* to teach in and of itself. St. Mark's is like an illuminated Bible, but it is not the Word of God. St. Mark's is filled with the Word of God only as it is read; otherwise it is a hollow ornament:

Let it be considered for a moment, whether the child, with its coloured print, inquiring eagerly and gravely which is Joseph, and which is Benjamin, is not more capable of receiving a strong, even a sublime, impression from the rude symbol which it invests with reality by its own effort, than the connoisseur who admires the grouping of the three figures in Raphael's "Telling of the Dreams;" and whether also, when the human mind is in right religious tone, it has not always this childish power—I speak advisedly, this power—a noble one, and possessed more in youth than at any period of after life, but always, I think, restored in a measure by religion—of raising into sublimity and reality the rudest symbol which is given to it of accredited truth. [10.127]

Because Ruskin is reading St. Mark's as he writes about it, the mosaics take on a sublime power; the Logos seems to be present. But it would be Proustian to say then that Ruskin has fixed the Logos to St. Mark's once and for all. Wordsworth lends the epitaph its own power to speak, either as the "fiction" of prosopopoeia, or, more generally, as a kind of genius locus. Proust does not resort to prosopopoeia (though he does apostrophize) but follows Wordsworth in attributing to the human icon or the Byzantine letters their own phenomenal influence in the form of light from the sun. For Ruskin, "reality" is an investment of one's "own effort" in the rude symbol. Proustian or Wordsworthian metaphors are empirically erroneous. We imagine that we see something or an event that does not really exist, but we may be blinded to this error if the error is sufficiently mimetic, in the Ruskinian sense. The rude symbolism of Byzantine mosaics cannot deceive empirically. Childish power differs from idolatry not in subtlety of observation or in attention to the aspect of the icon, but in the false belief in the symbol or icon's power, a power that we have attributed to it in the first place.

In a crucial appendix added to the chapter on St. Mark's, Ruskin defines for the first time the "proper sense of the word idolatry" (10.450–51).[13] Idolatry has little to do with sectarian practices within Christianity. It applies equally to Protestants and Catholics. The harsh condemnation of Romanism in the main text of the chapter is replaced, in the appendix, with a discussion of idolatry's ambiguity. This ambiguity has to do with the impossibility of deciding whether or not the worshiper of an icon has committed the error of attributing some power to the icon itself. The empirical character of the icon— whether it is ornately Romanist or austerely Protestant—makes no difference. It remains "utterly impossible for one man to judge of the feeling with which another bows down before an image."

[T]he point where simple reverence and the use of the image merely to render conception more vivid, and feeling more intense, change into definite idolatry by the attribution of Power to the image itself, is so difficultly determinable that we cannot be too cautious in asserting that such a change has actually taken place in the case of any individual. . . . I have no manner of doubt that half of the poor

and untaught Christians who are this day lying prostrate before crucifixes, Bambinos, and Volto Santos, are finding more acceptance with God than many Protestants who idolise nothing but their own opinions or their own interests. [10.451–52]

An epistemological dilemma is developing. For "which of us shall say that there may not be a spiritual worship in their apparent idolatry, or that there is not a spiritual idolatry in our own apparent worship?" (10.451). Idolatry cannot be determined because its basis, the subject's authenticity of worship, cannot be verified. Appearances are irrelevant. Certain inexcusable forms of idolatry are easily identified: the covetousness of wealth, which results in forgetting God, or the "priestly" manipulation of popular feeling by means of an icon. But these forms are of secondary importance, for even the true worshiper remains an idolater. The dilemma cannot be evaded. To exchange the emotional effort required to render the conception of God more vividly for "accurate" knowledge is to become "apathetic" instead. It would be better to have the "errors of affection" than such accuracy, Ruskin suggests. The imagination *must* be exercised in the worship of God. How do we prevent ourselves from becoming "slaves" of the imagination so that we follow its image rather than God's?

The conclusion of the appendix suggests one possibility for determining the difference between idolatry and imaginative worship. "Poetical effusions," which clearly indicate "imaginative enthusiasm" rather than "reasonable conviction" may be condemned as "illusory and fictitious [rather] than as idolatrous." When it is clear that we are dealing with a fiction idolatry does not come into question. Precisely because a fiction cannot be believed, a fiction dissociates imagination from idolatry. The point becomes central in Ruskin's subsequent writings on idolatry. A fiction, unlike an idol, may be analyzed in terms of its appearance or its referential errors. The erroneousness of an icon is of no significance. It must be erroneous by definition, for God cannot be represented properly. But the erroneousness of a fiction allows the mastering of the imagination by reason. As the problem of dissociating imagination from idolatry becomes ever more acute in Ruskin's theorizing, idols are increasingly treated as fictions. The sincerity of worship is adjudged by the *apparent* erroneousness of the object of worship. The error of affection becomes a discernible empirical error. Terms like "rude" or "childish," as applied to the Byzantine mosaics, become synonymous with the term "error." Sincerity of worship is in proportion to the disjunction between intense feeling of belief and the perceivable unbelievability of the icon or poetic image.

The definition of idolatry in this appendix is, to a remarkable degree, a foreshadowing of Ruskin's definition of the pathetic fallacy three years later in *Modern Painters* III (1856; see 5.201–20). Pathetic fallacies, like idols, are

the result of the *sincere* if self-deceiving attribution of power to an object or image that does not properly contain this power.[14] Such false attributions are characteristic of the romantic, or "secondary," class of poets: Wordsworth, Coleridge, Keats, and Tennyson. These poets must be read with vigilance, for they commit empirical errors all the time. But as soon as we recognize an error we must realize the sincerity of the emotion upon which it is based. When Pope, in his youthful pastoral "Summer" writes, "The moving mountains hear the powerfull call, / And headlong streams hang, listening, in their fall" (11.83–84), he is being coldhearted, hypocritical, and false. Pope does not believe for a moment in his pastoral fiction. But when Wordsworth commits a similar empirical error, Ruskin interprets it as a wild cry, springing from an internal agony.

> Oh, move, thou cottage, from beyond yon oak,
> Oh let the ancient tree uprooted lie,
> That in some other way yon smoke
> May mount into the sky.
>
> If still behind yon pine-tree's ragged bough,
> Headlong, the waterfall must come,
> Oh, let it, then, be dumb—
> Be anything, sweet stream, but that which thou art now.
> ["'T Is said That Some Have Died for Love," ll.13–16; ll.33–36]

As an empirical event, Pope's moving mountain or hanging stream is as absurd as Wordsworth's dumb waterfall or moving cottage. With Wordsworth, however, there is an ambivalence. Ruskin detects a conflict between the knowledge that the miraculous image is "impossible" and a belief that it is "possible." There is sufficient descriptive detail in the poem to indicate that Wordsworth's imaginative moment was grounded in the perception of an actual scene—the ancient oak, the pine's ragged bough—but Pope's nature is the merely formulaic scene of poetic diction. Pope has no difficulty expressing his theme in such terms, but Wordsworth must forcefully overcome his perception in order to release his emotion. The struggle of overcoming the senses attests to the "sincerity" of the emotion. This struggle causes an ambivalent relation between seeing and feeling, truth and "sincere" error, which defines the *weakness* of the modern mind for Ruskin. The pathetic fallacy, "so far as it *is* a fallacy, . . . is always the sign of a morbid state of mind, and comparatively of a weak one." Romantic poets achieve neither imaginative release from the object-world of sense nor perceptual clarity. Their world is always "cloudy," as Ruskin says. Reading romantic poets is therefore like observing idolaters: we can never be sure about the relation of appearance to subjective experience. We must assume that the attachment to empirical error or to an illusion of

presence before the divine is a sign of sincerity, but the blindness toward the error or idol remains troublesome.

The poets of the "first order"—Homer, Dante, and Shakespeare—represent the ideal. A radical disjunction exists in first-order poetry between descriptive detail and human significance. This is evident in Ruskin's contrasting of Dante with Coleridge:

> [W]hen Dante describes the spirits falling from the bank of Acheron "as dead leaves flutter from a bough," he gives the most perfect image possible of their utter lightness, feebleness, passiveness, and scattering agony of despair, without, however, for an instant losing his own clear perception that *these* are souls, and *those* are leaves; he makes no confusion of one with the other. But when Coleridge speaks of
>
> > "The one red leaf, the last of its clan,
> > That dances as often as dance it can,"
>
> he has a morbid, that is to say, a so far false, idea about the leaf; he fancies a life in it, and will, which there are not; confuses its powerlessness with choice, its fading death with merriment, and the wind that shakes it with music.
> [5.206–07]

Dante gives as much descriptive detail as Coleridge. The fluttering leaves suggest lightness, passiveness, and feebleness—a perfect metaphor for the despairing souls. Coleridge, however, confuses physical detail with human emotion. There is a similar fineness of detail in Coleridge's metaphor, but the effect of the fine observations is lost in a set of catachreses. Fluttering becomes dancing, and this leads to the pathetic fallacies of powerlessness described as volition, fading death as merriment. Ruskin does not value acute perception over intense feeling, or the reverse. The ideal, Dantean sort of poet "perceives rightly in spite of his feelings." This sort of poet sees a flower in the "plain and leafy fact of it, whatever and how many soever the associations and passions may be that crowd around it." The romantic poet "perceives wrongly, because he feels." This poet takes a flower, such as a primrose, and makes it into a "star, or a sun, or a fairy's shield, or a forsaken maiden." This poet allows images to substitute for the object of perception in order to maintain his poetic feeling. The first order poet is more associational, not in the negative sense described in *Modern Painters* II, but in a new "allegorical" sense: associations do not generate false metaphors based on external resemblances, thus ignoring all degrees of relative importance between objects. Association, in this context, refers to the gap that separates an object or image from an added human significance. Such a gap is by definition allegorical. There is no proper meaning of soul implied in a leaf. Rather, the image of the leaf, as it is scrutinized closely, suggests possible connections to the falling of the soul. At no point is the leaf confused with the soul or identified with it. In Rus-

kinian terms, the Dantean image is a fiction, not an idol. The purpose of the detail or the vividness of the image is not to establish that leaves are identical to souls but to provide a firm, nondeceptive empirical basis for an associational sequence of ideas having to do with the state of fallen souls. Dante's comparison is as false as Coleridge's, but for Ruskin a crucial difference remains. Coleridge's metaphoric mixing of leaf and soul is doubly false. The image of the leaf is falsified and the soul is rendered ambiguously, as a contradictory feeling of happiness in death. Dante's leaves retain their proper physical characteristics. The mimesis, if it may be called such, is nondeceptive because the leaf is not confused with wind or with a personification.

Parts of the argument concerning the pathetic fallacy are prefigured ten years earlier, in Ruskin's discussion of the Contemplative Imagination. This form of the imagination similarly attempts to achieve a distinct, detailed mental image. But once ideational clarity is achieved, we continue to encounter uncertainties. These uncertainties have to do with figurative language. Ruskin is never comfortable with the notion that imagination may be distinguished from idolatry, or allegorical clarity from metaphorical confusion, in terms of tropes or linguistic figures. Appearance or intuition is all important for him. As soon as Ruskin determines that Dante has not falsified the leaf, he immediately concludes that Dante has *seen* it more accurately in his mind's eye. Even allegory, or fiction, is distinguished from metaphor not in terms of linguistic structure—for example, the opposition of a simile using "as" to a set of catachreses, "dancing" or "clan"—but in terms of sentiment, mastery of emotion, or sincerity of feeling. As in the chapter on the Contemplative Imagination, verbal structures are subsumed under categories derived from empirical psychology. As soon as Dante is compared not to another poet but to a sculptor, or architect, or painter, he assumes an inferior position. The errors of language, no matter how distinct, or recognizably fictive, remain more deceptive and closer to the danger of mimesis than do sculptured or graven errors. This point is made most forcibly in a lecture entitled *The Mystery of Life and its Arts* (1868), which shortly precedes Ruskin's attempt to separate definitively imagination from idolatry, primarily in terms of the superiority of sculpture to poetry, in *Aratra Pentelici* (1871). These lectures and the lecture on the mystery of the arts bring to a climax the suppression of literary imagination that began in *Modern Painters* II.

In the 1868 lecture, Ruskin discusses the poets of his "first class": Homer, Dante, Shakespeare, and Milton. With Dante and Milton, we have poets who "try to discover and set forth, as far as by human intellect is possible, the facts of the other world." As such, these two poets exemplify human imagination, the sole faculty which gives access to ideas of the divine or the "superhuman ideal." But, Ruskin asks, "What have they told us?"

Milton's account of the most important event in his whole system of the universe,

the fall of the angels, is evidently unbelievable to himself; and the more so, that it is wholly founded on, and in a great part spoiled and degraded from, Hesiod's account of the decisive war of the younger gods with the Titans. The rest of his poem is a picturesque drama, in which every artifice of invention is visibly and consciously employed; not a single fact being, for an instant, conceived as tenable by any living faith. Dante's conception is far more intense, and, by himself, for the time, not to be escaped from; it is indeed a vision, but a vision only, and that one of the wildest that ever entranced a soul—a dream in which every grotesque type or phantasy of heathen tradition is renewed, and adorned. [18.157–58]

Ruskin concludes: "[I]t seems daily more amazing to me that men such as these should dare to play with the most precious truths, (or the most deadly untruths,) by which the whole human race listening to them could be informed, or deceived." These criticisms invert Ruskin's earlier praise of Milton as a poet who could make believable images of the fall and superhuman evil, or Dante as a "masterful," nonmorbid poet. This criticism, in the context of the whole lecture, is actually directed at figurative language. The entire class of poets, Christian or pagan, medieval or romantic, is full of lying deceptions. The human imagination is inevitably led astray by the distorting and corrupting power of linguistic figures, which set no limit on the development of artifice or the grotesque degradation of natural forms. Images of gods in particular, whether in Homer's *Iliad* or Shakespeare's *King Lear*, do not raise our imagination to a conceptualization of the divine. Poets "mysteriously" waste their faith; they seem to be beguiled consistently by their own tropes. Ruskin does not argue that they are idolaters (though he intimates that their readers may idolize their fictions as truths). The literary imagination is by definition deceptive. Even distinct images, achievable only through language in the imagination, substitute for something else. When such substitutions are extended from the imaging of a flower to that of a heaven or of a host of angels, a grotesque distortion of "living faith" results.

The situation is entirely different with the medieval artisan. Ruskin compares an eighth-century Irish illuminator of manuscripts to a Lombardic sculptor. The comparison parallels the earlier one in *Modern Painters* III, between Dante and Coleridge. In the material arts, if not in literature, we may yet tell the sincere from the false. More specifically, the comparison is between the Irish "incorrigible" Angel and the Lombardic "corrigible" Eve.

In both pieces of art there was an equal falling short of the needs of fact; but the Lombardic Eve knew she was in the wrong, and the Irish Angel thought himself all right. The eager Lombardic sculptor, though firmly insisting on his childish idea, yet showed in the irregular broken touches of the features, and the imperfect struggle for softer lines in the form, a perception of beauty and law that he could not render; there was the strain of effort, under conscious imperfection, in every

line. But the Irish missal-painter had drawn his angel with no sense of failure. [18.173]

Ruskin draws from this comparison a summary answer to the question of what art has to teach of life's mystery:

[T]he more beautiful the art, the more it is essentially the work of people *who feel themselves wrong;*—who are striving for the fulfilment of a law, and the grasp of a loveliness, which they have not yet attained, which they feel even farther and farther from attaining the more they strive for it. And yet, in still deeper sense, it is the work of people who know also that they are right. The very sense of inevitable error from their purpose marks the perfectness of that purpose, and the continued sense of failure arises from the continued opening of the eyes more clearly to all the sacredest laws of truth. [18.174]

Truth thus emerges in direct proportion to evident error, defined as the failure to realize perfectly the intended ideal. This failure, though childish and imperfect, represents a sincere form of knowledge. The material inferiority of the image to the idea, an inferiority not evident in literary imagery, finally establishes the desired link between sincerity and error. Unlike mimetically perfect art, a category that includes the seemingly antithetical forms of eighth-century Irish missals and fifteenth-century Venetian architectural ornament, sincerely erroneous art is not deceptive; for Ruskin, it literally opens the eyes. The rudeness of the form, a direct result of the limitations imposed by the medium of stone, aligns error with the childish but sublime force mentioned in the discussion of the Byzantine mosaics. Consequently, imaginative fictions (or errors) are dissociated from idols or mimetic deceptions on empirical grounds. "The strain of effort" in the lines of carving suggests a consciousness of imperfections. This consciousness is the mark, in turn, of sincerity. The rude lines of the Lombardic Eve are a long way from the tender, more finished lines and ornaments of the *Vierge Dorée.* Ruskin has moved the proper "midway point" several degrees back in the direction of imperfect realization. The problem of separating idolatry from sincerity, pathetic fallacy from self-consciousness of fiction, literary from sculptural imagination finally comes to rest on a debasement of the empirical aspect of the sign or image in relation to the intentional image in the mind of the artist. Childlike power may be safely invested in an "error" that could not be deceptive (because of its empirical worthlessness). The Lombardic Eve could be worshiped only as an error, and so, paradoxically, with sincerity. The worshiper could never rest content with this Eve as a final image; she has no intuitive appeal.

But does the empirical rudeness of the material image protect people from self-deception? Has figurative language been contained? As Harold Bloom has noted, all of Ruskin's later works, beginning perhaps with *Sesame and Lilies* (1865), are massive pathetic fallacies. Ruskin elaborates a series of mythologies

that "produce in us a falseness of all our impressions of external things," as
he wrote of Wordsworth. Bloom suggests a highly original but not, I think,
wholly correct explanation for Ruskin's persistent blindness to tropes.[15] Rus-
kin, Bloom argues, rejected Wordsworth not for humanizing nature, not for
bringing together the adverting mind and the universe of things, but for
proposing a "myth of continuity." The object world of sense is "reduced" so
as to fit into a certain "homogeneity" of sense experience. Such a reduction,
or deliberate "estrangement of things," is followed by an elevation, or a sub-
lime "enforced humanization," of the object world. Reduction permits the
constitution of the homogeneous or continuous man.

Ruskin the "intuitive phenomenologist" (as Bloom calls him) rejected the
falseness of the reduction and the subsequent humanization. Natural appear-
ances in Wordsworth, and in the romantics in general, are either sacrificed or
personified. I would emend Bloom here by suggesting that, in order to avoid
either false sense-perception or the enforced personification of nature, Ruskin
pushed even farther the Wordsworthian pattern into the opposition of rude,
or reduced, icons to sublimely "childish" realizations of the icon's significance.
Enforced humanization is made explicitly into an "error," but this error is not
phenomenal, or even empirical. No one, Ruskin assumes, would confuse a
rudely carved hawthorn with a personified or pathetically fallacious hawthorn.
If Ruskin has committed an intuitive error, it is in supposing that a pattern
of visual reduction of a material image followed by a sublimely enforced ele-
vation of this image's significance does away with figurative language gener-
ally, or pathetic fallacies specifically, for verbal fictions do not fit this pattern.
As soon as Ruskin shifts from an empirical examination of a Greek coin or
vase, in a later work such as *Aratra Pentelici*, to a reading of the myth in-
scribed, the raising of the rude object to the status of a mythology of the
Greek imagination generates a remarkable sequence of pathetic fallacies.

Proust's Reading of Ruskin

Proust's attempt to translate Ruskin's notions of idolatry, error, and sincerity
into an opposition of nonmimetic, empirically worthless icons to sensuously
rich impressions misrepresents Ruskin. Ruskin was not evading beauty but a
certain sensory, sometimes intuitive, blindness to empirical error. He coun-
tered this blindness with an ever more radical emphasis on the nondeceptive-
ness of primitive forms of art. Once Proust's misrepresentation is cleared
away we may read Ruskin's later writings on idolatry for what they are: highly
figurative texts that only pretend to be in control of their figurations. Ruskin's
texts on idolatry are perhaps the most contradictory of all his writings. To
the degree that we follow the Proustian reading of Ruskin, which is the usual
reading, we fail to notice Ruskin's struggle not to perceive rightly but to use

metaphor, personification, and so forth clearly and self-consciously. Proust supports the common idea of Ruskin as an empiricist, but his own difficulties in distinguishing on empirical grounds Ruskinian idolatry from sincerity should have dispelled this idea long ago.

Proust's characterization of Ruskin's idolatry is found in the postscript to his introduction to *The Bible of Amiens* (*CSB*, 129–41). The postscript suggests that Proust refused to accept the prime requisite of Ruskin's concept of sincerity, that is, the subordination of the inferiority of a perceived object or artistic fragment to the power of the imagination. Proust remains too conscious of the possible worthlessness or triviality of a literary or artistic fragment, which no act of the imagination ought to redeem. For Proust, the referential value of the literary or artistic fragment threatens to negate the purely imaginative value a reader may attach to it. Proust cannot forget the empirical context of a literary or artistic fragment when reading Ruskin. He does not accede to Ruskin's imaginative transformation of a detail from a cathedral or a detail from a painting by Turner or Tintoretto into an expression of spirit until he has first tested the detail's empirical influence. Proust considers idolatry to be the indulgence in a hollow, terribly narrow, relationship between the reading of literature and the experiencing of life. Idolaters, in their attachments to particular images or motifs from famous works of art or from literature, are egoists, Proust repeatedly emphasizes. Idolaters shut out the spontaneous, often bittersweet influence of nature (typified by Proust, somewhat bathetically, in the "souffrances" [caused by hayfever] that confirm his love for hawthorns).

Proust accuses Ruskin of idolatry whenever Ruskin seems to translate the perception of empirical beauty or an impression of the "vividness" or "reality" of a painting or cathedral into a swarm of only superficially related symbols. Ruskin's "sacred classic canon" of literature and art—with its comparisons of Hercules to Samson, Isaiah to the Cumaen Sybil, or a Greek maiden carrying a basket to the daughter of Herodias carrying the head of John the Baptist—is paradigmatic, for Proust, of his idolatry, his "fétichisme dans l'adoration des symboles eux-mêmes" (*CSB*, 117). Proust uses the term "idolatry" in a variety of contexts, but, in the simplest terms, his definition of idolatry is the translation of some sublime fullness—Ruskin's "enthusiasm," his perception of "infinite reality," his "height" of intellectual insight—into some mediocre emptiness—a "cultish," "artificial" worship of a literary or artistic fragment. Such idolatry is typified in France by the writer who pays reverence to the *toilette* of Honoré de Balzac's Madame de Cadignan, or to the drape of Gustave Moreau's figure of death. Behind idolatry, suggests Proust, lurks the emptiness of "pure" signs, given substance only by tenuous associations that link them to common experience. As Proust says of Madame de Cadignan's *toilette*, "une fois dépouillée de l'esprit qui est en elle, elle n'est plus qu'un signe

dépouillé de sa signification, c'est-à-dire rien; et continuer à l'adorer, jusqu'à s'extasier de la retrouver dans la vie sur un corps de femme, c'est là proprement de l'idolâtrie" (*CSB*, 136). If Ruskinian idolatry is the reduction of an object or a work of art followed by an elevation, then Proustian idolatry is the reverse—the wasting of passion on the worship of the hollow. The overall movement of Proust's essay is the reversal of Ruskin's position. Proust begins where he left off in his discussion of the *Vierge Dorée:* he praises Ruskin's ability to unite the intellectual and the realistic and Ruskin's ability to make matter "an expression of the spirit." But Proust ends by comparing Ruskin to French fetishists, whose idolatry is "le péché intellectuel favori."

Proust sees his own reading of Ruskin as an attempt to recapture the spirit of Ruskin, to find Ruskin's thoughts still living in the cathedrals he visited and the sights he saw. Proust's resurrection of Ruskin's spirit is treated as an act of remembering Ruskin (as opposed to discovering Ruskin's own memories, as in the *Vierge Dorée*). A visit to Rouen Cathedral is described as an encounter with Ruskin's spirit by means of one of Rouen's carved "petites figures oubliées," which Ruskin had once described, and which still seems to contain Ruskin's thoughts. Similarly, Proust visits St. Mark's. The visit is set in the context of a recollection of the first time Proust read a page from *The Stones of Venice*, within St. Mark's during a storm. The essay ends with Proust suggesting that he has spoken of Ruskin's thoughts and passions "à l'aide de la mémoire et d'une mémoire qui ne se rapelle que les faits" (*CSB*, 141). Proust says that memory, in the end, may not have the "power" to accomplish a "resurrection" of Ruskin's spirit, but it nonetheless is the guarantee of the "reality" of Ruskin's thoughts. He concludes that memory affirms a "paradis perdu"; memory captures the cinder if not the flame of Ruskin. It is more like science in its retention of facts, not passions.

Memory seems to stand in opposition to Ruskin's idolatry, which subordinates empirical awareness to the egotism of a passion for symbols. Proustian memory, in its ultimate substitution of facts for power, revalues the essay's earlier praise of Ruskin's passion, enthusiasm, spirit. It seems to have two advantages over the Ruskinian spirit: first, it circumvents Ruskin's violent swings between sublime fullness and idolatrous emptiness; second, it seems to be able to hold onto empirical observation yet achieve a sense of *continuous* meaningfulness. Memory, in this essay, is able to act as the medium which unites what Ruskin saw with what Ruskin thought, without subordinating one to the other. How does Proustian memory accomplish this? The answer may be found in a third theme in Proust's essay, one coextensive with the themes of idolatry and memory: the theme of Ruskin as a liar.

Proust repeatedly calls Ruskin a "liar." As we look closely at Proust's references to Ruskin's supposed lies, we see that lying is actually a highly ambiguous concept. Lying seems to apply equally to what at first sight would

appear to be opposites. Proust tells us that Ruskin lies when he substitutes morality for beauty. In this sense lying is synonymous with idolatry: "Les doctrines qu'il professait étaient des doctrines morales et non des doctrines esthétiques, et pourtant il les choisissait pour leur beauté. Et comme il ne voulait pas les présenter comme belles, mais comme vraies, il était obligé de se mentir à lui-même sur la nature des raisons qui les lui faisaient adopter" (*CSB*, 130). Ruskin's moralizing of beauty, as in his severe, didactic explanation of the meaning of St. Mark's mosaics, represents his incessant "attitude mensongère." But beauty itself is also defined as a lie. Referring to the distorted perspective of Ruskin's sketch of Amiens, which crowds the buildings of Amiens alongside the banks of the Somme and includes a panorama of the surrounding countryside, Proust says: "La gravure *Amiens, le jour des Trépassés*, semble mentir un peu pour la beauté" (*CSB*, 121). Proust approves of this empirical lie, for this false perspective provides the richness of a memory as well as an impression of beauty. The sketch of Amiens is described by Proust in terms very similar to his own account of the *Vierge Dorée:*

> Mais du moins cette gravure de *la Bible d'Amiens* aura associé dans votre souvenir les bords de la Somme et la cathédral plus que votre vision n'eût sans doute pu le faire à quelque point de la ville que vous vous fussiez placé. Elle vous prouvera mieux que tout ce que j'aurais pu dire, que Ruskin ne séparait pas la beauté des cathédrales du charme de ces pays d'où elles surgirent, et que chacun de ceux qui les visite goûte encore dans la poésie particulière du pays et le souvenir brumeux ou doré de l'après-midi qu'il y a passé. [*CSB*, 122]

Proust seeks a clear contrast between memory and idolatry and, analogously, beauty and morality in terms of empirical richness versus hollow, egotistically sustained "signs." It is therefore very puzzling that Proust should allow these antithetical pairs to mix with each other in terms of variant forms of lying. In piercing the veil of Ruskin's idolatry, in seeking out the beauty hidden behind the *trompe l'oeil* of morality in Ruskin's description of a cathedral, we do not arrive at an empirical truth. We arrive at yet another layer of lies. Beauty is an empirical lie, but it is a lie for the sake of what Proust calls the "truth." This is evident in Proust's use of a term that goes hand in hand with "lie," that is, "error."

The term "error" is first used by Proust to characterize those critics who would reduce Ruskin to either a "realist" or an "intellectualist": "Il y a dans ces critiques erreur d'altitude" (*CSB*, 111). These criticisms fail to see that at the height of Ruskin's achievement the two categories are reconciled. The metaphorical connection of error with height continues, but it undergoes a major revaluation. At first Ruskin himself, according to Proust, seems to commit the same error as his critics. In the "excess" of his sublime vision of art Ruskin seems to separate the meaning of a painting from its representation:

"Ruskin commet la même erreur quand il dit qu' 'une peinture est belle dans la mesure où les idées qu'elle traduit en images sont indépendantes de la langue des images'" (*CSB*, 112). Instead of focusing on a specific empirical representation, Ruskin proceeds to "translate" all forms of art into a single continuum: "[S]i la realité est une et si l'homme de génie est celui qui la voit, qu'importe la matière dans laquelle il la figure, que ce soit des tableaux, des statues, des symphonies, des lois, des actes?" Error, in this sense, borders on idolatry, with its similar translation of sublimity into a canon of superficially related images or authors. Proust goes on to suggest that in his "enthusiasm" and "inspiration" Ruskin translated all of reality into a single religious vision so as to avoid the slightest taint of estrangement from his vision that a colder, rational composition of empirical reality might produce: "Et le respect religieux qu'il apportait à l'expression de ce sentiment, sa peur de lui faire subir en le traduisant la moindre déformation, l'empêcha . . . de mêler jamais à ses impressions devant les oeuvres d'art aucun artifice de raisonnement qui leur fût étranger" (*CSB*, 113). Proust makes a very similar statement about Ruskin's idolatry later, when he says that Ruskin idolized primitive religious art because "Chez tout autre, les sensations esthétiques eussent risqué d'être refroidies par le raisonnement" (*CSB*, 118).

But as Proust's essay develops, Ruskin's enthusiastic errors become less idolatrous. They become instead visions of beauty, just as Ruskin's lies were, at different moments, defined as either beautiful or idolatrous. The errors of enthusiasm become the criteria of *truth* in art. Following his own extremely enthusiastic, apocalyptic rendition of the *petite figure* of Rouen, Proust generalizes about the role of enthusiasm in aesthetic description:

> Celui qui enveloppa les vielles cathédrales de plus d'amour et de plus de joie que ne leur en dispense le soleil quand il ajoute son sourire fugitif à leur beauté séculaire ne peut pas, à le bien entendre, s'être trompé. . . . Les grandes beautés littéraires correspondent à quelque chose, et c'est peut-être l'enthousiasme en art qui est le critérium de la vérité. A supposer que Ruskin se soit quelquefois trompé, comme critique, dans l'exacte appréciation de la valeur d'une oeuvre, la beauté de son jugement erroné est souvent plus intéressante que celle de l'oeuvre jugée et correspond à quelque chose qui, pour être autre qu'elle, n'est pas moins précieux. [*CSB*, 128]

Proust continues that Ruskin erred greatly when he described the Christ of Amiens as one of the most tender of sculptures ever attained, for, as Joris-Karl Huysmans pointed out, this Christ was a "bellâtre à figure ovine." Yet, "les vérités dont se compose la beauté des pages de *La Bible* sur *Le Beau Dieu* d'Amiens ont une valeur indépendante de la beauté de cette statue." This assertion confuses truth with error, beauty with lack of attraction. Is the Christ of Amiens really beautiful? Or is he the fop Huysmans describes? Empirical consciousness, which at first seemed to be the criterion of memory

and of beauty, turns out to be as problematic as sublimity. Proust leads us to believe that it is possible to separate Ruskin's idolatrous passion, which can be found in his attachment to primitive art, from Ruskin's passion for beauty, which can be found in his attachment to scenes of unquestionable beauty, such as the view of Amiens from a hillside or the interior of St. Mark's. But if beauty is a matter of erroneous judgment, and not a matter of empirical, referential accuracy of description, then what grounds are there to call one interpretation idolatrous and another beautiful? Is not an enthusiastic description of a hawthorn painted by Tintoretto as "true" or as "beautiful" as a description of a rude little figure on the wall of the Amiens Cathedral? One might well ask where the empirical level of perception (the "facts" of memory) is to be found in the first place.

The passage just quoted on "les grandes beautés littéraires" provides an answer. "The criterion of truth" in literature is compared to the passing of the sun over the surface of a cathedral. The sun would be the guarantee that we are dealing with an empirical perception. The metaphor of "truth" and "beauty" as sunlight is made explicit just this once in Proust's essay. If we bear this metaphor in mind, however, we suddenly detect the major role it plays. In each of the main descriptive passages in the essay, there is a reference to the presence of sunlight that grounds a mnemonic impression in the mind. Ruskin's sketch of Amiens suggests for Proust the taste of a "souvenir brumeux ou doré de l'après-midi" that the hypothetical visitor to Amiens has passed there. And before he praises Ruskin's sketch as a beautiful lie, Proust mentions that Ruskin did not study nature or architecture in the abstract in his sketches: "Sur chaque pierre vous voyez la nuance de l'heure unie à la couleur des siècles" (*CSB*, 120). Similarly, before his resurrection of the forgotten little figure of Rouen, Proust sets the scene in sunlight:

Mais quand j'arrivai près de l'immense cathédral et devant la porte où les saints se chauffaient au soleil, plus haut, des galeries où rayonnaient les rois . . . quand je vis, rangés devant ses porches ou penchés aux balcons de ses tours, tous les hôtes de pierre de la cité mystique respirer le soleil ou l'ombre matinale, je compris qu'il serait impossible de trouver parmi ce peuple surhumain une figure de quelques centimètres. [*CSB*, 125]

Finally, the mnemonic account of St. Mark's beauty is set in a "mysterious" texture of sunlight and shadow. The impression of Ruskin's description of St. Mark's mosaics is at once beautiful and religious. The Old and New Testament figures *in Ruskin's text* "apparaissent sur le fond d'une sorte d'obscurité splendide et d'éclat changeant" (*CSB*, 133). This metaphorical play of light and shadow that Proust reads into Ruskin's language parallels the literal play of light and shadow that Proust recalls on the mosaics themselves, with their "lettres byzantines à côté de leurs fronts nimbés." Proust adds: "Et peut-

être cette page des *Stones of Venice* était-elle surtout de me donner précisément ces joies mêlées que j'éprouvais dans Saint-Marc, elle qui, comme l'église byzantine, avait aussi dans la mosaique du son style éblouissant dans l'ombre, à côté de ses images sa citation biblique inscrite auprès" (*CSB*, 133).

Each of these three passages attempts to persuade the reader that Proust is recording an empirical perception. We are supposed to read each passage as a representation of a play of light on the surface of the cathedrals of Amiens and Rouen or on the interior of St. Mark's. But if we recall that light is a metaphor for a beautiful lie, then each passage may be read alternatively as a fiction. Once the illusion of empirical representation has been accomplished by means of references to light, the burden of Proust's essay is to maintain the distinction that Proust's descriptions are "true," while Ruskin's idolatries are "false." At the center of Proust's essay, where the metaphor of light as error becomes the criterion of truth, idolatry is indistinguishable from beauty or memory. Lies are initially Proust's rationale for the creation of beauty and memory. But in the end, Proust wishes the reader to be persuaded that memory records facts and sensations.

Proust's reading of Ruskin's apocalyptic account of the message of St. Mark's mosaics, from *The Stones of Venice*, is meant to expose and summarize the faults of idolatry: insincerity, the subordination of beauty to hollow morality, the egotism of the idolater. It is also meant to expose Ruskin's hidden love of beauty. The text contains a play of truth and falsehood. Ruskin's description of St. Mark's is false. Nonetheless, "Il n'en est pas moins vrai que ce passage des *Stones of Venice* est d'une grande beauté, bien qu'*il soit assez difficile de se rendre compte des raisons de cette beauté. Elle nous semble reposer sur quelque chose de faux et nous avons quelque scrupule à nous y laisser aller*" (emphasis added; *CSB*, 132). The association of true beauty with falsehood had already been established in the paradoxical metaphor of the sun as a true falsehood. What is new here is Proust's hesitation, his refusal to give a ready and explicit account of the reasons why Ruskin's text is beautiful. This hesitation is no doubt rhetorical: Proust is trying to retreat from his earlier association of error with enthusiasm or passion, which would sanction the idolatry of Ruskin's text as well as its beauty. Proust clearly sees Ruskin's worship of the biblical quotations of St. Mark's mosaics as a form of idolatry, for he says of these quotations, "Aujourd'hui elles ne nous donnent plus que du plaisir." To worship the biblical message literally is to commit the same sort of idolatry as the worshiper of Madame de Cadignan's toilette. In both cases, one worships a sign that has lost its original significance.

Rather than proceed in terms that are highly ambivalent in meaning, such as enthusiasm, the exposure of idolatry must now proceed in terms of a certain truth that can serve as the foundation of beauty. Proust goes on to say, "Il n'y a pas à proprement parler de beauté tout à fait mensongère, car le plaisir

esthétique est précisément celui qui accompagne la découverte d'une vérité" (*CSB*, 132). But this truth, like beauty itself, is of an indeterminable order. Proust never makes explicit the truth of beauty in his description of St. Mark's that follows this statement. Yet there is an implicit connection made between truth, beauty, and sunlight. The "mysterious," "splendid obscurity" of the luminosity and reflection of the mosaics that Proust refers to is analogous to the uncertainty of truth and beauty. Sunlight, in its subtle, delicate manifestation, is the truth and beauty that we are supposed to recognize, not only in the mosaics but in the "style éblouissant dans l'ombre" of Ruskin's text.

Seductive as Proust's style is, with its sensuous depiction of the play of light upon the mosaics, its emotive claims for its own sincerity, its admonitory protestation against the egotism of Ruskin, who would sharpen ("aviver") the light and shadow into the moral message of the Byzantine letters, the most illusory aspect of Proust's page is the very texture of the sunlight, which subsumes Ruskin's text. The play of sunlight in St. Mark's is as much a matter of artifice as its presence within Ruskin's sketches, or in his prose, or on the surface of the cathedral at Rouen, or in the temporally arrested representation of the *Vierge Dorée*. In the case of St. Mark's, however, we are supposed to forget the "lying" function of sunlight and *read* its presence as truth. Proust's emphasis on St. Mark's *appearance* is intended to sustain the illusion of the separation of truth from falsehood. Once the truth is separated out it may be retained in memory. Enthusiastic description becomes irrelevant. What need is there for willed lies about the appearance of cathedrals or works of art when a factual beauty seems to radiate in cathedrals or works of art themselves?

For Proust there is no such thing as an empirically simple allegorical figure. It is the idolater, with his weakened empirical consciousness, who fails to notice the rich, sensuous visual context of even the rudest icon. In this sense, Proust is more of a Wordsworthian than a Ruskinian. For Proust and Wordsworth, spirituality can emerge only out of acts of perception. Ruskin's readings are not based on "beautiful" perceptions; he takes an allegory at its face value. Rather than follow Ruskin, Proust chooses to lie so as to achieve perceptual complexity. I say "lie" because Ruskin teaches his readers that the complex perception of an allegory is a rhetorical *trompe l'oeil*.

Allegory versus Metaphor in Proust: The de Manian Model

Paul de Man, in a densely wrought essay on the theme of reading in Proust's *Recherche*, has offered a theoretical account of Proust's practice of translating an allegorical figure into a perception of indeterminable meaning—what Proust, in his essay on Ruskin, calls "mystery," or what de Man terms "aporia." "Reading" is Proust's ambivalent term for the impossibility of keeping apart the literal aspect of an allegorical figure from a series of metaphorical

meanings. The metaphorical meanings are admittedly improper, but they cannot be dismissed. The act of reading, de Man demonstrates, seeks to ground an allegorical figure in some empirical, referential truth but inevitably discovers only another rhetorical falsehood. De Man's subtle analysis of this sort of reading parallels in many ways the structure of Proust's essay on Ruskin and its treatment of the mystery of allegorical figures. In fact, de Man's argument centers upon Proust's reading of Giotto's allegory of Charity (fig. 21), an allegory that Proust discovered in Ruskin's *Fors Clavigera*. De Man's analysis summarizes and clarifies the general nature of Proust's treatment of allegory, or, more specifically, what Proust calls the "allegory of the act of reading."

Proust's main text on the act of reading treats the narrator Marcel's solitary retreat into his room during a summer day. In the course of reading in seclusion, "Marcel's imagination finds access to 'the total spectacle of summer.' " De Man traces in great detail the metaphorical "substitutions" and "crossings" by which Proust unites the inner world of Marcel's room with the outer world of the summer day. In his use of metaphors of light and physical motion, Proust is able to reconcile the phenomenal opposites of light and darkness, stasis and motion, etc. The passage results in what de Man calls a "totalizing chiasmus." This metaphorical reconciliation of phenomenal opposites parallels Proust's description of the *Vierge Dorée*. There, too, Proust achieves a "totalizing" account of the *Vierge Dorée* by means of the reconciliation of phenomenal opposites, culminating, no less, in the reconciliation of animate and inanimate nature.

De Man then goes on to argue that Proust overturns his "seductive" metaphorical illusion. Proust portrays the "irresistible motion that forces any text beyond its limits and projects it towards an exterior referent." This is the text's "negative epistemology." Proust's metaphorical "intra-textual complementarity chooses to submit itself to the test of truth" and "Proust's novel leaves no doubt that this test must fail." Proust becomes aware that, in their natural state, things upon which we have projected our *âme* ("consciousness" in this context) lack seductiveness, which in fact they owed to the proximity of certain ideas in the first place. As de Man says, "[I]f the 'proximity' between the thing and the idea of the thing fails to pass the test of truth, then it fails to acquire the complementary and totalizing power of metaphor and remains reduced to 'the chance of a mere association of ideas.'"[16] De Man defines this chance association of ideas as "metonymy," but Proust defines the same lack of complementarity between idea and object as idolatry.

We can draw an even closer theoretical parallel to de Man's argument by emphasizing the way in which Proust, later in his essay on Ruskin, explicitly states the erroneousness of metaphor, aside from his discussion of Ruskin's idolatry. Idolatry is threatening to Proust because of the radical separation of empirical experience from symbolic thinking that it stands for, not so much

because it is given to erroneous perception. For erroneous perception, as defined in the metaphor of the sun, could actually save idolatry, link it back to metaphor. The erroneousness of metaphor is made explicit by Proust in his appreciation of Ruskin's sketch of Amiens. There is a similarity between this interpretation of Ruskin's sketch and Proust's description of the *Vierge Dorée*. But the interpretation of Ruskin's sketch is based on the claim that Ruskin had *lied* for the sake of beauty. No mention of lying is present in Proust's earlier description of the *Vierge Dorée*. There we find no reference to the sun as a sanction for error. In the shift from the description of the *Vierge Dorée* to the interpretation of the Amiens sketch, we have a shift from metaphorical "totalization" to negative epistemology which parallels the movement de Man describes.

De Man next turns to what he considers "the allegory of the play of truth and falsehood" that "would ground the stability of Proust's text." Proust, de Man argues, is able to contain the contradiction between truth and falsehood, the literal and the figurative, in his reading of Giotto's allegory of Charity. This thesis is intriguing. Again, there is a parallel in Proust's reading of Ruskin. In order to avoid the contradictions in Ruskin between metaphorical description and idolatrous description, both of which are now considered equally false, Proust searches in Ruskin for an ambiguous mingling of truth and falsehood, beauty and idolatry, empirical reference and rhetorical deception, and finds it in Ruskin's mysterious account of St. Mark's mosaics. Similarly, the contradictions between literal reference and figurative description may be found in Giotto's equally mysterious allegory.

The first metaphorical reading of Giotto's allegory is traced by de Man with regard to Charles Swann. Swann, as de Man says, is "the personification of metaphor." Swann interprets Giotto's allegories in the Arena Chapel in Padua in terms of physical resemblance between their surcoats and the "humble basket" of the kitchen maid's pregnancy. This physiognomic trait of the kitchen maid is "raised to the level of an emblem," but an emblem of the "agonies and humiliations" of successive kitchen maids. De Man concludes: "An allegory thus conceived is in no way distinguished from the structure of a metaphor, of which it is in fact the most general version." The physiognomic trait of pregnancy makes possible a sequence of metaphorical resemblances. But, as de Man continues, "By generalizing itself in its own allegory, the metaphor seems to have displaced its proper meaning." That is, the metaphorical resemblances that Swann perceives, which signify agony and humiliation, displace the proper meaning of the allegory by which Swann nicknames the maid, Charity. Metaphorical meaning (agony) displaces allegorical meaning (charity) here in the same way that Proust's concentration on the physical appearance of St. Mark's frescoes displaces the frescoes' proper meaning, the story of man's judgment and redemption.

Marcel, de Man suggests, perceives a more "literary (that is to say, rhetorically less naive)" resemblance between Giotto's Charity and the kitchen maid. Marcel perceives the true nature of allegory:

> In a metaphor, the substitution of a figural for a literal designation engenders, by synthesis, a proper meaning that can remain implicit since it is constituted by the figure itself. But in allegory, as here described, it seems that the author has lost confidence in the effectiveness of the substitutive power generated by the resemblances: he states a proper meaning, directly or by way of an intra-textual code or tradition, by using a literal sign which bears no resemblance to that meaning and which conveys, in its turn, a meaning that is proper to it but does not coincide with the proper meaning of the allegory.[17]

The literal sign, such as the face of Giotto's Charity, with its "heavy and mannish" features, connotes nothing charitable. Allegory usually displays such a disjunction between the literal appearance of the icon and its proper meaning. We are able to know the meaning of the literal sign only because it is named as a certain moral principle by the painter.

Ruskin would agree with this definition. He, too, noted a disjunction between the rudeness of an allegory's appearance and its intended intellectual significance. But while Ruskin favored this disjunction as an occasion for rising above the empirical level of perception to a state of imaginative sublimity, the narrator proceeds in the opposite direction. He returns to the perception of the literal sign as the locus of meaning in an allegory. As soon as the narrator does this, allegory is once again transformed into metaphor, for the focus is still the way in which Giotto's allegories and certain characters in the novel are physically comparable. This sort of metaphor may be seen in the comparison of the kitchen maid to the allegory of Envy. De Man writes: "Marcel insists that the kitchen maid and the Giotto frescoes resemble each other by their common claim to focus our attention on an allegorical detail"—the action of the lips, in the case of Envy, the burden of the belly in the case of the maid. These two physical details do not directly resemble each other and so one cannot say that there is a metaphorical relationship between the maid and Envy in the same sense as in Swann's metaphor. Yet the emphasis on perception suggests that Marcel is nonetheless approaching allegory as if it were metaphorical. Just as Swann displaces proper meaning by literal resemblance, so Marcel displaces proper meaning by an equation of physical attractiveness. I would argue, against de Man, that the notion of physical attraction belongs to a metaphorical, not an allegorical, mode of description. Ruskin writes that allegories are precisely those signs that lack mimetic or empirical value. Of course, a detail from an allegory may be examined closely, but that is quite different from attributing to a detail an inherent attractiveness. I can imagine the validity of Proust's (or Marcel's) claim for empirical attraction in the case

of the maid. Everyone, I think, has a tendency to be drawn to an unusual physical detail in someone else's appearance. But to transfer the maid's power of attraction to an allegorical figure is to create a metaphor.

The "aporia" of Giotto's Charity, its supposed confusion of literal and figurative meanings, occurs with the introduction of yet another level of metaphorical resemblance: the resemblance between the action of Giotto's Charity raising her heart to God and the action of a cook raising her hand to pass a corkscrew through a basement window suggesting an image of Françoise. As de Man suggests, in a moment of understandable empirical puzzlement, this resemblance is "unlikely." Yet the metaphorical reading of Giotto's allegory as resembling, in one sense, the kitchen maid, and, in another sense, Françoise, leads to a severe strain between the literal and allegorical senses of Charity. Françoise, as a literal imitation of Charity, contradicts the proper allegorical meaning of Charity, for she treats the kitchen maid in a very uncharitable way. The kitchen maid corresponds to Charity in the allegorical sense suggested by de Man: they do not literally look like each other, but they do seem to signify a common intellectual value. The maid's pathetic expression could easily be mistaken for an expression of charity. When Françoise mistreats the poor kitchen maid we have a situation which de Man wittily describes thus: "[T]he literal sense of this allegory [Charity] treats its proper sense in a most uncharitable manner." The literal and figurative meanings of Giotto's allegory overlap and contradict each other as long as we read Giotto's allegory as an emblem of the relationship between Françoise and the kitchen maid. But we must remember that these seeming contradictions in Giotto's allegory do not inhere in the allegory itself. The contradictions arise from the superimposition of resemblances to fictional characters made upon Giotto's allegory. The confusion of literal and figurative meanings is the result of this superimposition. De Man concludes that in Proust the "literal meaning obliterates the allegorical meaning." If we make relative the meaning of the word "literal" for a moment, we can see that de Man's remark is true of every case. Swann displaces the proper meaning of Charity by means of general resemblances of pregnancy. Marcel obliterates allegorical meaning by positing the attractiveness of the literal sign itself. Proust obliterates the meaning of Charity by constructing a resemblance between Charity and an uncharitable character. As long as we naively assume that there is a "true" literal level of representation in an allegory, we may be fooled by Proust's play of resemblances. We trap ourselves in the futile task of giving proper meanings to singular images.

De Man assumes that a literal meaning is one of allegory's illusions, because, unlike metaphor, allegory is "considered to be a referential and empirical experience that is not confined to an intra-textual system of relationships." In other words, allegories can stand alone. But once the simple empirical aspect of allegory has been tampered with, then indeed reading it becomes the "im-

possibility" that de Man suggests it is in Proust. From a Ruskinian perspective, Proust has attempted to subsume the rudeness and literal worthlessness of allegory under what Ruskin had long since dismissed as "metaphors" of associationism: false meanings based on improper juxtapositions of images in terms of external resemblance.

Idolatry versus Imagination in Aratra Pentelici

Ruskin's lectures on Greek art are principally concerned with revaluating the "rudeness" and "childishness" of Greek sculpture and coins. The apparent gap between the delicacy of natural description that we admire in Homer, or the sublimity of Pindar, and the inferiority of the mimetic realization of the gods in the contemporary material arts must be closed, indeed reversed. For it is the sculpture, Ruskin argues, that conveys more precisely the imagination and the love of nature, if not the empirical acuity, of the ancient Greeks. A large part of the lectures is given over to a critique of mimetic values. This critique continues the argument of earlier discussions of architecture and sculpture that I have mentioned and so will not repeat here. What is perhaps new is Ruskin's linking of the social preference for mimetic art to certain forms of Victorian "idolatry," specifically the worshiping of wealth and the reduction of appearances to scientific empiricism. In either case we have a failure of the human imagination. Wealth is idolatrously reified into a substantial power, with its own laws. Mammon is an economic force rather than a moral personification. Victorian science, in a strangely connected way, also represents a failure of the imagination, for it is predicated upon a passive acceptance of the empirically given. The imaginative ranking of the importance of appearance or the creation of invisible entities is no longer valid. Ruskin complains that the scientific mechanics of thermodynamics, for example, treats as equal the energy organized as a teapot and that organized as an eagle. Science represents the tyranny of the eye, commercialism the tyranny of blind error. That Ruskin should class these errors as forms of mimesis is not totally unexpected, given the rather extended definition of the term in his theoretical writings. Mimesis always implies intellectual blindness and the domination of the senses.

The Victorian entrapment in mimesis precludes a proper appreciation of the primitive forms of ancient Greek art. But for Ruskin these forms represent the exercise of the human imagination at its best, particularly because the rudeness of the forms suggests that the Greek imagination was not operating deceptively. Greek imagination seems idolatrous to a benighted Christian who lives within a truly idolatrous culture. Greek imagination is "the desire to see as substantial the powers that are unseen, and bring near those that are far off, and to possess and cherish those that are strange." There is a reverence

for the natural elements, the "powers," and a desire to go beyond immediate sense-experience. Yet the symbols and personifications that perform the imaginative function are nondeceptive. Imagination is

the invention of material symbols which may lead us to contemplate the character and nature of gods, spirits, or abstract virtues and powers, without in the least implying the actual presence of such Beings among us, or even their possession, in reality, of the forms we attribute to them.

For instance, in the ordinarily received Greek type of Athena, in the vases of the Phidian time . . . no Greek would have supposed the vase on which this was painted to be itself Athena, nor to contain Athena inside of it, as the Arabian fisherman's casket contained the genie; neither did he think that this rude black painting, done at speed as the potter's fancy urged his hand, represented anything like the form or aspect of the goddess herself. Nor would he have thought so, even had the image been ever so beautifully wrought. The goddess might, indeed, visibly appear under the form of an armed virgin, as she might under that of a hawk or a swallow, when it pleased her to give such manifestation of her presence; but it did not, therefore, follow that she was constantly invested with any of these forms, or that the best which human skill could, even by her own aid, picture of her, was, indeed, a likeness of her. The real use, at all events, of this rude image, was only to signify to the eye and heart the facts of the existence, in some manner, of a Spirit of wisdom, perfect in gentleness, irresistible in anger; having also physical dominion over the air which is the life and breath of all creatures, and clothed, to human eyes, with aegis of fiery cloud, and raiment of falling dew. [20.242–43]

The elaboration of this definition becomes the principal task of the lectures on imagination and idolatry (20.220–71). Material symbols, sculptures and coins, are examined as signs for the eye and the heart of the gods, spirits, or abstract virtues. Ruskin allows for extensive imaginative speculation—as in the multiplication of forms of Athena in this passage—on the assumption that idolatry has been precluded from the outset. None of the forms has a mimetic or deceptive appeal. Nature is allegorized, as Athena, or the Spirit of wisdom. She is explicitly named a "fiction."[18]

The purpose of the lecture is not to make Oxford students into pagan worshipers but to demonstrate how the imagination may be employed to raise a feeling of gentleness or anger: gentleness in the love of nature personified as a benevolent deity; anger toward the idols that interpose themselves before the truly imaginative moment, that is, commercialism and science. The Greeks become the teachers. As long as exercise of the imagination remains fictive we are on the right path. As soon as we lapse from Greek imagination to idolatry we fail to understand the significance of the rude Greek sign. As idolaters, the Victorian audience is all the more likely to lapse in this way as they look upon a coin or "childish" figure of Minerva as the owl. Yet Ruskin advises, regarding such rudely based grounds for the imagination:

[Y]ou will see more and more clearly as we proceed, that the deliberate and
intellectually commanded conception is not idolatrous in any evil sense whatever,
but is one of the grandest and wholesomest functions of the human soul; and that
the essence of evil idolatry begins only in the idea or belief of a real presence of
any kind, in a thing in which there is no such presence. [20.230]

Intellectually commanded conception is grounded in the empirical rudeness
of the sign or image in Greek art. The imaging of the emergence of Athena,
for example, presents one of "the most painful and childish of sacred myths"
(20.245). Her birth out of the head of Zeus by means of Hephaestus's blow
of an axe appears to be "ludicrous," whether we study the image on a Greek
vase (fig. 22) or read the event in Pindar's seventh Olympian ode. Yet the
"ruder the symbol, the deeper would be its purpose. And this legend of the
birth of Athena is the central myth of all that the Greeks have left us respecting
the power of their arts" (20.246). Athena's myth is rude, ugly, childish, yet,
for Ruskin, it presents the deepest allegory of the Greek imagination. Athena
is the personification of intellectually commanded conception.

Athena, more than Apollo or Hephaestus, or even Zeus, is the perfect
allegory of the imagination because of her associations with the manual arts
of Greece: sculpture, agriculture, and weaving. Hephaestus's agency at the
birth of Athena is only the beginning of the development of manual skill. His
axe is the double-edged *pelekus*, the same that Calypso gives to Ulysses for the
purpose of shipbuilding. The axe is a symbol of the rudimentary crafts of
agriculture and navigation, out of which more sophisticated forms of skill will
come, that is, sculpture and weaving, which signal the birth of Athena. Fur-
thermore, in comparison to the dullness of Victorian thermodynamics, the
personification of fiery craft as Hephaestus gives a notion of the "thrilling
power of heat in the heavens, rending the clouds, and giving birth to the blue
air" (20.247).

The apparently rude image of the birth of Athena thus allows Ruskin to
read imaginatively. The myth virtually activates the human imagination, even
as it tells the story of the imagination's birth. The allegorical gap between the
unbelievability of the images that make up this myth and the meaning of the
myth prevents the reading from being taken literally. For Ruskin the activation
of the imagination is a real issue, but Athena herself does not, of course, exist,
nor is she meant to.

Built into the allegory is a preference for material art over poetry, sculpture
over writing. Not only is the highest wisdom manual (the arts of sculpture
and agriculture), the figuring of this wisdom is proper in carving or vase
decoration rather than in poetry. The rude Callias Vase (in the British Mu-
seum) showing Hephaestus striking Zeus, in its empirical rudeness, mirroring
the rudeness of the myth itself, gives a more sincere account of the imagination
than is possible in poetry. Only Pindar, in Ruskin's opinion, does not distort

or degrade the imaging of the gods with deceitful language—no doubt because Pindar seems to emphasize the manual crafts, such as sculpture and road-building. Pindar, though a poet, seems to support the idea that sculpture is the wiser art, for language may be idolatrous, while sculpture, as Ruskin would say, opens our eyes. In the seventh Olympian ode, Pindar tells how Athena bestowed the art of sculpture upon the people of Rhodes so that along the paths of their island remarkably lifelike sculptures could arise. In this way they surpassed all other mortals by the deftness of their hands. Ruskin attaches great importance to Pindar's epithet for the Rhodian sculptors, δαέντι (*Daenti*). He renders Pindar's "infinitely pregnant passage" thus:

> But she, the goddess herself, gave to them to prevail over the dwellers upon earth, *with best-labouring hands in every art. And by their paths there were the likenesses of living and of creeping things:* and the glory was deep. For to the cunning workman, greater knowledge comes, undeceitful. [20.262]

Pindar, in Ruskin's interpretation, has seized the essential nature of the art given by Athena: "[H]er purpose is never in word only, but in a word and a blow. She guides the hands that labour best, in every art." A general conclusion follows:

> Sculpture, it thus appears, is the only work of wisdom that the Greeks care to speak of; they think it involves and crowns every other. Image-making art; *this* is Athena's, as queenliest of the arts. Literature, the order and the strength of word, of course belongs to Apollo and the Muses; under Athena are the Substances and the Forms of things. [20.263]

The forming of images, as Pindar implies, is "undeceitful" knowledge. Pindar's Rhodian sculptors belong to the same class as Ruskin's Lombardic sculptor. (In fact, the lecture frequently equates Greek sculpture to primitive Christian ornamentation.) The concreteness of the sculptured image, which is always inferior in its realization to the idea of the god it would signify, is undeceitful precisely because of its inferiority. The ruder the image, the deeper would be its purpose. The tactile experience of the hand, or the non-mimetic image before the eye, is the condition for the hyperbolic imaginative leap into the realm of personified wisdom. To seek wisdom in poetry or in the order of words leaves one prone to idolatry. It is therefore upon a new respect for manual labor in economics and a turning away from the mimetic entrapment of the eye in science that the rebirth of the Victorian imagination rests.

But as we approach Athena directly, as Ruskin guides readers to the moment of her rebirth, a certain idolatry intrudes into his discussion. Ruskin exhorts his readers not only to take up manual arts but, simultaneously, to personify natural substances. Manual labor is not an end in itself; it serves the purpose of aiding the imaginative task of personification. But various personifications,

in Ruskin's text, seem to lose their imaginative status and become deceitful. Athena's birth is on the verge of miscarrying. The problem becomes evident in the discussion of *Charis*, the allegory of gratitude and physical beauty.[19] *Charis*, for Ruskin, is an allegory that conditions the ability to conceive other allegories. *Charis* decides the difference between idolatry and imagination:

> [I]t is part of the constitution of humanity—a part which, above others, you are in danger of unwisely contemning under the existing conditions of our knowledge, that the things thus sought for belief with eager passion, do, indeed, become trustworthy to us; that, to each of us, they verily become what we would have them; the force of the μῆνις and μνήμη with which we seek after them, does, indeed, make them powerful to us for actual good or evil; and it is thus granted to us to create not only with our hands things that exalt or degrade our sight, but with our hearts also, things that exalt or degrade our souls; giving true substance to all that we hoped for; evidence to things that we have not seen, but have desired to see; and calling, in the sense of creating, things that are not, as though they were.
>
> You remember that in distinguishing Imagination from Idolatry, I referred you to the forms of passionate affection with which a noble people commonly regards the rivers and springs of its native land. Some conception of personality, or of spiritual power in the stream, is almost necessarily involved in such emotion; and prolonged χάρις, in the form of gratitude, the return of Love for benefits continually bestowed, at last alike in all the highest and the simplest minds, when they are honourable and pure, makes this untrue thing trustworthy; ἄπιστον ἐμήσατο πιστὸν, until it becomes to them the safe basis of some of the happiest impulses of their moral nature. [20.258–59]

In this passage we see Ruskin repeating many of the principles of the imagination that he has stated before. The imagination makes present a spiritual power that is absent from sight. The imagination provides ennobling fictions or illusions; it personifies nature. The passage we must remember—in which imagination is distinguished from idolatry (according to Ruskin's own gloss)—makes clear that, in the case of the imagination, the vision of the nature-god or its realization in the form of a statue, is *not to be taken literally:* "[People] might take delight in the beautiful image of a god, because it gathered and perpetuated their thoughts about that god; and yet never suppose, nor be capable of being deceived by any arguments into supposing, that the statue *was* the god" (20.230). The personification of nature or the materialization of a spiritual power in the form of a statue is nonidolatrous as long as it is strictly allegorical. The visible stands for the invisible; the literal sign has a purely figurative value. The passage on *Charis*, itself already a personification of one of the imagination's functions, seems to blur the distinction between imagination and idolatry in a fundamental way, for *Charis* is an allegory that "makes the untrue thing trustworthy." "The untrue thing" is, of course, the

personification of nature. What does it mean to make this "trustworthy"? Ruskin seems to want to make the imagination's fictions permanent in some way, to make them a habit of mind.

Charis's power to make untrue allegories true is shown a few sentences later, with reference to the "personality of the fountain Arethusa": "But without restriction to those days of absolute devotion, let me simply point out to you how this untrue thing, made true by Love, has intimate and heavenly authority even over the minds of men of the most practical sense, the most shrewd wit, and the most severe precision of moral temper" (20.259). The price of *Charis*'s "truth" seems to be a belief in her literal power; she "makes" other allegories true. The intellectual distance from the various visions of the imagination that defines Wisdom, or that characterizes the cunning workman, seems to be lost in the operation of *Charis*. The allegory's truth seems to verge dangerously close to the pathetic fallacy and to idolatry itself. This is evident in Ruskin's misreading of the passage in Pindar's first Olympian ode (ll.49–50), from which he draws his key phrase:

> Grace, which creates everything that is kindly and soothing for mortals, adding honour, has often made things, at first untrustworthy, become trustworthy through Love.
>
> I cannot, except in these lengthened terms, give you the complete force of the passage; especially of the ἄπιστον ἐμήσατο πιστὸν—"made it trustworthy by passionate desire that it should be so." [20.258]

The Greek text offers no grounds for adding the adverbial phrase "by passionate desire that it should be so," which sounds like a neat definition of the pathetic fallacy. In fact, Ruskin has missed the point of the entire passage in Pindar, for Pindar, far from praising the effects of *Charis*, cautions that her presence can charm men into accepting falsehoods.

How are we to account for this lapse in Ruskin's argument? It is possible that, in spite of his claim that *Charis* makes allegories of nature into "truth," Ruskin could have intended his audience to take his words figuratively rather than literally. For polemical purposes, Ruskin might have meant "truth" in the sense of beneficial "error."

No matter how charitable we try to be toward Ruskin, the introduction of *Charis* into his argument seems to place too much strain on an already delicately supported distinction between imagination and idolatry. *Charis* confuses the distinction between literal and figurative meanings. Everything becomes metaphorical, so that there is *no* level of literal perception or literal truth in what Ruskin says. *Charis* is like Proust's metaphor of the sun as the criterion of truth—a falsehood that is "true." The gap that separates the empirically rude from the visionary, that separates imagination from idolatry, is closed up.

Richard Jenkyns has described this uncertainty in one of Ruskin's earlier mythological works, *The Queen of the Air* (1869). Jenkyns appreciates Ruskin's attempt to exonerate the Greeks from the charge of idolatry, but he finds Ruskin's extraordinary concern with the immediate presence of the goddess Athena to be extremely problematic. "We react with incredulity," Jenkyns suggests, when Ruskin seems to believe "literally" in the Greek gods.

> On the one hand, [Ruskin] insists that Greek mythology is "literal belief," "deeply rooted" in the mind of the general people and "vitally religious"; and there are one or two moments of startling insight that seem almost to anticipate Frazer or Freud. On the other hand, much of the book is devoted to the rationalization of Greek myth. Athena, for example, is the goddess of fresh air, and so when Homer says that she laid Penelope into deep sleep, "and made her taller, and made her smoother, . . . and breathed ambrosial brightness over her face", he means that the lady went to bed early and left the window open. To us such allegorical interpretations seem to be not only wrong but prosaic, robbing the *Odyssey* of its magic, but Ruskin would have viewed the matter the other way round: he was bringing magic back to the experiences of everyday life. "Whenever you throw your window wide open . . . ," he wrote, "you let in Athena, as wisdom and fresh air at the same instant; and whenever you draw a . . . full breath . . . , you take Athena into your heart, through your blood; and with the blood, into the thoughts of your brain." One would normally assume that such language is figurative, but with Ruskin one can never be quite sure.[20]

Jenkyns asks the right question. Is Athena literal or figurative? If the language of the imagination cannot be said to refer to anything concrete or empirical, then it is impossible to distinguish it from the language of idolatry. Is *Charis* a material symbol of Love and Grace? Or is *Charis* the name of a trope, personification, that seems to secure imagination in a fiction but in fact suspends all referential certainty? *Charis* marks the intrusion of deceitful language into the discourse of the material realization of the imagination.

Charis's deceptiveness is evident in a later passage in Ruskin's lecture, in which the sculptural power of Athena is contrasted with the scientific idolatry of the Victorians. The passage condenses numerous themes of the lecture in the basic opposition. *Charis* appears in two of her guises, as Love and Beauty. There is also an implicit contrast made between the Victorian science of heat and the fires of Hephaestus. But the passage makes it impossible to locate an empirical symbol or a literal referent that would ground the allegorical oppositions.

> The laws under which matter is collected and constructed are the same throughout the universe: the substance so collected, whether for the making of the eagle, or the worm, may be analyzed into gaseous identity; a diffusive vital force, apparently so closely related to mechanically measurable heat as to admit the conception of its being itself mechanically measurable, and unchanging in total quantity, ebbs

and flows alike through the limbs of men and the fibres of insects. But, above all this, and ruling every grotesque or degraded accident of this, are two laws of beauty in form, and of nobility in character, which stand in the chaos of creation between the Living and the Dead, to separate the things that have in them a sacred and helpful, from those that have in them an accursed and destroying, nature; and the power of Athena, first physically put forth in the sculpturing of these ζῷα and ἕρπετα, these living and reptile things, is put forth, finally, in enabling the hearts of men to discern the one from the other; to know the unquenchable fires of the Spirit from the unquenchable fires of Death; and to choose, not unaided, between submission to the Love that cannot end, or to the Worm that cannot die.

The unconsciousness of their antagonism is the most notable characteristic of the modern scientific mind; and I believe no credulity or fallacy admitted by the weakness (or it may sometimes rather have been the strength) of early imagination, indicates so strange a depression beneath the due scale of human intellect, as the failure of the sense of beauty in form, and loss of faith in heroism of conduct, which have become the curses of recent science, art, and policy. [20.266–67]

The passage is structured in terms of a division.[21] Chaos must be divided into the Living versus the Dead, the helpful versus the accursed, the fires of the Spirit versus the fires of Death, Love versus the Worm. But this chaotic substance, heat, seems to be devoid of any certain empirical properties. Either side of these oppositions is equally figurative in meaning. Death, its fires, and the Worm have no more empirical existence than their opposites. A contrast between a concrete fountain of Arethusa and its host of mythological associations would constitute a proper imaginative exercise. But that is different from a contrast between two imaginative constructs, the Living and the Dead, especially when the exemplars of the Living (the Greeks) are really dead, while those of the Dead (the Victorians) are really living. Ruskin does not contrast a literal worm, an object of scientific observation, to a mythological figure, say, a dragon. Instead, Victorian science as a whole is allegorized as the Worm, which is then opposed to another allegory, Love. These rhetorical oppositions are deceptive, or idolatrous, because there is no empirical escape from the mode of figuration. The passage might be described as a "totalizing chiasmus" (de Man's term), in which opposed referents, such as light and darkness, achieve an integration of meaning on nonempirical grounds. The "diffusive vital force" cannot, in fact, be measured mechanically. It exists only as long as it is repeatedly named under the imaginative power of Athena. As in his discussion of the Purity of Vital Beauty in *Modern Painters* II, Ruskin seems to confuse metaphorical with material aspects of a substance. The power of Athena and *Charis* to "sculpt" the vital force is actually the power of language which seems to name an object without giving any specific referent.

The last paragraph of the passage requires further comment, for it reminds

readers that the first paragraph may be read as a "fallacy." The earlier passage on *Charis* had already suggested a connection between fallacies, the sense of beauty in form, and the human intellect. This paragraph does not clarify any better than that passage on *Charis* the actual meaning of the word "fallacy" in relation to the word "intellect." There is no mention of an allegorical entity in this paragraph, but Ruskin's terms here seem to be just as ambiguous as they were in the discussion of *Charis*. By the use of the word "intellect," Ruskin implies that the fallacies of the imagination—myths, allegories, personifications—are known as such, are known as useful fictions. The "intellect," thus read, would differentiate imagination from idolatry. The "unconsciousness" of the Victorians would then be another term for the idolatry with which Ruskin charges them. Yet such a reading is confused by the fact that the previous paragraph suggests that the Victorians have no fallacies in the first place. The Victorian sees only a worm, while it is Ruskin who imagines the Worm. The intellect, like *Charis*, is given a contradictory function: it must deny, in the last analysis, the existence of the Worm, yet it must also deny any value in the perception of a literal worm, for the perception of the worm implies a "depression of intellect," even though there is nothing fallacious about such a perception. Like *Charis*, the intellect, it would seem, is good only for making the untrue true.

The same contradictions exist in the word "fallacy." The syntax of the paragraph suggests that the word "fallacy" applies to both the ancient and the Victorian mind: no fallacy of the "early imagination" is so strange a depression of intellect as the fallacies produced by the failure of the sense of beauty in form of the "modern scientific mind." What we have then is the opposition of fallacy to fallacy, not truth to fallacy. Such, indeed, is the structure of the previous paragraph, which opposes allegory to allegory. Yet the argument of the first paragraph suggests a furthering of knowledge in the antithesis of fallacies. Presumably, this increase in knowledge comes from the ability to tell imaginative fallacies from idolatrous fallacies. But the language of the passage, which gives all the allegorical entities an equal claim to power, makes it impossible to tell the difference. We must resort to the ideological thrust of the passage and hope that the evil allegories will be idolatrous and the good ones imaginative.

The one argument in the passage I have not yet fully discussed is "the power of Athena." The power of Athena, invoked from Pindar's ode, is actually a claim to knowledge. It is Athena who first gives the power of sculpture and "finally" enables men "to discern" the fires of the Spirit from the fires of Death. There is the suggestion that to the sculptor who physically transforms matter into sculpture, under Athena's guidance, knowledge comes undeceitfully; Athena's workmen are "cunning." Leaving aside the question of how literally we are to read Athena herself for the moment, Ruskin's argument is

crucial. It is sculpture not language that gives knowledge. Throughout the lecture Ruskin states that "all knowledge" must be accompanied by manual labor. Perhaps in emphasizing the semantic confusion of the passage we miss the main point of the lecture. Language may indeed confuse idolatry and imagination, but this need not be the case with sculpture.

The superiority of sculpture to poetry, of Athena to Apollo, is the argument that seems to separate, finally, the imagination from idolatry. Unfortunately, Ruskin does not confine the power of Athena to the creation of sculpture. Athena's power is extended to include the sculpturing of the surface of the earth. Ruskin's sublime vision of Athena's power of sculpture is found in a short reading of Pindar's seventh Olympian ode (20.261–65). Citing Pindar, Ruskin returns to the moment in which Hephaestus strikes the blow against Zeus that gives birth to Athena. This time, however, the association of Hephaestus with the manual arts is extended beyond anything in Pindar's text. Hephaestus's axe-blow signifies "the first birth of prudent thought out of rude labour." The vision of Athena emerges out of the "efforts to express, though with hands yet failing . . . the first truth by which they knew that they lived; the birth of wisdom." Athena is the "goddess of Doing"; she "guides the hands that labour best"; she is "begotten of the woodman's axe." Athena's sculptors provide "undeceitful knowledge," for they have the habit of "some elementary practice of manual labour."

The imagining of Athena seems to be governed by physical work. Athena's influence would therefore be expected to be restricted. Her power ought to go no further than the power of human labor. But this limit is quickly broken by Ruskin as he concludes his account of Athena. The limit of the imagination of the hand is broken, significantly, by the limitless vision expressed in *words:*

> But there is more to be gathered yet from the words of Pindar. He is thinking, in his brief intense way, at once of Athena's work on the soul, and of her literal power on the dust of the Earth. His "κέλευθοι" is a wide word, meaning all the paths of sea and land. Consider, therefore, what Athena's own work *actually is*— in the literal fact of it. The blue, clear air *is* the sculpturing power upon the earth and sea. Where the surface of the earth is reached by that, and its matter and substance inspired with and filled by that, organic form becomes possible. You must indeed have the sun, also, and moisture; the kingdom of Apollo risen out of the sea: but the sculpturing of living things, shape by shape, is Athena's, so that under the brooding spirit of the air, what was without form, and void, brings forth the moving creature that hath life. [20.265]

Ruskin's diction has become idolatrous: Athena is a "literal power." Her work "actually is—in the literal fact of it" the air's sculpturing power upon the earth and sea. Athena is equated with the Holy Spirit of Genesis as truly creating all living, animate shapes. The word "sculpture," on this level of creation, has undergone a reversal of meaning: it was literal in meaning when associated

with the work of the hands, but it is now figurative in meaning, used to describe the movement of air. At the same time, Athena has undergone a matching reversal: she was a figure of the imagination, but she is now seen as a literal, natural yet divine, power. Ruskin praised Homer for keeping apart the Abstract Sea Power and the actual waves of the sea; Homer thus avoided the pathetic fallacy. But Ruskin himself seems to fall victim to the pathetic fallacy when he confuses the power of Athena with the air.

The extension of Athena's power, as air, over all creation begins with a word quoted from Pindar—κέλευθοι'—which Ruskin interprets as a "wide word, meaning all the paths of sea and land." Such a wide meaning of the word does, in fact, exist in ancient Greek usage, in Homer, for example. But in the context of Pindar's ode, the word expresses simply the Rhodian roads, or paths, beside which the skilfully vital sculpture of the Rhodians arose. These sculptures were, for Ruskin, forms of undeceitful knowledge. Moreover, the road itself, as a sign of manual labor, ought to keep in mind the limits of the imagination. In figuratively extending the sense of the word Ruskin's imagination oversteps its limits and becomes idolatrous.

Ruskin's widening of the significance of the word begins with another misreading of Pindar's ode, made a few paragraphs earlier (20.262). Before Ruskin comes to what is for him the key passage in the ode—the statement of the cunning workman's undeceitful knowledge—Ruskin refers to the cry Athena utters as she is born from Zeus's head: "From the high head of her Father, Athenaia rushing forth, cried with her great and exceeding cry; and the Heaven trembled at her, and the Earth Mother." Ruskin goes on to give this interpretation, plus a new, modified translation of the same lines:

> The cry of Athena, I have before pointed out, physically distinguishes her, as the spirit of the air, from silent elemental powers; but in this grand passage of Pindar it is again the mythic cry of which he thinks; that is to say, the giving articulate words, by intelligence, to the silence of Fate. "Wisdom crieth aloud, she uttereth her voice in the streets," and Heaven and Earth tremble at her reproof. [20.262]

There is nothing in Pindar to sanction the translation "Wisdom crieth aloud, she uttereth her voice *in the streets*," which, in fact, Ruskin has taken from Proverbs 1:20. Ruskin wants the cry to be in the streets, the very streets, as he goes on to say, alongside which the Rhodian sculpture rose up. Ruskin has substituted the streets of Rhodes for the cleft in Zeus's head, struck by Hephaestus. This extraordinary confusion of images is no doubt motivated by Ruskin's concern with the theme of manual labor; the streets, Hephaestus's axe, which strikes the blow and which symbolizes agriculture and shipbuilding, and the fact that, as Ruskin argues, Athena's cry is the "sign" of her gift to the Rhodians of the "best labouring hands in every art," all merge into a single complex in this misreading of Pindar's text. Such a misreading fits,

indeed anticipates, the image that soon follows of the air-Athena sculpturing "all the paths of sea and land." And yet the whole argument has nothing to do with physical labor; the argument is purely mythological. For there is no literal sculptor of the earth (except as a personification from the imagination). The moving sculptures are themselves mythological, as is Hephaestus's action.

Ruskin speaks of manual labor and of sculpture, but his vision of Athena is what he claims "Pindar thinks": "a mythic cry," that is to say, "the giving articulate words, by intelligence, to the silence of Fate," Fate being synonymous with Chaos. By Fate or Chaos, Ruskin means unformed, primordial matter. He is simply making matter speak, making nature tell a mythic tale of its physical process. Ruskin's vision of Athena's power of articulation is not representable in sculpture (though, of course, an inarticulate Athena is). The vision is representable only in words, where the price of the representation is idolatry, or the pathetic fallacy. Ruskin calls language "air," and he characterizes Athena, according to convention, as the goddess of sculpture. But air and sculpture prove to be deceptive terms for the power of linguistic articulation.

Ruskin began his autobiography, *Praeterita*, at about the same time that he was composing his lectures at Oxford. *Praeterita* was one of Proust's favorite works by Ruskin, one that Proust had planned to translate along with *The Bible of Amiens* and *Sesame and Lilies*. A main theme of *Praeterita* is the story of Ruskin's failure as an artist. Ruskin characterizes himself as being unable to do anything well with his hands. He claims that he became a critic of art because he could not hope to become an artist. But perhaps Proust was a better reader of Ruskin than Ruskin. Proust was possibly the first to see that Ruskin, contrary to popular opinion, was not a literal-minded critic. He also recognized that Ruskin was more than a liar, that he was a powerful rhetorician who could make the figurative seem literal. Ruskin's true failure derives from his continual inability to master his own brilliant rhetorical inventiveness. Figurative language provides Ruskin with an unlimited scope for interpretation, for making all that he perceived in nature or "read" in art into meaningful patterns. The failure of these multiple meanings to cohere is no indication of a deformed personality. It is the indication of John Ruskin's remarkably analytic rigor, which guarded vigilantly against ideational or empirical error, even as he idolatrously interposed metaphor before all that he perceived.

Appendix 1

William Bell Scott's *A View of Ailsa Craig and the Isle of Arran* and Ruskin's Pre-Raphaelite Landscape

The sole painting by William Bell Scott in the Yale Center for British Art is a coastal view, in oil, entitled *A View of Ailsa Craig and the Isle of Arran* (fig. 23). There is no evidence that Scott himself gave this title to his little study. It is more than likely that the painting remained untitled until the time it was sold. The title is useful insofar as it situates us in Ayrshire, in the southwest corner of Scotland, tells us that we are looking northwest, and calls attention to those two faintly perceived, rather nondescript land masses in the distance, Ailsa Craig (the smaller one, in the center) and the Isle of Arran. But it is clear that neither Ailsa Craig nor the Isle of Arran is the primary focus of this painting, unlike, say, Clarkson Stanfield's drawing of Ailsa Craig surrounded by sailboats, where, in the words of Black's *Guide to Scotland* (1889) "the face of the rock, flattened and abruptly precipitous . . . with its imposing grandeur" comes through vividly.

Scott's painting belongs to a series of easel studies done in and around Penkill Castle, which overlooks the Firth of Clyde (as seen in the painting). Scott began the series in the summer of 1860—when this painting was done— and continued it intermittently up to the time of his death in 1890. According to James Holloway, of the National Gallery of Scotland, there are several studies of Ailsa Craig in the series, as well as studies of Penkill, the glens that surround it, and the nearby Penwhapple Stream (the subject of Rossetti's famous poem "The Stream's Secret"). I rely on Holloway's authority because few of the drawings, watercolors, and oils in the series have ever been exhibited or reproduced; they have remained in Penkill. In Holloway's words, these views are "the small fragmentary leftovers of private life, never intended for public exhibition." Holloway compares them to a private diary.[1]

Scott himself is uncharacteristically reticent about these paintings and draw-

ings. They are intimately associated with his friend Miss Alice Boyd, whose family owned Penkill, and to whose legatees the paintings have fallen. Here is Scott, in his *Autobiographical Notes* (1892), describing the communion of minds between himself and Miss Boyd in the contemplation of nature. Miss Boyd began as Scott's drawing pupil but seems to have ended as his muse.

> Every summer for nearly ten years I painted there. The "friendship at first sight" was confirmed. Time could not strengthen it, but the impression or instinct of sympathy was changed by experience into satisfied conviction and confident repose. I speak of my own feelings of course. . . . [H]ere at last was a perfect intercourse, made possible by the difference of the sexes. As we sat painting together by the rushing Penwhapple stream, in the deep glen, . . . there had never occurred a misunderstood word or wish which might divide us. My wife had faith in us too, and AB.'s brother as well.[2]

And for her part, here is Miss Boyd recollecting a typical instance of Scott seizing upon a view from the coast on one of their excursions from Penkill. "He always had a great love of the sea, seen from the land, for he was no sailor, and one of the drives he loved best was along the coast, south of Girvan. . . . Sometimes when the sea was very calm he would stop the carriage to listen to the wash of the waves till his eyes filled with tears."[3] The situation Miss Boyd describes could well be similar to the one behind this painting, with its calm sea and coastal setting.

The privacy of the situation behind the painting is in no way a barrier to an interpretation of it. On the contrary, it is ironic that we know so much about this kind of painting, based, supposedly, on intense emotion. The privacy or solitude of perception, the accidental, almost random, discovery of a satisfying view, the inner emotion swelling up as the imagination embraces a panoramic view—what Addison called the "Pleasures of the Imagination"— are a few of the most well published themes, one might say even myths, of eighteenth- and nineteenth-century English schools of landscape painting and poetry. There is a direct, if revisionary, line that goes from Joseph Addison to Edmund Burke to William Wordsworth on up to John Ruskin. Martin Price has neatly summarized the dialectic that makes up this tradition: "[T]he landscape is the outward and correspondent form of the mind that regards it (and in imagination creates it). Therefore the emergence of the natural scene becomes at the same time the discovery of new metaphors for the powers of mind."[4]

What concerns us at the moment is the role of emotion in the discovery of these new metaphors, the reason why Scott should break into tears at the sight of the sea. Price has convincingly demonstrated that as one moves from the discovery of the aesthetic pleasure of sense experience in Addison to Wordsworth's discovery of the mind's ability to seem to penetrate, through sight,

into the very depths of nature's vital forces, there is an accompanying "recognition of the constructive force of emotions in the associative process, their fusion or coalescence of images, to build a structure of problematic epistemological value but great strength and appeal."[5] I hope to make clear very shortly what the epistemological problem of Scott's painting is. For the moment, I wish to emphasize that by the time Scott executed this painting the acute perception of a brilliantly illuminated landscape had become a common metaphor for a heightened emotional state. Here is Scott as he describes the early morning scene outside his window at Penkill:

> From the window the landscape was as still as the house within. The sky was white, the sun unspeakably white, making the shadows of the trees faintly chequer the smooth green terrace. On the point of one of the leaves of a great aloe below, perched a thrush, silent and motionless; two wild rabbits were sitting on the green terrace still as if they were carved in stone. In the clear air every leaf on every tree had an individuality, and every pebble on the walk, as if shade and even colour were defects of nature, yet there was a luminosity at that hour that gave a peculiar unity to the whole scene, removing it from mid-day impressions. It was as if I had looked from the palace of the Sleeping Beauty, in its enchanted and limitless repose. But it suggested a higher tone of feeling than this; it was as if I had awoke into another world beyond the pulsation of the senses, a state of things that would last for ever.[6]

This scene Scott calls an "emotional moment." As the eye moves over each luminous detail, the details seem to coalesce into one brilliantly reflected light, "as if shade and even colours" were defects of nature. The brilliant light suggests an almost transcendental vision—beyond the pulsation of the senses. This vision, in turn, suggests a higher tone of feeling. The movement from acute perception, which requires brilliant light so that one may see clearly individual shadows (the faint chequers), colors and shapes, to a moment of unified, pure vision of light in and of itself is familiar to students of romantic poetry. Light at first defines the landscape with a new clarity, but eventually it becomes a metaphor for an emotionally charged vision on the very threshold of transcending empirical perception. Light is the metaphor that expresses the fusion of associated images through the force of the emotions. It is also the most problematic epistemological value in any painting. No painting can do without color or shadow.

In contrast to the verbal record I have just quoted, Scott's view of Ailsa Craig is primarily concerned with color and shadow. Moreover, to judge from the position of the sun's rays, it is a "mid-day impression"—thus posing the most challenging problem to the unity of perception. Let us assume for the moment that the brilliantly reflected light signifies Scott's emotional attachment to this particular scene. The luminosity of the painting suggests depth of emotion. The problem is to render that light in realistic, not symbolic,

terms. Once brilliant light has been introduced into a landscape it changes the way we see. It makes shadows, shapes, and colors more vivid. It unifies our feelings, but it dissociates our perceptions by the clarity with which it presents the various objects of nature to our eye. The eye does not give up the pulsations of perception for a unified emotional state so easily. A new solution must be found to the problem of structuring associated images, of moving from one image to the next. In the passage from Scott cited above, we move from the point of one of the leaves of a great aloe, past individual leaves and pebbles, to a general condition of luminosity. Is it so easy to move with our eyes similarly in this picture? To move from the striking group of irises in the foreground on the right, through the texture of richly colored grasses and mosses, the shadowy rocks and pebbles, to a glaring reflection of white sunlight in the upper left of the painting? I shall try to answer these questions toward the end of this paper. But first I want to look more closely at this group of irises, which we may take as an epitome of the transition from the idealized yet dim English landscape of the mid-eighteenth century to the more clearly perceived yet unpredictable landscape of the Victorian period.

Paint not the individual streaks of the tulip, Samuel Johnson advises the aspiring artist in *Rasselas*. The artist's concern is not with the individual but with the universal in nature. Johnson's friend, Sir Joshua Reynolds, the greatest art critic in England before Ruskin, followed Johnson in commending the universal over the particular. Reynolds (to quote Price more more) "offers an empirical approach to the 'perfect state of nature,' a method of discerning through 'sober' study the tendencies that actual nature strives to realize but always falls short of attainting."[7] Here is Reynolds applying his empirical approach to the question of "minute particulars":

> [A] nice discrimination of minute circumstances, and a punctilious delineation of them, whatever excellence it may have . . . never did confer on the Artist the character of Genius.
>
> Beside those minute differences in things which are frequently not observed at all, and, when they are, make little impression, there are in all considerable objects great characteristick distinctions, which press strongly on the senses, and therefore fix the imagination. These are by no means, as some persons think, an aggregate of all the small discriminating particulars; nor will such an accumulation of particulars ever express them. . . .
>
> The detail of particulars, which does not assist the expression of the main characteristick, is worse than useless, it is mischievous, as it dissipates the attention, and draws it from the principal point. It may be remarked, that the impression which is left on our mind, even of things which are familiar to us, is seldom more than their general effect; beyond which we do not look in recognising such objects.[8]

Reynolds wrote this in 1782. A brief tour of the exemplary collection of the British Art Center at Yale, particularly of the Wilson bay, and including Turner's *Lake Avernus* in the Turner bay, provides ample illustration of Reynolds's idealized landscape.[9] The light in most of these pictures is soft, and many portions of the foreground are quite dark. In the Constable bay a more dramatic clash of light and shadow may be found, also, in a generally darker tone, however. Most important of all, one does not find any flower or bit of herbage, or piece of grass or leafage painted with as much verisimilitude as the bunch of irises in Scott's painting. Scott has painstakingly delineated the form of these flowers and has tried to reproduce their vivid color as seen in bright light.

Ruskin, often quoting Wordsworth as an authority on the perception of individual flowers and the various effects of sunlight, is the major theorist of Victorian English landscape. Against Reynolds, Ruskin defines landscape painting in terms of exacting representations of nature's particular forms. "Truth" of vegetation, "truth" of clouds, "truth" of rocks—these were the iconoclastic themes of the first volume of *Modern Painters*, in 1843. Only three years later, in the second volume of *Modern Painters*, did Ruskin begin to take up the problems of Beauty and Relation: that is, how the separate truths of nature were to be reunited so as to achieve an imaginative, emotionally satisfying whole. For Ruskin was beginning to find himself trapped in what Reynolds called the "mischievous dissipation of our attention." When Ruskin turned his attention to the problem of the imagination, the results were startling and peculiar, as peculiar as Scott's painting of Ailsa Craig. To look at his painting, one would probably not think of it as very imaginative or very beautiful, though one could sense immediately Scott's attempt to be mimetic, or truthful. But is it truthful? The painting seems to attempt the categories of truth Ruskin set down: rocks, clouds, vegetation, water. Yet, when examined closely, the painting once again poses the problem of unifying these truths.

The problem of this painting, as well as of other so-called Pre-Raphaelite landscapes, was neatly summarized by the French critics of the Paris Exhibition of 1855 in their response to Holman Hunt's *Strayed Sheep* (fig. 24)—which was a pivotal work in the Pre-Raphaelite movement and very possibly an inspiration for Scott's painting here. The French critics

> recognized the picture's originality but had mixed opinions about its success. In general, they agreed that it may have been truthful, but that it did not appear very natural. The *Art Journal*, in a survey of French criticism of English pictures at the Exhibition, quoted the *Athenaeum Français:* "The grass gives the individuality of each blade, each with its own light, its reflection and its shadow—each part astonishes by the truthfulness of its reproduction, and nevertheless the whole wants truth, and wholly fails to recall nature." . . . No painting in the exhibition

was as disconcerting; although it appeared most false, it was [in Théophile Gautier's words] *précisément le plus vrai.*"[10]

In his attempt to record the true brilliance of sunlight on natural form, as directly studied outdoors, Hunt felt the need to free himself from the "conventional schemata of light and shade" (Allen Staley), that is, "from brown foliage, smoky clouds, dark corners; the relation of dark and light areas which had provided the main organization of a picture from Claude through Constable was scrapped." Local color—the color of shadows partaking of the tints of objects on which they are cast—such as you can see in the shadows of Scott's painting, took precedence over a consistent tonal scheme. But the attention to local colors and precise forms seemed to fail to coalesce. Looked at closely, each detail seemed to be true. Looked at from a little farther back, the painting seemed to be garish in color; it disturbed viewers who were more used to an even progression from foreground, to middleground, to background, or who were used to seeing the light of a painting diffused over the scene rather than captured in narrowly focused perceptions.

The situation is similar in Scott's painting. Scott has carefully tinted the shadows brown, grey, and green in an attempt to capture local color. Moreover, the painting seems to invert the conventional scheme of placing shadows at the extremes and light in the center. Scott is deliberately calling our attention to the local truths of shadow in this coastal cleavage in the same way that Hunt sought to call attention to the shadows and colors on a coastal edge. Yet the greens and blues in Scott's painting seem peculiar: they are cool, but the intense light and stillness of the scene suggest warmth. Also, the light on the water is reflected narrowly, suggesting a low-lying, early morning sun, but the (just visible) beam is aimed from a "mid-day" position.

Scott's painting does not, of course, parallel Hunt's perfectly. Scott has moved the sheep farther into the distance and has not focused on the sunlight reflected in their woolen coats as attentively as Hunt has. There is also less attention given to the variety of shadow and color in the foreground foliage in Scott's painting. Where Hunt gives us a mixture of flowers, tendrils, and sheep wool, Scott gives us a simpler contrast of greens and browns, and has shaded in his sheep rather heavily. Yet there is a similar delicacy of observation in Scott's painting, for example, the careful delineation of the shadow on the pole near the lookout and the way the smoke from the ship fades into the glare of the reflected light. The inclusion of these sorts of subtle effects in Scott's painting belongs to the same sensibility that we find in Hunt. The greatest difference between the two paintings is in their respective attention to the sea. Scott has vastly extended the view of the sea, aiming not for the effect of mist, as has Hunt, but dazzling us with a reflected beam. But the attempt

to be precise about color and shadow, within the same sort of setting, playing off vegetation against the sea, vivid greens against atmospheric blues and against exposed earth and rock, invites a comparison between the two paintings.

Hunt claimed that his intense focus on the truth of natural color and shadow had been inspired by Ruskin, especially by the first volume of *Modern Painters*. In an essay on Pre-Raphaelitism (*Contemporary Review*, 1886), Hunt wrote of *Modern Painters* I: "[O]f all readers, none so strongly as myself could have felt that it was written expressly for him. . . . [T]he echo of its words stayed with me, . . . whenever my more solemn feelings were touched in any way." But while Hunt thought that he was painting Ruskinian truths of nature, Ruskin himself was trying to develop some new definition of the perceptual unity of a painting. To bring together the truths of perception, Ruskin realized that an imaginative pictorial language, or "grammar" as he called it, was necessary. As the French critics noted, the individual, detailed truths seemed to require some new structure if local truths were not to end in an impression of visual falsehood.

In the joint context of Hunt's enthusiasm for the Ruskin of *Modern Painters* I and the French critics' pronouncement of *Strayed Sheep* as unnatural, it is ironic that Ruskin seized upon *Strayed Sheep* as one of his prime examples of an accomplished landscape that revealed the pictorial language for which he was looking. To Ruskin, if not to the French critics, *Strayed Sheep* had a unity of visual truth and feeling, but in Ruskinian terms: Ruskin saw Hunt, and the other Pre-Raphaelites, as descendants of the later Turner, and his championing of the Pre-Raphaelites repeated his earlier championing of Turner. In both cases, Ruskin saw truth to nature in an organized form where the rest of the art world saw aberration and visual chaos.

I want to dwell on Ruskin's theory of *Strayed Sheep* for a little while because I think it will help us to understand a great deal about Scott's painting. Ruskin's reordering of the truths of perception in the imagination, and the high value he places on the effects of strong light in this imaginative reordering, help to explain the two striking aspects of Scott's painting that differentiate it from other paintings in the Mellon collection (and, more generally, differentiate Victorian from late eighteenth-century landscape). The two aspects are the irises in the foreground, with their minute particularity, and the brilliant, deliberately off-center light. I have already mentioned, as well, the fact that Scott has inverted the typical Claudean landscape by placing the major block of shadow at the center. With Ruskin, I think we may finally cross over from the irises in the foreground to that reflected beam in the distance.

I pass over several minor references to Hunt's *Strayed Sheep* in Ruskin's

works and turn directly to his climactic interpretation of the painting. Lecturing to his Oxford students in 1883, Ruskin suggests that there is no difficulty in taking in the overall effect of the painting:

> You have, for the last ten or fifteen years, been accustomed to see among the pictures principally characteristic of the English school, a certain average number of attentive studies, both of sunshine and the forms of lower nature, [i.e., vegetation, rocks] whose beauty is meant to be seen by its light. . . . But we forget, in the enjoyment of these new and healthy pleasures connected with painting, to whom we first owe them all. The apparently unimportant picture by Holman Hunt, "The Strayed Sheep," which—painted thirty years ago—you may perhaps have seen last autumn in the rooms of the [Fine] Art Society in Bond Street, at once achieved all that can ever be done in that kind: it will not be surpassed—it is little likely to be rivalled—by the best efforts of the times to come. It showed us, for the first time in the history of art, the absolutely faithful balances of colour and shade by which actual sunshine might be transposed into a key in which the harmonies possible with material pigments should yet produce the same impressions upon the mind which were caused by light itself.
>
> And remember, all previous work whatever had been either subdued into narrow truth, or only by convention suggestive of the greater. Claude's sunshine is colourless—only the golden haze of a quiet afternoon;—so also that of Cuyp; Turner's, so bold in conventionalism that it is credible to few of you, and offensive to many. But the pure natural green and tufted gold of the herbage in the hollow of that little sea-cliff must be recognized for true merely by a minute's pause of attention. Standing long before the picture, you were soothed by it, and raised into such peace as you are intended to find in the glory and the stillness of summer, possessing all things. [33.272–73]

The unified impression of Hunt's picture is thus the result of an act of translation of visual color into mental harmony: peace is the result produced in the *mind by pigments transposed into a harmonious key.* These terms suggest an analogy of color to music—an unoriginal, not unfamiliar, analogy, since Turner as well as major English romantic poets such as Wordsworth or Coleridge often speculated on the translation of visual into mental imagery through terms of music. In Wordsworth and Coleridge, for example, light is often metaphorically expressed in terms of music or seeing is suddenly translated into hearing. Whenever such metaphorical exchanges take place we are usually passing from the realm of the bodily eye, from physical sight, into the realm of the imagination. The imagination arranges the truths of the eye into new, emotionally charged structures of images. Ruskin would therefore dismiss the French critics' response to *Strayed Sheep* as incorrect. If a painting seems to fail to satisfy the bodily eye, if, simply, the painting looks unnatural, it may be the case that it requires an imaginative response. We must read *Strayed Sheep* and other brilliant Pre-Raphaelite paintings not in terms of the "narrow truth" of what the painting sacrifices but in terms of the "recognition" of its

truth. The painting ought to *remind* us of nature, through images of the sea, or of clouds, or of mountains stored in our imaginations.

The conclusion of Ruskin's text recalls Scott's description of the early morning scene outside his window at Penkill, which I quoted earlier from his *Autobiographical Notes*. Scott and Ruskin emphasize peacefulness, stillness, luminosity. But as in all cases of tranquillity in romantic and Victorian poetry and art, the tranquillity belies a tremendous tension. The eye and the imagination often conflict. They founder on what one critic has called the "reef of theoretical irreconcilables."[11] My point should become clear if we ask of Ruskin why landscape paintings such as Hunt's *Strayed Sheep* need to be considered in musical terms. Ruskin gives us a clear, if troubling, answer: *Strayed Sheep* as well as numerous paintings by Turner failed "in their effect on the popular mind" because "it is wholly impossible to paint an effect of sunlight truly. It has never been done, and never will be done. Sunshine is brighter than any mortal can paint, and all resemblances to it must be obtained by sacrifice" (*Academy Notes*, 1859; 14.225). Brilliant sunshine, like that we find in Turner or in numerous Pre-Raphaelite paintings, such as Scott's, gives paintings a truthfulness that earlier, more dimly painted landscapes lacked; bright light is the condition of truthfulness but is itself unrepresentable. Ruskin suggests that we can represent the clear forms of rocks and flowers, and even capture the precise outlines of shadows and their tints, but we can never truly paint the sunshine that enables us to see the rest.

There is a double burden on the imagination: the imagination harmonizes the local truths of a painting, but it tells us that this harmony is really impossible. There is an element of discontent or restlessness in the Ruskinian imagination that we do not find in Reynolds's theory of the imagination, where the imagination is appealed to directly by the sacrifice of local truths. Ruskin seems to have moved the conflict of the colors of a Pre-Raphaelite landscape from the surface of the canvas into the mind itself. To Ruskin, the imagination is the summoning of things absent or impossible; and when the mind is informed as to the true nature of things, the affecting it with a contrary impression is no dishonesty, but an appeal to the imagination (see 8.58, 8.62). Only in a theory of art that attaches such uncompromising importance to the truth of landscape painting could we have such a conflict. Ruskin tries never to forget what is and what is not absolutely true in a painting, even though he assumes that one could still find "pleasure" in such a difficult situation.

Ruskin never satisfactorily resolved the conflicts of the eye and the mind, or local truth and harmonious truth, but he did formalize the conflict in several ways, ways that I think are relevant to Scott's painting. Ruskin made visual truth a property of the foreground of a painting, and he assigned the imagination and "conventional" representation to the background. The phrase "truth of foreground" was coined by Ruskin in *Modern Painters* I, and it is

still used today as a critical epithet for the Pre-Raphaelite landscape. Truth of foreground works in this way: the "more marked objects of the picture may be taken one by one and then examined and known." These particular truths ought to be so "united in all their points that the eye cannot take them by divisions, but is guided from stone to stone, and bank to bank, discovering truths totally different in aspect, according to the direction in which it approaches them." The almost mannered furrows in the cliffs of Scott's painting lead our eye with the sort of forcefulness Ruskin describes. The eye is led from the striking group of irises to the thistles on the right, and then on to the carefully delineated stones and shadows of the lookout. To the left, the curves guide the eye through the carefully drawn and colored grasses and shadows. But note that no matter which sequence we follow we never seem to get very far into the picture. We *know* that the cliffs are receding into the distance, for we see the sheep trailing in from the distance, and the cleavage in the center of the picture seems to thrust the eye in the direction of the sea. But, oddly enough, the movement suggested by the sheep paths and the cleavage is more upward and downward than forward. The visual truths of flowers, rocks, and grasses seem to remain firmly in the foreground of the picture.

Yet Scott, unlike Hunt in *Strayed Sheep*, is clearly attempting to include a massive background of sea, sky, clouds, and islands in his painting. Scott prided himself on his attempts to put a large background into his paintings. He mocked fellow Pre-Raphaelites such as William Morris and Dante Gabriel Rossetti for their inability to make the transition from a carefully laid foreground to a successful background. Vera Walker, Scott's biographer, tells us that Scott frequently chose a foreground of considerable height and a background far below so that he could combine nearness and detail with distance and generality.[12]

But how well does Scott's background work? Scott by and large did not have much respect for Ruskin's theories of art, yet I think that the background of this painting expresses the conflict between the imagination and the eye in precisely the way Ruskin formalized it. At the edge of the cliff there are white dots of paint, which are supposed to represent sheep in the distance as the *eye* would see them. The dots are almost an impressionist depiction of sheep. Up to this point, Scott is being utterly faithful to the eye. Beyond these dotlike sheep there are clearly delineated waves, made up of blue lines painted in a wavelike pattern over the body of the water. No waves ever looked like these. They are conventionalized waves, painted from the imagination or memory, but an imagination that nonetheless is aiming at particularized rather than general form. Otherwise there would be no reason for Scott to paint on the waves, which simulate, if not represent, the movement and multiple reflections of the water. The same excessive yet well-intended form may be seen in the

outline of the clouds in the distance. Because of their vastness and their continuous movement, clouds and water, like light itself, were the two aspects of nature Ruskin thought could never be truthfully—in the absolute sense—represented. They could be painted only from that conflicting source of inspiration, the imagination.

I turn at last to that reflecting beam on the water. The Pre-Raphaelites had developed a technique for vividly rendering local color by painting over a layer of white. In Scott's painting, this technique has broken through the surface of the painting in the reflected sunlight, which, seen close up, looks like an oil impasto. As a representation of light, nothing could be more artificial. The reflection is virtually a "sign" of light, in contrast to the realistic details of the foreground. The sign of light, however, is not intended for the eye. As we pass from the foreground to the background, we must read the painting not with our eyes but with our imaginations.

Appendix 2

"Neither a palace nor of crystal": Ruskin and the Architecture of the Great Exhibition

By pure coincidence, the Crystal Palace (fig. 25), built at Hyde Park in 1851, went up at the same time that John Ruskin was in the middle of writing his most elaborate architectural treatise, *The Stones of Venice*. Ruskin began the work in 1850 and completed it in 1853, just before the reconstruction of the Crystal Palace at Sydenham, in a greatly expanded form, in 1854. *The Stones of Venice* is an ambitious work, even by Ruskinian standards. It attempts to be nothing less than a bible of architecture, which traces, from the ark of Venice, the wanderings of the three architectural tribes descended from Noah: Japheth, the builder of strong, Romanesque arches; Shem, who foliated and spiritualized the arch; and Ham, the servant of the other brothers, who built the Grecian (and possibly Egyptian) pillar. But nowhere in this encyclopedic mythology of architecture is there room for the builders of glass and iron, the builders of the Crystal Palace.

While preparing *The Stones of Venice*, Ruskin, much to the astonishment of the Venetians, would hang from scaffolding, counting the number of stones in the archivolts of a Byzantine palace. Or, he would climb on ladders to sketch for hours the sculptured figures on the capitals of the Ducal Palace. In the bitter winter, much to the consternation of his gondolier, Ruskin would request to be set in the middle of the Grand Canal so that he could sketch the façades of the Renaissance casas. The Crystal Palace, by contrast, was something that Ruskin cared to look at only from afar. From the window of his home at Herne Hill he found that the Crystal Palace obstructed his view of the Norwood hills, and perceived the Palace as a giant cucumber frame stuck between two chimneys. On the opening day of the Great Exhibition at Hyde Park in 1851, Ruskin sat in his study at his parents' home at Denmark Hill, across the Thames, and chose to ignore the opening festivities, writing

in his diary: "All London is astir, and some part of the world. I am alone in my quiet room, hearing the birds sing, and about to enter the true beginning of the second part of my Venetian Work." Even his pamphlet on the reopening of the Crystal Palace at Sydenham opens from a distance: "I read the account in the *Times* newspaper of the opening of the Crystal Palace at Sydenham as I ascended the hill between Vevay and Châtel St. Denis, and the thoughts which it called up haunted me all day long, as my road wound among the grassy slopes of the Simmenthal" (12.417).

Ruskin, therefore, would seem to be the last person whose thoughts on the Crystal Palace we would want. He is famous for his ability to focus his attention on detail; for his perception of the exact curvature of an aspen tree; for his ability to detect the slightest manipulation of shadow in the recess of an ornamental hawthorn, carved into the façade of a Gothic church. Ruskin's collected observations run to thirty-nine stout volumes in the Library Edition of his works, but there are folios of architectural and floral studies that remain unpublished, stored at the Ashmolean Museum in Oxford (fig. 26). Yet Ruskin could not see or think about the Crystal Palace except in passing. Even his pamphlet on the Crystal Palace soon changes course and turns into a plea for an end to the restoration work then being done on ruined abbeys and castles by Gothic Revivalists such as Gilbert Scott in England and Viollet-le-Duc in France. What was it about the Crystal Palace that Ruskin saw, or did not see? Did Ruskin simply ignore the Crystal Palace? Or, as with other gaps in his overarching vision of architecture and sculpture, such as the exclusion of the female nude, did he repress or displace the Crystal Palace?

To answer these questions, which I do not pose in a frivolous way, it is necessary to know something about Ruskin's architectural theories. There are several predominant ideas about Ruskin's theories, any one of which could tempt us to explain too easily his evasion of the Crystal Palace.

First, there is the idea of Ruskin the sentimental neo-medievalist, who wished, vainly, for the industrialized working man to obtain the same dignity and independence of design that the medieval artisan had. This is the Ruskin who seems to idealize the architect in the root sense of the word: the first, or master, builder. This is the Ruskin who names Ghiberti and Niccolò Pisano and Giotto architects in the proper sense, because these men were not mere designers of bell towers or pulpits or baptistries but brilliant sculptors or painters in their own right. Ruskin therefore dismissed the Crystal Palace because it was the result of machine labor. In the construction of the Palace the workers served the engineers and so had no creative contribution to make.[1]

Another idea about Ruskin is that he did not know how a building was actually put together. This view is perhaps best exemplified by Peter Collins. Collins would be the last to deny that Ruskin has left to us the most beautiful descriptions of the cathedrals of St. Lô, Amiens, and Rouen, or vivid de-

scriptions of the play of shadow and color over the polychromatic Venetian mosaics of the churches of St. Mark's and San Donato at Murano. Ruskin's description of the façade of St. Mark's is, in particular, "among the most beautiful in the English language." Yet, Collins argues, Ruskin's sensitivity to the beauty of the façade hides his ignorance of architectural structure. He singles out Ruskin from the other major Gothic Revivalists of the period—such as Augustus Welby Pugin, Viollet-le-Duc, G. E. Street, and Gilbert Scott—because Ruskin had practically no experience of building methods: "[*The Stones of Venice*] shows how [Ruskin's] deeply felt emotion could transmute architecture into literature without contributing anything at all to the public's understanding of the problems of architectural design, or of the nature of building as such."² Ruskin, by this argument, simply was unable to appreciate Joseph Paxton's revolutionary design and his adaptation of new materials, glass and iron. Ruskin reveals his (supposed) ignorance when he compares, in his pamphlet, the Crystal Palace to a frigate or a suspension bridge—two technologies about which Ruskin certainly knew nothing.

Finally, and perhaps most damaging of all, there is the idea, derived from the other two, that Ruskin so confused the sculptor with the architect that he lost sight of the architect altogether and spent all his energies analyzing the sculptural ornaments of Gothic architecture. It is not difficult to find many texts in Ruskin's works that seem to support this criticism. For example, Ruskin was enthusiastic about the new Oxford Museum of Natural History, whose quasi-Venetian Gothic façade was largely inspired by his own writings. With his friend Henry Acland, then Regius Professor of Medicine and later an advocate of Ruskin's election to the Slade Professorship of Fine Arts at Oxford, Ruskin published two letters on the opening of the Museum in 1859. In the second of these letters, he writes: "I am entirely glad . . . that you have decided on engraving for publication one of O'Shea's capitals [James O'Shea being the Irish sculptor who carved many of the floral ornaments on the capitals of the museum]; it will be a complete type of the whole work, in its inner meaning, and far better to show one of them in its completeness than to give any reduced sketch of the building" (16.231). The designers of the building, Deane and Woodward, are neglected for the sake of O'Shea. In the single sculptured capital the reader is meant to see an epitome of the science museum and is meant to understand, in principle, the Gothic style's "faith in nature." Similarly, in *The Stones of Venice*, Ruskin typifies the architectural history of the Ducal Palace by describing each of the eight sides of the thirty-six capitals of the Palace's pillars. Ruskin's myopic point of view suggests that he missed the intended effect of the Crystal Palace, which was based on volume, symmetry, and repetition—difficult aspects to typify in a single ornament.

Yet none of these criticisms explains Ruskin's evasion of the Crystal Palace.

Each criticism begs a definition of architecture. From Ruskin's point of view, the architects of the Royal Academy, the administrators in the government schools of design, and the engineers of the principal railway companies—the main bodies that could take responsibility for the achievement of the Great Exhibition—separated labor from design, beauty from function, and ornament from architectural structure.[3] Unfortunately, the division of architecture into separate categories, such as design, ornament, function, was occurring at the same time that Ruskin was attempting a philosophical synthesis of these same categories in *The Stones of Venice*. Several years later, in the preface to a series of lectures on the role of art in manufacturing and design, published in 1859 under the title *The Two Paths*, Ruskin looked back on his alienation from the architectural profession and explained it as the consequence of the fragmentation of the architect's training and duties. Ruskin reverses the criticism that he was attached to the ornamental surface of a building and places the architects in the niches instead. Adopting one of his favorite, if common, metaphors, the organic unity of the plant, Ruskin compares his unified vision to the narrow vision of the architects:

> We are all of us willing enough to accept dead truths or blunt ones; which can be fitted harmlessly into spare niches, or shrouded and coffined at once out of the way. . . . But a sapling truth, with earth at its root and blossom on its branches . . . most men . . . dislike the sight or entertainment of, if by any means such a guest or vision may be avoided. And, indeed, this is no wonder; for one such truth, thoroughly accepted, connects itself strangely with others, and there is no saying what it may lead us to.
> And thus the gist of what I have tried to teach about architecture has been throughout denied by my architect readers. . . . [16.251–52]

To his architect readers, Ruskin did indeed seem to make strange connections, and there seemed to be no saying what his arguments might lead to. In the simultaneous conception of a literary work such as *The Stones of Venice* and an architectural work such as the Crystal Palace, we suddenly seem to find ourselves at the crossing of two philosophical paths. To Ruskin, the Crystal Palace seemed to be meaningless, or unreadable, an "unwritten page," as George Hersey has called it.[4] In his pamphlet on the building, its blankness comes through in a series of metaphors having to do with whiteness. The leaps from the Crystal Palace to the discussion of restoration work, which was defacing the cathedrals of Normandy, and from the restoration work to the mass boulevardization then going on in Paris, precipitated by the earlier introduction of the arcades, or little Crystal Palaces, are made through metaphors of whiteness. The "white accuracies of novelty" appear first in the gables of the cathedrals; Paris becomes a "whitened city praised for its splendour"; the houses of Normandy are "whitewashed" and so lose their ornamentation. Each of these images refers back to the central image of whiteness haunting Ruskin,

Paxton's Crystal Palace. Whiteness is Ruskin's metaphor for erasure, for blankness: for the erasure of the past in novelty, a sort of mass amnesia, leading to a "new born population without a record and without a ruin," for the erasure of beauty in the repetition of a single form, for the erasure of the Gothic ornament with its power to recall nature. In his manipulation of the metaphor of whiteness, Ruskin gives us a simple example of how his arguments connect, even if to his contemporaries the connections seemed strange. As a rhetorical argument, Ruskin's vision of the spread of mnemonic whiteness over the monuments of the past, out of which we constitute our selfhood, is comparable to Pope's vision, at the conclusion of the *Dunciad*, of the Goddess of Dulness spreading her stupefying mists over the churches, chapels, schools, and halls of England.

To the engineers who were Paxton's colleagues, and who were trained in the construction of railways and suspension bridges, to the engineers who were literally path-makers, the Crystal Palace was far from a blank page. It conveyed accomplishment: the largest building of its time, the first assembled out of modular components, an impressive refinement of greenhouse technology. But to Ruskin these aspects of the Crystal Palace were reducible to pride: "haughty with hope of endless progress and irresistible power"; and pride, to Ruskin, was the first sign of forgetfulness, and for the loss of the ability to see natural beauty or to read a historical legend in a work of architecture.

"Neither a palace nor of crystal," Ruskin quipped in a parenthetical remark in the second volume of *The Stones of Venice* (10.114), which translates into neither a historical expression, appealing to our memories in the way the sight of the Ducal Palace does, nor a reference to nature, a crystal being generally angular, not rounded, in shape. Thus the so-called Crystal Palace was mute, expressionless. Its clear glass surface could not age and thereby gain historical character in the way that a stone building with carvings could. Its absence of naturalistic ornament severed it, in Ruskin's mind, from the organic path of discovering the interrelatedness of facts. On the façade of St. Mark's, Ruskin claimed, the careful observer could find nature symbolized but also purposefully ordered. The vital relation of leaf to stem is emblematized, but the lines of carving also direct light and shadow in harmonious arrangements as the sun passes over the façade. But the Crystal Palace was one monotonous equation repeated ad nauseam.

I do not think Ruskin would have reacted so strongly to the Crystal Palace were it not such an antithesis to the architectural philosophy he was just bringing to maturity. The Crystal Palace challenged Ruskin's treatment of ornament as symbolic expression and picturesque value. Most of all, it challenged the totality of what he called the Organic Path. It substituted, on a mass scale, a simple, predictable form for a complex one. It threatened to make the public response to architecture passive, negligent, superficial.

One of the most difficult chapters in *The Stones of Venice* is the second chapter of the first volume, entitled "The Virtues of Architecture." This chapter, as well as the twentieth chapter in the same volume, on the material of ornament, cost Ruskin the greatest labor to compose, as revisions in his manuscripts indicate. The chapters contain pivotal arguments in Ruskin's architectural philosophy, yet there are few references or discussions of these chapters in books on Victorian architecture, or even in books on Ruskin, including books on Ruskin's theory of architecture.[5] Perhaps this accounts for the oversimplified versions of Ruskin's views they contain. I cannot attempt a summary of these two complex chapters in this brief paper. Instead, I would like to focus on an appendix Ruskin added to the second chapter in which he distinguishes his concept of architecture from one put forward by James Fergusson in his *Principles of Beauty in Art* (1849), specifically Fergusson's sixth chapter, "The Classification of the Arts." In Ruskin's appendix, entitled "Mr. Fergusson's System" (9.440–44), I think we may see how Ruskin could properly feel that it was the engineers, especially in the case of a building like the Crystal Palace, who were fragmenting the public's perceptions and blotting out their historical consciousness.

The chapter on the virtues of architecture opens with a division of architecture into two, and then suddenly three, virtues. Ruskin writes that we may ask of a building that it perform a practical duty well and that it be "graceful and pleasing in doing it." It turns out that practical duty can be subdivided into two branches, acting and talking: "acting so as to defend us from weather or violence; talking, as the duty of monuments or tombs, to record facts and express feelings; or of churches, temples, edifices, treated as books of history, to tell such history clearly and forcibly." Thus we have three branches of architectural virtue: that a building be useful, "that it speak well, and say the things it was intended to say," and that it "look well." The second virtue, that a building should speak well, immediately becomes problematic. We can usually tell if a building is serving a practical purpose well and we can usually tell if a building is aesthetically pleasing by its proportions, natural setting, and decoration. But it is impossible to establish how well a building speaks because, Ruskin says, there are "countless methods of expression"—some conventional, some natural. Nevertheless, difficult though it may be to tell what a building is saying, Ruskin's major architectural insight lies in his attention to this problematic virtue. Ruskin, as we ought to know, was not being eccentric in asking of a building that it speak well. George Hersey has shown the prevalence of the theory of speaking architecture in his study of the High Victorian Gothic style.[6] That architecture addressed the intellect in a speech of its own was a Victorian commonplace. Buildings, to the Victorians, spoke as distinctly as, say, fashions, or costumes, speak today, as when we think of adopting an image by changing the way we dress. What is aston-

ishing, perhaps, about the Victorian architectural mentality is the ease with which any single architectural unit could be said to have the power of speech. Ruskin, in his more playful moods, could take a fence and virtually make it sing.

To draw us quickly into the Victorian frame of mind, I quote Ruskin on fences from *The Two Paths:*

> [There is a] garden or park wall of brick, which has indeed often an unkind look on the outside, but there is more modesty in it than unkindness. It generally means, not that the builder wants to shut you out from the view of his garden, but from the view of himself. . . .
>
> [Next comes your] wooden paling, which is more objectionable, because it commonly means enclosure on a larger scale. . . . Still, it is significative of pleasant parks, and well-kept field walks, and herds of deer, and other such aristocratic pastoralisms. . . .
>
> Next to your paling comes your low stone dyke, your mountain fence, indicative at a glance either of wild hill country, or of beds of stone beneath the soil; the hedge of the mountains—delightful in all its associations, and yet more in the varied and craggy forms of the loose stones it is built of: and next to the low stone wall, your lowland hedge, either in trim line of massive green, suggestive of the pleasances of old Elizabethan houses, and smooth alleys for aged feet, and quaint labyrinths for young ones. . . . And then last, and most difficult to class among fences, comes your hand-rail, expressive of all sorts of things; sometimes having a knowing and vicious look, which it learns at race-courses; sometimes an innocent and tender look, which it learns at rustic bridges over cressy brooks; and sometimes a prudent and protective look, which it learns on passes of the Alps. . . . But what meaning has the iron railing? . . . Your iron railing always means thieves outside, or Bedlam inside;—it *can* mean nothing else than that. [16.388–91]

Ruskin, to use a modern term, is free-associating in this passage. In his more solemn moods, Ruskin treated the question of architectural "voice" with great care and subtlety as the crucial aspect of an architectural style. The reason Ruskin seemed to spend so much time treating ornamentation in *The Stones of Venice*, devoting a lengthy chapter to the conventionalization of the physical world in ornament, was that Venice seemed to speak so powerfully to him. To Ruskin, studying Venice was equivalent to studying the Bible, as Proust, in his essays on Ruskin, has shown. And Ruskin did not want to miss a syllable.

In the appendix to the second chapter, it turns out that the virtue of speech, though it is the most problematic of the virtues, governs and integrates the other virtues of practicality and beauty. The unity of the virtues causes Ruskin to dissociate himself from any comparison to Fergusson's *Principles of Beauty:*

> The reader may at first suppose this division of the attributes of buildings into

action, voice, and beauty, to be the same division as Mr. Fergusson's, now well known, of their merits, into technic, aesthetic, and phonetic.

But there is no connection between the two systems: mine, indeed, does not profess to be a system, it is a mere arrangement of my subject, for the sake of order and convenience. [9.440]

Ruskin proceeds to show how the technical, aesthetic, and phonetic aspects of architecture cannot be systematized because they are inseparable. Fergusson's central error, suggests Ruskin, is in his original division of man into muscles, senses, and intellect, as if architecture could correspond in function to one of these divisions without involving the others at the same time. But a muscular or technical expression, Ruskin argues, could very well have a phonetic or intellectual significance. Carving can be as meaningful as writing. (Indeed, writing originates out of carving.) Similarly, the aesthetic disposition of light and shadow by means of ornamental carving appeals not only to the eye but to the intellect; the manipulation of light suggests the sublimity of man's power of design.

Ruskin proceeds to argue that a systematic division of topics has its usefulness, but it should never be forgotten that the system is arbitrary. If we err in believing too literally any system of classification, we run the risk of limiting our ability to understand. Architectural speech, unlike building materials or geometric patterns of color and shadow, can never be fully systematized, and precisely for that reason it is the highest virtue a building can have. Later in this appendix, Ruskin gives an example of the difference between system and speech with reference to mineralogy:

[T]o any person who is really master of his subject, many different modes of classification will occur at different times; one of which he will use rather than another, according to the point which he has to investigate. I need only instance the three arrangements of minerals, by their external characters, and their positive or negative bases, of which the first is the most useful, the second the most natural, the third the most simple; and all in several ways unsatisfactory.

But when the subject becomes one which no single mind can grasp, and which embraces the whole range of human occupation and inquiry, the difficulties become as great, and the methods as various, as the uses to which the classification might be put; and Mr. Fergusson has entirely forgotten to inform us what is the object to which his arrangements are addressed. For observe: there is one kind of arrangement which is based on the rational connection of the sciences or arts with one another; an arrangement which maps them out like the rivers of some great country. . . . There is another kind of classification which contemplates the order of succession in which they might most usefully be presented to a single mind, so that the given mind should obtain the most effective and available knowledge of them all; and, finally, the most useful classification contemplates the powers of mind which they each require for their pursuit. [9.443]

To adapt Ruskin's argument here to the Crystal Palace, one could say that the architecture of the Palace is like a map to the distant viewer. The countries have been placed on an axis, Britain and her colonies to one side, Europe and America to the other. Within the Palace, the viewer walks in an order of succession and observes each country displaying something in which it excels (fig. 27). As such, the Crystal Palace is an exemplary, and very useful, mode of classification. But to Ruskin it was definitely not a novel order of architecture, as he makes very clear in his pamphlet.

Replying to Mr. Samuel Laing, chairman of the Crystal Palace Company at Sydenham, and a former chairman of the London, Brighton and South Coast Railway, Ruskin says: "[W]e suppose ourselves to have invented a new style of architecture, when we have magnified a greenhouse!" For the Crystal Palace does not address the crucial power of the mind, the ability to make architecture speak, to transform it into symbolic statement. The Crystal Palace, in substituting a technical structure for an ornamental surface, and in simplifying the aesthetic play of light and shadow in the transparency of a wall of glass, becomes like Fergusson's system. It isolates technique and senses from speech, and so becomes mute, meaningless, a lower order of classification. And similarly to Fergusson's system, the Crystal Palace easily makes us forget its simple, temporary purpose, so that an arbitrary scheme for an exhibition becomes, to the chairman of the committee, a novel order of architecture. The Crystal Palace, though it is crystal clear and bright, blinds us intellectually. If, as Ruskin frequently argues, taking over many commonplaces from the doctrine of the sublime, intellectual design is figured in the division of light and shadow, then the Crystal Palace is a figure of the purely white forgetfulness of the noncreative system.

Ruskin pushed his analysis of architectural speech further than any of his contemporaries, as George Hersey has shown. Hersey even calls *The Stones of Venice* an "apotheosis" of the Victorian doctrine of architectural speech. The ecclesiologists, and functionalists such as John Claudius Loudon and Archibald Alison, made remarkably superficial associations between appearance and meaning in architecture. The usual superficiality of the association comes through in Ruskin's playful discussion of fences, where a single hedge may signify an Elizabethan history, a lover's labyrinth, or the pleasures of softness to old feet. The only "system" Ruskin ever applied to architectural speech in all seriousness was "nature": "The law which it has been my effort chiefly to illustrate is the dependence of all noble design, in any kind, on the sculpture and painting of Organic Form." But as the definition of the Organic Path which immediately follows this statement suggests, this system is really no system, for the truths are strangely connected and there is no saying what the organic path may lead to. The crudity of Victorian associationism comes through in the very designation of Paxton's glass structure: Crystal Palace.

Crystal could be equated with glass by superficial association, but the exhibition hall, being totally devoid of historical context, could be called a palace perhaps only in terms of sheer quantity of material wealth.

In Ruskin's use of the term "crystal," by contrast, we have one of his most powerful metaphorical interpretations of "architecture." All the "powers of mind" alluded to in the appendix on Fergusson, which no mode of classification can capture, are metaphorically represented for Ruskin in the crystal. References to crystals run throughout Ruskin's architectural writings and even turn up as the ruling metaphor of a series of fabulous dialogues written for the schoolgirls of Winnington, entitled *The Ethics of the Dust* (1866). The fables often seem painfully didactic to the mature reader, but they demonstrate, in simplified form, Ruskin's remarkable capacity for synthetic judgment. The dialogues begin with a scientific examination of "foliated and granular" crystals, "The Crystal Orders," then shift to the morality of the "Crystal Virtues," purity and strength. Another dialogue moves on to the inevitable conflicting of geological strata, called the "Crystal Quarrels." The dialogue on "Crystal Caprice" makes an explicit analogy between geological disruption and the decay of the Gothic brought on by the Flamboyant school. Finally, we have the "Crystal Rest," in which geological, architectural, and moral order win out over catastrophe.

In his first major work on architecture, *The Seven Lamps of Architecture* (1849), Ruskin refers to crystals in a very superficial way; later in his career, he was to look back upon these references as hasty, premature thoughts. Adopting the Alisonian psychology, then common, Ruskin defines beauty as the ability of a perceived object to call up, in the viewer's mind, familiar memories. Ruskin explains the "ugliness" of the Greek design on the Casa Grimani in Venice (fig. 28; Casa Grimani shown right of center) by the rarity of its crystalline associations in the memory. The frets remind one of bismuth. "But crystals of bismuth not only are of unusual occurrence in every-day life, but their form is . . . unique among minerals. . . . I do not remember any other substance or arrangement which presents a resemblance to this Greek ornament. . . . On this ground, then, I allege that ornament to be ugly" (8.143). Here we detect Ruskin making an aesthetic judgment in a crude way. Rather than suggest the frets do not resemble anything, Ruskin stretches their resemblance to the rarest of crystals, even if that forces the building to become ugly in principle.

Two years later, when Ruskin began *The Stones of Venice*, he went beyond this sort of crude associationism, as the doctrine was called. Crystals had become the "arch"—in multiple senses of the word—of his theory of architecture. The crystal was the "arch" in the Greek sense *arkho*: the first or chief principle of architecture. The crystal is a figure of the power of design inherent in the human mind.[7] Ruskin's most famous architectural statement is his

chapter entitled "The Nature of Gothic" in the second volume of *The Stones of Venice*. (This chapter and *Sesame and Lilies* are Ruskin's two most widely read works.) Ruskin's diaries show that he conceived approximately half of this chapter on the theme of the "crystal" as visible intellect. The chapter's central concern, with reference to Gothic architecture, is to demonstrate the integration of the creative laborer with the intellectual mastery of the designer, and to reconcile the specific ornamental representation of leaves, flowers, birds, and devils with a contemplation of the divine battle of God against Satan. As a dialectical reading of Gothic architecture, the chapter repeats the thrust of the appendix on Fergusson. Specific systems, such as the class of floral ornaments, must give way to a higher, unpredictable act of contemplation, in this case the medieval man's awareness of temptation and his sense of imperfection.

The crystal is also an "arch" in the literal sense, derived from the Latin *arcus:* that is, a trefoiled, Venetian pointed arch, which Ruskin considered the building block of the Gothic style, just as crystals are the building blocks of the earth. The trefoiled arch in Gothic architecture was simple yet remarkably strong. It was capable of much decorative variation. It could be read as a symbol of the Trinity. And it appealed to the mind because its pointedness was as familiar as the pointedness of the common crystal. The literal equation of the arch point with the crystalline point is the one remnant of associationism in Ruskin's theory of the Gothic, but Ruskin adds that the arched point was *not* intended to imitate the crystalline point. It simply leads the memory back to an awareness of the prevalence of crystals.

Finally, Ruskin treats the crystal itself, without reference to the properties of the mind or the Gothic arch, as the "systematized natural structure of the earth." As such, it functions in its natural forms as ornament. In his lengthy chapter on ornament in *The Stones of Venice*, Ruskin makes the crystal, and not the more sublimely associative mountain, one of the principal memories expressed in the ornamentation of the Gothic.

> [The crystalline form] is an endless element of decoration. . . . The four-sided pyramid, perhaps the most frequent of all natural crystals, is called in architecture a dogtooth; its use is quite limitless, and always beautiful: the cube and rhomb are almost equally frequent in chequers and dentils; and all mouldings of the middle Gothic are little more than representations of the canaliculated crystals of the beryl, and such other minerals. [9.271]

The prevalence yet variety of the crystal form in nature makes it one of the key "systems" of ornament. In using the word "system" to describe the crystal, Ruskin intends the same meaning as in the appendix on Fergusson: one class of geology, crystals, provides effective and available knowledge, easily grasped

by a single mind. Crystals, to adapt Jonathan Swift, are proper ornaments in their proper subordinate place on a building.

Only an architectural philosophy based on a much broader vision of the Organic Path could reach such an insight. Ruskin's crystal metaphors may seem strange and unpredictable, yet it is Ruskin who sees that crystals, not mountains, are feasible sources of beauty, while it is the "poetical public" (as Ruskin calls them) who designate a mountain-sized work of architecture a crystal.[8] It often is not easy to follow Ruskin in his metaphorical leaps along the different crystal paths of interpretation, but we know, at least, that if the interpretation seems to be going astray, it is for the sake of trying to discover another level of architectural speech, which cannot be systematized. Ruskin does not make "systematic" errors of forgetfulness which are liable to end up in muteness and blankness.

I am not claiming that Ruskin's crystal metaphors are valid, or truthful; no metaphor could be. But if architecture is to speak, as the Victorians, at least, thought it must, then Ruskin, not Paxton, was making the crucial discoveries. Why, therefore, I repeat, was Ruskin haunted by the Crystal Palace? I would like to draw to a conclusion by suggesting an answer.

Parallel to the development of his metaphors of crystals, in the movement from *The Seven Lamps of Architecture* to *The Stones of Venice*, was another de-velopment in Ruskin's thought: the recognition of the inevitability of the col-lapse of Gothic architecture—the most expressive sort of architecture—into hollow formalism. The collapse, as Ruskin saw it, was brought on by the overdevelopment of Gothic tracery. One of the few passages in *The Seven Lamps of Architecture* that Ruskin looked back upon with satisfaction was his discus-sion of the "momentous" collapse of Gothic ornament in the overdevelopment of tracery. And the famous chapter on the nature of the Gothic in *The Stones of Venice* concludes similarly with a discussion of excessively foliated tracery that heralds the collapse of the Gothic (10.264–69). In these discussions of tracery we have the key to Ruskin's hatred of the Crystal Palace. The Crystal Palace is a sort of monument of pure tracery, and to Ruskin it probably signaled the complete undoing of his own crystal vision of architectural expressiveness, just as Gothic tracery had undone the Gothic pointed arch, which Ruskin associated with the order of crystals.

Ruskin describes the destruction of the pointed arch by tracery in the *Seven Lamps* in this way (see fig. 29):[9]

> [T]racery arose from the gradual enlargement of the penetrations of the shield of stone which . . . occupied the head of early windows. . . . [T]he frequent and typical form is that of the double sub-arch, decorated with various piercings of the space between it and the superior arch; with a simple trefoil under a round arch, in the Abbaye aux Hommes, Caen . . . with quatrefoils, sixfoils, and sept-foils, in the transept towers of Rouen . . . with a trefoil awkwardly, and a very

small quatrefoil above, at Coutances, . . . then, with multiplications of the same figures . . . giving very clumsy shapes of the intermediate stone, (. . . from one of the nave chapels of Bayeaux,) and finally, by a thinning out of the stony ribs . . . like that of the glorious typical form of the clerestory of the apse of Beauvais.

[Now, Ruskin continues,] during the whole of this process, the attention is kept fixed on the forms of the penetrations, that is to say, of the lights as seen from the interior, not of the intermediate stone. [The] drawings of the traceries as seen from within, [show] the effect of the light thus treated, at first in far off and separate stars, and then gradually enlarging, approaching, until they come and stand over us. . . . That tracery marks a pause between the laying aside of one great ruling principle, and the taking up of another. . . . It was the great watershed of Gothic art. Before it, all had been ascent; after it, all was decline. . . .

The change of which I speak, is expressible in a few words; but one more important, more radically influential, could not be. It was the substitution of the *line* for the *mass*, as the element of decoration.

. . . Up to that time, up to the very last instant in which the reduction and thinning of the intervening stone was consummated, [the architect's] eye had been on the openings only, on the stars of light. . . . But when that shape had received its last possible expansion, and when the stonework became an arrangement of graceful and parallel lines, that arrangement, like some form in a picture, unseen and accidentally developed, struck suddenly, inevitably, on the sight. It had literally not been seen before. [8.88–91]

Ruskin goes on to explain in detail how the sudden delight in visible lines took over the imagination of the architects. The lines of tracery grow ever more intricate and delicate. The weblike transformation of the stone degenerates into tracery for its own sake. The lines no longer have the power to manipulate light and shadow, but become instead flamboyant linearity, meaningless invention, devoid of associative power, unlike the trefoils whose light came through a flowerlike shape to spread itself over the surface of a wall like starlight. The intellectual manipulation of light ends in pride and a certain kind of perceptual chaos, which leads, in turn, to the decline of the Gothic arch.

Ruskin repeats this argument in a slightly different form at the conclusion of the chapter on the nature of the Gothic. Ruskin begins: "Of what I stated in the second chapter of the *Seven Lamps* respecting the nature of tracery, I need repeat here only this much, that it began in the use of penetrations through the stonework of windows or walls, cut into forms which looked like stars when seen from within, and like leaves when seen from without" (10.259). The principle of foliation, or the curvilinear carving of the arches, begins to overdevelop, like the penetration of the tracery. Ruskin defines "noble" imagination as the disposition of traceries associated with floral or animal ornament. Inventive and progressive architecture uses the foliation principle, or curvilinear principle, moderately, but the actual sculpture of floral and

figure ornament is used profusely. Poor imagination reverses the relationship: it uses linear foliation profusely, floral and figure sculpture moderately. "The two schools touch each other at the instant of momentous change dwelt upon in the *Seven Lamps*," Ruskin claims. Ruskin illustrates the clash with a plate showing six different figures ("Linear and Surface Gothic," 10.262; see this book's fig. 30). Figure 1 shows a frieze around one of the windows at Rouen cathedral. The foliation is carried around the arch, and the principal cusp is the point of intersection of three kinds of curve. Figure 2 represents half of an eight-foiled aperture from Salisbury; there is foliation in the larger disposition of the star, but it is subdued at the points. Similarly, in figures 3 and 5, both from the lateral niche of a church at Abbeville, the crockets are so filled with various patterns of foliation that the whole comes to resemble "lace." The pinnacle from Verona, figures 4 and 6, however, "depends for its effect on one broad mass of shadow, boldly shaped into the trefoil on its bearing arch. . . . All the rest of the decoration is floral, or by almonds and bosses; and its surface is unpierced, and kept in broad light."

To Ruskin, the manipulation of light by sculptured bosses was preferable to the over-refinement of carving for its own sake. When line supersedes surface the Gothic is in jeopardy. The lines of Gothic are not really comparable to the extended lines of the Crystal Palace, but I suggest that, to Ruskin, the linearity of the Crystal Palace was not only mute, but, like the linear Gothic, a sign of decay. The systematization of lines, typified perhaps better by the Crystal Palace than by any possible example of Gothic tracery, represents the isolation of technique from architectural voice and aesthetics. Like Fergusson's system, the Crystal Palace fractures the power of contemplation. If contemplation is not perfectly expressible, as Ruskin suggests in the appendix on Fergusson, it at least impels us to connect, to follow the Organic Path from visual ornament to symbolic expression. The term "crystal" is merely one of Ruskin's numerous metaphors for this contemplative path. Ruskin adopts different metaphors for different subjects. We should never interpret too literally the metaphorical impulse in Ruskin, his search for an image that seems to sum up the density of possible associations.

Architectural historians err when they assume that Ruskin's condensation of a building's voice to a single ornament reveals his lack of perception of the building as a whole. When, for example, Ruskin singles out an iron spandrel of horse-chestnut leaves, designed by F. A. Skidmore for the Oxford Museum (fig. 31), and treats the spandrel as a type of the museum, he shows the unity of his thought. Ruskin suggests that this spandrel, though deviating from nature in the excess curvature of its wrought-iron boughs, has a "suggestive and informative power" (16.233), in other words, a metaphorical power of leading the mind on to test its recollection of nature's curvilinear lines against Skidmore's design. Were Skidmore's lines just a bit more mannered, he might

lead the viewer astray by the attractiveness of the lines themselves, seen as
the product of the architect's fancy. Ruskin reads architecture along subtle
lines like these, along paths that continuously open into the metaphorical or
close into system. The Crystal Palace, as perfect systematization of the ab-
stract line, signals to Ruskin the end of architecture as one possible mode of
contemplation.

The development of the Crystal Palace was largely the work of railway men.
Paxton was a railway board member as well as a horticultural engineer. The
contracts for the Palace went to engineers with railway building experience.
There is even a story that Paxton conceived the Crystal Palace while on a
railway journey. In a haunted way, Ruskin intuited the monotonous regulation
of construction prefigured by the Palace, but could only imagine it, I think,
as the ultimate form of tracery, or as part of the development of glass and iron
roofing then used in railway stations or even on the roof of the Oxford Museum
(for Acland had decided that he wanted the museum to make at least some
use of new "railway materials"). The brilliant German literary critic, Walter
Benjamin, coming about seventy years later, looked back and recognized the
influence of the railway more directly than Ruskin. Discussing the emergence
of the Parisian arcades, which prefigure the Crystal Palace in their glass and
iron roofing, Benjamin wrote:

> In iron, an artificial building material makes its appearance for the first time in
> the history of architecture. It undergoes a development that accelerates in the
> course of the century. The decisive breakthrough comes when it emerges that the
> locomotive . . . could only be used on iron rails. The rail becomes the first pre-
> fabricated iron component, the forerunner of the girder.[10]

Benjamin did not see the arcades as the end of architectural voice, a Victorian
personification of an object he would, in any case, have questioned; like Rus-
kin, he saw the glass and iron construction of the arcades causing a readjust-
ment of perceptual awareness. Ruskin thought that glass and iron architecture
could not be read. Benjamin thought that it exerted its strongest influence in
the "shock-experience." The mind cannot take in the increase of scale grad-
ually; the scale impinges on the mind too quickly to be interpreted, or read.
The result: the "flâneur," or stroller, typified for Benjamin in the populariza-
tion of the panorama picture. The panorama is an elongated picture that
mimics reading as we absorb it, like the lines on a page, looking from one
end to another. But the panorama is, in fact, a discontinuous mode of per-
ception; we easily forget what went behind, nor do we anticipate what comes
ahead. We might call such a condition a path, but it is not John Ruskin's path,
where things may be strange, but where they always connect.

Notes

Chapter 1

1 Ruskin's drawing masters include A. V. Copley Fielding, Samuel Prout, J. D. Harding, and David Roberts. Paul Walton, *The Drawings of John Ruskin* (New York: Oxford Univ. Press, 1972), has offered the best account of the development of Ruskin's technique, which proceeds from the picturesque toward an increasingly vortexlike arrangement of details not localizable in space.

2 R. H. Wilenski, *John Ruskin* (London: Faber and Faber, 1933), has performed the lengthiest psychoanalysis of Ruskin as a manic depressive whose artistic theories reflect his own alternations among euphoria and apathy and boredom with art. For a connection between Ruskin's wife, his study of ornament while in Venice, and Sir John Everett Millais, see Nicholas Penny, "Ruskin's Ideas on Growth in Architecture and Ornament," *British Journal of Aesthetics* 13 (1978): 276–86.

3 Patricia M. Ball, *The Science of Aspects: The Changing Role of Fact in the Work of Coleridge, Ruskin and Hopkins* (London: Athlone Press, 1971), p. 81.

4 I take this definition of epistemology from Richard Rorty, *Philosophy and the Mirror of Nature* (Princeton: Princeton Univ. Press, 1980), pp. 132–34.

5 Quoted in Rorty, p. 136.

6 Walter E. Houghton is particularly helpful on this uncertainty. Beneath what he calls the "mask" of Victorian infallibility and its self-serving "epistemological basis for dogmatism," he finds extreme uncertainty. Ruskin, and other Victorian prophets, "were often plagued with doubt, and their dogmatism was as natural as it was rhetorical." In Ruskin Houghton notes a severe tension between an egotistical sense of infallibility and humility. See *The Victorian Frame of Mind* (New Haven: Yale Univ. Press, 1957), pp. 137–60.

7 W. G. Collingwood, *The Life and Work of John Ruskin* (Cambridge, MA: Houghton Mifflin, 1893), 1:133.

8 See Francis G. Townsend, *Ruskin and the Landscape Feeling: A Critical Analysis of His Thought During the Crucial Years of His Life, 1843–1860*, Univ. of Illinois Studies in Language and Literature, vol. 35, no. 3 (Urbana: Univ. of Illinois Press, 1951), p. 26.

9 Ball, p. 98.

10 Elizabeth Helsinger, *Ruskin and the Art of the Beholder* (Cambridge: Harvard Univ. Press, 1982), p. 169.

11 On Helsinger's overemphasis on the visual, see my review of her book, "Figural Language in the Criticism of Ruskin," *University of Toronto Quarterly*, forthcoming.

12 Collingwood, p. 127.

13 *The Complete Works of John Ruskin*, Library Edition, ed. E. T. Cook and Alexander Wedder-

burn, 39 vols. (London: George Allen, 1903–1912), 3:91–92. Hereafter all citations will be made within the text, i.e., 3.91–92.

14 Quoted in Rorty, pp. 48–49n.

15 Sir Joshua Reynolds, *Discourses on Art*, ed. Robert R. Wark (1975; repr., New Haven: Yale Univ. Press, 1981), p. 57.

16 Henry Ladd, *The Victorian Morality of Art: An Analysis of Ruskin's Aesthetic* (New York: Ray Long and Richard R. Smith, 1932), p. 37.

17 Several critics have noted the ambiguity of this tension in Ruskin's early writings. Solomon Fishman notes a "contradiction most striking to readers" in Ruskin's joint insistence on visual truth and imaginative modification. See *The Interpretation of Art: Essays on the Art Criticism of John Ruskin, Walter Pater, Clive Bell, Roger Fry, and Herbert Read* (Berkeley: Univ. of California Press, 1963), p. 15.

Similarly, Richard L. Stein explores Ruskin's "dialectic" of truth, which attempts to reconcile physical and spiritual sight, a material and a sacramental landscape. See *The Ritual of Interpretation: The Fine Arts as Literature in Ruskin, Rossetti, Pater* (Cambridge: Harvard Univ. Press, 1975), p. 37.

18 Robert Langbaum, *The Modern Spirit* (New York: Oxford Univ. Press, 1970), p. 20. I am indebted to Langbaum for this preliminary distinction between Locke and the romantics.

19 Locke's explanation of the categories of the modal, the relational, and the abstract is found in bk. 2, chap. 12, of *An Essay Concerning Human Understanding*, entitled "Of Complex Ideas."

20 Addison as quoted in Ernest Lee Tuveson, *The Imagination as a Means of Grace: Locke and the Aesthetics of Romanticism* (Berkeley: Univ. of California Press, 1960), p. 114.

21 See Tuveson, pp. 114–15.

22 Fishman, p. 29.

23 Edmund Burke, *A Philosophical Enquiry into the Origin of Our Ideas of the Sublime and the Beautiful* (1759), ed. James T. Boulton (1958; repr., Notre Dame: Univ. of Notre Dame Press, 1968), p. 49. Ruskin is alluding to Burke's discussion of imitation in pt. 1, sec. 16, of the *Enquiry*.

24 For Locke's discussion of "ABSTRACTION" see the *Essay*, bk. 2, chap. 11, "Of Discerning, and other Operations of the Mind."

25 John Locke, *An Essay Concerning Human Understanding*, ed. Peter H. Nidditch (New York: Oxford Univ. Press, 1975), p. 134. Nidditch follows the fourth edition of the *Essay*, published in 1700. Further references to Locke are to Nidditch's edition and are made parenthetically within the text.

26 W. K. Wimsatt's remarks on Addisonian aesthetics are particular apt in this context:

> The sense of sight (aside from the fact that in the Lockean and Addisonian system it enjoyed only a secondary and subjective status) suffered the limitation of being but another sense of touch—long-range and hypersensitive, "more delicate and diffusive." Addison's main thesis, unmistakable despite the cul-de-sacs with which his papers are amusingly varied, is that the pleasures of the imagination are the pleasurable sensations stimulated in ourselves directly by certain external causes or indirectly by reasonably close imitations of or substitutes for such causes.

W. K. Wimsatt and Cleanth Brooks, *Literary Criticism: A Short History* (Chicago: Univ. of Chicago Press, 1957), p. 257. Ruskin clearly does not subordinate sight to touch; he implies that when sight is strictly a matter of material causality, it becomes intellectually blind, like touch. This is especially the case when, as Wimsatt demonstrates, an imitation acts like a cause.

The epistemological debate over the relation of touch to sight, which includes Reid and Leibniz, originates in the famous example of M. Molyneux, in bk. 2, chap. 9, of Locke's *Essay:* the issue is whether forms are conceptual (as Leibniz argued), whether even a blind

person has a sense of geometry, or, as Locke argued, form is a matter of judgment, of connecting the image of a flat surface present to the eye with the knowledge of its squareness presented through the touch. Ruskin seems to play upon this famous example when he suggests, somewhat ironically, that the eye says a thing is round, while the finger says it is flat. Of course, that applies to a painting, not a real object. So perhaps Ruskin is further driving home the deceptiveness of mimesis, which is capable of reversing sensory judgment.

Needless to say, this Ruskinian critique of sensation and causality has nothing to do with the doctrine of "Freshness of Sensation and the Disordering of the Senses" that M. H. Abrams identifies in Emerson, Thoreau, Baudelaire, and Rimbaud. See *Natural Supernaturalism* (New York: Norton, 1971), pp. 412–17.

27 I. A. Richards, *Principles of Literary Criticism*, 2d ed. (1926; repr., London: Routledge and Kegan Paul, 1976), p. 126.

28 Tuveson, p. 26.

29 Jerome Buckley, *The Victorian Temper: A Study in Literary Culture* (Cambridge: Harvard Univ. Press, 1951), p. 155.

30 Graham Hough, *The Last Romantics* (London: Gerald Duckworth, 1949), p. 13.

31 Roger Fry, *Vision and Design* (1920; repr., New York: Oxford Univ. Press, 1981), p. 36.

32 Hough, p. 3.

33 In a recent study, Raymond Fitch has noted that in *Modern Painters* I ideas of truth tend to turn into their opposite, "illusionistic imitation." The volume's ideal truth "merges with techniques of representation and art appears to be more mimetic than expressive." *The Poison Sky: Myth and Apocalypse in Ruskin* (Athens: Ohio Univ. Press, 1982), p. 225.

34 Paul de Man, "The Epistemology of Metaphor," *Critical Inquiry* 5 (1978): 16.

35 De Man, p. 21.

36 See Rorty, pp. 143–44.

37 Martin Price, *To the Palace of Wisdom: Studies in Order and Energy From Dryden to Blake* (New York: Doubleday, 1964), pp. 378–80.

John Dixon Hunt has made the strongest case for the influence of the doctrine of the picturesque on Ruskin. He explains Ruskin's later apparent rejection of Gilpin as "typical of Ruskin's mixture of debt and independence." Hunt argues that the picturesque shaped Ruskin's whole career. He notes that Ruskin's power of description, when it seems most "inefficacious" or "mute," reveals the "legacy" of the picturesque. See *"Ut pictura poesis*, the picturesque, and John Ruskin," *MLN* 93 (1978): 794–818.

Both Paul Walton and Elizabeth Helsinger, in their respective studies of Ruskin, emphasize the importance of the picturesque in Ruskin's thought. Walton discovers the influence of Gilpin in Ruskin's youthful drawing techniques, especially the "succession of points of view" which convey the "rhythm of the traveller's progress." Walton also notes that Ruskin's early appreciation of the abstract harmonies of lines and colors leads him dangerously close to aestheticism later in his career. Ruskin tried to resist aestheticism by forbidding his students' use of abstract compositional techniques. See Walton, p. 97. Helsinger makes the dialectic between partial, excursive, or picturesque sight and a sublimely unanalyzable whole central to an understanding of Ruskin's works. She, too, notes Gilpin as a source for Ruskin's assimilation of the picturesque. See Helsinger, pp. 83–84.

In a more recent study, Price takes up Ruskin's later difficulties with the picturesque: "Ruskin seizes upon the problem that enters picturesque thought from the outset in William Gilpin: that the aesthetic and the moral may conflict." Price notes Ruskin's attempt to attach moral significance to the picturesque by making it an "external form of the sublime." See "The Picturesque Moment," in *From Sensibility to Romanticism: Essays Presented to Frederick A. Pottle*, ed. F. W. Hilles and Harold Bloom (New York: Oxford Univ. Press, 1965), p. 265.

38 See Price, *To the Palace of Wisdom*, pp. 378–80. The term "aestheticism," which I have adapted

from Price, deserves further comment. By "aestheticism" I mean, following Price, an "intensity" of image that seems to outweigh moral import. An aesthetic effect creates either bewilderment or passive disinterestedness; intellectual judgment is suspended. Aestheticism, in the English tradition, derives from Addison, and operates by heightening sense-impressions so as to block intellectual reflection. I am arguing that Ruskin valued meaning more than sense-impression, but could not help confusing the two in his theory of the sign. Ruskin tries to subordinate aestheticism by calling it a "mystery," thus attaching a divine meaningfulness to his inability to control his grasp of details or natural forms.

39 Leigh Hunt, *Imagination and Fancy*, 2d ed. (London: Smith, Elder, 1846), p. 4.

40 Hunt, p. 5.

41 Lady Elizabeth Eastlake; review of *Modern Painters*, vols. 1–3, and *Notes on some of the principal Pictures exhibited in the Rooms of the Royal Academy*, by John Ruskin; *The Quarterly Review* 98 (1856): 411.

42 Wimsatt and Brooks, *Literary Criticism: A Short History*, p. 261.

43 For Herbert Read's discussion, see *The Philosophy of Modern Art* (New York: Horizon Press, 1953), pp. 79–83; for Helsinger's discussion, see *Ruskin and the Art of the Beholder*, pp. 171–89. See also Anthony H. Harrison, "Ruskin against Tradition: Two Theories of Landscape Painting in Early Victorian England," *Victorians Institute Journal* 5 (1976): 1–15; Harrison focuses upon the text on *The Slave Ship* as a reply to Reynolds.

44 For Turner's opposition to slavery in this painting see Andrew Wilton, *J. M. W. Turner: His Life and Art* (New York: Rizzoli, 1979), p. 18. A color plate of the painting may be found on p. 207 of Wilton's book.

45 Ruskin, quoted in Read, p. 82.

46 Helsinger, p. 189.

47 See Wilton, pp. 212, 218.

48 Wilton (p. 218) makes this point:

> We cannot fail to be impressed by the picture's message of disaster, though the lines from the *Fallacies of Hope* that go with the title do not allude to the inhumanity of the action recorded: the victim of "fallacious hope" is the slaver himself, for whom the impending typhoon means a loss of profits and a threat to his ship: Turner ironically condoles with the profiteer whom he is able to present objectively as the protagonist of a high moral drama:
>
>> "throw overboard
>> The dead and dying—ne'er heed their chains.
>> Hope, Hope, fallacious Hope!
>> Where is thy market now?"

49 Robert de la Sizeranne as quoted in Robert Hewison, *John Ruskin: The Argument of the Eye* (Princeton: Princeton Univ. Press, 1976), p. 194.

50 See Lars Aagaard-Mogensen, "Aesthetic Qualities," in *Essays in Aesthetics: Perspectives on the Work of Monroe Beardsley*, ed. John Fisher (Philadelphia: Temple Univ. Press, 1983), pp. 21–34, especially pp. 27–30.

Chapter 2

1 Katherine Gilbert, "Ruskin's Relation to Aristotle," *Philosophical Review* 49 (1940): 52–62, has given the fullest account of Ruskin's Aristotelianism in *Modern Painters* II.

2 Cook and Wedderburn, in their introduction to this volume, give a complete account of the textual revisions and editions. They have appended some of the deleted passages on the sublime. They have followed the 1883 text of the volume, and have included at the foot of

the text all Ruskin's commentary. Prior to the rearranged edition of 1883, there were five editions between 1846 and 1869. See 4.liii–lv.

3 I take the term from Anselm H. Amadio, who applies it to Aristotle in his article about him in the *Encyclopedia Britannica*, 15th ed. Aristotle's method was "deliberately aporetic"; "he raised difficulties that he knew had to be faced but for which he supplied no immediate or straightforward solution."

4 Malcolm Mackenzie Ross, "Ruskin, Hooker and 'the Christian Theoria,'" in *Essays in English Literature from the Renaissance to the Victorian Age Presented to A. S. P. Woodhouse*, ed. Millar Maclure and F. W. Watt (Toronto: Univ. of Toronto Press, 1964), p. 294.

5 For Aristotle's fullest account of *theoria*, see *The Nicomachean Ethics*, X.1177a–1179a.

6 Ross, p. 293.

7 Having examined this manuscript at the Pierpont Morgan Library (call number MA 394 R–V) in New York, I find Cook and Wedderburn's description to be very accurate: "loose sheets, roughly stitched together; the order is not consecutive, and the intended arrangement is not always easy to make out." They date this manuscript between 1843 and 1844, which makes it practically simultaneous with the first volume of *Modern Painters*. See 4.361–62 for their complete description.

The notes on the type of purity are of particular interest. They show a considerably less developed argument than eventually resulted. Purity is placed last in the consideration of beauty, and is equated with "simplicity." Interestingly, Ruskin compares the purity of visual beauty to that of poetry. He invokes Wordsworth to argue that poetic diction is incompatible with purity, which ought to appear without effort. The final text which Cook and Wedderburn published conforms to the original outline insofar as it illustrates purity through a number of poetic examples. The question of poetic diction is not raised, however.

8 Ruskin equates "purity" with "energy." Perhaps we should recognize in the word "energy" a subtle allusion to Aristotle. Alexander Grant notes that the word "energy" has "ceased to convey the philosophical meaning of its original, being restricted to the notion of force and vigour." In Aristotle, and especially in the *Ethics*, "energy" ought to be read as "actuality." Ruskin's emphasis on the substantiality of purity becomes clearer when we keep the Aristotelian sense in mind.

See Alexander Grant, *The Ethics of Aristotle* (London: John W. Parker and Son, 1857), p. 181.

9 See James Clark Sherburne, *John Ruskin, or the Ambiguities of Abundance* (Cambridge: Harvard Univ. Press, 1972), p. 6.

10 Francis G. Townsend notes Ruskin's troubled realization that "Tintoretto's religious masterpiece did nothing to stem the tide of immorality which overwhelmed Venice." Moral art does not necessarily belong to a moral society. "Furthermore, Ruskin saw clearly that his theory of beauty as a therapeutic agent broke down in individual cases. Evil men had produced beautiful interpretations of nature. How, then, could the perception of beauty be called moral?" *The Stones of Venice*, the "enormous footnote to *Modern Painters* II," is, in Townsend's opinion, Ruskin's attempt to work out this paradox. See *Ruskin and the Landscape Feeling*, pp. 50–51.

11 Ruskin's reading (4.265) is quoted in George Landow, *The Aesthetic and Critical Theories of John Ruskin* (Princeton: Princeton Univ. Press, 1971), p. 445.

12 Herbert Sussman, *Fact into Figure: Typology in Carlyle, Ruskin and the Pre-Raphaelite Brotherhood* (Columbus: Ohio State Univ. Press, 1979), p. 10. For the typology of *The Stones of Venice*, see pp. 25–30. Robert Hewison, too, makes Evangelical typology "the most important source" of Ruskin's reconciliation of abstract form and material existence. The reconciliation constitutes "symbols of the Divine." See *John Ruskin: The Argument of the Eye*, pp. 62–63.

13 See Erich Auerbach's essay entitled "Figura," in *Scenes from the Drama of European Literature*, trans. Ralph Manheim (1959; repr., Gloucester, MA: Peter Smith, 1973), pp. 11–76.

14 In his next study, *The Seven Lamps of Architecture* (1849), Ruskin directly addresses the difficulty of keeping ornaments as "types" distinct from those that become "idols," aesthetically attractive for their own sake. The distinction is made in terms of "sacrifice": ornament should be typical of God's pleasure in the Old Testament in the sacrifice of wealth. Yet Ruskin's argument is by no means clear or conclusive. Architectural ornaments as types have a tendency to transform into idols. The problem recurs frequently in *The Stones of Venice*.

 When Landow discusses the type of sacrifice in *Seven Lamps*, he completely ignores the issue of idolatry. Ruskin's discussion of sacrifice shows "how thoroughly typology had permeated [his] habits of thought," reflecting the influence of Henry Melvill's sermons upon the youthful Ruskin. Landow is far more sanguine about this influence and its permeation than was Ruskin. See Landow, pp. 339–41.

 For further discussion of the conflict between idolatry and typology in the Lamp of Sacrifice, see my "Ruskin's Use and Abuse of 'Types' in *The Seven Lamps of Architecture*," *Dalhousie Review* 63 (1983): 516–25.

15 Carol Christ, rebutting Sussman, has noted the "symbolic" aspect of Pre-Raphaelite art. The naturalism and detail of a Pre-Raphaelite painting seem to suggest typological representation, but the quantity of detail pulls the painting "back toward status as a symbol." Total comprehensiveness of the scene is impossible; there remains something "artificial," an "unnatural clarity." Christ's argument could, I think, apply as well to Ruskin on Tintoretto, though she (mistakenly) faults Ruskin, placing him in the same class as Sussman, for overemphasizing the concreteness of depicted details. See *The Finer Optic: The Aesthetic of Particularity in Victorian Poetry* (New Haven: Yale Univ. Press, 1975), pp. 60–61. For a discussion of the tension between details and symbolic form in Pre-Raphaelite art, see my paper on Ruskin and William Bell Scott, Appendix 1.

16 Ruskin condemns any treatment of Christ that would direct the mind "painfully" to the bodily agony, for such treatments are either "coarsely expressed by outward anatomical signs, or else they rest on that countenance inconceivable by man at any time, but chiefly so in this its consummated humiliation." Giotto, Perugino, and Angelico are all "cramped" by their effort to represent Christ's agony. Tintoretto finds the right solution when he fills his picture "with such various and impetuous muscular exertion, that the body of the Crucified is, by comparison, in perfect repose, and . . . has cast the countenance altogether into shade" (4.270–71).

 Patrick Conner seems to have misunderstood completely when he writes: "It was Ruskin, who, above all others, had insisted on the significance of facial expression in art; but this insistence became an embarrassment when he came to describe, for example, the face of Christ in the Scuola di San Rocco *Crucifixion*, which is foreshortened and obscured by shadow." See his "Ruskin and the 'Ancient Masters,'" in *New Approaches to Ruskin*, ed. Robert Hewison (London: Routledge and Kegan Paul, 1981), p. 29.

17 Samuel Monk, in his discussion of Archibald Alison, makes this semiotic principle explicit: "It is only when, through association, the qualities of matter—form, color, sound,—come to be regarded as *signs* or *expressions* of qualities, which *can* produce emotion—it is only then that the external world attains through association the significance that renders it sublime or beautiful." *The Sublime: A Study of Critical Theories of XVIII–Century England* (1935; repr., Ann Arbor: Univ. of Michigan Press, 1960), p. 151.

18 Van Akin Burd, "Ruskin's Quest for a Theory of Imagination," *Modern Language Quarterly* 17 (1956): 60–72. See especially pp. 66—69 for Ruskin's difficulty in controlling his associations and for the importance of Fra Angelico.

19 "Distinct in similarity" is a slightly puzzling phrase, which I take to mean not connected because not differentiated.

20 Archibald Alison, *Essays on the Nature and Principles of Taste* (Dublin: Byrne et al., 1790), p. 322. All further references to Alison are to this edition and are made within the text. Alison's discussion of proportion may be found on pp. 316—62.

21 See Edmund Burke, *A Philosophical Enquiry into the Origin of Our Ideas of the Sublime and the Beautiful*, pt. 3, secs. 2–5. Page references within the text are to James T. Boulton's edition, cited in chap. 1. The discussion of proportion is found on pp. 92–104 of this edition.

22 For an interesting connection between the doctrine of the association of ideas and the Darwinian revolution, see A. Dwight Culler, "The Darwinian Revolution and Literary Form" in *The Art of Victorian Prose*, ed. George Levine and William Madden (New York: Oxford Univ. Press, 1968), pp. 224–46. Culler notes that David Hume's critique of the objectivity of causality had "far more radical" implications than the Darwinian theory of evolution, for Hume asserted that "it is not design which implies a designer but the appearance of design which gives rise in our minds to the conception of a designer." The causal link between appearance and concept is made entirely subjective and open to "error." See p. 230.

23 For an elaboration of the connection between seeing, cognition, and architectural ornament, as Ruskin expounds it in *The Stones of Venice*, see my paper on Ruskin and the Crystal Palace, Appendix 2.

24 The distinction between appearance and representation may seem too nice, since representations must somehow appear. Yet the distinction is crucial for Ruskin. For example, in *The Seven Lamps of Architecture*, he writes:

> The other condition which we had to notice, was the *value of the appearance* of labour upon architecture. I have spoken of this before; and it is, indeed, one of the most frequent sources of pleasure which belong to the art, always, however, within certain somewhat remarkable limits. For it does not at first appear easily to be explained why labour, *as represented by materials of value*, should, without sense of wrong or error, bear being wasted; while the waste of actual workmanship is always painful, so soon as it is apparent. But so it is, that, while precious materials may, with a certain profusion and negligence, be employed for the magnificence of what is seldom seen, the work of man cannot be carelessly and idly bestowed, without an immediate sense of wrong. [8.46; emphasis added]

The text suggests that apparent waste of labor is always and immediately painful; but when this waste is mediated by the representation of material value, the represented value cancels the apparently wasted value. So too the represented value of a peacock's nobility may cancel the apparent distortion of its natural form in a particular ornament.

25 To avoid confusion at the outset, it should be noted that the term "purity," as Ruskin uses it, always concerns the way in which organic structure suggests the divine. Ruskin is not interested in chemical notions, such as the purity of a particular element in a compound or mixture.

26 The references are to John Milton's "Lycidas," 26; "Il Penseroso," 69; *Paradise Lost*, bk. 4, 1.249.

27 Ruskin refers explicitly to the 1815 preface in the chapters on Associative Imagination (4.229–30) and Contemplative Imagination (4.299).

28 See Sister Mary Dorothea Goetz, *A Study of Ruskin's Concept of the Imagination* (Washington, DC: Catholic Univ. of America Press, 1947), pp. 87–103; see Hewison, pp. 69–70, 77–78. Michael Sprinker, "Ruskin on the Imagination," *Studies in Romanticism* 18 (1979): 115–39, tries to situate the Ruskinian imagination within an "allegorical" tradition that includes the grotesque and the sublime. He emphasizes the "allegorical" nature of the Contemplative Imagination, meaning its attempt to represent "spiritual" truth.

29 Wordsworth refers to W. Taylor's *British Synonyms Discriminated* (London, 1833), p. 242. See

the text of the 1815 preface in *The Prose Works of William Wordsworth*, ed. W. J. B. Owen and Jane Worthington Smyser (Oxford: Oxford Univ. Press, 1974), 3:30. All quotations from Wordsworth's preface may be found on pages 30–31 of this edition.

30 Hewison, p. 77, noted: "At its simplest level the contemplative imagination acts as a metaphor-making faculty."

31 I. A. Richards has stressed this point about metaphor: "Words are the meeting points at which regions of experience which can never combine in sensation or intuition come together." *Philosophy of Rhetoric* (1936; repr., New York: Oxford Univ. Press, 1981), p. 131. Richards criticizes doctrines of metaphor that emphasize "visualization" rather than "meaning." Paul Ricoeur notes Richards's attempt to separate the study of metaphor from "anything borrowed from the notion of mental image. . . . Nothing is more misleading . . . than the confusion between figure of style and image, if image is understood as the copy of a sensible perception." See *The Rule of Metaphor*, trans. Robert Czerny (Toronto: Univ. of Toronto Press, 1977), p. 81. Richards's criticism of visualization is apt in the context of Ruskin's discussion of imagination because Richards directs his criticism specifically against T. E. Hulme. Hulme's famous essay, "Romanticism and Classicism," argues for a revaluation of "fancy." Hulme attacks Ruskin's "romantic" view of the imagination because it is too full of "unstateable" things, such as instinct and infinity. Against Ruskin and romanticism in general, Hulme seeks a form of imagination based on clear, distinct analogies. He seems to have been unaware of Ruskin's own interest in distinctness and fancy. See Hulme's essay in *Speculations*, ed. Herbert Read (London: Kegan Paul, 1936), pp. 113–40.

32 W. K. Wimsatt, *The Verbal Icon* (Lexington: Univ. of Kentucky Press, 1954), p. 149.

Chapter 3

1 Ruskin's careful attempt to define the limits of any part's realization within an ideal framework has an affinity with Samuel Taylor Coleridge's essays on painting, "On the Principles of Genial Criticism concerning the Fine Arts" (1814). Coleridge too argues that parts and details should "distract the attention" of the viewer in the "least possible degree" from the painting's idealistic significance. The painting's formal outline and composition should be instantly recognizable; yet the picture must be "interpenetrated" with a variety of sharply realized human figures. Coleridge's chief example is Washington Allston's *Dead Man Revived by Touching the Bones of the Prophet Elisha* (1811–13). Allston's painting presents a perfect "circle" of youth and age. It moves from the daughter to the mother to the reviving body of the husband and back to the daughter, who is connected to the husband by the figure of the slave standing at his head. Like Ruskin, Coleridge sets this circle between the extremes of pure formalism and sensual mimesis. Coleridge compares purism to light in air, where there is no particularity; sensualism to light in a cloud, where form is confused and irregular; the ideal to light shining through a crystal. Ruskin seems to fluctuate in his own writings between states of cloud, air, and crystal.

2 Bertrand H. Bronson, "Personification Reconsidered," in *New Light on Dr. Johnson*, ed. F. W. Hilles (New Haven: Yale Univ. Press, 1959), p. 207.

3 Jeffrey Hurwit finds that Ruskin may have been correct in absolving the Greeks from the pathetic fallacy, but that does not mean that the Greeks, especially in the Archaic period, did not personify nature. Hurwit identifies variations of the pathetic fallacy, which he calls the "apathetic fallacy" (nature has emotions other than the poet's), the "antipathetic fallacy" (in which man and nature are estranged), and the "sympathetic or empathetic fallacy" (which is close to the pathetic fallacy, except that it is found primarily in Latin rather than Greek poetry). Interestingly enough, the only evidence for the pathetic fallacy in Greek culture is in vase decoration of the Archaic period. This has important consequences for Ruskin's

discussion of Greek idolatry, later in his career, in his lectures on Greek sculpture and carving. Ruskin's definition of Greek idolatry, as I argue in chapter 4, is based upon his discussion of the pathetic fallacy. See "Palm Trees and the Pathetic Fallacy in Archaic Greek Poetry and Art," *The Classical Journal* 77 (1982): 193–99.

4 For his discussion of Shelley's "To a Skylark" as an ambiguity of the fifth type, see William Empson, *Seven Types of Ambiguity*, 3d ed. rev. (London: Chatto and Windus, 1977), pp. 155–61.

5 I take the terms from Charles Singleton's well-known discussion, "Two Kinds of Allegory." Singleton defines poetic allegory as a fiction that must be perfectly coherent. There is a hidden meaning, and each part of the allegory must contribute to the understanding of that meaning. "Theological" allegory has a literal meaning that is not fictive but true. Such allegories, like Holy Scripture, need not give every word a divine as well as a literal meaning. See *Dante's Commedia: Elements of Structure* (1954; repr., Baltimore: Johns Hopkins Univ. Press, 1977), pp. 84–98.

6 The famous discussion of grass in Ruskin's chapter on medieval landscape was first praised by Matthew Arnold, in "The Literary Influence of the Academies" (1864). Ruskin's poetic description of grass reveals his "genius" and "temperament," compared, for example, to his contorted etymological explanations of the significance of the names of Shakespeare's heroines. See *Lectures and Essays in Criticism*, ed. R. H. Super and Sister Thomas Marion Hoctor (1962; repr., Ann Arbor: Univ. of Michigan Press, 1980), p. 251.

Arnold's "Pagan and Mediaeval Religious Sentiment" (1864) presents a considerably less refined comparison of the two sentiments than Ruskin's. For Arnold, the pagan is merely a sensualist, while the medieval Christian, typified by St. Francis, "lived by the heart and the imagination." See *Lectures and Essays in Criticism*, pp. 212–31.

7 John Freccero, discussing the figure of Matilda in the context of Dante's confrontation with the problem of idolatry, or "self-petrification," notes her erotic danger; she threatens to entrap the poet and so has a certain affinity with Medusa.

Like Ruskin, however, Freccero attaches great importance to the Dantean urge to exceed all limits, to make poetic language a way of "beckoning the beholder" beyond the immediate significance of an image.

See "Medusa: The Letter and the Spirit," *Yearbook of Italian Studies* (1972): 1–18.

8 Ruskin's interpretation of this passage finds support in Renato Poggioli's discussion of Matilda. For Poggioli, as for Ruskin, Matilda's work is ornamental rather than practical; more than that, however, it is work that serves "God's ends even by fulfilling the highest demands of [man's] own nature." Man's faculties unfold "in the free development of his powers." Matilda teaches that "man is bound to imitate God's magnificent artifice, and contemplate in joyful admiration the Lord's glorious handiwork." Matilda's Garden of Eden "is the place of both pleasure and leisure: of a disinterested and productive *otium* allowing man to exercise fully and freely not the mechanical but the liberal arts, those, as Montaigne would say, that render us free." See *The Oaten Flute: Essays on Pastoral Poetry and the Pastoral Ideal* (Cambridge: Harvard Univ. Press, 1975), pp. 143–48.

9 Proud mimesis, the sort criticized in *Modern Painters* I, is also figured as a smile: the illuminated pages of Franco Bolognese "smile more" than those of Oderisi da Grubbio (see canto 11 of the *Purgatorio*). Ernst Gombrich refers to this smile as evidence of art's "multiple context" in the medieval period. Oderisi's trope points to a conception of art as art, not art as sacred imagery. See *Meditations on a Hobby Horse* (London: Phaidon Press, 1963), pp. 81–82.

10 Georg Wilhelm Friedrich Hegel, *Aesthetics: Lectures on Fine Art*, trans. T. M. Knox (Oxford: Oxford Univ. Press, 1975), 1:401–02.

11 On the depersonalization of the act of reading personifications, see J. Hillis Miller's "Walter

Pater: A Partial Portrait," *Daedalus* 105 (1976): 97–113. Miller very subtly demonstrates how Pater's work "can be defined as an exploration and deconstruction of the problematic trope of personification, that turn of language or art which gathers impersonal forces under a human figure." Miller's reading of Pater applies, analogically, to Ruskin and Proust. Miller carefully debunks the authenticity of the intense "subjectivism" of Pater's reading of Giotto's allegories. My reading of Ruskin on Turner's *Garden* is indebted to Miller's argument.

For a positive interpretation of Ruskin's resort to archetypes in his reading of Turner's *Garden*, see Charles T. Dougherty, "Of Ruskin's Gardens," in *Myth and Symbol: Critical Approaches and Applications*, ed. Bernice Slote (Lincoln: Univ. of Nebraska Press, 1963), pp. 141–51.

Chapter 4

1 This preface is actually composed of a series of essays, most of which were published in 1900, the year of Proust's most intense study of Ruskin. The essays are: "John Ruskin," *La Chronique des arts et de la curiosité* (Jan. 27, 1900): 35–36; "Pèlerinages ruskiniens en France," *Le Figaro*, Feb. 13, 1900; "Ruskin à Notre Dame d'Amiens," *Mercure de France* 34 (Apr. 1900): 50–88; "John Ruskin," *Gazette des Beaux-Arts* 23 (Apr. 1900): 310–18, and 24 (Aug. 1900): 135–46. An excellent summary of the revisions and additions to these essays in the final form of the preface of 1904 may be found in Richard Macksey, "Proust on the Margins of Ruskin," in *The Ruskin Polygon*, ed. John Dixon Hunt and F. M. Holland (Manchester: Manchester Univ. Press, 1981), pp. 172–97. All citations from Proust's essay will be from the final version of the preface reproduced in the volume of Proust criticism entitled *Contre Saint-Beuve*, ed. Pierre Clarac and Yves Sandre (Paris: Gallimard, 1971), pp. 63–141. Documentation will appear parenthetically thus, for example, "(*CSB*, 63)." I shall not be referring to Proust's preface to his translation of Ruskin's *Sesame and Lilies*, entitled "Journées de lecture." This essay really has little to do with Ruskin, and in its emphasis on the phenomenal pleasure of reading presents a false picture of Proust's assimilation of Ruskin.

2 Philip Kolb has given an extremely sanguine interpretation of Proust's study of Ruskin, finding in *A la recherche du temps perdu* a similarity of mental "rhythm" and a descriptive "richness" characteristic of Ruskin's writing. Noting that Proust did have some difficulties with Ruskin's lack of methodological consistency, Kolb nevertheless emphasizes that Proust's interests were "grander" than his interest in Ruskin. See "Proust et Ruskin: nouvelles perspectives," *Cahiers de L'Association internationale des études françaises*, no. 12 (June 1960): 259–73. For a complete bibliography of studies comparing Ruskin to Proust (which, however, contains few discussions of the problem of idolatry), see Macksey's companion article: "'Conclusions' et 'Incitations': Proust à la recherche de Ruskin," *MLN* 96 (1981): 1113–19. One of the few important sources of Proust's criticism of Ruskin, which is not sufficiently recognized in the critical literature, is a pair of articles by J. Milsand: "Une nouvelle théorie de l'art en angleterre," *Revue des Deux Mondes* 28 (1860): 184–213 and "De L'Influence littéraire dans les beaux-arts," *Revue des Deux Mondes* 34 (1861): 870–915. Milsand emphasizes a disaccord between Ruskin's apparent opinions and his "véritable impressions." There is a contradiction in Ruskin's writings between dogmatism and visual impression, the latter being "sincere." This is evident in Ruskin's attachment to the play of light over the surface of a Gothic façade. On numerous other points as well, Proust seems to have been indebted to Milsand's extremely perceptive essays.

3 I take the term "flat" from Samuel Beckett, who calls "allegorical" writing, as in Spenser or Dante, "flat writing." Beckett has many relevant comments on the general opposition of allegory to metaphor in Proust's writing. Beckett opposes to allegorical writing the "chain-reflex" of the artist, whose "only reality is provided by the hieroglyphics traced by inspired

perception (identification of subject and object)." The result is neither realism nor aestheticism. "The Proustian world is expressed metaphorically by the artisan because it is apprehended metaphorically by the artist: the indirect and comparative expression of indirect and comparative perception. The rhetorical equivalent of the Proustian real is the chain-figure of the metaphor." See *Proust* (1957; repr., New York: Grove Press, 1978), pp. 60–68.

4 Marc Shell sees Proust as a "most careful and sympathetic" reader of Ruskin. Shell argues that "perhaps" as Proust suggested in the introduction to his translation of *Sesame and Lilies*, "Ruskin does not pay enough attention to the act of reading." Ruskin thus fears that all literature is "necessarily misleading, false, or counterfeit," for literature is like a material idol, a coin, in that it seems to contain an abstract value, i.e., Wisdom, which in fact it "contains" only as a signifier, not as a real object. Ruskin, in Shell's opinion, dissolves the distinction between "container and contained" and so idolizes, as Proust would say, literature; Ruskin falsely equates texts with commodities. Shell, I think, gives a very poor estimate of Ruskin's epistemological struggle to separate economic and literary idols, which indeed he saw as equivalents in Victorian society, from knowingly imaginative fictions. Shell is himself too easily swayed by Proust's reading of Ruskin. See "Ruskin and the Economy of Literature," *Journal of the History of Ideas* 38 (1977): 65–84.

5 Marcel Proust, *Time Regained*, trans. Stephen Hudson (London: Chatto and Windus, 1949), p. 239.

6 Walter Kasell, "Proust the Pilgrim: His Idolatrous Reading of Ruskin," *Revue de Littérature Comparée* 49 (1975): 547–60. See especially pp. 552–58. Kasell does not refer to Ruskin's *Aratra Pentelici*, unfortunately. He, like Proust, does not seem to be aware of Ruskin's own lengthy consideration of the problem of idolatry.

David Ellison's more recent work, *The Reading of Proust* (Baltimore: Johns Hopkins Univ. Press, 1984), gives a very fine account of Proust's entire treatment of Ruskin, though Ellison is not primarily concerned with the topic of idolatry. His discussion touches on many of the same points I do, particularly on the important texts on the *Vierge Dorée* and St. Mark's mosaics (see pp. 70, 81). Ellison is more a student of Proust than Ruskin and so, not surprisingly, he tends to give a more Proustian account of Ruskin's idolatry, which ignores *Aratra Pentelici*. He emphasizes the sensuous, stylistic "intermingling of forms" (p. 58) in Ruskin's prose which interferes with, even falsifies, the religious or moral message Ruskin purports to state. Ellison seems most acute to me when he gives recognition to Ruskin's consistent emphasis on the "rudeness" of religious symbols, or the disjunction between the triviality of the sign and the worth of its transcendental meaning. For Ruskin, idolatry is indeed losing oneself in the distracting properties of the sign as such. But Ellison wrongly, I think, sees Ruskin falling victim to this sort of distraction. This would be more characteristic of the early Ruskin, not the Ruskin who theorizes about idolatry. For Ellison, Ruskin's only way out of idolatry is to give the sign very specific referential meaning. Proust, by contrast, sees in the sign an opportunity for subjective release, a play of meaning. Ellison's argument misdirects Ruskin's, which tends toward imagination not referentiality—a direction Proust seems to have recognized in his attention to Ruskin's "enthusiasm." Ellison is generally more concerned with Ruskin the "dreamer," the Ruskin whose subjective associations fit in with the Proustian narrative style.

7 Meyer Abrams, *The Mirror and the Lamp: Romantic Theory and the Critical Tradition* (1953; repr., New York: Oxford Univ. Press, 1979), p. 318. For Richards's discussion of sincerity see *Practical Criticism: A Study in Literary Judgment* (1929; repr., London: Routledge and Kegan Paul, 1978), *passim*. For Richards, sincerity is a criterion of the poet's ability to maintain the distinction between his "genuine promptings" and those which he hopes would make a good poem. Richards speaks of the poet's "shaping impulses." The reader senses insincerity when there is a discrepancy between these shaping impulses and the poem's claim upon the reader's response.

8 For a comparison of Wordsworth to Proust, see Roger Shattuck, "This Must Be the Place: From Wordsworth to Proust," in *Romanticism: Vistas, Instances, Continuities,* ed. David Thorburn and Geoffrey Hartman (Ithaca, NY: Cornell Univ. Press, 1973), pp. 177–97. Shattuck finds a "great distance" between Wordsworth and Proust: "Wordsworth is all directness and nakedness. Proust reaches reality, and himself, only through an elaborate feint. Things do not interfuse; they interfere." Yet both writers are principally concerned with "the development of a single sensibility." Proust focuses upon character, Wordsworth upon landscape. Shattuck touches indirectly but acutely on the theme of "idolatry" when he notes Proust's disturbing sense that society is made up of "tiresome and fraudulent people" who have inflated the ordinary "by literary processing." Shattuck detects in this dissatisfaction Montaigne's "erreur d'ame": "the incapacity to give full status to one's own life and experience." Proust alternates between self-deprecation and a "self-defense" that seeks an impossible perfection or the inaccessible. Proust and Wordsworth demonstrate, in contrasting ways, the "Romantic" estrangement from things that is followed by an attempted reconciliation.

9 See Paul de Man's essay on Proust, entitled simply "Reading (Proust)," in *Allegories of Reading: Figural Language in Rousseau, Nietzsche, Rilke and Proust* (New Haven: Yale Univ. Press, 1979), pp. 57–78.

10 Jean Autret, in his detailed study of Ruskin's influence upon Proust, carefully notes all the cross-references to Ruskin's works that Proust makes in his translation of *The Bible of Amiens.* His exhaustive table makes no reference to *Aratra Pentelici.* See *L'Influence de Ruskin sur la vie, les idées et l'oeuvre de Marcel Proust* (Geneva: Librarie Droz, 1955), p. 58.

 But Proust's *Sésame et les lys* (Paris: Mercure de France, 1906) does contain one reference to *Aratra Pentelici* in a note on p. 92. The note indirectly alludes to Ruskin's concept of idolatry: the belief that the Word could be worshiped and honored simply by carrying about expensive editions of the Bible in one's pocket. Such idolatry was a common enough object of attack. It is found in Coleridge's attack on "bibliolatry" and in the writing of John Stuart Mill. I know of no substantive reference to *Aratra Pentelici* elsewhere in Proust.

11 See Robert Hewison, *John Ruskin: The Argument of the Eye,* pp. 193–94.

12 See Wordsworth's "Essay Upon Epitaphs, I" in *The Prose Works of William Wordsworth* 2:49–63. Parenthetical documentation accompanying quotations from this essay refers to this edition, which is abbreviated as *PrW.*

 On the epitaph as the "epitome of poetic language" in Wordsworth see Frances Ferguson, *Wordsworth: Language as Counter-Spirit* (New Haven: Yale Univ. Press, 1977), pp. 31–34. Ferguson's argument supports my assertion that Wordsworth seeks to subsume language as such under phenomenal or spiritual moments of consciousness. For Wordsworth in general, but especially in the essay on epitaphs, language points either to the feelings that precede it or to an "incarnation" of the spirit world. The epitaph gives a "midway" representation of the affections of the living and the spirit of the deceased. Its function is "ultralinguistic." Language always suggests something beyond language. Language should avoid becoming a "counterspirit which would wed a man too straitenedly to the outward form which he must lose." Ruskin, too, wishes to free spiritual meaning from outward forms, but to avoid imaginative delusion, he preserves the outward, linguistic form in a way Wordsworth and Proust do not.

13 The arguments of this appendix seem to be clearly indebted to Thomas Carlyle's lecture "The Hero as Priest: Luther; Reformation; Knox; Puritanism" (1840). This is the fourth lecture in the volume entitled *On Heroes, Hero-Worship and the Heroic in History,* ed. Carl Niemeyer (Lincoln: Univ. of Nebraska Press, 1966), pp. 115–53. Carlyle defines an idol as "a thing seen, a symbol. It is not God, but a Symbol of God." Carlyle investigates whether any mortal ever took an idol for more than a symbol. All worship, he concludes, in anticipation of Ruskin, necessarily involves idols. All religions are idolatrous, only more or less so. "Condemnable Idolatry is *insincere* Idolatry": the pretense of worshiping an image that one knows is false, or

the authenticity of which one doubts. Carlyle gives Ruskin the idea that sincere faith must be blind. But Ruskin ultimately reverses Carlyle, and his own position, and makes doubt and error the condition of "sincere" worship.

14 Henry Ladd first suggested a connection between the pathetic fallacy and Ruskin's later writings on idolatry. Ladd does not connect the pathetic fallacy with Ruskin's earlier appendix on idolatry from *The Stones of Venice*, however. See *The Victorian Morality of Art: A Study of Ruskin's Aesthetic*, pp. 242–43.

15 See Harold Bloom, *The Ringers in the Tower: Studies in Romantic Tradition* (Chicago: Univ. of Chicago Press, 1971), pp. 182–83.

16 De Man, p. 71.

17 De Man, p. 74.

18 Sculpture is defined at the outset of the lecture on idolatry as "the art of fiction in solid substance" (20.220).

19 In many respects Ruskin's *Charis* conforms with the ancient Greek conception. In Homer, for example, *Charis* is associated with the crafts of Hephaestus and Athena (*Od.* 6.232). In the story of Apelles commenting upon the remarkable image of Ialysus painted by Protogenes, Protogenes' art is contrasted with the "grace" of workmanship that would touch heaven. Protogenes' art is visually stunning but it lacks the divine sort of grace.

 Also Ruskin is quite faithful to the term when he says that *Charis* implies a favor given or received. But even in Greek the term ambiguously suggests either a purely subjective appreciation of the imagination in a work of art or its objective, visually beautiful properties.

 My account of *Charis* paraphrases J. J. Pollitt's definition and commentary in *The Ancient View of Greek Art: Criticism, History, Terminology* (New Haven: Yale Univ. Press, 1974), pp. 297–99.

20 Richard Jenkyns, *The Victorians and Ancient Greece* (Cambridge, MA: Harvard Univ. Press, 1980), p. 183.

21 John Rosenberg has noted that "almost invariably the greatest passages in Ruskin's prose are structured around two opposing visions, one of felicity and the other of some form of hell." Rosenberg notes the "brilliant transference of attributes" in such passages. "Death" and "Life" are applied chiastically to animate and inanimate objects respectively. See "Style and Sensibility in Ruskin's Prose," in *The Art of Victorian Fiction*, ed. George Levine and William Madden (New York: Oxford Univ. Press, 1968), pp. 186–87.

Appendix 1

1 James Holloway and Lindsay Errington, *The Discovery of Scotland* (Edinburgh: The National Gallery of Scotland, 1978), p. 131.

2 William Bell Scott, *Autobiographical Notes*, ed. W. Minto (1892; repr., New York: AMS Press, 1970) 2:76.

3 Quoted in Scott, 2:324.

4 Martin Price, ed., *The Restoration and the Eighteenth Century* (New York: Oxford Univ. Press, 1973), p. 619.

5 Martin Price, "The Picturesque Moment," in *From Sensibility to Romanticism*, p. 271.

6 Scott, 2:292.

7 Price, *The Restoration*, p. 608n.

8 Reynolds, p. 192.

9 This tour would include such works as George Stubbs's *Two Gentlemen Going Shooting* (1768 and 1769) and *A Repose After Shooting* (1770); Thomas Gainsborough's *Woody Stream with Pastoral Figures* (1770–75); and Richard Wilson's *Dinas Bran* (1769–76).

10 Allen Staley, *The Pre-Raphaelite Landscape* (Oxford: Oxford Univ. Press, 1973), pp. 63–64. I am indebted to Staley for my discussion of *Strayed Sheep*.

11 W. F. Axton, "Victorian Landscape Painting: A Change in Outlook," in *Nature and the Victorian Imagination*, ed. U. C. Knoepflmacher and G. B. Tennyson (Berkeley: Univ. of California Press, 1977), p. 288.

12 Vera Walker, "The Life and Work of William Bell Scott, 1811–1890," (Ph.D. diss., Univ. of Durham, 1951), p. 330.

Appendix 2

1 As George Hersey has written: "[W]ith the Crystal Palace, the machine literally *became* the building." Rivets, girders, and drains superseded ornament. The Crystal Palace reinforced the revolutionary principle of "industrial ornament," which was a by-product of construction itself. See *High Victorian Gothic: A Study in Associationism* (Baltimore: Johns Hopkins Univ. Press, 1972), p. 178.

Ruskin made explicit the contrast between ornament proper, which he considered a creative product of the individual laborer, and the machine ornament of the Crystal Palace in the seventeenth appendix to the first volume of *The Stones of Venice*, entitled "Answer to Mr. Garbett": architectural ornament is that "which proceeds from an individual mind, working through instruments which assist, but do not supersede, the muscular action of the human hand, upon the materials which most tenderly receive, and most securely retain, the impression of human labor." In the same appendix he calls the Crystal Palace a "single and very admirable thought" extended through "very ordinary algebra" which is "all that glass can represent of human intellect" (9.456).

2 Peter Collins, *Changing Ideals in Modern Architecture, 1750–1950* (Montreal: McGill-Queens Univ. Press, 1965), p. 259.

Collins's view is supported by Kenneth Clark's, in *The Gothic Revival* (London: John Murray, 1962). Clark dissociates Ruskin from Pugin on the grounds that Pugin was a "trained architect and Ruskin an art critic." "Ruskin stressed the importance of ornament and Pugin of construction. . . . There is no doubt that Pugin's theory inspired a far sounder school of architects" (p. 200).

More recently, Kristine Garrigan has repeated this criticism of Ruskin. She notes that many of Ruskin's contemporaries who were architects frequently charged him with a lack of technical knowledge. See *Ruskin on Architecture* (Madison: Univ. of Wisconsin Press, 1973), p. 67.

Nikolaus Pevsner cites William Whewell's review of Ruskin's *Seven Lamps of Architecture* (1849) in *Fraser's Magazine*, as a "perspicacious" assessment of Ruskin's relevance to his contemporaries: "Whewell recognizes Ruskin's 'glowing and picturesque eloquence,' but says that the *Lamps* give 'not so much light as splendour'; for they do not represent, as one would expect, 'exactly co-ordinated principles.'" *Some Architectural Writers of the Nineteenth Century* (Oxford: Oxford Univ. Press, 1972), p. 152.

3 Cook and Wedderburn, in their introduction to their edition of *The Two Paths* (16.xxvi–xxix), recount Ruskin's opposition to the government schools of design, whose general superintendent was Sir Henry Cole, and whose art advisor was Richard Redgrave—two of the members of the Executive Committee for the Great Exhibition. Ruskin did not object to the principle for which these schools stood: the reconciliation of ornament with function. He simply doubted that the principle of design could be systematically taught, or that industrial manufacturing techniques were compatible with the philosophy of the schools. Specifically, Ruskin objected to the axiom that ornament should abstract natural forms to a high degree and that mass reproduction of designs would inevitably educate public tastes.

Tobin Sparling summarized very well Ruskin's opposition to the Cole group:

In a lecture on modern manufacture and design delivered at Bradford in 1859, on the occasion of the opening of another government school of design, Ruskin addressed more specifically his opposition to the curriculum established by Henry Cole for the training of industrial designers. He admonished his audience to "Get rid . . . at once of any idea of Decorative Art being a degraded or a separate kind of art." Having invoked Michelangelo's Sistine Ceiling and the Raphael cartoons as proof that all art is decorative art, he proceeded to strike a blow against the conventional treatment of natural forms espoused by the Cole circle.

The Great Exhibition: A Question of Taste (New Haven: Yale Center for British Art, 1982), pp. 68–69.

4 Hersey, p. 159.

5 Garrigan emphasizes the importance of ornament in Ruskin's architectural theory but does not elaborate the crucial relation of ornament to architectural speech in the twentieth chapter of volume 1 of *Stones*. John Unrau, in *Looking at Architecture with Ruskin* (London: Thames and Hudson, 1978), discusses ornament as an optical problem, based on Ruskin's definition of ornamental abstraction as a proportional function of its distance from the viewer. Nikolaus Pevsner, in a published lecture comparing Ruskin to Matthew Digby Wyatt (one of the principal executives of the Crystal Palace Committee and a prominent "railway" architect), recognizes Ruskin's genius but takes the general view of the architectural profession in finding Ruskin's views on ornament strange and unconnected. See *Matthew Digby Wyatt* (Cambridge: Cambridge Univ. Press, 1950).

6 Hersey, *passim*, but in particular see pp. 29–32 for Ruskin's theory of architectural "speech."

7 An interesting footnote Ruskin added to the 1880 edition of *The Seven Lamps of Architecture* makes explicit the wordplay on the Greek ἀρχή as the intellectual prerequisite of architecture; see 8.68. Cook and Wedderburn note on p. 28 analogous passages on the link between ἀρχή and "architecture" scattered throughout Ruskin's works. Ruskin's note is all the more interesting for its opposition of ἀρχῆς to the "crystalline structure of iron" over which "no builder has true command."

8 To some extent, Ruskin's contrasting of the sublimity of the mountain and the beauty of the crystal depends on Burkean ideas about the grandeur of the sublime as opposed to the smallness of the beautiful.

9 This lengthy quotation comes from the chapter "Lamp of Truth" in *Seven Lamps*. A curious analogue to Ruskin's point here about the loss of the effect of the traceries is found in Longinus's treatise on the sublime. Longinus notes that the "introduction of gaps or open tracery in architecture . . . utterly spoils the effect of sublime ideas, well ordered and built into one coherent structure." See *"Longinus" on the Sublime*, trans. W. Hamilton Fyfe (1927; repr., New York: G. P. Putnam's Sons, 1932), p. 161. To the best of my knowledge, this analogue has never been noted in the Ruskin criticism. Ruskin often hid his sources, and it is very likely that he knew Longinus's treatise. His comments on the sublime, both in *Modern Painters* and his architectural writings, show complete familiarity with the doctrine.

Ruskin's most direct source for the comments on tracery, as he points out, is R. Willis's *Remarks on the Architecture of the Middle Ages* (Cambridge, 1835). Willis was primarily interested in principles of construction. Ruskin cites him as an authority again in the first volume of *The Stones of Venice*, a text devoted to the "laws" of construction. The metaphorical significance that Ruskin attaches to the overdevelopment of tracery is made all the more satisfying by its emergence out of, not ignorance of, the principles of construction.

10 Walter Benjamin, *Reflections: Essays, Aphorisms, Autobiographical Writings*, trans. Edmund Jephcott, ed. Peter Demetz (New York: Harcourt Brace Jovanovich, 1978), p. 147.

Illustrations

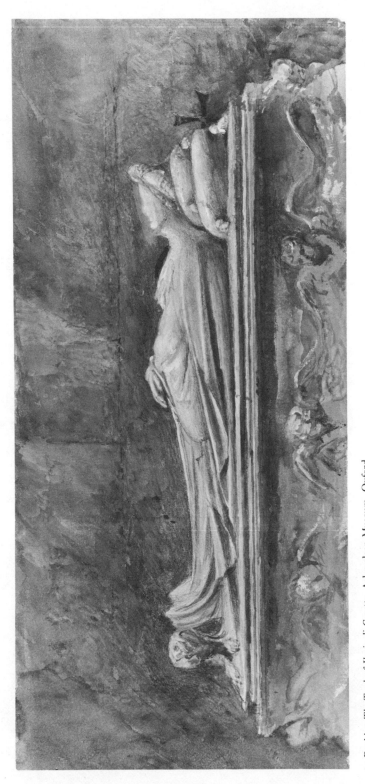

1. Ruskin, *The Tomb of Ilaria di Caretto*. Ashmolean Museum, Oxford.

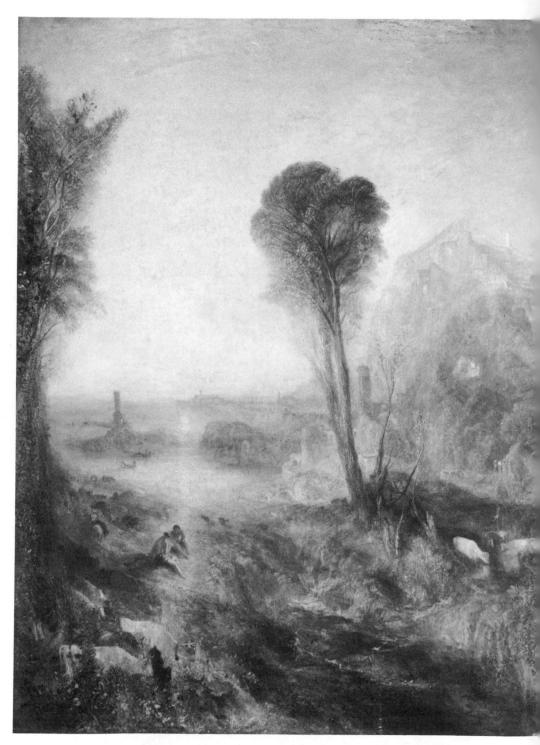

2. Turner, *Mercury and Argus*. National Gallery of Canada, Ottawa.

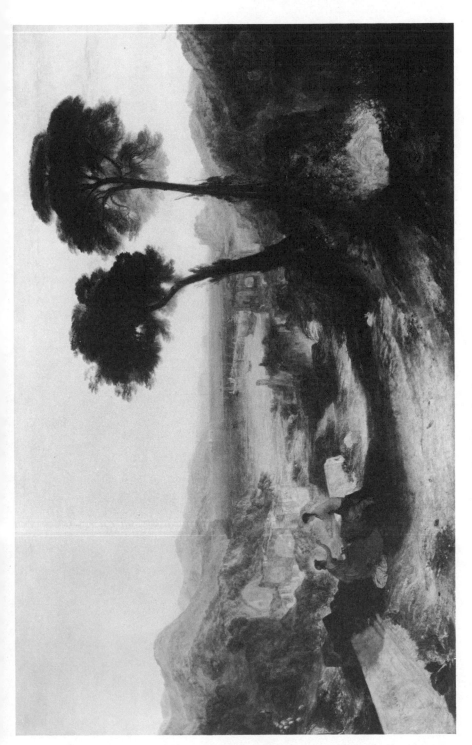

3. Turner, *The Bay of Baiae, with Apollo and the Sibyl*. The Tate Gallery, London.

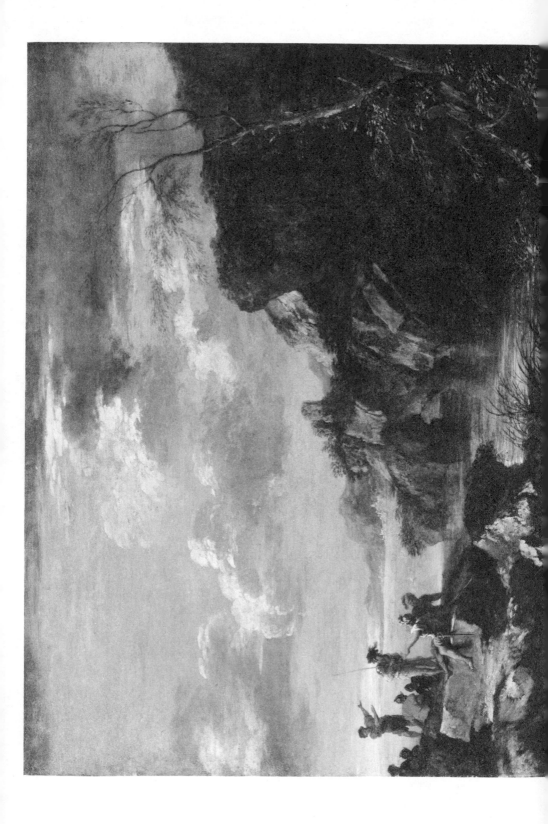

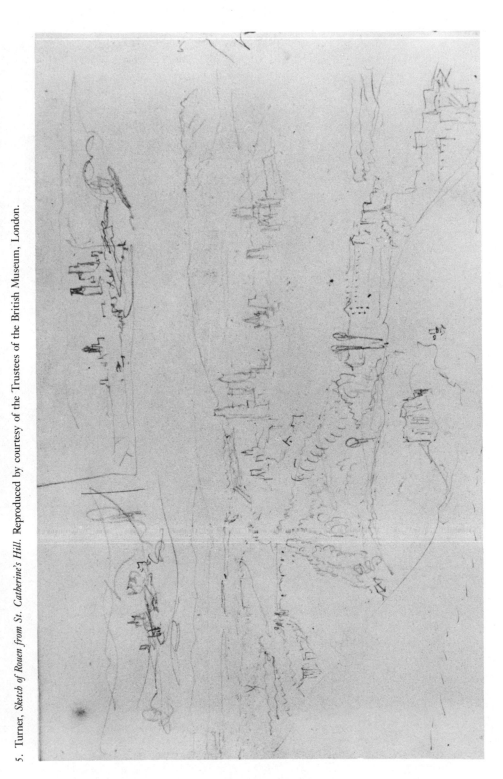

4. Rosa, *Bandits on a Rocky Coast*. The Metropolitan Museum of Art, New York. Charles B. Curtis Fund, 1934.

5. Turner, *Sketch of Rouen from St. Catherine's Hill*. Reproduced by courtesy of the Trustees of the British Museum, London.

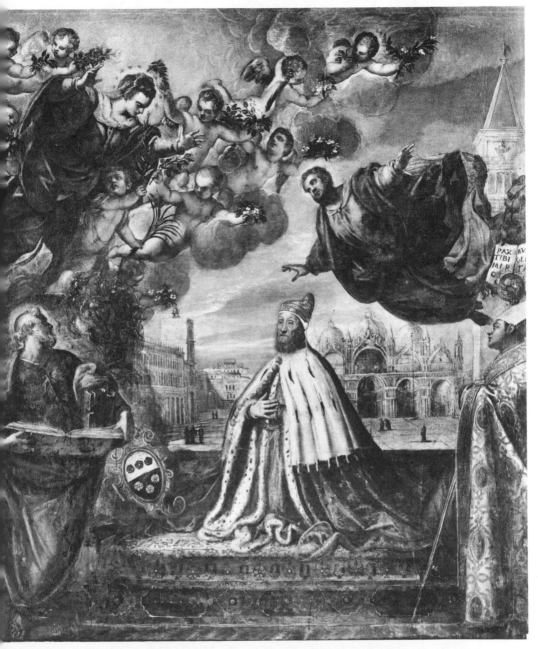

Turner, *The Slave Ship (Slavers Throwing Overboard the Dead and Dying, Typhon Coming On)*. Courtesy, Museum of Fine s, Boston. Purchase, Henry Lillie Pierce Fund.

Tintoretto, *Doge Loredano before the Virgin*. Ducal Palace, Venice. Courtesy, Archivi Alinari/Art Resource.

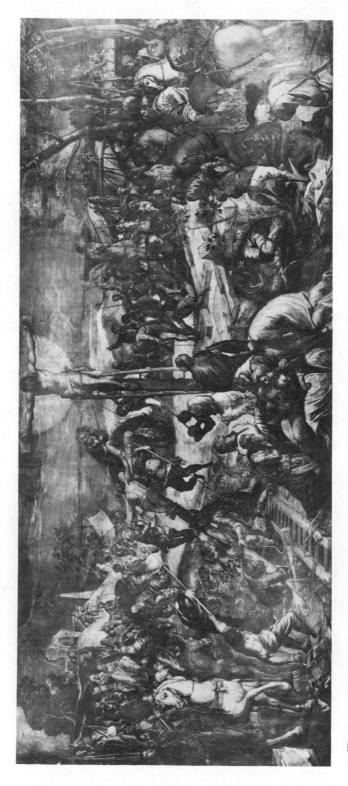

8. Tintoretto, *Crucifixion*. Scuola di San Rocco, Venice. Courtesy, Archivi Alinari/Art Resource.

9. Ruskin, *Decoration by Disks*. From *The Works of John Ruskin: Library Edition*, ed. E. T. Cook and Alexander Wedderburn (London: George Allen, 1903–12). Photo by Michael Marsland.

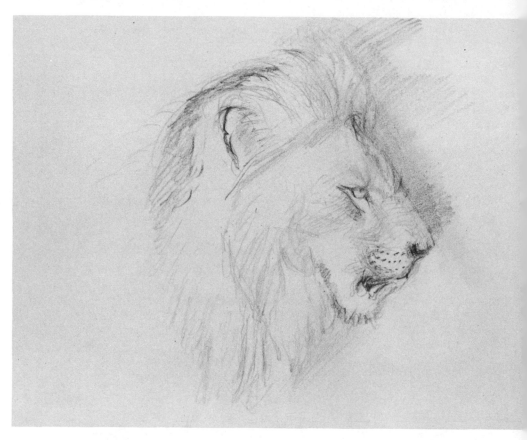

10. Ruskin, *Sketch of the Head of a Living Lion*. Ashmolean Museum, Oxford.

11. Ruskin, *Sketch of the Head of an Eagle*. Ashmolean Museum, Oxford.

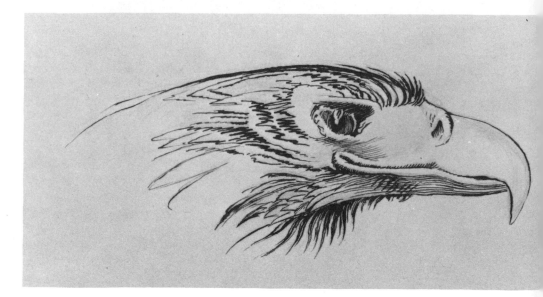

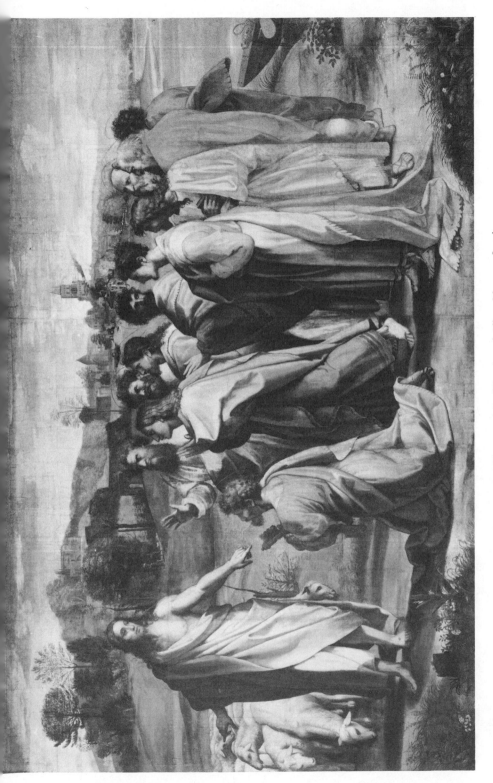

12. Raphael, *Christ's Charge to St. Peter*. By courtesy of the Board of Trustees of the *Victoria and Albert Museum*, London.

13. Ruskin, *Study of Tintoretto's "Adoration of the Magi."* The Ruskin Galleries, Bembridge School, Isle of Wight.

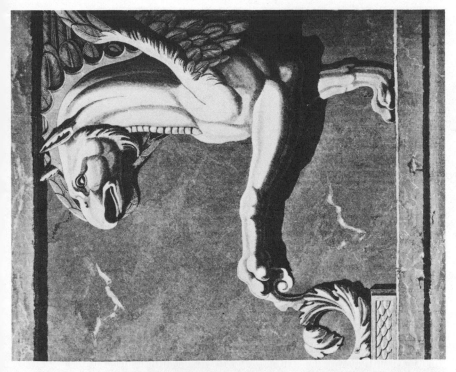

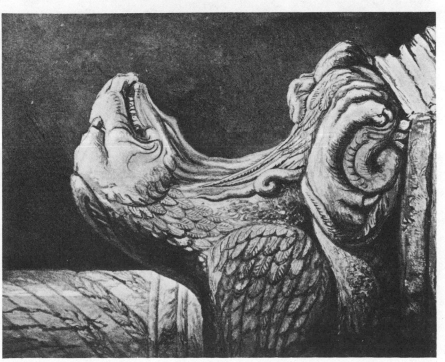

14. Ruskin, *True and False Griffins*. From *The Works of John Ruskin: Library Edition*, ed. E. T. Cook and Alexander Wedderburn (London: George Allen, 1903–12). Photo by Michael Marsland.

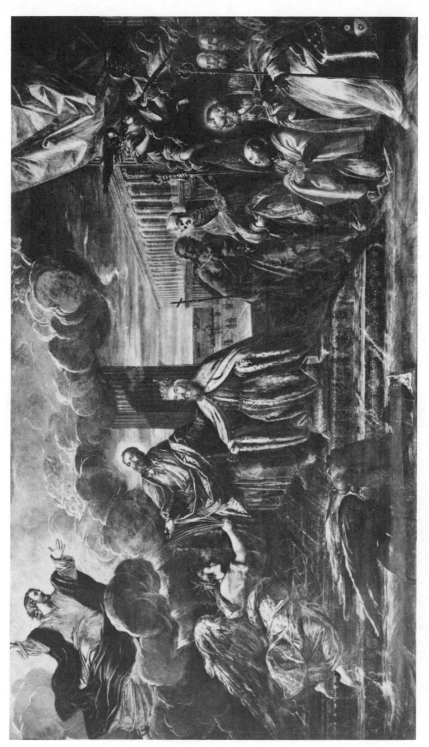

15. Tintoretto, *Doge Mocenigo*. Ducal Palace, Venice. Courtesy, Archivi Alinari/Art Resource.

16. Turner, *The Goddess of Discord Choosing the Apple of Contention in the Garden of the Hesperides*. The Tate Gallery, London.

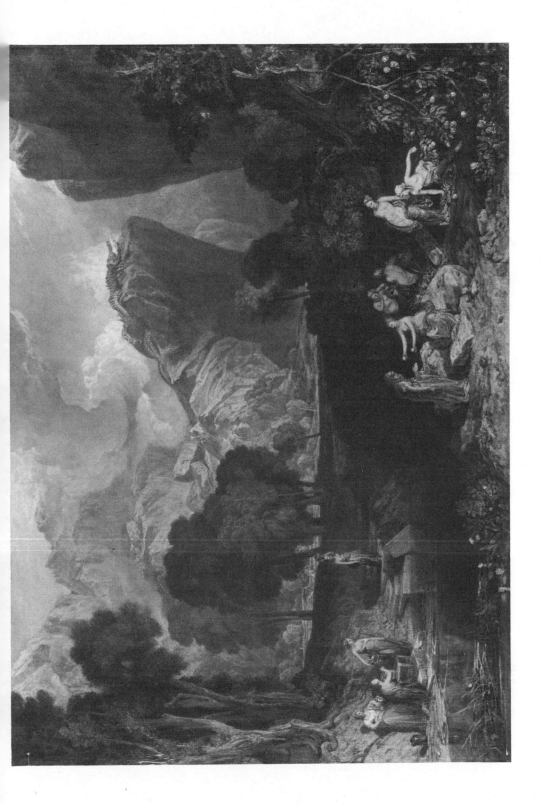

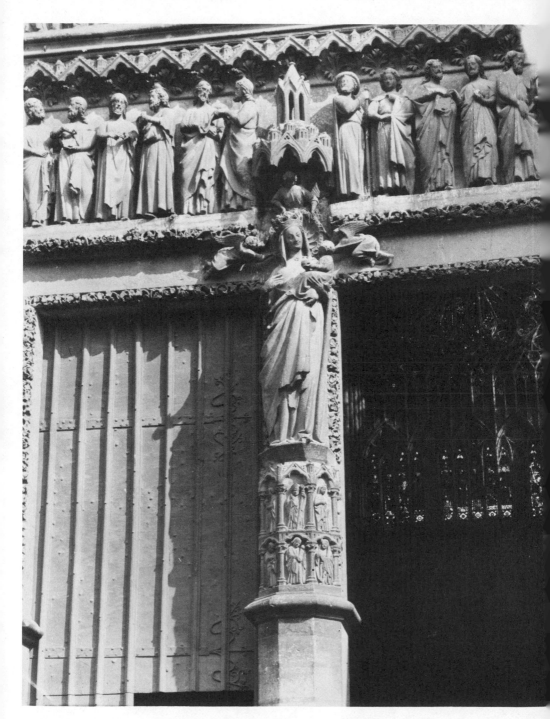

17. *Vierge Dorée*, Amiens Cathedral. Conway Library, Courtauld Institute of Art, London.

18. South Front, Amiens Cathedral. Conway Library, Courtauld Institute of Art, London.

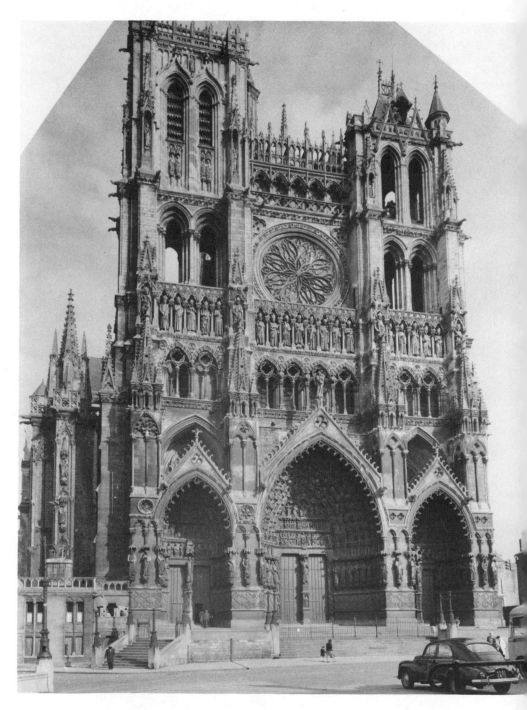

19. West Front, Amiens Cathedral. Conway Library, Courtauld Institute of Art, London.

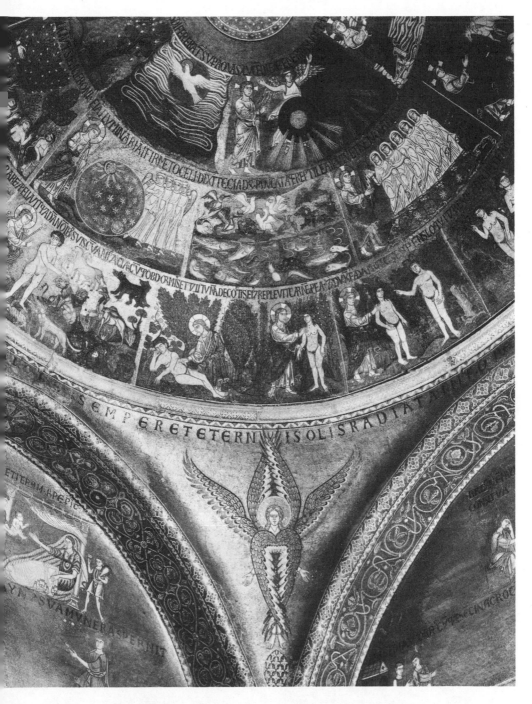

Mosaics, St. Mark's Cathedral, Venice. Conway Library, Courtauld Institute of Art, London.

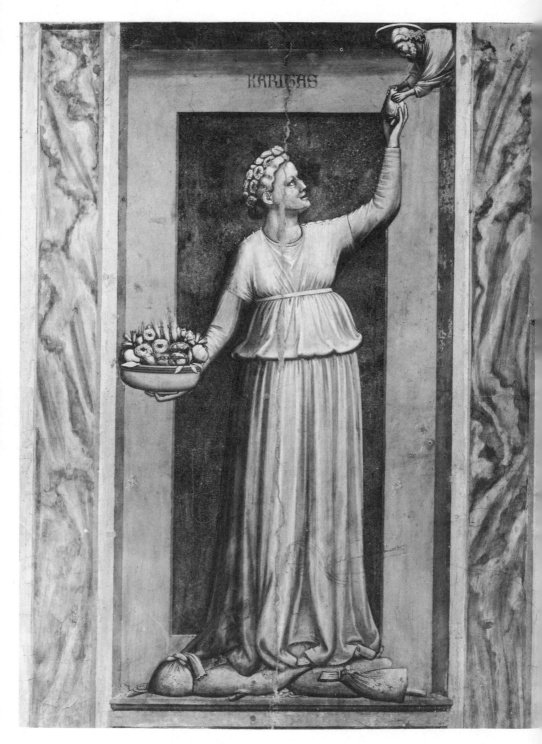

21. Giotto, *Charity*. Arena Chapel, Padua. Courtesy, Archivi Alinari/Art Resource.

22. Uhlrich, *The Nativity of Athena*. From *The Works of John Ruskin: Library Edition*, ed. E. T. Cook and Alexander Wedderburn (London: George Allen, 1903–12). Photo by Michael Marsland.

23. Scott, A *View of Ailsa Craig and the Isle of Arran*. Yale Center for British Art, New Haven. Paul Mellon Collection.

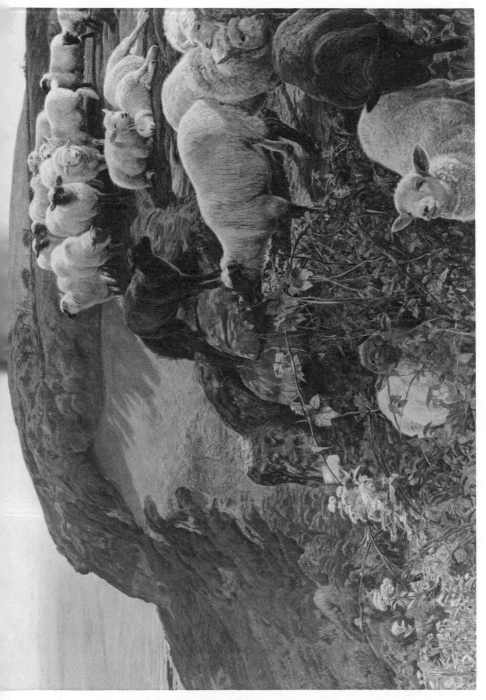

24. Hunt, *Our English Coasts* (*Strayed Sheep*). The Tate Gallery, London.

25. Dickinson Brothers, *The Exterior of the Crystal Palace*. From *Dickinsons' Comprehensive Pictures from the Great Exhibition of 1851* (London: Dickinson Brothers, 1854). Yale Center for British Art, New Haven. Paul Mellon Collection.

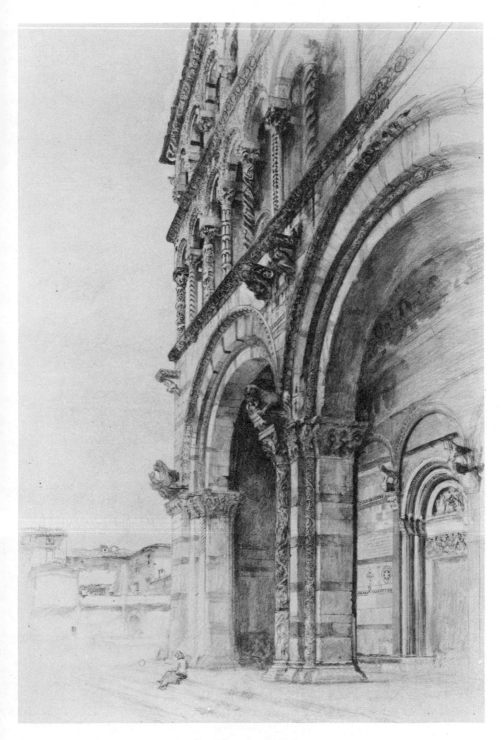

26. Ruskin, *San Martino, Lucca*. Ashmolean Museum, Oxford.

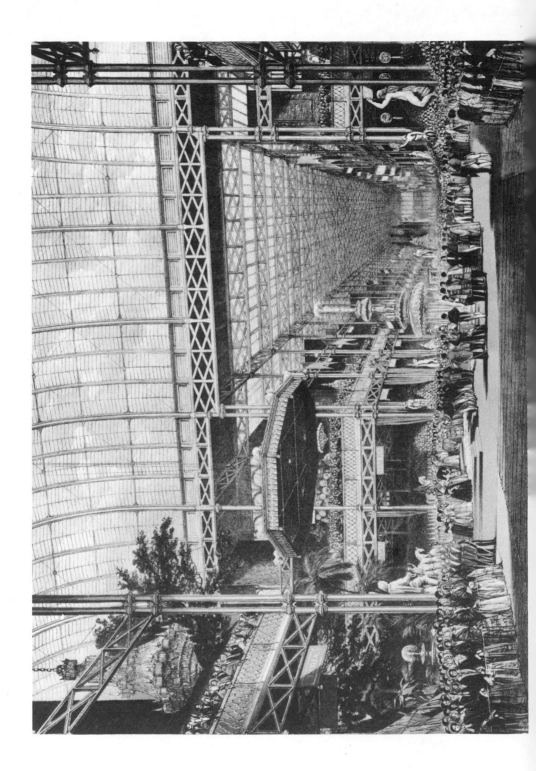

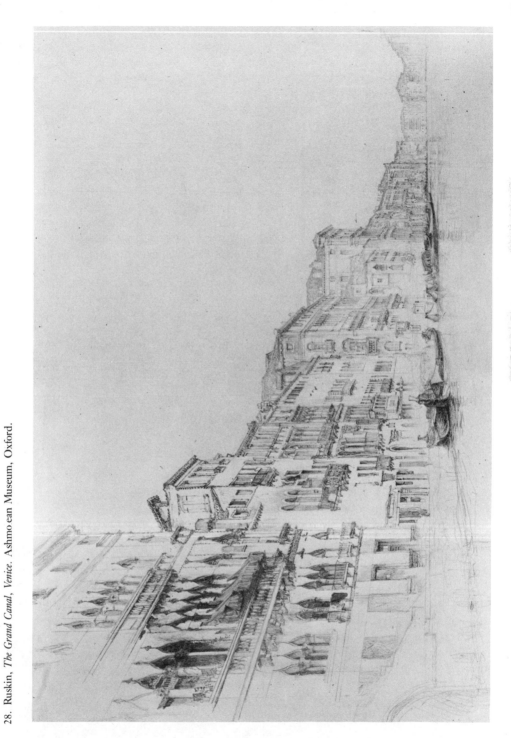

27. Dickinson Brothers, *interior view*, from *Dickinson's Comprehensive Pictures of the Great Exhibition of 1851* (detail). Yale Center for British Art, New Haven. Paul Mellon Collection.

28. Ruskin, *The Grand Canal, Venice*. Ashmoean Museum, Oxford.

29. Ruskin, *Traceries from Caen, Bayeux, Rouen and Beauvais*. From *The Works of John Ruskin: Library Edition*, ed. E. T. Cook and Alexander Wedderburn (London: George Allen, 1903–12). Photo by Michael Marsland.

30. Ruskin, *Linear and Surface Gothic*. From *The Works of John Ruskin: Library Edition*, ed. E. T. Cook and Alexander Wedderburn (London: George Allen, 1903–12). Photo by Michael Marsland.

31. *Chestnut Spandrel in Iron Work*. From *The Works of John Ruskin: Library Edition*, ed. E. T. Cook and Alexander Wedderburn (London: George Allen, 1903–12). Photo by Michael Marsland.

Index

Aagaard-Mogensen, Lars, 41
Abrams, Meyer, 113
Academy Notes, 165
Acland, Henry, 170, 182
Addison, Joseph, 9, 33, 158; on imagination and understanding, 20, 21
Adoration of the Magi (Tintoretto), 87, 89
Alison, Archibald, 43, 59, 60, 62, 176, 177; on proportion, 50, 55–58; and metaphorical associations, 54, 61, 66
Angelico, Fra, 42, 54, 58, 62, 92, 100; *The Spirits in Prison*, 52; as a purist, 53, 82, 87
Annunciation (Tintoretto), 45
Aratra Pentelici, 112, 114, 115, 122, 129, 132; theme of idolatry, 144–55
Aristotle, 12, 42, 43, 44, 45
Arnold, Matthew, 43, 75, 103, 113
Athena, 114, 115; as personified imagination, 145–47, 150–55
Auerbach, Erich, 46, 47

Ball, Patricia, 3
Balzac, Honoré de, 133, 138
Bay of Baiae, with Apollo and the Sibyl (Turner), 26
Beaumont, George, 82
Bell, Sir Charles, 61
Benjamin, Walter, 182
Bennett, Jonathan, 5
Berkeley, George, 45
Bible of Amiens, 46, 109, 110, 115, 119, 120, 133, 135, 155
Bloom, Harold, 2, 108, 131, 132
Botticelli, Sandro, 92
Boyd, Alice, 158
Braudel, Fernand, 119

Bronson, Bertrand H., 92, 93
Bronzino, Agnolo, 54
Brown, W. L., 40
Buckley, Jerome, 18
Burd, Van Akin, 53
Burke, Edmund, 7, 18, 33, 61, 62, 158; on imitative pleasure, 12–13; on proportion, 50, 58–60
Byron, George Gordon, Lord, "The Prisoner of Chillon," 84

Caravaggio, Michelangelo Merisi da, 82
Carlyle, Thomas, 43, 45, 110, 113, 120
Carpaccio, Vittore, 110
Charis, 148–52
Christ's Charge to St. Peter (Raphael), 85, 86, 89, 91, 92
Claude Lorraine, 7, 30, 162, 163, 164
Coleridge, Samuel Taylor, 3, 9, 12, 45, 72, 77, 130, 164; and pathetic fallacy, 128–29
Collingwood, W. G., 2, 1
Collins, Peter, 169, 170
Constable, John, 34, 35, 82, 161, 162
Cook, E. T., 2, 109
Crucifixion (Tintoretto), 47
Cuyp, Aelbert, 30, 164

Dante Alighieri, 85, 92, 98–104, 109, 130; his mimetic capacity, 100–01; allegory of Matilda, 100–04, 105; contrasted to Coleridge, 128–29
Deane and Woodward (architects), 170
De Man, Paul, 151; on Lockean sign, 24, 25, 27; on allegory and metaphor in Proust, 114, 139–44
Diana: as "real" allegory, 96–98, 105, 108